CW00558151

Cool Restaurants
Copenhagen

teNeues

Imprint

Editors: Christian Datz, Christof Kullmann, Mainz

All photos by Christoph Kraneburg, Köln

Except food photos courtesy of Restaurant Extra (page 28), Mojito Group (page 38), restaurant paustian bo bech (page 88), Admiral Hotel (page 96) and Sushitarian (page 122).

Imaging & Pre-press: Jan Hausberg, Vanessa Kuhn, Martin Herterich

Translations: CET Central European Translations GmbH
Michael Dobbins (English), Frederic Charreron (French / recipes), Virginie Delavarinya-Ségard (French), Stefan Scheuermann (Spanish), Fjona Stühler (Italian)
Nina Hausberg (German, English / recipes)

Produced by fusion publishing GmbH, Stuttgart . Los Angeles www.fusion-publishing.com

Published by teNeues Publishing Group

teNeues Verlag GmbH + Co. KG
Am Selder 37
47906 Kempen, Germany
Tel.: 0049-2152-916-0
Fax: 0049-2152-916-111
Press department:
arehn@teneues.de
Phone: 0049-2152-916-202

teNeues
International Sales Division
Speditionstraße 17
40221 Düsseldorf, Germany
Tel.: 0049-211-994597-0
Fax: 0049-211-994597-40
E-mail: books@teneues.de

teNeues Publishing Company
16 West 22nd Street
New York, NY 10010, USA
Tel.: 001-212-627-9090
Fax: 001-212-627-9511

teNeues Publishing UK Ltd.
P.O. Box 402
West Byfleet
KT14 7ZF, Great Britain
Tel.: 0044-1932-403509
Fax: 0044-1932-403514

teNeues France S.A.R.L.
4, rue de Valence
75005 Paris, France
Tel.: 0033-1-55766205
Fax: 0033-1-55766419

teNeues Ibérica S.L.
Pso. Juan de la Encina 2–48
Urb. Club de Campo
28700 S.S.R.R. Madrid, Spain
Tel.: 0034-657-132133
Tel./Fax: 0034-91-6595876

www.teneues.com

ISBN-10: 3-8327-9146-9
ISBN-13: 978-3-8327-9146-9

Bibliographic information published by Die Deutsche Bibliothek.
Die Deutsche Bibliothek lists this publication in the Deutsche Nationalbibliografie; detailed bibliographic data is available in the Internet at http://dnb.ddb.de.

Average price reflects the average cost for a dinner main course, menu price for a multiple course menu. All prices exclude beverages. Recipes serve four.

Contents

Page

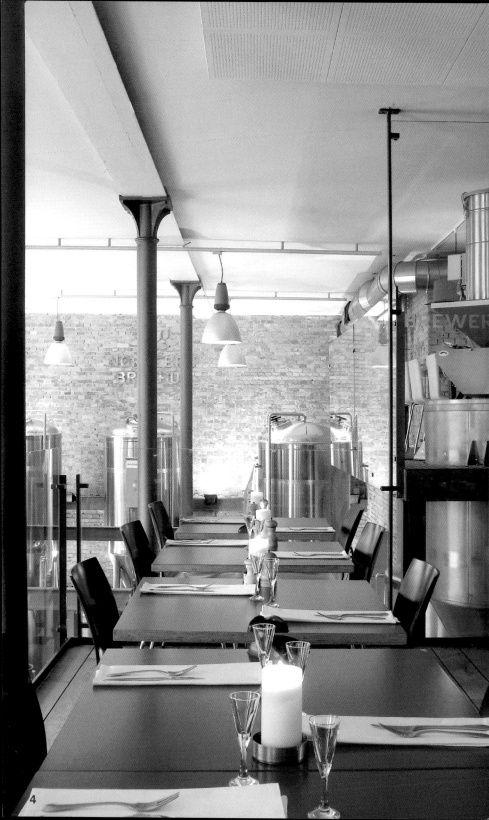

Introduction

The famous Danish architect Arne Jacobsen claimed that he enjoyed visiting old-fashioned cafés the most: there was nothing left for a designer to rescue in their plushy ambience anyway, he said. Therefore, he was allegedly able to relax better there than anywhere else. Of course, there are no plushy cafés among the restaurants, bars, lounges and clubs compiled here. Instead, the broad array of different localities—from a Gothic basement vault to an elegant panorama restaurant—shows that cool design and good taste are nearly omnipresent in Copenhagen.

As expected in a capital and port city, the culinary offers are international and extremely diverse. While several of the presented locations—for example the restaurants De Gaulle, Kokkeriet, Rasmus Oubæk or Le Sommelier—are inspired by French cuisine, friends of Italian cooking will get their money's worth at Era Ora or Alberto K. Tapasbaren offers Spanish appetizers, while Sushitarian offers Asian fish specialties and noodle dishes. The restaurant Noma, on the other hand, is entirely devoted to Nordic gourmet cuisine. The design and décor of the various restaurants are just as diverse: the minimalist chic look of the restaurant Extra allows for contemplative pleasure, and Formel B surprises with a combination of noble stone claddings and deliberately simple plaster surfaces. The Laundromat Café, where you may eat breakfast, borrow books, and do wash at the same time in an easy-going elegant atmosphere, is also unique. As a contrast, there is the exclusive restaurant The Paul in Tivoli with its bright roof construction made of steel and glass—the Danish queen is reported to be a frequent guest here as well.

So it's time to head to Copenhagen! This city has something to offer for every taste—as long as it's good taste. As a special offer for all of those who not only want to experience this on location, but also at their own stove, some of Copenhagen's best chefs have revealed their favorite recipes in this book.

Christian Datz, Christof Kullmann

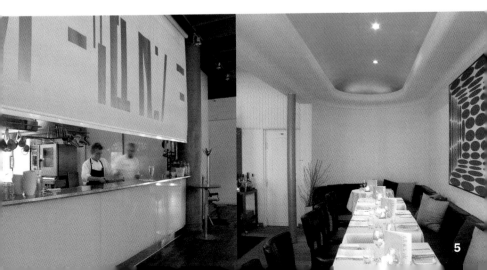

Einleitung

Von dem berühmten dänischen Architekten Arne Jacobsen heißt es, er habe am liebsten altmodische Cafés besucht: In deren plüschigem Ambiente wäre, wie er meinte, für einen Designer ohnehin nichts mehr zu retten. Darum könne er sich hier am besten entspannen. Plüschige Cafés sind unter den hier versammelten Restaurants, Bars, Lounges und Clubs natürlich nicht zu finden. Stattdessen zeigt ein breites Spektrum unterschiedlicher Lokalitäten – vom gotischen Kellergewölbe bis zum eleganten Panoramarestaurant –, dass cooles Design und guter Geschmack in Kopenhagen nahezu allgegenwärtig sind.

Wie in einer Haupt- und Hafenstadt zu erwarten, sind die kulinarischen Angebote dabei international und höchst unterschiedlich. Während einige der vorgestellten Küchen – beispielsweise die Restaurants De Gaulle, Kokkeriet, Rasmus Oubæk oder Le Sommelier französisch inspiriert sind, kommen im Era Ora oder dem Alberto K Freunde italienischer Kochkunst auf ihre Kosten. Die Tapasbaren bietet spanische Häppchen, das Sushitarian asiatische Fischspezialitäten und Nudelgerichte. Das Restaurant Noma hingegen widmet sich ganz der nordischen Gourmetküche. Ebenso vielfältig sind Design und Ausstattung der verschiedenen Restaurants: Der minimalistische Chic des Restaurants Extra ermöglicht kontemplativen Genuss, das Formel B überrascht mit einer Kombination aus edlen Natursteinverkleidungen und bewusst schlicht verputzten Wandflächen. Ungewöhnlich ist auch das Laundromat Café, wo man in lässig-eleganter Umgebung gleichzeitig frühstücken, Bücher entleihen und Wäsche waschen kann. Als Gegensatz dazu findet sich im Tivoli das exklusive Restaurant The Paul mit seiner lichten Dachkonstruktion aus Stahl und Glas – hier ist, so wird berichtet, nicht selten auch die dänische Königin zu Gast.

Auf also nach Kopenhagen! Diese Stadt hat für jeden Geschmack etwas zu bieten – solange es ein guter ist. Als besonderes Angebot für alle, die dies nicht nur vor Ort erleben, sondern auch am eigenen Herd nachvollziehen wollen, haben einige der besten Köche Kopenhagens in diesem Buch ihre Lieblingsrezepte verraten.

Christian Datz, Christof Kullmann

Introduction

On dit du fameux architecte danois Arne Jacobsen qu'il aurait préféré les cafés anciens : dans leur ambiance velouteuse, pensait-il, il n'y avait de toute façon plus rien à faire pour un designer, et que cela lui permettait de se détendre au mieux. Parmi les restaurants, bars, lounges et clubs regroupés dans cet ouvrage vous ne trouverez naturellement pas de cafés velouteux. Vous y trouverez par contre une large gamme de lieux les plus divers – du cellier gothique au restaurant panoramique élégant – qui illustrera que le design cool et le goût sont presque universels à Copenhague.

Comme on doit s'y attendre pour une ville capitale et portuaire, les offres culinaires sont internationales et très diverses. Tandis que certaines des cuisines présentées – par exemple les restaurants De Gaulle, Kokkeriet, Rasmus Oubæk ou Le Sommelier – sont d'inspiration française, les amis de la cuisine italienne seront plutôt attirés par le Era Ora ou le Alberto K. Le Tapasbaren propose des mets espagnols et le Sushitarian des spécialités de poisson asiatiques et des pâtes. Le restaurant Noma par contre se consacre entièrement à la cuisine de gourmets nordique. Le design et l'aménagement des différents restaurants sont également très diversifiés : Le chic minimaliste du restaurant Extra vous pousse à la dégustation contemplative, le Formel B surprend par une combinaison d'habillages nobles en pierres naturelles et des surfaces crépies. Le Laundromat Café sort également de l'ordinaire, puisqu'on peut y prendre son petit-déjeuner et emprunter des livres, tout en y lavant son linge dans une ambiance décontractée et élégante. Dans le Tivoli vous trouverez le The Paul, un restaurant très exclusif avec une toiture en acier et en verre, qui compte, dit-on, la Reine du Danemark parmi ses hôtes réguliers.

Alors en route pour Copenhague ! Cette ville offre des plaisirs culinaires pour tout les goûts, tant qu'ils sont bons. Pour toux ceux, qui souhaitent non seulement en profiter sur place, mais également les reproduire chez eux, quelques-uns des meilleurs chefs de Copenhague nous ont confiés dans ce livre leurs recettes préférées.

Christian Datz, Christof Kullmann

Introducción

El famoso arquitecto danés Arne Jacobsen tenía, según la leyenda urbana, una predilección por los salones de café horteras. Consideraba que, cuanto más caduco y hortera un bar, mejor lugar es para que un diseñador pueda resignarse ante la fatalidad y encontrar descanso. Estos cafés venidos a menos naturalmente no figuran entre los restaurantes, bares, lounges y clubs aquí seleccionados. En cambio, el lector hallará un amplio espectro de diferentes y atractivos establecimientos, desde un sótano gótico abovedado hasta un elegante restaurante con vistas panorámicas, y podrá convencerse de que en Copenhague el diseño vanguardista y el buen gusto se hacen casi omnipresentes.

Como es de esperar en una gran capital portuaria, la oferta gastronómica se presenta internacional y muy diversa. Mientras algunas de las cocinas sugeridas, por ejemplo los restaurantes De Gaulle, Kokkeriet, Rasmus Oubæk o Le Sommelier denotan una clara inspiración francesa, los amantes del arte de la cocina italiana quedarán bien atendidos en el Era Ora o el Alberto K. El Tapasbaren, como su nombre indica, ofrece tapas españolas y el Sushitarian especialidades asiáticas de pescado y pasta. Por otro lado, el restaurante Noma se dedica exclusivamente a la cocina nórdica gourmet. La misma variedad caracteriza el diseño y equipamiento de los diferentes restaurantes: La elegancia minimalista del restaurante Extra es propicio para el placer contemplativo, mientras el Formel B sorprende con un revestimiento que conjuga la nobleza de la piedra natural y la austeridad intencionada de los enlucidos. También el Laundromat Café es un lugar que se sale de lo habitual. En este espacio elegante y desenfadado se puede desayunar, pedir libros prestados y lavar ropa. En un plano bien diferente, en el Tivoli se encuentra el exclusivo restaurante The Paul, que, como cuentan los entendidos, recibe a menudo bajo su luminoso techo acristalado con estructura de acero la visita de la Reina de Dinamarca.

¡Vayamos, pues, a Copenhague! Esta ciudad ofrece algo para todos los gustos, siempre y cuando el gusto sea bueno. Como oferta especial dirigida a aquellos que no se conforman con haber tenido la experiencia culinaria in situ, sino que quisieran repetirla en su propia cocina, algunos de los mejores cocineros de Copenhague han revelado en este libro algunas de sus recetas preferidas.

Christian Datz, Christof Kullmann

8

Introduzione

Del famoso architetto danese Arne Jacobsen si dice che egli amasse molto andare in caffè fuori moda: in questo ambiente così feudale, un designer, questa l'opinione di Jacobsen, non avrebbe più comunque potuto migliorare nulla, per questo motivo lì egli riusciva a rilassarsi al meglio. Naturalmente non è più possibile trovare dei caffè così feudali tra i ristoranti, bar, lounge e club qui riuniti. Al contrario un ampio spettro delle più diverse località – dall'ambiente a cantina con soffitti gotici a volta, fino all'elegante ristorante-panorama – mostra che un design particolare ed il buon gusto a Copenhagen sono praticamente onnipresenti.
Come ci si aspetta da una città capitale e portuale, le offerte culinarie sono internazionali e molto variegate. Mentre alcune delle cucine presentate – ad esempio i ristoranti De Gaulle, Kokkeriet, Rasmus Oubæk oppure Le Sommelier hanno un'ispirazione francese, nell'Era Ora oppure nell'Alberto K le richieste degli amici della cultura culinaria italiana verranno completamente soddisfatte. Il Tapasbaren offre bocconcini spagnoli, il Sushitarian offre specialità di pesce asiatiche e piatti a base di pasta. Il ristorante Noma al contrario si concentra completamente sulla cucina per gourmet alla nordica. Ugualmente variegate sono il design e l'arredamento dei diversi ristoranti: lo chic minimalistico del ristorante Extra permette un piacere contemplativo, il ristorante Formel B sorprende con una combinazione di nobili rivestimenti in pietra naturale e le superfici di pulizia volutamente semplici. Diverso dal solito è anche il Laundromat Café, dove è possibile fare colazione in un ambiente leggero-elegante, ed al contempo noleggiare libri e fare il bucato. In contrapposizione ad esso si trova nel Tivoli il ristorante esclusivo The Paul con la sua chiara costruzione del tetto in acciaio e vetro – qui viene anche spesso, così si dice, la Regina danese.
Partiamo allora subito per Copenhagen! Questa città ha qualcosa da offrire per ogni gusto – fintanto che si tratta di buon gusto. Come offerta speciale per tutti che non desiderano vivere tutto ciò solo lì, ma che desiderano invece vivere tutto ciò anche a casa, alcuni dei migliori cuochi di Copenhagen hanno raccolto le loro ricette preferite in questo libro.

Christian Datz, Christof Kullmann

9

Alberto K

Design: Arne Jacobsen | Chef: Betina Repstock
Owner: Radisson SAS Royal

Hammerichsgade 1 | 1602 København V
Phone: +45 33 42 61 61
www.aok.dk/albertok
Opening hours: Mon–Sat 6 pm to midnight
Menu price: DKK 555–675
Cuisine: Scandinavian, Italian

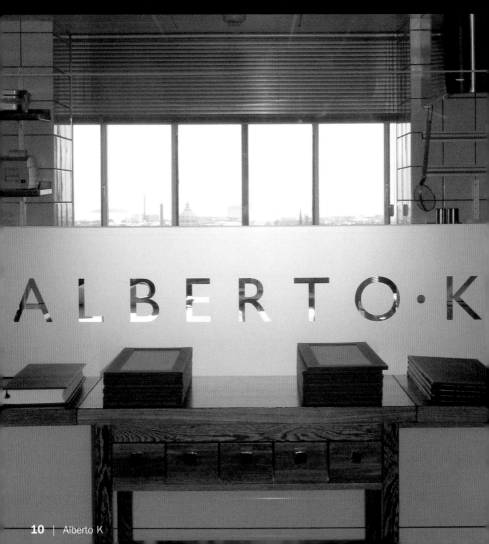

Brasserié ego

Design: Mikkel Shafi, Karina Kejser Bøhl | Chef: Heine Knudsen
Owner: Mikkel Shafi

Hovedvagtsgade 2 | 1103 København K
Phone: +45 33 12 79 71
www.egocph.dk
Opening hours: Mon–Thu 11:30 am to 11 pm, Fri 11:30 am to 2 am,
Sa 10 am to 2 am
Menu price: DKK 245
Cuisine: Brasserie with a twist

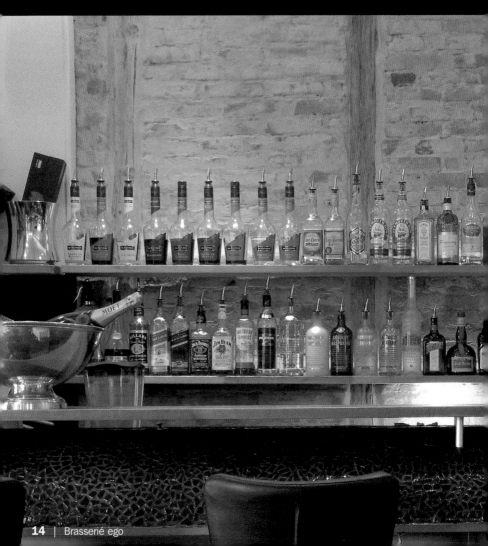

Pâté de Foie Gras
with Apple Chutney

Gänseleberterrine mit Apfelchutney
Terrine de foie gras au chutney de pommes
Terrina de foie gras con chutney de manzana
Terrina di foie gras con Chutney di mela

6 ½ oz foie gras
50 ml Madeira
Salt, pepper
Clean the foie gras, remove tendons and veins and cut in rough chunks. Season with Madeira, salt and pepper and fill in a square pan, lined with aluminium foil. Press tightly and bake at 260 °F for 15 minutes.

2 apples
2 tbsp lemon juice
2 tbsp sugar
100 ml apple juice
1 clove
1 tsp pepper corns, crushed
1 bay leave
1 star anise

Peel and dice the apples and drizzle with lemon juice. Bring sugar, apple juice and spices to a boil, drain and cook the apple cubes in the spice fond until reduced.

3 tbsp sugar
1 tbsp water
Combine sugar and water and cook until you have a light brown caramel. Put one stripe caramel on each plate, while still hot.

Cut the pâté in thick slices and place with a scoop of apple chutney next to the caramel decoration. Decorate with a rice paper.

200 g Gänsestopfleber
50 ml Madeira
Salz, Pfeffer
Die Gänseleber putzen, von Sehnen und Adern befreien und in grobe Stücke zerteilen. Mit Madeira, Salz und Pfeffer würzen und in eine mit Alufolie ausgelegte Kastenform füllen. Fest andrücken und bei 130 °C 15 Minuten backen.

2 Äpfel
2 EL Zitronensaft
2 EL Zucker
100 ml Apfelsaft
1 Nelke
1 TL Pfefferkörner, zerstoßen
1 Lorbeerblatt
1 Sternanis

Die Äpfel schälen und würfeln und mit Zitronensaft beträufeln. Zucker, Apfelsaft und die Gewürze aufkochen, abseihen und die Apfelwürfel in dem Gewürzsud weich kochen.

3 EL Zucker
1 EL Wasser
Zucker und Wasser mischen und zu einem hellbraunen Karamell einkochen. Im noch heißen Zustand einen Streifen Karamell auf vier Teller geben.

Die Gänseleberterrine in dicke Scheiben schneiden und mit einer Nocke Apfelchutney auf den Teller neben die Karamelldekoration setzen. Mit einem Reispapier dekorieren.

200 g de foie gras d'oie
50 ml de madère
Sel, poivre
Nettoyer le foie d'oie, le débarrasser des tendons et veines et le découper en gros morceaux. Assaisonner de madère, sel et poivre et remplir un moule à cake foncé de papier d'aluminium. Bien tasser et faire cuire 15 minutes au four à 130 °C.

2 pommes
2 c. à soupe de jus de citron
2 c. à soupe de sucre
100 ml de jus de pomme
1 clou de girofle
1 c. à café de grains de poivre, moulus
1 feuille de laurier
1 anis étoilé

Peler les pommes et les couper en dés, puis arroser de jus de citron. Faire bouillir le sucre, le jus de pomme et les épices, filtrer et réduire les dés de pommes dans le jus d'épices.

3 c. à soupe de sucre
1 c. à soupe d'eau
Faire cuire sucre et eau ensemble pour obtenir un caramel brun clair. Déposer un ruban de caramel encore chaud sur chacune des quatre assiettes.

Couper la terrine de foie gras en tranches épaisses, former une quenelle de chutney de pommes avec une cuillère et la déposer sur l'assiette à côté de la décoration de caramel. Décorer avec du papier de riz.

200 g de foie gras
50 ml de vino de Oporto
Sal, pimienta
Limpiar el foie gras de tendones y venas y cortarlo en trozos grandes. Sazonar con el vino de Oporto, sal y pimienta y poner en un molde rectangular, cubierto con papel de aluminio. Apretar y hornear a 130 °C durante 15 minutos.

2 manzanas
2 cucharadas de zumo de limón
2 cucharadas de azúcar
100 ml zumo de manzana
1 clavo
1 cucharadita de pimienta en grano machacada
1 hoja de laurel
1 anís estrellado

Pelar las manzanas y cortarlas en cuadritos, rociar con zumo de limón. Hervir el zumo de manzana con el azúcar y las especias, pasar por un colador y reducir los cuadritos de manzana en la decocción.

3 cucharadas de azúcar
1 cucharada de agua
Mezclar el azúcar y el agua y dejar que reduzca hasta obtener un caramelo de color moreno claro. Dibujar una cinta de caramelo en cada plato mientras esté caliente.

Cortar la terrina de foie gras en lonchas gruesas, dar forma al chutney de manzana con una cuchara y colocarla en el plato junto a la cinta de caramelo de la decoración. Decorar con un papel de arroz.

200 g di foie gras
50 ml madeira
Sale, pepe
Pulire il foie gras, togliere i tendini e le venette e tagliare in grossi pezzi. Aggiungere madeira, sale e pepe e riempire una forma preparata con foglio di alluminio. Premere bene e cuocere a 130 °C per 15 minuti.

2 mele
2 cucchiai di succo di limone
2 cucchiai di zucchero
100 ml succo di mela
1 cannella
1 cucchiaino di grani di pepe, sbattuti
1 foglia di alloro
1 anice stellata

Sbucciare le mele e tagliarle a quadretti ed aggiungerci sopra del succo di limone. Scaldare zucchero, succo di mela e spezie, scolare e far restringere le mele nel brodo degli aromi.

3 cucchiai di zucchero
1 cucchiaio d'acqua
Mescolare lo zucchero e l'acqua e cuocerli creando un caramello di colore bruno scuro. Allo stato ancora caldo porre rispettivamente una riga di caramello su quattro piatti.

Tagliare la terrina di foie gras in grosse fette, usando un cucchiaio dare forma al Chutney di mela e porlo su un piatto vicino alla decorazione di caramello.

Kronborggade 3 | 2200 København
Phone: +45 35 85 58 66
www.de-gaulle.dk
Opening hours: 6 pm to 1 am, kitchen 6 pm to 10 pm
Menu price: DKK 585
Cuisine: French, Danish

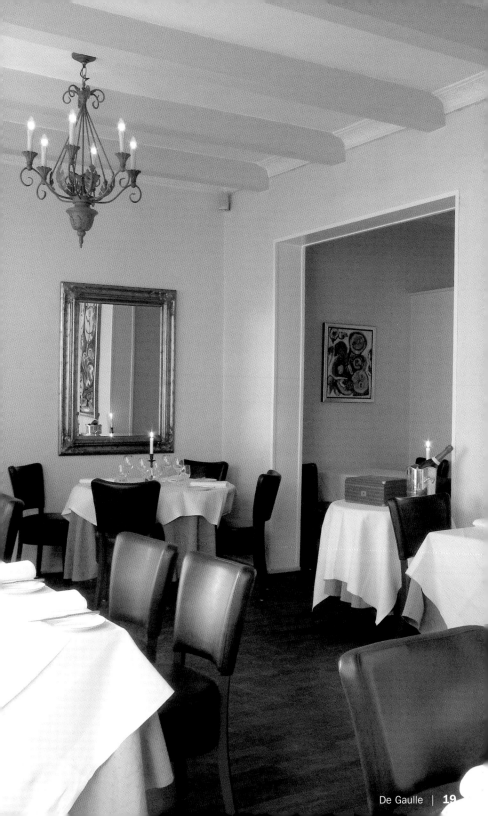

Overgaden Neden Vandet 33 B | 1414 København K
Phone: +45 32 54 06 93
www.era-ora.dk
Opening hours: Mon–Sat noon to 3 pm, 7 pm to 1 am
Menu price: DKK 680–880
Cuisine: Italian

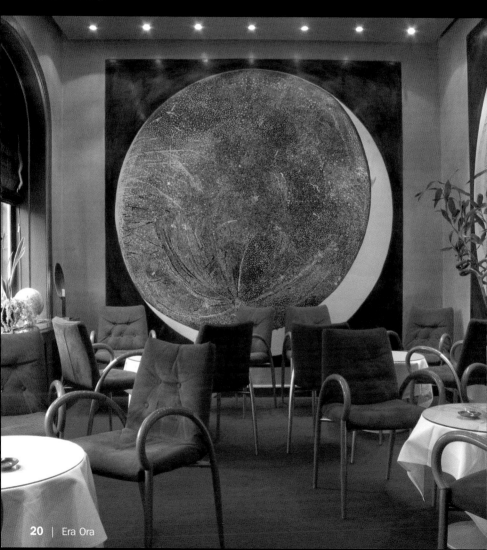

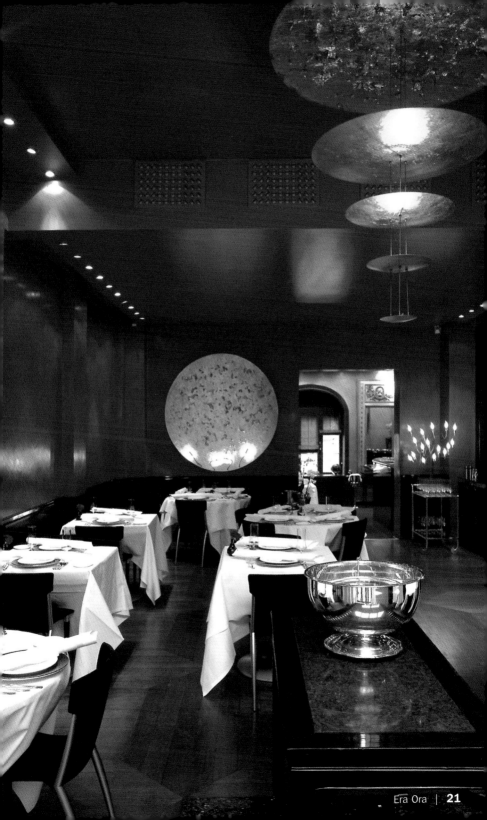

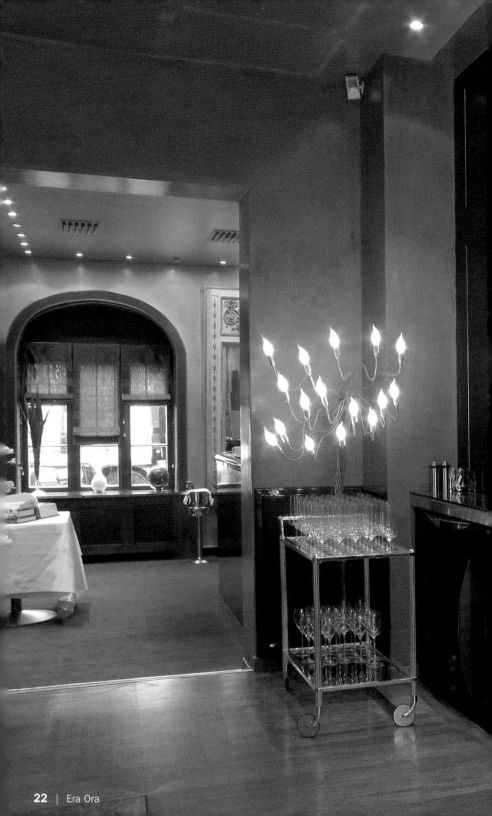

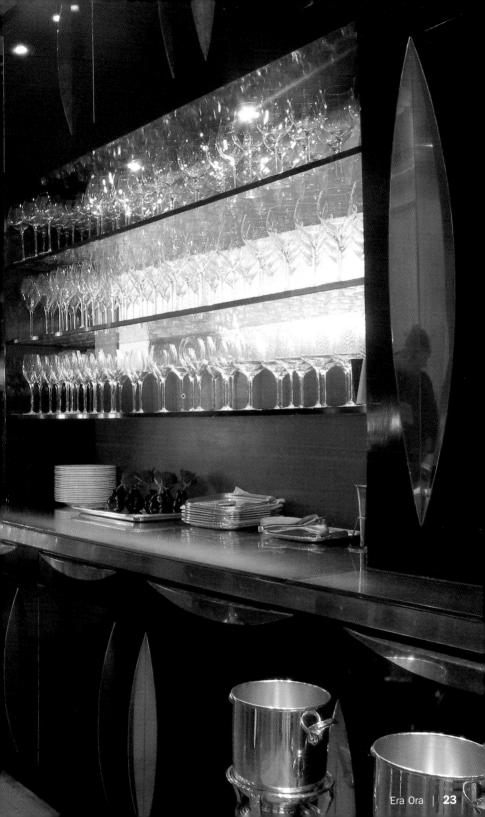

Østergade 13 | 1100 København K
Phone: +45 35 26 09 52
www.extra-cph.dk
Opening hours: Mon–Sat noon to 11 pm, Fri midnight to 3 am lounge,
Sat midnight to 5 am nightclub, guestlist and members only
Menu price: DKK 350
Cuisine: Euro latino

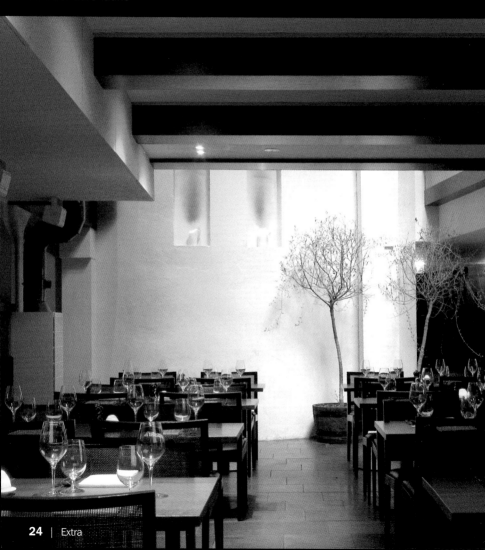

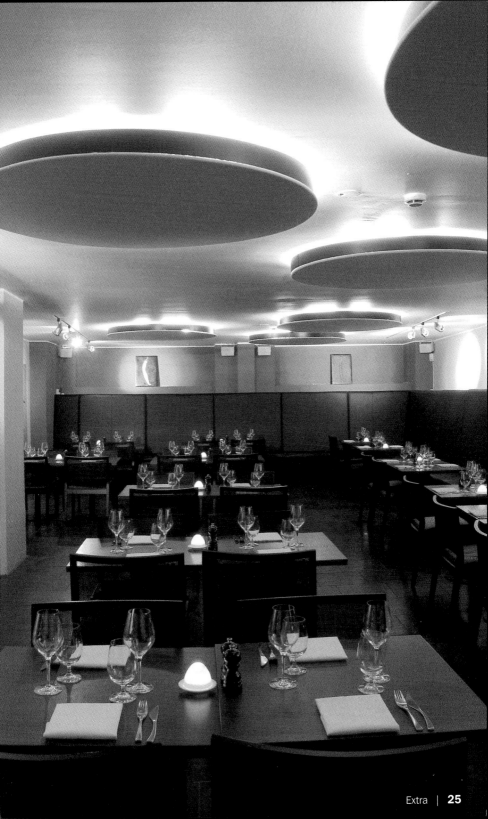

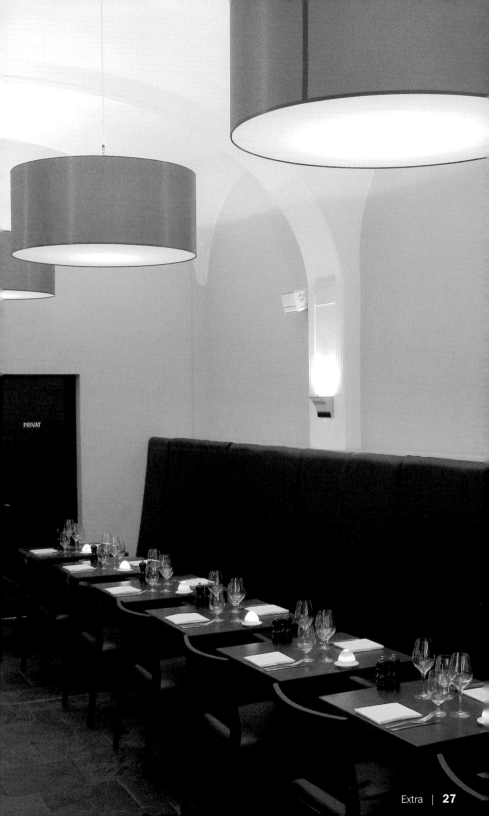

Iberican Ham
with Bread Chips

Iberischer Schinken mit Brotchips
Jambon ibérique aux chips de pain
Jamón de pata negra con chips de pan
Prosciutto iberico con chip di pane

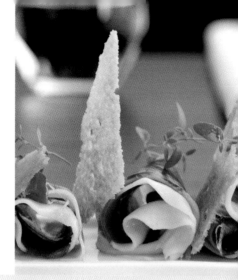

12 slices Pata Negra (Iberican ham)
1 baguette (French bread)
4 tbsp olive oil
Different herbs for decoration, e. g. thyme

Cut the bread in very thin slices, place on a baking sheet and drizzle with olive oil. Bake at 390 °F for approx. 10 minutes, until the slices are lightly browned.

Shape the Iberican ham into rolls and place 3 ham rolls on each plate. Lean the bread chips against the rolls and decorate with herbs.

12 Scheiben Pata Negra (iberischer Schinken)
1 Baguette
4 EL Olivenöl
Verschiedene Kräuter zur Dekoration, z. B. Thymian

Das Baguette in sehr dünne Scheiben schneiden, auf ein Backblech legen und mit Olivenöl beträufeln. Bei 200 °C ca. 10 Minuten backen, bis die Scheiben leicht gebräunt sind.

Den iberischen Schinken zu Röllchen formen und jeweils 3 Schinkenröllchen auf jeden Teller legen. Die Brotchips an die Röllchen lehnen und den Teller mit Kräutern dekorieren.

12 tranches de jambon pata negra (jambon ibérique)
1 baguette
4 c. à soupe d'huile d'olive
Différentes herbes pour décorer, p. ex. du thym

Former des rouleaux avec le jambon ibérique et disposer 3 rouleaux de jambon sur chaque assiette. Accoler les chips de pain aux rouleaux et décorer l'assiette d'herbes.

Couper la baguette en tranches très minces, les disposer sur une plaque de four et les arroser d'huile d'olive. Faire cuire au four pendant environ 10 minutes à 200 °C, jusqu'à ce que les tranches soient légèrement dorées.

12 lonchas de jamón de pata negra
1 barra de pan
4 cucharadas de aceite de oliva
Hierbas al gusto para la decoración, por ej. tomillo

Preparar rollitos con el jamón y poner 3 rollitos en cada plato. Colocar los chips de pan junto a los rollitos y decorar el plato con hierbas.

Cortar el pan en lonchas muy finas, colocarlo en una bandeja de horno y rociarlo con aceite de oliva. Dejar que se haga durante aprox. 10 minutos a 200 °C hasta que las lonchas estén levemente doradas.

12 fette di Pata Negra (prosciutto iberico)
1 baguette
4 cucchiai di olio d'oliva
Diverse erbe per la decorazione, ad es. timo

Arrotolare il prosciutto iberico e posare 3 rotolini su ogni piatto. Porre i chip di pane vicino ai rotolini e decorare il piatto con delle erbe.

Tagliare la baguette in fette molto sottili, porre su una teglia per torte e aggiungere dell'olio d'oliva. Cuocere a 200 °C per ca. 10 minuti facendo soffriggere le fette.

Formel B

Design: Søren Vester
Chef & Owners: Kristian Moeller, Rune Jochumsen

Vesterbrogade 182 | 1800 København Frederiksberg C
Phone: +45 33 25 10 66
www.formel-b.dk
Opening hours: Mon–Sat 6 pm to 1 am
Menu price: DKK 700
Cuisine: Classic French with a modern touch

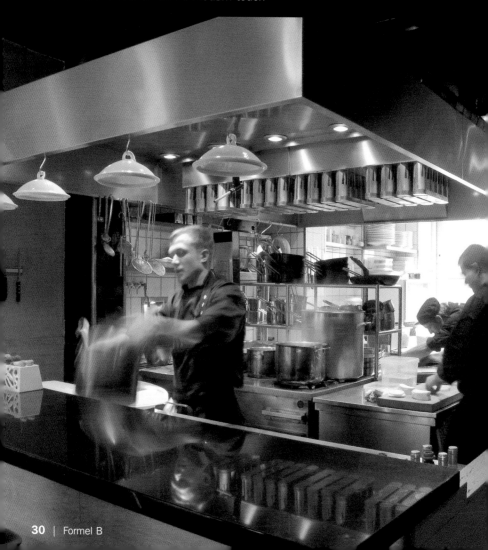

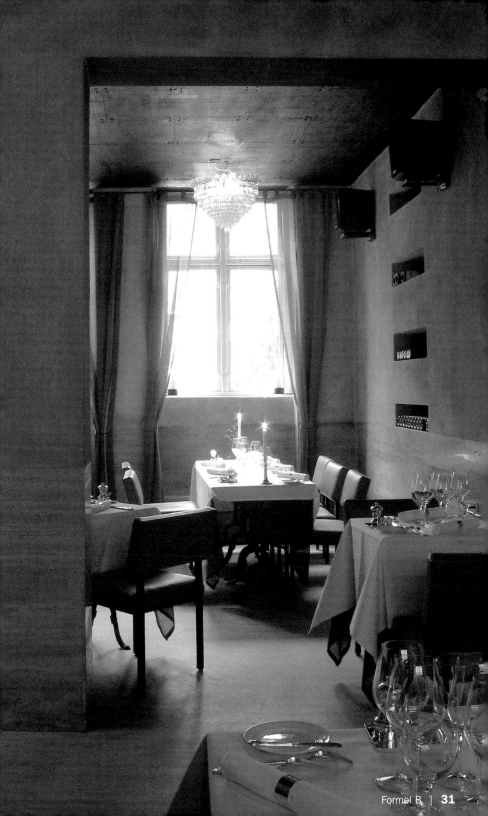

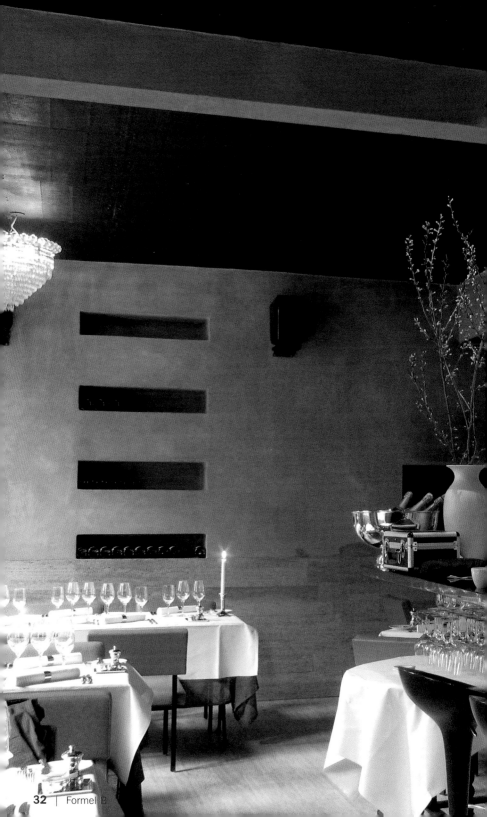

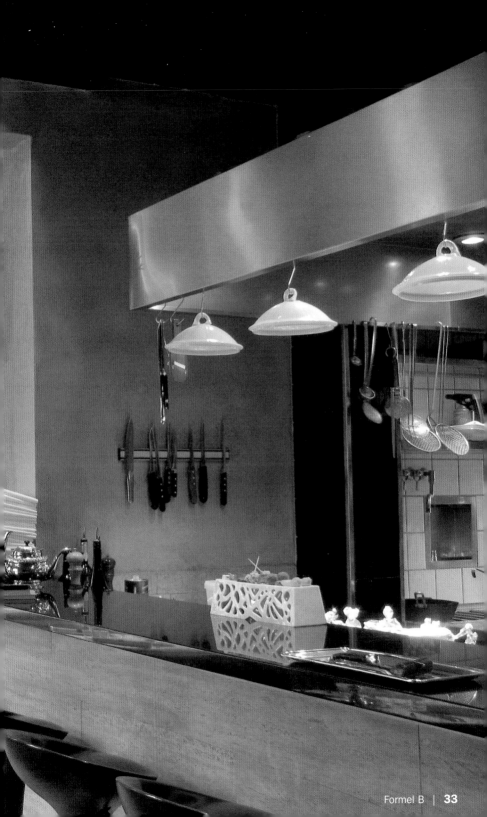

FOX kitchen & bar

Design: Anders Saelan, 2 arkitekter | Chef: Anders Barsoe
Owner: Mojito Group

Jarmers Plads 3 | 1551 København
Phone: +45 33 38 70 30
Opening hours: Sun–Thu 5 pm to midnight, Fri–Sat 5 pm to 2 am
Menu price: DKK 270
Cuisine: Healthy food, seasonal ingredients from the Nordic countries

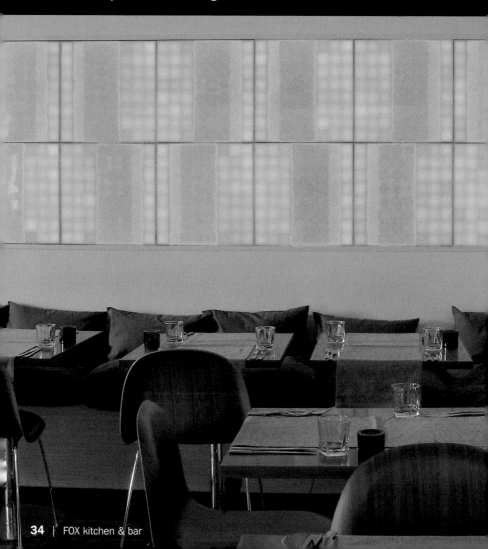

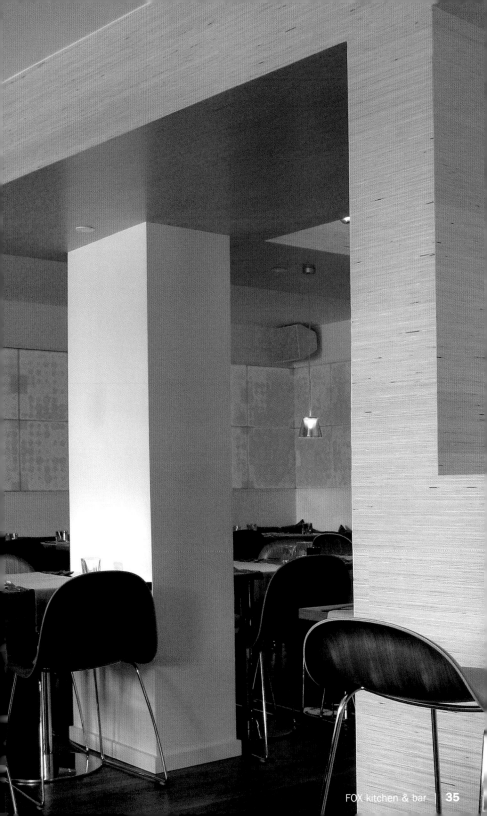

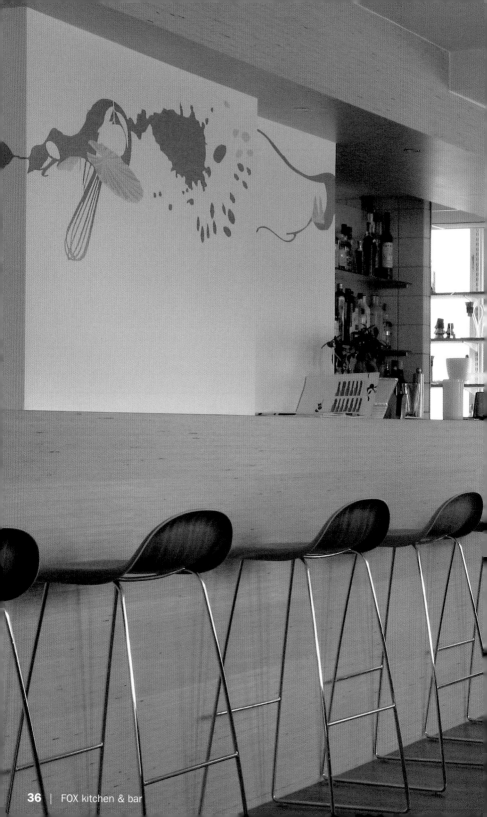

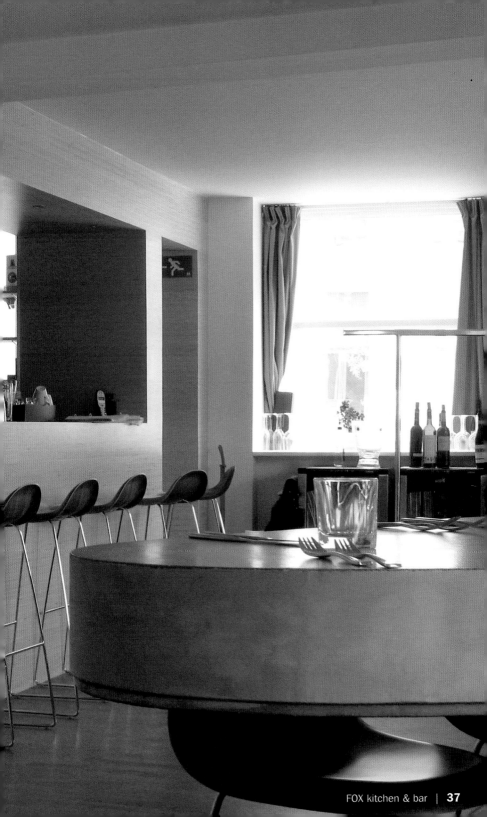

Seared Scallop
with Smoked Onion Puree

Gebratene Jakobsmuschel mit geräuchertem Zwiebelpüree

Coquilles Saint-Jacques grillées à la purée d'oignons fumée

Vieiras fritas con puré de cebollas ahumadas

Conchiglie cotte con purè di cipolle affumicate

10 onions
3 tbsp wood shavings for smoking
Salt, pepper, sugar
Peel, blanch and halve the onions. Put the wood shavings in a pot with a tightly closing lid and heat on large flame until they start to smoke. Remove from the heat immediately, place the halved onions on a plate, place on top of the smoking wood shavings and close the lid. Smoke for approx. 2 hours, then remove the lid next to an open window and take out the onions. Place in a blender, season with salt, pepper and sugar and mix until smooth. Keep warm.

1 turnip
Juice of one lemon
2 tbsp grape seed oil

Peel the turnip, cut in very thin slices and marinate with salt, pepper, lemon juice and grape seed oil.

8 scallops, without shell
Salt, pepper, lemon juice
3 tbsp butter
Season scallops with salt, pepper and lemon juice and sear in butter for 1 minute on each side, so that they are still glassy on the inside.

4 rye crackers
Divide onion puree, 2 scallops and rye crackers into four deep plates. Shape the marinated turnip slices into small roses.

10 Zwiebeln
3 EL Holzspäne zum Räuchern
Salz, Pfeffer, Zucker
Zwiebeln schälen, blanchieren und halbieren. Die Holzspäne in einen Topf mit gut schließendem Deckel geben und auf höchster Flamme so lange erhitzen, bis sie anfangen zu rauchen. Sofort von der Herdplatte nehmen, die Zwiebelhälften auf einen Teller setzen, diesen auf die glimmenden Späne stellen und den Deckel schließen. Ca. 2 Stunden räuchern lassen, dann bei geöffnetem Fenster den Topf öffnen und die Zwiebeln herausnehmen. In einen Mixer geben, mit Salz, Pfeffer und Zucker würzen und fein pürieren. Warm stellen.

1 Kohlrabi
Saft einer Zitrone
2 EL Traubenkernöl

Kohlrabi schälen, in sehr dünne Scheiben schneiden und mit Salz, Pfeffer, Zitronensaft und Traubenkernöl marinieren.

8 Jakobsmuscheln, ohne Schale
Salz, Pfeffer, Zitronensaft
3 EL Butter
Jakobsmuscheln mit Salz, Pfeffer und Zitronensaft würzen und in der Butter von jeder Seite 1 Minute braten, so dass sie innen noch glasig sind.

4 Roggencräcker
Zwiebelpüree, 2 Jakobsmuscheln und Roggencräcker auf vier tiefe Teller verteilen. Aus den marinierten Kohlrabischeiben kleine Rosen formen.

10 oignons
3 c. à soupe de copeaux de bois à fumer
Sel, poivre, sucre
Eplucher, blanchir et couper en deux les oignons. Mettre les copeaux dans une casserole bien fermée et les faire chauffer sur feu vif jusqu'à ce qu'ils fument. Retirer aussitôt de la plaque, disposer les moitiés d'oignon sur une assiette, puis sur les copeaux rougeoyants et fermer le couvercle. Laisser fumer 2 heures, puis ouvrir la casserole, fenêtre ouverte, et retirer les oignons. Mettre dans un mixeur, assaisonner de sel, poivre et réduire en purée fine. Tenir au chaud.

1 chou-rave
Le jus d'un citron
2 c. à soupe d'huile de pépin de raisin

Peler et émincer le chou-rave et le faire mariner dans un mélange de sel, de poivre, de jus de citron et d'huile de pépin de raisin.

8 coquilles Saint-Jacques sans coquille
Sel, poivre, jus de citron
3 c. à soupe de beurre
Assaisonner les coquilles Saint-Jacques de sel, poivre, jus de citron et les faire revenir au beurre de chaque côté pendant 1 minute, afin qu'elles restent fondantes à l'intérieur.

4 craquelins de seigle
Répartir la purée d'oignons, 2 coquilles Saint-Jacques et les craquelins de seigle dans quatre assiettes creuses. Former de petites roses avec les lamelles de chou-rave marinées.

10 cebollas
3 cucharadas de serrín para ahumar
Sal, pimienta, azúcar
Pelar las cebollas, blanquearlas en agua en ebullición y cortarlas en mitades. Verter el serrín en una cazuela con la tapa bien cerrada y calentarla a fuego máximo hasta que comience a humear. Retirarlo inmediatamente del fuego, colocar las mitades de las cebollas en un plato, ponerlo en las virutas incandescentes y volver a tapar la cazuela. Dejar que se ahumen durante 2 horas. Después abrir la cazuela con la ventana abierta y sacar las cebollas. Ponerlas en una batidora, sazonarlas con sal, pimienta y azúcar y convertirlas en un puré fino. Conservar en caliente.

1 colinabo
Zumo de un limón
2 cucharadas de aceite de pepita de uva

Pelar el colinabo y cortar en lonchas muy finas. Poner a macerar con sal, pimienta, zumo de limón y aceite de pepita de uva.

8 vieiras, sin concha
Sal, pimienta, zumo de limón
3 cucharadas de mantequilla
Salpimentar las vieras, rociarlas con zumo de limón y freírlas en la mantequilla durante un minuto en cada lado, para que mantengan su apariencia vidriosa por dentro.

4 tostas de centeno
Distribuir el puré de cebolla, 2 vieiras y las tostas de centeno en cuatro platos hondos. Colocar las lonchas de colinabo marinadas formando pequeñas rosas.

10 cipolle
3 cucchiai di trucioli di legno da affumicare
Sale, pepe, zucchero
Pelare le cipolle, sbollentare e tagliare a metà. Porre i trucioli di legno in una pentola, e con coperchio ben chiuso riscaldare a fiamma alta fino a quando essi non iniziano a fumare. Togliere subito dal fuoco, porre le metà di cipolla su un piatto, porre quest'ultimo sui trucioli bollenti e chiudere il coperchio. Lasciar cuocere per ca. 2 ore, aprire la pentola con finestra aperta e togliere le cipolle. Porre in un mixer, aromatizzare con sale, pepe e zucchero e creare un purè fine. Mettere a caldo.

1 rapa
Succo di un limone
2 cucchiai di olio di noce d'uva

Pelare la rapa, tagliare in sottili fette e marinare con sale, pepe, succo di limone e olio di noce d'uva.

8 conchiglie, senza buccia
Sale, pepe, succo di limone
3 cucchiai di burro
Aromatizzare le conchiglie con sale, pepe e succo di limone e cucinare nel burro da un lato per 1 minuto in modo tale che all'interno restino vitree.

4 cracker di segale
Porre il purè di cipolle, 2 conchiglie ed i cracker di segale su quattro piatti profondi. Formare delle piccole rose dalle fette marinate di rapa.

Gothersgade 38 | 1123 København K
Phone: +45 33 33 15 21 22
www.restaurant-godt.dk
Opening hours: Tu–Sat 6 pm to midnight
Menu price: DKK 450–600
Cuisine: European

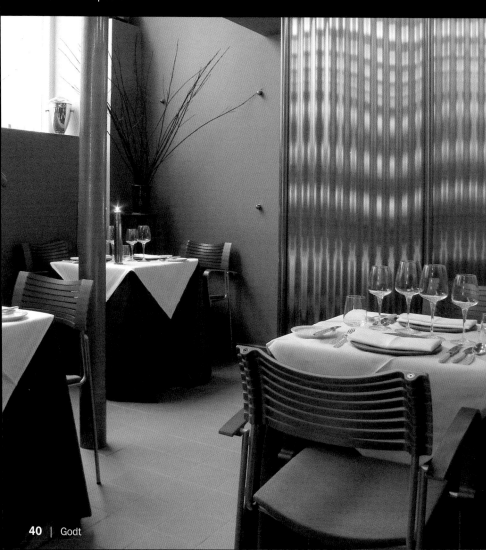

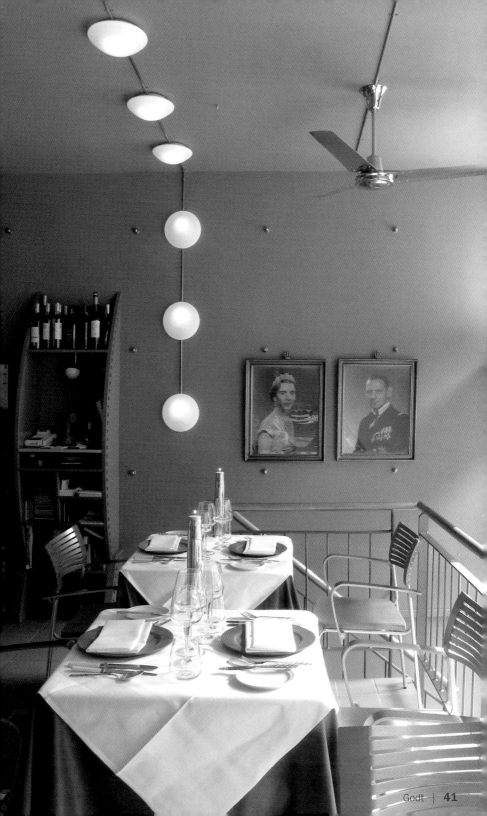

Restaurant Jacobsen

Design: Arne Jacobsen | Chef: Jesper Børglum
Owners: Frederik Ricard, Jesper Børglum

Strandvejen 449 | 2930 Klampenborg
Phone: +45 39 63 43 22
www.restaurantjacobsen.dk
Opening hours: Mon–Fri noon to midnight, Sat 11 am to midnight
Menu price: DKK 320
Cuisine: French, Scandinavian

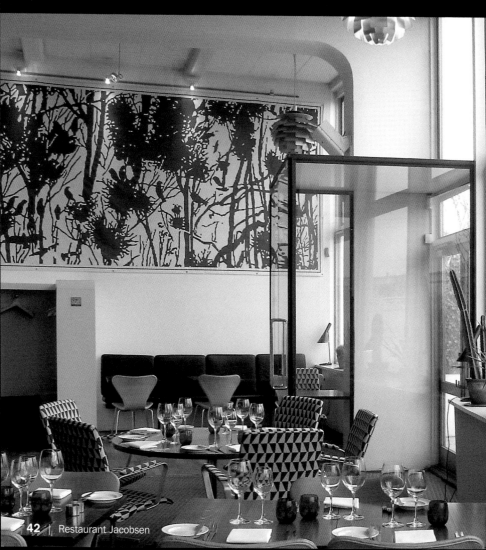

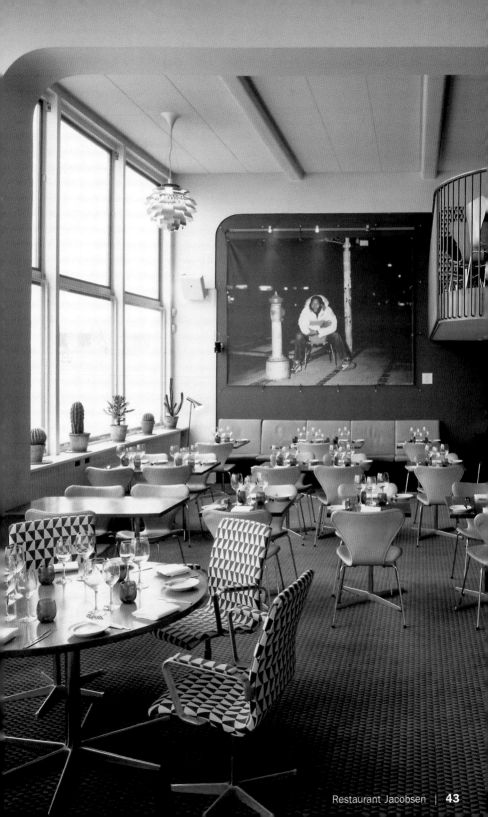

"K" Bar

Chef & Owner: Kirsten Holm

Ved Stranden 20 | 1061 København K
Phone: +45 33 91 92 22
www.k-bar.dk
Opening hours: Mon–Thu 3 pm to 1 am, Fri 3 pm to 2 am, Sat 5 pm to 2 am

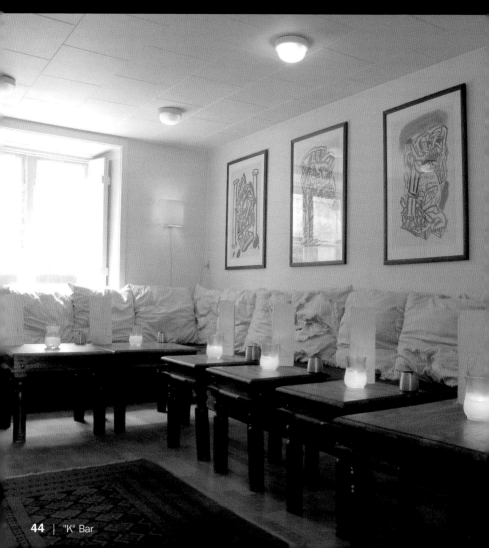

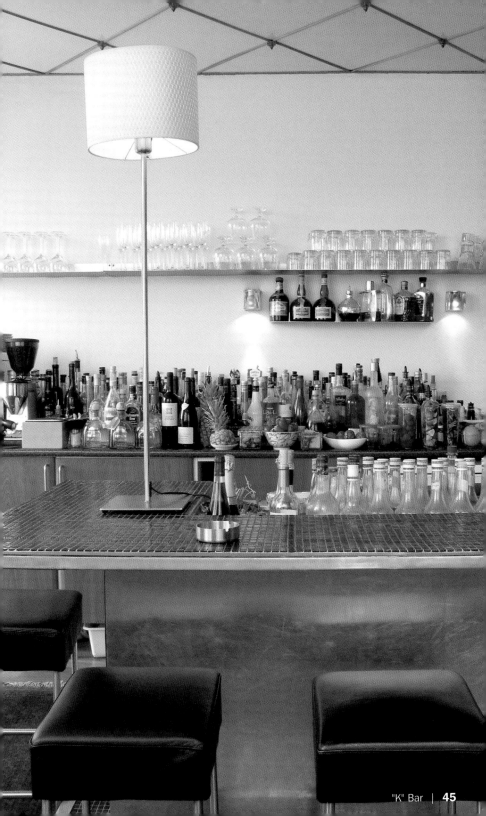

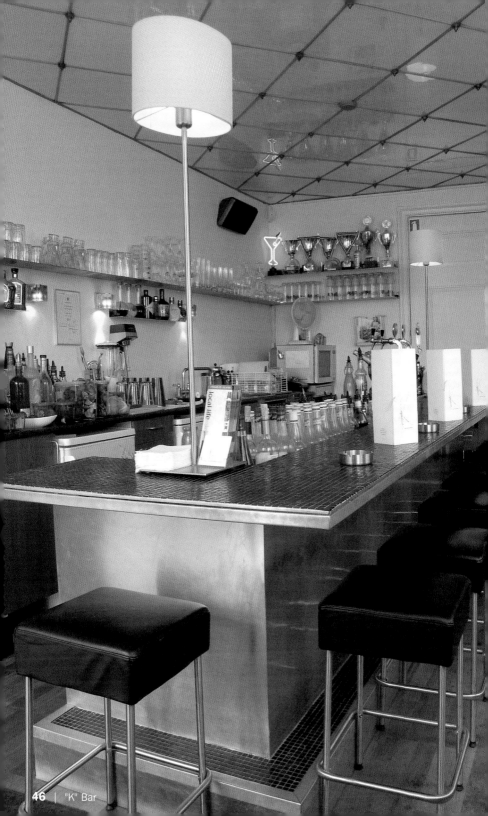

Rissitini
(right cocktail)

3 cl Hammer Gin
3 cl sake
1 splash ginger syrup
1 splash lychee liqueur
1 canned lychee, stuffed with pickled ginger

Shake Gin, sake, ginger syrup and lychee liqueur in a shaker, pour into a Martini glass and put the stuffed lychee on a toothpick into the glass.

3 cl Hammer Gin
3 cl Sake
1 Spritzer Ingwersirup
1 Spritzer Litschilikör
1 Litschi aus der Dose, gefüllt mit einem Streifen eingelegtem Ingwer

Gin, Sake, Ingwersirup und Litschilikör in einem Shaker kräftig schütteln, in ein Martiniglas geben und die gefüllte Litschi auf einem Zahnstocher in das Glas geben.

3 cl de gin Hammer
3 cl de saké
1 goutte de sirop de gingembre
1 goutte de liqueur de litchi
1 litchi en boîte, farci d'une lanière de gingembre mariné

Secouer énergiquement le gin, le saké, le sirop de gingembre et la liqueur de litchi dans un shaker, verser dans un verre à Martini et mettre le litchi farci sur un pic à apéritif dans le verre.

3 cl de ginebra Hammer
3 cl de sake
1 chorrito de jarabe de jengibre
1 chorrito de licor de lichi
1 lichi de lata relleno de una .tirita de jengibre en conserva

Agitar la ginebra, el sake, el jarabe de jengibre y el licor de lichi fuertemente en una coctelera. Verter el cóctel en una copa de Martini y decorarla con el lichi relleno, pinchado en un palillo de dientes.

3 cl Hammer Gin
3 cl Sake
1 spruzzo di sciroppo di zenzero
1 spruzzo di liquore di Litschi
1 Litschi in scatola, riempito con una striscia di zenzero in conserva

Sbattere log in, sake, lo sciroppo di zenzero ed il liquore di Litschi in uno shaker, versare in un bicchiere di Martini e versare il Litschi ripieno su uno stuzzicadenti nel bicchiere.

Kong Hans Kælder

Chef: Thomas Rode Anderson
Owner: Fam. Grönlykke

Vingaardsstræde 6 | 1070 København K
Phone: +45 33 11 68 68
www.konghans.dk
Opening hours: 6 pm to 1 am
Menu price: DKK 735–925
Cuisine: International gourmet with Danish accents

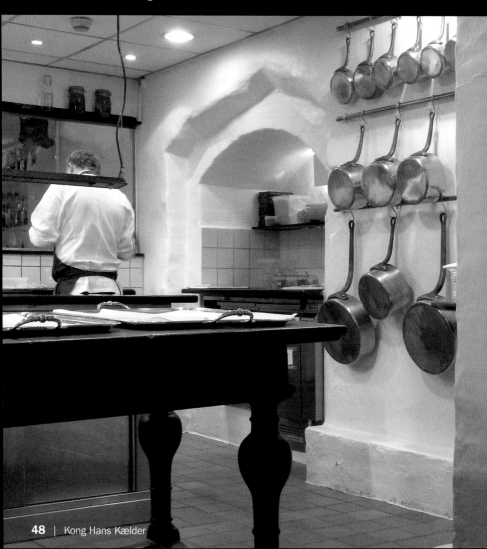

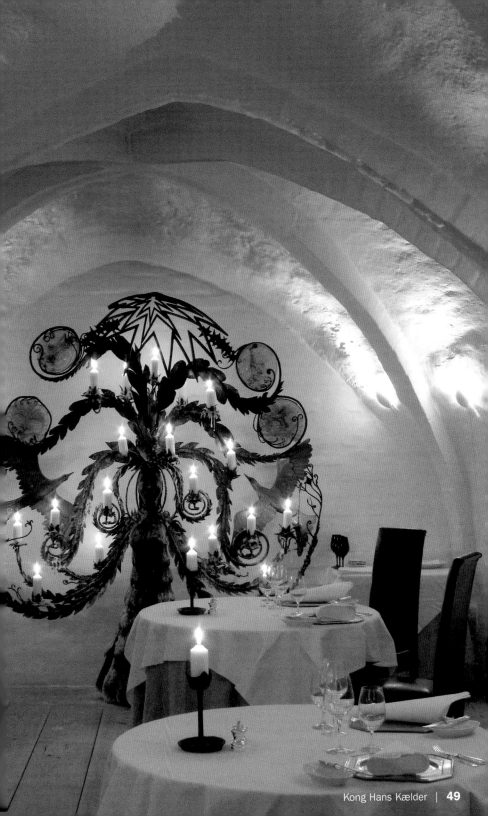

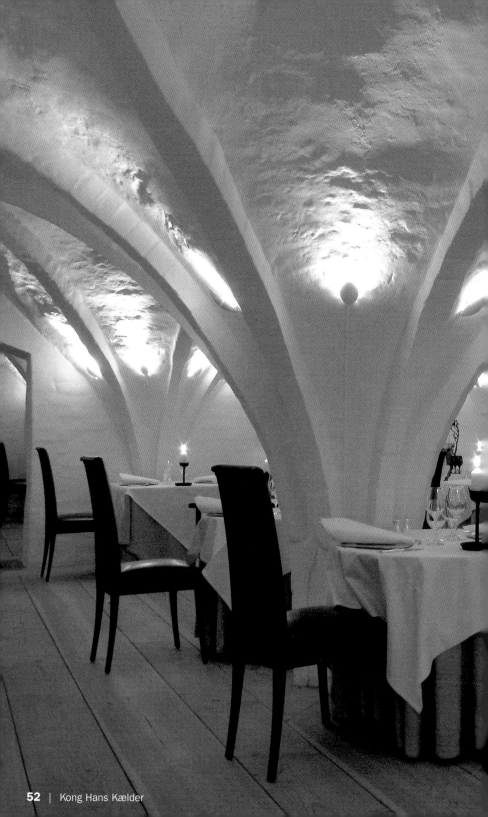

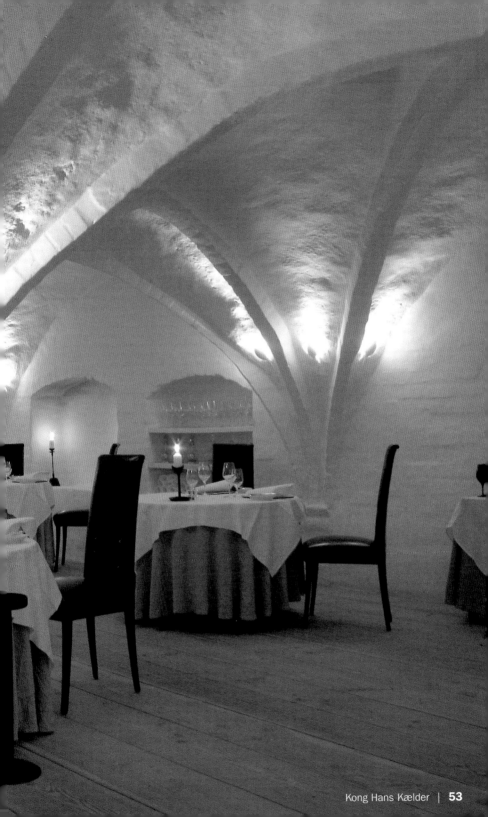

Baba

5 oz flour
1 tsp sugar
1 pinch salt
1 tsp dried yeast
3 eggs
2 oz soft butter
Work all ingredients into a soft dough, divide among four greased and dusted baba-baking dishes and let rest for 20 minutes. Bake at 390 °F for 20 minutes until golden brown. Let dry over night.

5 oz brown sugar
50 ml water
100 ml white wine
150 ml Barley Wine (special beer)
1 piece cinnamon, 1 star anise, 1 bay leave, 1 vanilla beam and 1 pepper corn

Combine all ingredients in a pot, bring to a boil and drain. This is the syrup to marinate the babas in.

2 tbsp sugar
100 ml evaporated milk
2 tbsp dark Balsamic-vinegar
Melt the sugar in a small pot, deglaze with evaporated milk, season with Balsamic-vinegar and reduce to a syrup for decoration.

6 ½ oz dried fruit
4 scoops vanilla ice cream
Mint leaves for decoration
Cut a part of the dried fruits in thin slices and place as carpaccio on four plates, dice the rest. Cut the babas in half, soak in syrup and heat up in the oven. Place on the plates with vanilla ice cream and the leftover dried fruits.

150 g Mehl
1 TL Zucker
1 Prise Salz
10 g Trockenhefe
3 Eier
60 g weiche Butter
Alle Zutaten zu einem geschmeidigen Teig verrühren, auf vier gefettete und mehlierte Baba-Förmchen verteilen und 20 Minuten gehen lassen. Bei 200 °C 20 Minuten goldbraun backen. Über Nacht trocknen lassen.

150 g brauner Zucker
50 ml Wasser
100 ml Weißwein
150 ml Barley Wine (Spezial-Bier)
Je ein Stück Zimtstange, Sternanis, Lorbeer, Vanillestange und Pfefferkorn

Zutaten in einen Topf geben, aufkochen und abseihen. Sirup zum Einlegen der Babas.

2 EL Zucker
100 ml Kondensmilch
2 EL dunkler Balsamico-Essig
Den Zucker in einem kleinen Topf schmelzen lassen, mit der Kondensmilch ablöschen, mit Balsamico-Essig abschmecken und zu einem Sirup einkochen lassen. Zur Dekoration.

200 g Dörrobst
4 Kugeln Vanilleeis
Minze zur Dekoration
Einen Teil des Dörrobsts dünn aufschneiden und als Carpaccio auf vier Tellern verteilen, den Rest würfeln. Die Babas halbieren, in den Sirup einlegen und im Ofen nochmals erwärmen. Mit Vanilleeis und dem restlichen Dörrobst auf den Tellern verteilen.

150 g de farine
1 c. à café de sucre
1 pincée de sel
10 g de levure sèche
3 œufs
60 g de beurre mou
Mélanger tous les ingrédients pour former une pâte malléable, répartir le mélange dans 4 moules à baba beurrés et farinés et attendre 20 minutes. Faire dorer 20 minutes à 200 °C. Laisser tremper toute la nuit.

150 g sucre brun
50 ml d'eau
100 ml de vin blanc
150 ml de vin d'orge (bière spéciale)
1 bâton de cannelle, 1 anis étoilé, 1 feuille de laurier, 1 bâton de vanille et 1 grain de poivre

Mettre les ingrédients dans une casserole, les faire cuire et filtrer. Imbiber les babas de sirop.

2 c. à soupe de sucre
100 ml de lait condensé
2 c. à soupe de vinaigre balsamique foncé
Faire fondre le sucre dans une petite casserole, déglacer en versant le lait condensé, rectifier l'assaisonnement en rajoutant du vinaigre balsamique et faire cuire jusqu'à obtention d'un sirop. Pour décorer.

200 g de fruits secs
4 boules de glace à la vanille
Menthe pour décorer
Couper finement une partie des fruits secs et répartir sur quatre assiettes comme carpaccio, couper le reste en dés. Couper les babas en deux, les imbiber de sirop et les réchauffer au four. Répartir sur les assiettes avec la glace à la vanille et le reste de fruits secs.

150 g de harina
1 cucharadita de azúcar
1 pizca de sal
10 g de levadura de cerveza en seco
3 huevos
60 g de mantequilla blanda
Mezclar los ingredientes hasta obtener una masa uniforme y ponerla en los cuatro moldes de babá untados con mantequilla y espolvoreados con harina y dejar fermentar durante 20 minutos. Hornear a 200 °C durante 20 minutos hasta que estén dorados. Dejar que se sequen durante la noche.

150 g de azúcar morena
50 ml de agua
100 ml de vino blanco
150 ml Barley Wine (cerveza especial)
1 rama de canela, 1 anís estrellado, 1 laurel, vainilla en 1 rama y grano de pimienta

Poner los ingredientes en una cazuela, llevar a ebullición y colar el líquido para empapar las babás.

2 cucharadas de azúcar
100 ml de leche condensada
2 cucharadas de vinagre balsámico oscuro
Derretir el azúcar en una cazuela pequeña, rebajar con leche condensada, condimentar con vinagre balsámico y dejar que reduzca hasta obtener un jarabe. Como decoración.

200 g de frutas secas
4 bolas de helado de vainilla
Menta para decorar
Cortar parte de las frutas secas en láminas finas y repartirlas como carpaccio en cuatro platos, esparcir el resto a ojo. Cortar los babás en dos mitades, ponerlos en el jarabe y volver a calentarlos en el horno. Distribuirlos con el resto de las frutas secas y el helado de vainilla en los platos.

150 g farina
1 cucchiaino di zucchero
1 pizzico di sale
10 g lievito asciutto
3 uova
60 g burro morbido
Mescolare tutti gli ingredienti ottenendo un impasto morbido, posare su quattro forme imburrate e infarinate di babà e cuocere per 20 minuti. Cuocere a 200 °C per 20 minuti fino ad ottenere un colore dorato. Lasciar raffreddare durante la notte.

150 g zucchero di canna
50 ml acqua
100 ml vino bianco
150 ml Barley Wine (birra speciale)
1 pezzo di cannella, 1 anice stellata, 1 foglia di alloro, 1 vaniglia e 1 grano di pepe

Porre gli ingredienti in una pentola, cuocere e scolare. Sciroppo per conservare i babà.

2 cucchiai di zucchero
100 ml latte condensato
2 cucchiai di aceto balsamico scuro
Far sciogliere lo zucchero in una piccola pentola, raffreddare con latte condensato, assaggiare con aceto balsamico e far cuocere fino a diventare uno sciroppo. Per la decorazione.

200 g frutta secca
4 palline di gelato alla vaniglia
Menta per la decorazione
Tagliare finemente la frutta secca e porre su quattro piatti come il carpaccio, tagliare a quadretti il resto. Dividere a metà i babà, porre nello sciroppo e riscaldare nuovamente in forno. Porre con gelato alla vaniglia e la frutta secca restante sui piatti.

Kokkeriet

Design: Mikkel & Sammy Shafi, Karina Kejser Bøhl
Chef: Lasse Askov | Owners: Mikkel & Sammy Shafi

Kronprinsessegade 64 | 1306 København K
Phone: +45 33 15 27 77
www.kokkeriet.dk
Opening hours: Tue–Sat 6 pm to 1 am
Menu price: DKK 500
Cuisine: French

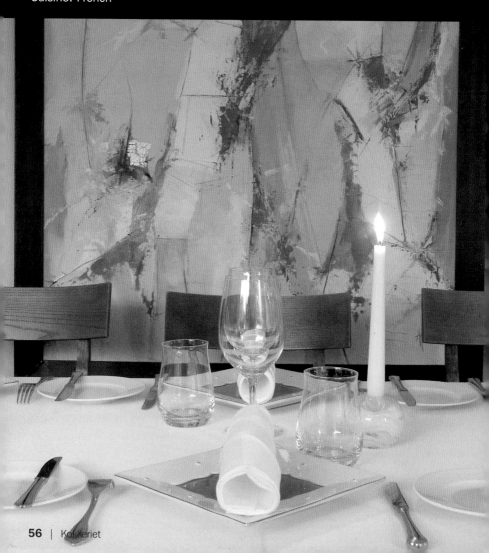

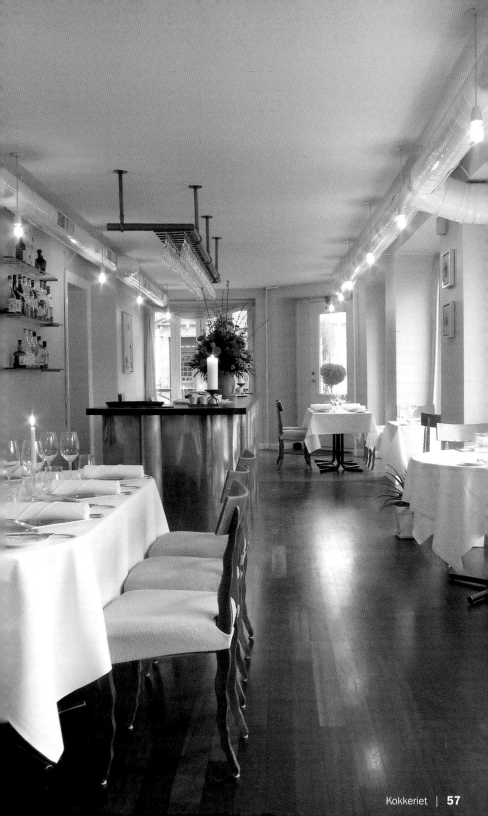

The Laundromat Café

Design: Fridrik Weisshappel | Chef: Brynjólfur Gardarsson
Owners: Fridrik Weisshappel, Brynjólfur Gardasson,
Ingvi Steinar Ólafsson

Elmegaade 15 | 2200 København N
Phone: +45 35 35 26 72
www.thelaundromatcafe.com
Opening hours: Mon–Thu 8 am to midnight, Fri 8 am to 2 am, Sat 10 am to 2 am,
Sun 10 am to midnight
Menu price: DKK 95
Cuisine: Kano Med – American Mediterranean brasserie

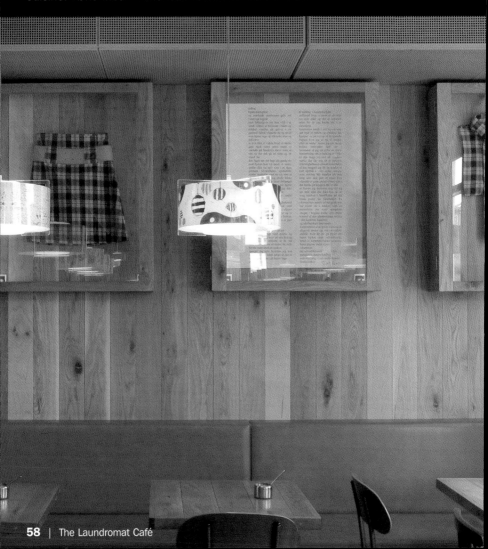

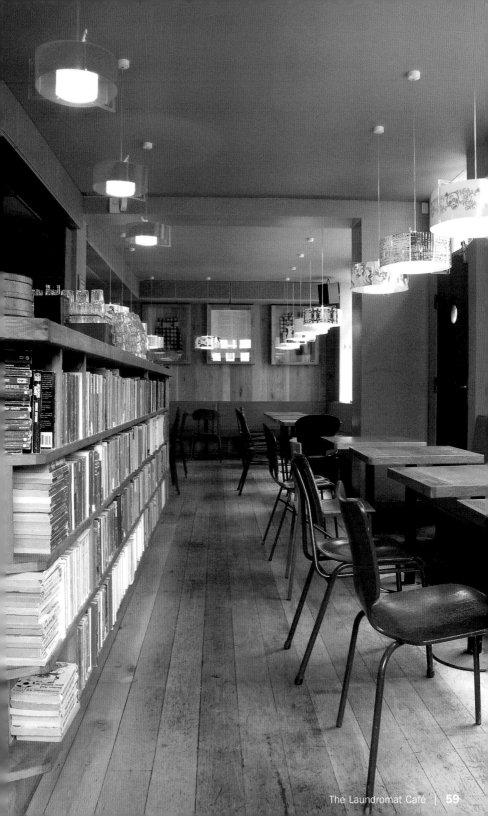

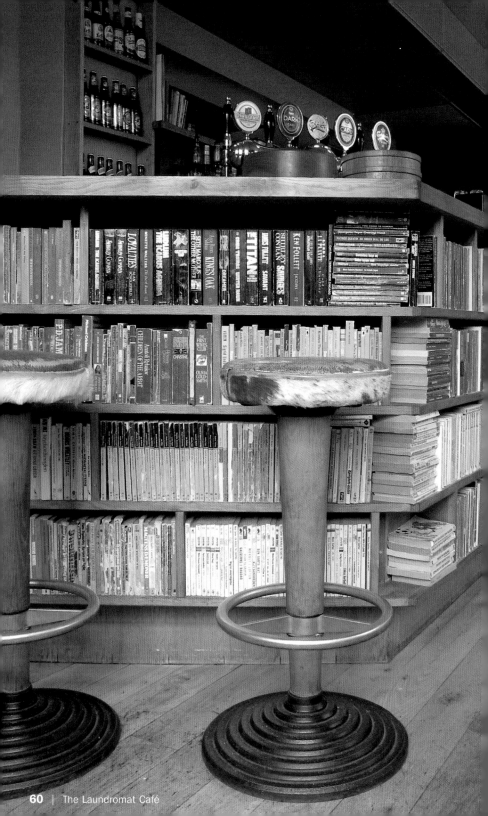

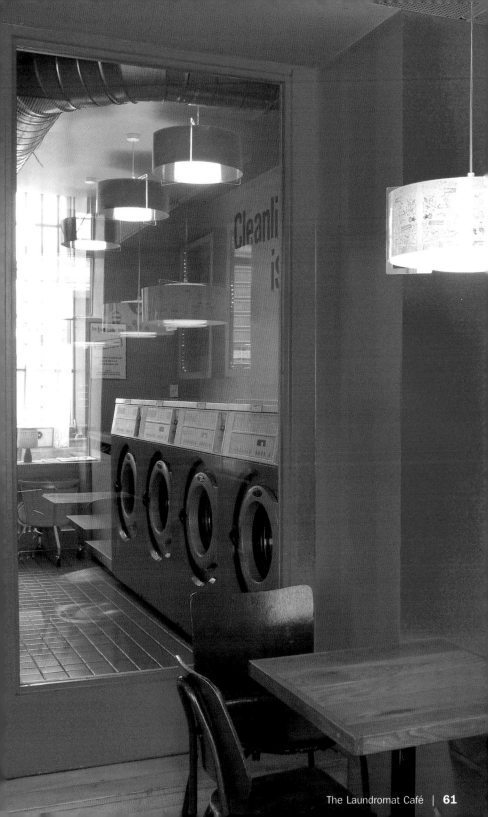

Brunch

6 eggs
3 tbsp cream
2 tbsp butter
Whisk the eggs with the cream until foamy, season with salt and pepper. Cook the eggs in a pan with butter over medium heat.

2 tomatoes
1 clove of garlic
1 tbsp olive oil
Cut the tomatoes in half, rub the cut side with the garlic and season with salt and pepper. Sear on the cut side in 1 tbsp olive oil.

6 ½ oz new potatoes, sliced
1 clove of garlic, chopped
2 shallots, diced
3 tbsp vegetable oil

100 ml chicken stock
Salt, pepper
1 tsp chopped thyme
1 tbsp chopped parsley
Sear the potatoes with the garlic and the shallots in oil, season and deglaze with chicken stock and cook with a closed lid for 15 minutes until tender. Stir in the herbs and season again if necessary.

1 egg
4 ½ oz flour
1 tsp baking soda
1 tbsp sugar
250 ml butter milk
2 tbsp vegetable oil
Butter for frying
Combine all ingredients to a thick batter and bake 8 pancakes in a pan.

6 Eier
3 EL Sahne
2 EL Butter
Die Eier mit der Sahne kräftig aufschlagen, mit Salz und Pfeffer würzen. Die Eier in einer Pfanne mit Butter bei mittlerer Hitze garen.

2 Tomaten
1 Knoblauchzehe
1 EL Olivenöl
Die Tomaten halbieren, mit der Knoblauchzehe die Schnittstelle einreiben und mit Salz und Pfeffer würzen. Auf der Schnittstelle in 1 EL Olivenöl kräftig anbraten.

200 g neue Kartoffeln, in Scheiben
1 Knoblauchzehe, gehackt
2 Schalotten, gehackt
3 EL Pflanzenöl

100 ml Geflügelbrühe
Salz, Pfeffer
1 TL gehackter Thymian
1 EL gehackte Petersilie
Kartoffeln mit Knoblauch und Schalotten in Öl kräftig anbraten, würzen, mit Brühe ablöschen und mit geschlossenem Deckel 15 Minuten gar kochen. Kräuter unterrühren, evtl. nochmals abschmecken.

1 Ei
140 g Mehl
1 TL Backpulver
1 EL Zucker
250 ml Buttermilch
2 EL Pflanzenöl
Butter zum Ausbacken
Alle Zutaten zu einem dickflüssigen Teig verrühren und in einer Pfanne mit Butter 8 Pfannekuchen ausbacken.

6 œufs
3 c. à soupe de crème fraîche
2 c. à soupe de beurre
Battre énergiquement les œufs avec la crème, assaisonner de sel et de poivre. Faire frire les œufs au beurre dans une poêle à feu moyen.

2 tomates
1 gousse d'ail
1 c. à soupe d'huile d'olive
Couper les tomates en deux, frotter l'intérieur avec la gousse d'ail et assaisonner de sel et de poivre. Faire revenir dans 1 c. à soupe d'huile d'olive en dirigeant l'entame vers le bas.

200 g de pommes de terre nouvelles, en rondelles
1 gousse d'ail, hachée
2 échalotes, hachées
3 c. à soupe d'huile végétale

100 ml de bouillon de volaille
Sel, poivre
1 c. à café de thym haché
1 c. à soupe de persil haché
Faire revenir les pommes de terre avec l'ail et les échalotes dans l'huile, assaisonner, déglacer en versant le bouillon et faire cuire à point 15 minutes avec le couvercle fermé. Ajouter les herbes et assaisonner.

1 œuf
140 g de farine
1 c. à café de levure chimique
1 c. à soupe de sucre
250 ml de babeurre
2 c. à soupe d'huile végétale
Beurre pour la cuisson
Mélanger tous les ingrédients jusqu'à obtention d'une pâte épaisse et faire cuire 8 crêpes dans une poêle beurrée.

6 huevos
3 cucharadas de nata
2 cucharadas de mantequilla
Batir los huevos con la nata, salpimentar. Freír los huevos a fuego medio en mantequilla en una sartén.

2 tomates
1 diente de ajo
1 cucharada de aceite de oliva
Cortar los tomates por la mitad, frotar el lado del corte con el diente de ajo y salpimentar. Freír por el lado del corte en 1 cucharada de aceite de oliva a fuego vivo.

200 g de patatas nuevas en lonchas
1 diente de ajo picado
2 chalotas picadas
3 cucharadas de aceite vegetal

100 ml de caldo de pollo
Sal, pimienta
1 cucharadita de tomillo picado
1 cucharada de perejil picado
Freír las patatas con el ajo y las chalotas en aceite a fuego vivo, condimentar, rebajar con el caldo y cocer durante 15 minutos con la cazuela tapada. Añadir las hierbas y, si fuera necesario, volver a condimentar.

1 huevo
140 g de harina
1 cucharadita de levadura química
1 cucharada de azúcar
250 ml de suero de manteca
2 cucharadas de aceite vegetal
Mantequilla para freir
Mezclar los ingredientes hasta obtener una masa espesa y freir 8 panqueques en la mantequilla.

6 uova
3 cucchiai di panna
2 cucchiai di burro
Mescolare bene le uova con la panna, aromatizzare con sale e pepe. Cuocere le uova in un tegame col burro a fiamma media.

2 pomodori
1 spicchio d'aglio
1 cucchiaio di olio di oliva
Tagliare a metà i pomodori, mescolare con la parte dell'aglio tagliata e aromatizzare con sale e pepe. Sulla parte d'aglio tagliata cuocere bene in 1 cucchiaio di olio d'oliva.

200 g patate nuove, a fette
1 spicchio d'aglio, tagliuzzato
2 cipolle, tagliuzzate
3 cucchiai di olio vegetale

100 ml brodo di pollo
Sale, pepe
1 cucchiaino di timo tagliuzzato
1 cucchiaio di prezzemolo tagliuzzato
Cuocere nell'olio le patate con l'aglio e le cipolle, aggiungere aromi, raffreddare con brodo e col coperchio chiuso cucinare per 15 minuti. Aggiungere le spezie ed eventualmente assaggiare.

1 uovo
140 g farina
1 cucchiaino di farina di lievito
1 cucchiaio di zucchero
250 ml latticello
2 cucchiai di olio vegetale
Burro per la cottura
Mescolare tutti gli ingredienti fino a diventare una pasta densa e cuocere 8 frittate col burro in una padella.

Kultorvet 5 | 1175 København K
Phone: +45 33 91 09 49
www.mr-restaurant.com
Opening hours: 6 pm to midnight, lunch by reservation in advance
Menu price: DKK 500–1000
Cuisine: Modern, innovative, gourmet

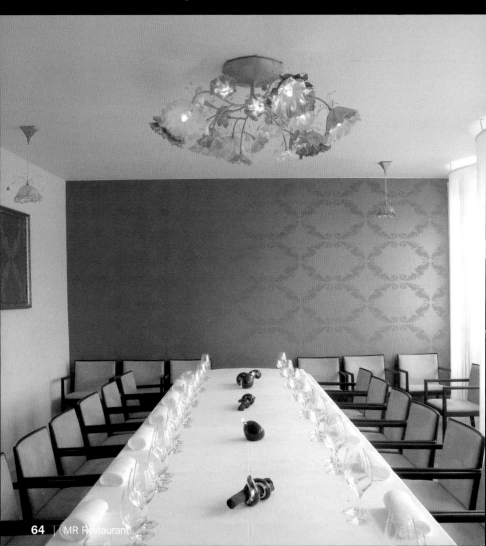

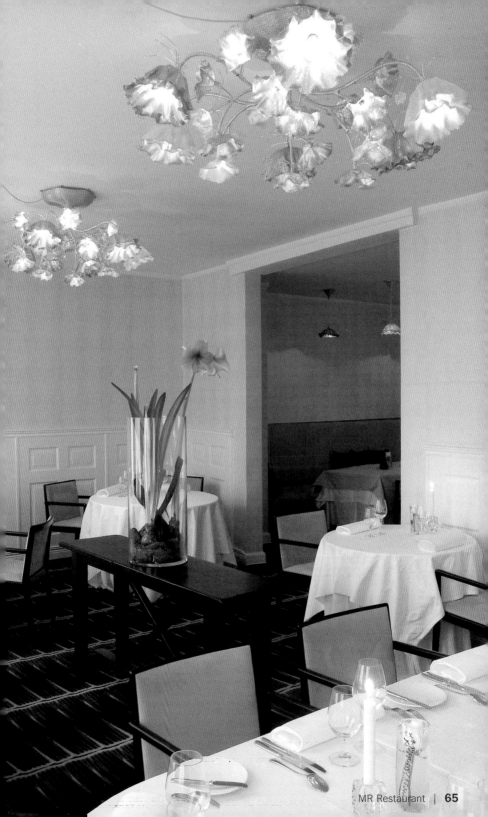

Baked Cod
with Quail Egg and Pear

Gebackener Kabeljau mit Wachtelei
und Birne

Cabillaud cuit accompagné d'un œuf de
caille et de poire

Bacalao al horno con huevo de codorniz
y pera

Merluzzo fritto con uovo di quaglia e pera

4 pieces cod, 2 oz each
Salt, pepper
4 quail eggs
3 tbsp vinegar
2 lbs button mushrooms
1 pear
2 tbsp lemon juice
Cress and fresh mushroom slices for decoration

Chop up the mushrooms, place in an ovenproof
vacuum bag or alternately a very strong freezer
bag and simmer for 24 hours in water. Open
the bag and reduce the liquid to a concentrated
sauce. Strain and season.

Peel the pear and cut in small cubes, marinate
with lemon juice. Season the cod and bake in an
oven at 360 °F for 7–8 minutes. Boil the quail
eggs in salted vinegar water for approx. 1–2 min-
utes, chill and peel.

Place the cod in the middle of the plate, put one
quail egg and a spoonful of pear cubes beside
it. Drizzle with sauce and garnish with cress and
fresh mushroom slices.

4 Stücke Kabeljau, à 50 g
Salz, Pfeffer
4 Wachteleier
3 EL Essig
1 kg Champignons
1 Birne
2 EL Zitronensaft
Kresse und frische Champignonscheiben zur
Dekoration

Die Champignons klein schneiden, in einen
Vakkumierbeutel oder alternativ sehr haltbare
TK-Beutel geben und 24 Stunden im Wasserbad
sieden lassen. Den Beutel öffnen und den
Champignonfond zu einer konzentrierten Sauce
einkochen. Passieren und abschmecken.

Die Birne schälen und in kleine Würfel schneiden,
mit Zitronensaft marinieren. Den Kabeljau würzen
und bei 180 °C 7–8 Minuten im Backofen garen.
Die Wachteleier in gesalzenem Essigwasser ca.
1–2 Minuten kochen, abschrecken und pellen.

Den Kabeljau in die Mitte des Tellers setzen
und das Wachtelei und einen Löffel Birnenwürfel
daneben platzieren. Mit Sauce beträufeln und
mit Kresse und frischen Champignonscheiben
garnieren.

4 morceaux de cabillaud de 50 g
Sel, poivre
4 œufs de caille
3 c. à soupe de vinaigre
1 kg de champignons de Paris
1 poire
2 c. à soupe de jus de citron
Cresson et lamelles de champignons de Paris frais pour décorer

Couper finement les champignons de Paris, les mettre dans un sac sous vide ou dans un sachet de cuisson thermorésistant et les faire bouillir dans l'eau pendant 24 heures. Ouvrir le sac et faire cuire le fond de champignons pour obtenir une sauce concentrée. Passer et assaisonner.

Peler les poires et les couper en petits dés, puis les faire mariner dans le jus de citron. Assaisonner le cabillaud et le faire cuire au four pendant 7 à 8 minutes à 180 °C. Faire cuire les œufs de caille dans de l'eau vinaigrée et salée pendant 1 à 2 minutes, les laisser refroidir et les écaler.

Disposer le cabillaud au centre de l'assiette et placer l'œuf de caille et une cuillère de dés de poire à côté. Arroser de sauce et garnir de cresson et de lamelles de champignons de Paris frais.

4 trozos de bacalao de 50 g cada uno
Sal, pimienta
4 huevos de codorniz
3 cucharadas de vinagre
1 kg de champiñones
1 pera
2 cucharadas de zumo de limón
Berros y láminas de champiñón fresco para decorar

Cortar los champiñones y ponerlos en una bolsa de envasado al vacío o una bolsa para congelados termoestables y dejar al baño María durante 24 horas. Abrir la bolsa y reducir el caldo de los champiñones obtenido hasta que se convierta en una salsa concentrada. Colar y condimentar.

Pelar la pera y cortarla en pequeños dados, marinar con zumo de limón. Condimentar el bacalao y ponerlo en el horno a 180 °C durante 7–8 minutos. Hervir los huevos de codorniz en agua con vinagre durante 1–2 minutos, pasarlos por agua fría y pelar.

Poner el bacalao en el centro del plato y colocar el huevo de codorniz y una cucharada de cubitos de pera al lado. Salpicar con la salsa y decorar con berros y láminas de champiñón fresco.

4 pezzi di merluzzo, à 50 g
Sale, pepe
4 uova di quaglia
3 cucchiai di aceto
1 kg champignons
1 pera
2 cucchiai di succo di limone
Crescione e fettine di champignons fresche per la decorazione

Tagliuzzare gli champignons, porre in un sacchetto a vuoto o per cucinare resistente al calore e far lessare per 24 ore a bagno maria. Aprire il sacchetto e cuocere il fondo degli champignon fino a farli diventare una salsa omogenea. Passare e assaggiare.

Pelare la pera e tagliare a quadretti, marinare con succo di limone. Aggiungere aromi al merluzzo e cuocere in forno a 180 °C per 7–8 minuti. Cuocere le uova di quaglia in acqua di aceto salata per ca. 1–2 minuti, raffreddare con acqua e pelare.

Porre il merluzzo al centro del piatto con l'uovo di quaglia ed un cucchiaio di quadretto di pera vicini. Aggiungere la salsa e guarnire con crescione e fettine di champignon freschi.

Noma

Design: Signe Henriksen | Chef: Rene Redzepi
Owners: Rene Redzepi, Claus Meyer

Strandgade 93 | 1401 København K
Phone: +45 32 96 32 97
www.noma.dk
Opening hours: Lunch Mon–Fri noon to 2 pm, Dinner Mon–Sat 6 pm to 10 pm
Menu price: DKK 525
Cuisine: Nordic gourmet

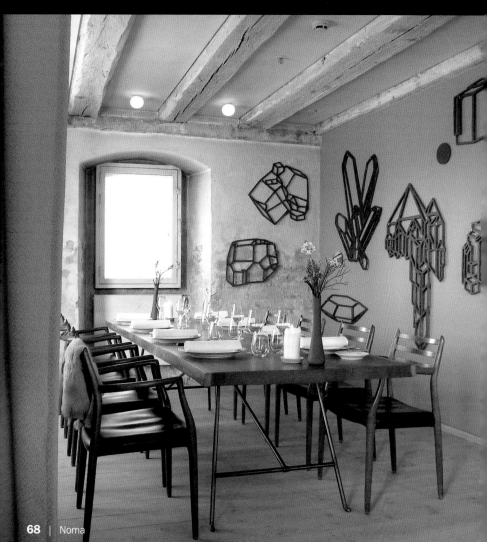

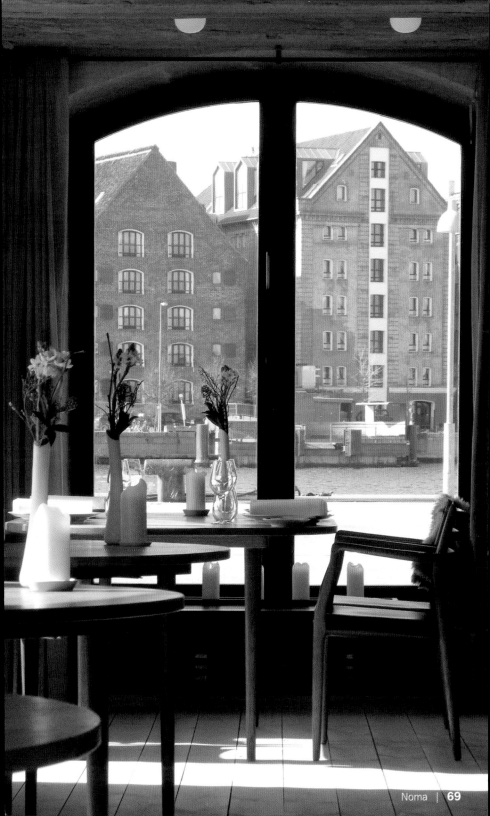

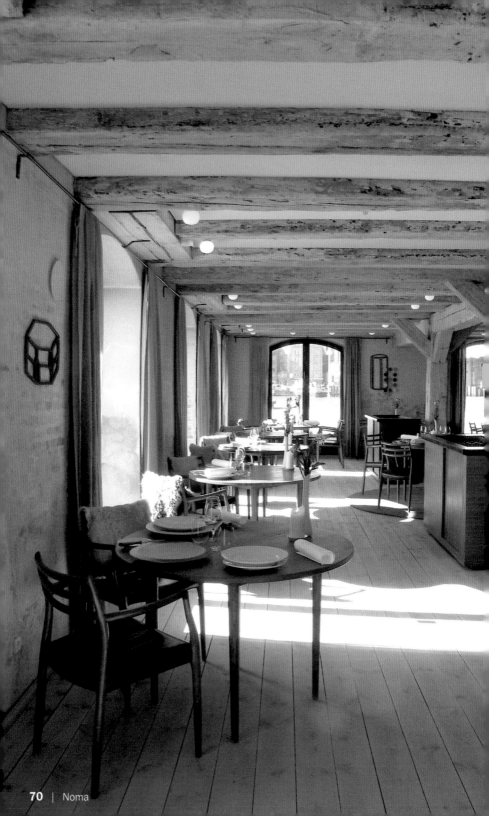

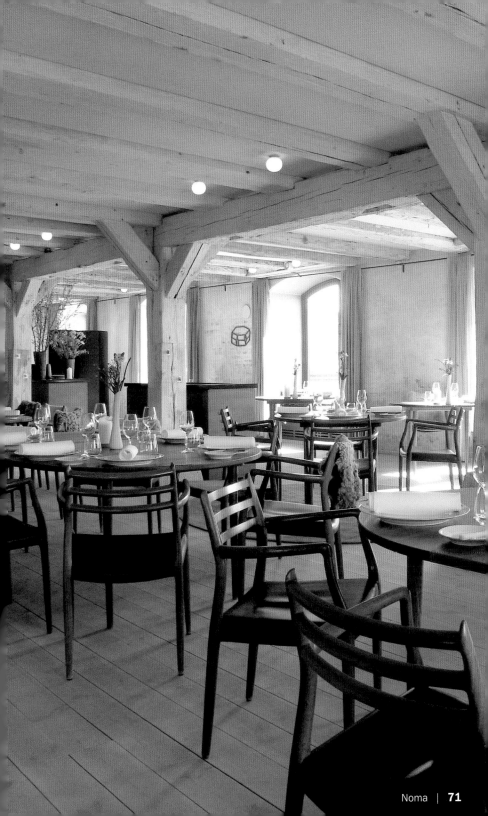

Nørrebro Bryghus

Design: Søren Varming
Director of the Brewery: Anders Kissmeyer

Ryesgade 3 | 2200 København N
Phone: +45 35 30 05 30
www.norrebrobryghus.dk
Opening hours: Mon–Wed 11 am to midnight, Thu–Sat 11 am to 2 am,
Sun 11 am to 10 pm
Menu price: DKK 398–498
Cuisine: Modern Danish brasserie

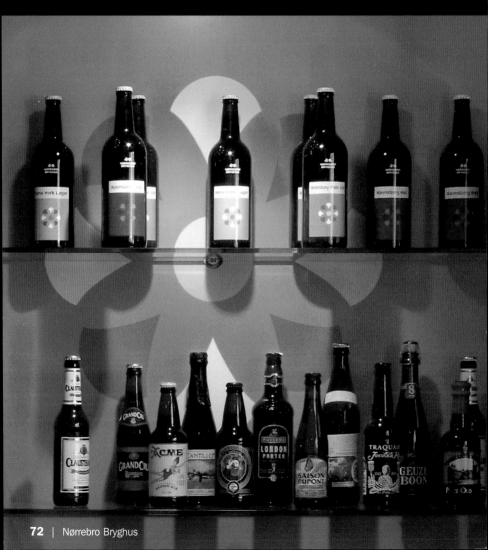

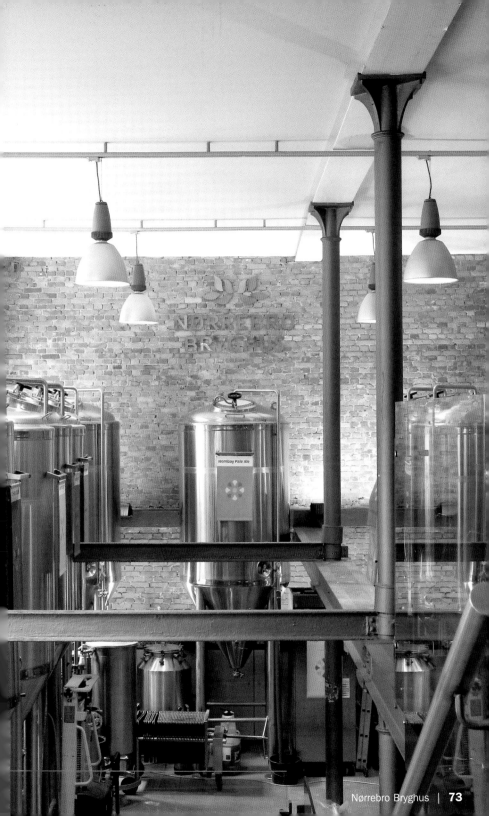

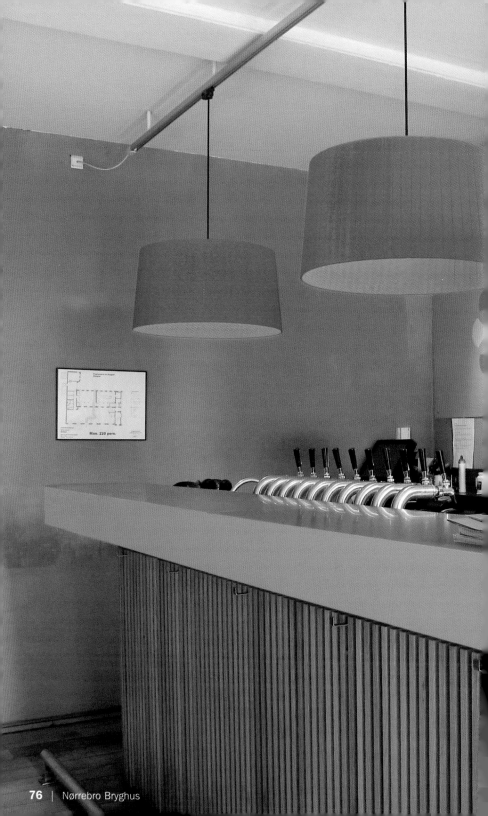

Østerbrogade 79 | 2100 København Ø
Phone: +45 35 42 62 48
www.parkcafe.dk
Opening hours: Mon–Tue noon to midnight, Wed–Fri noon to open end,
Sat 10 am to open end, Sun 10 am to midnight
Average price: DKK 169
Cuisine: Pacific Rim, Fusion

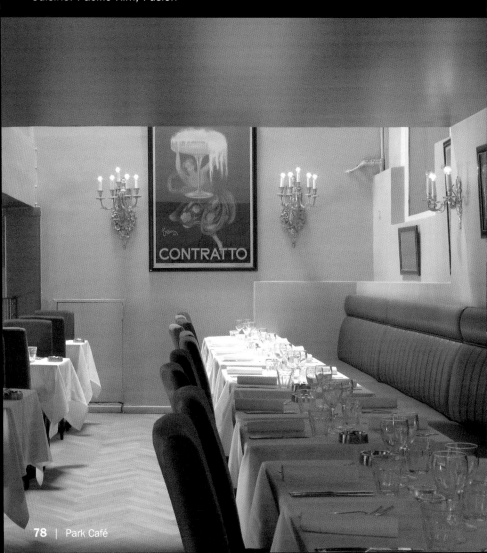

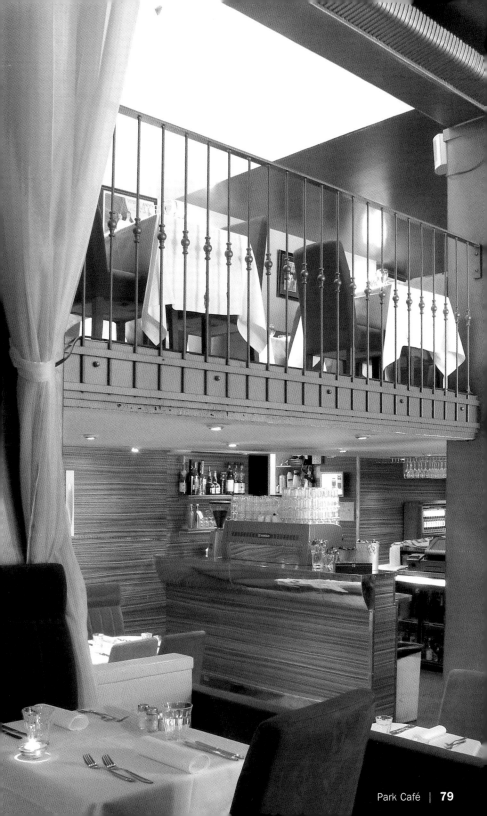

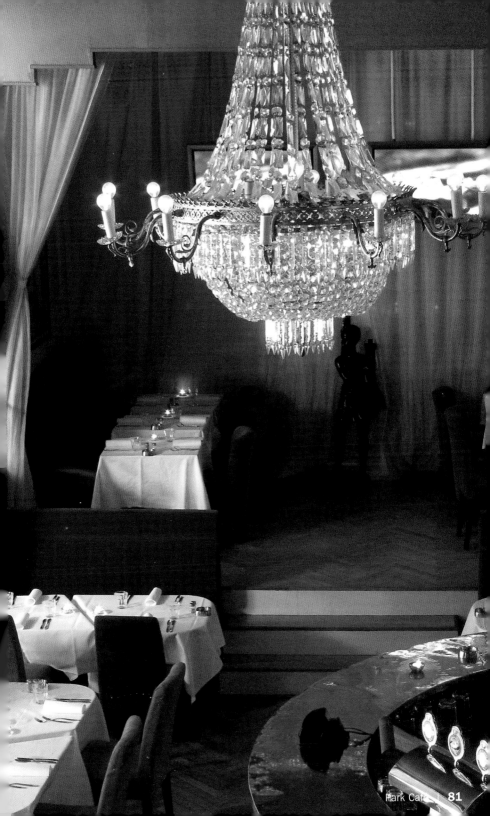

Stor Kongensgade 52 | 1264 København D
Phone: +45 33 32 32 09
www.rasmusoubaek.dk
Opening hours: Mon–Sat 6 pm to midnight
Menu price: DKK 700
Cuisine: Danish, French

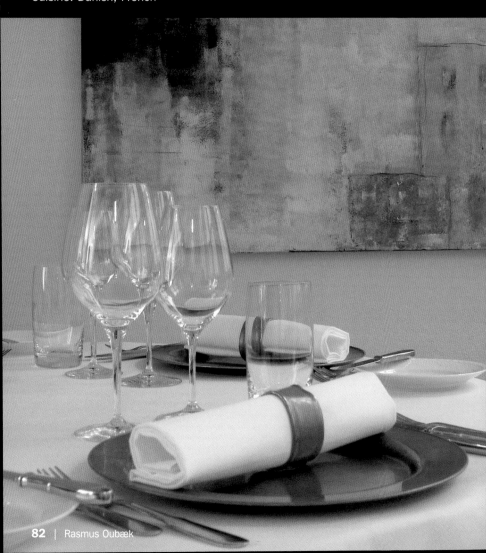

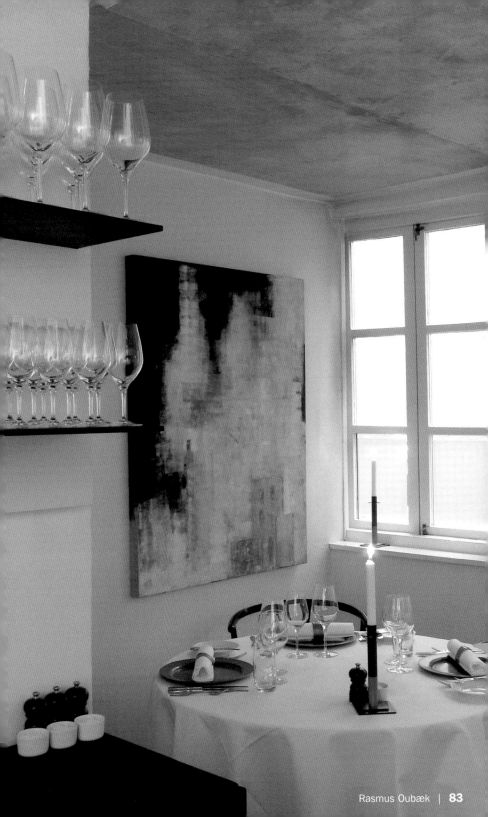

restaurant paustian
bo bech

Design: Jørn Utzon | Chef & Owner: Bo Bech

Kalkbrænderiløbskaj 2 | 2100 København Ø
Phone: +45 39 18 55 01
www.restaurantpaustian.dk
Opening hours: noon to 4 pm, 6 pm to midnight
Menu price: DKK 700
Cuisine: International

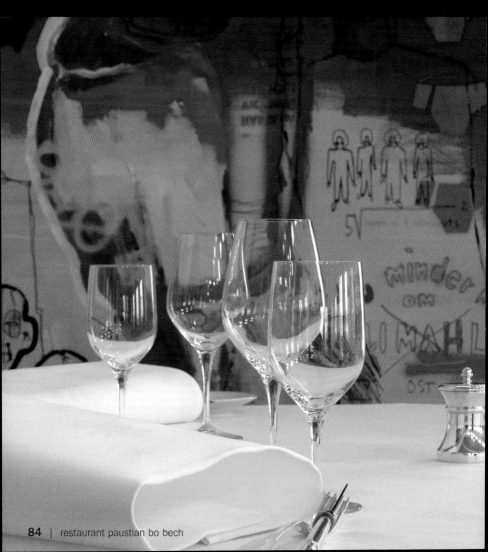

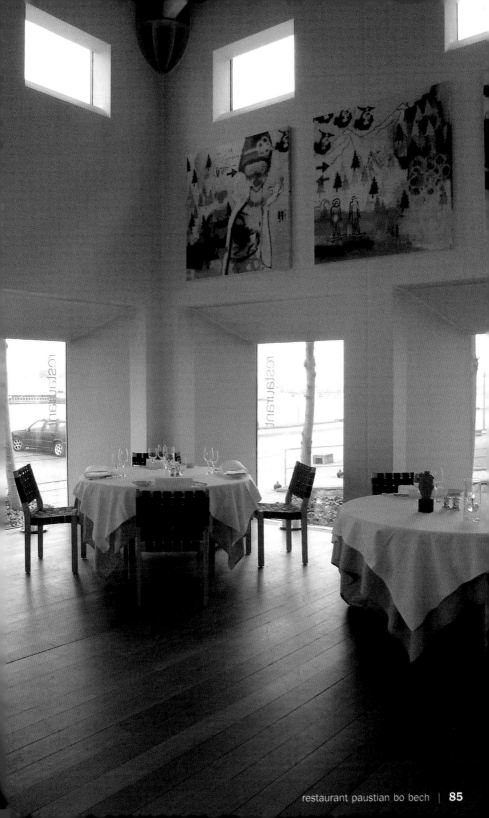

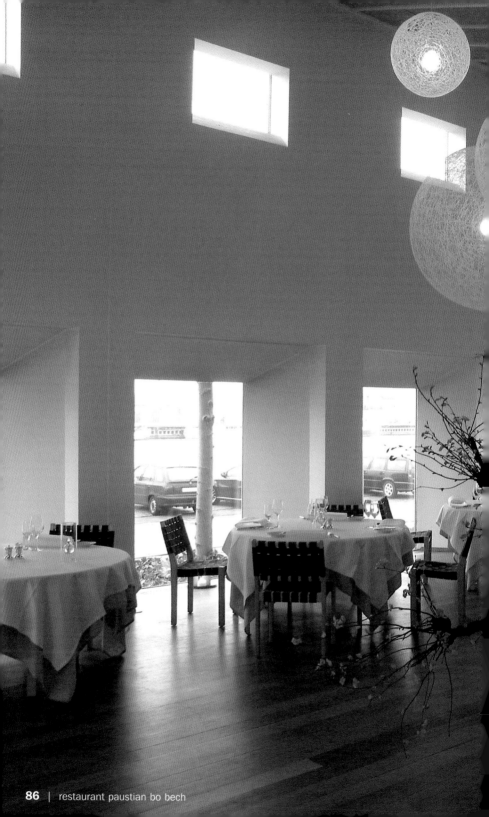

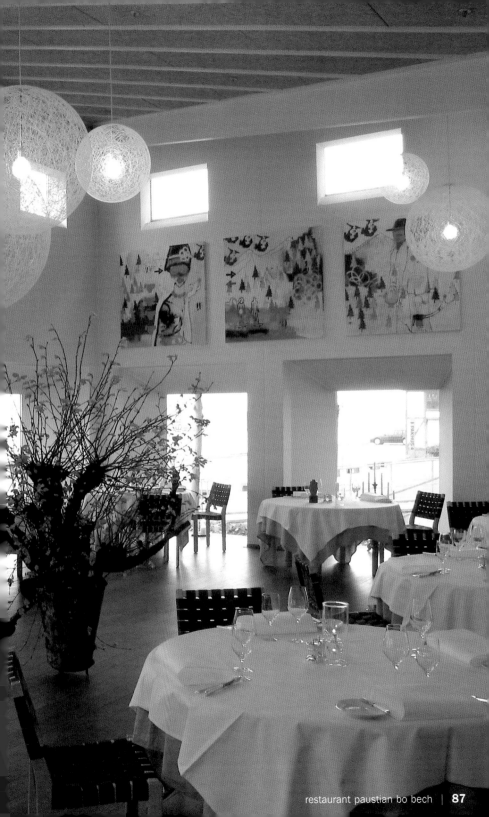

Avocado
with Almonds and Caviar

Avocado mit Mandeln und Kaviar
Avocat aux amandes et au caviar
Aguacate con almendras y caviar
Avocado con mandorle e caviale

13 oz almonds with skin
200 ml milk
Sugar

2 ripe avocados
Milk
Salt, pepper, tabasco

4 tbsp black caviar
4 unpeeled almonds
2 tbsp almond oil

Blanch the almonds, chill and remove the skin. Place in a blender and mix with the milk until smooth. Season with a little sugar.
Remove the stone from the avocados, peel and mash as well. Add just enough milk, depending on the softness of the avocado, until it resembles a smooth paste. Season with salt, pepper and tabasco.
Pour both pastes in plastic bags and squirt small and large dots on four plates. Garnish with caviar, almonds and almond oil.

400 g Mandeln mit Haut
200 ml Milch
Zucker

2 reife Avocados
Milch
Salz, Pfeffer, Tabasco

4 EL schwarzer Kaviar
4 ungeschälte Mandeln
2 EL Mandelöl

Die Mandeln blanchieren, abschrecken und von der Haut befreien. In einen Mixer geben und mit der Milch zu einer glatten Paste pürieren. Mit etwas Zucker abschmecken.
Die Avocados schälen, den Stein herauslösen und ebenfalls pürieren. Je nach Reife der Avocados soviel Milch zufügen, dass eine cremige Paste entsteht. Mit Salz, Pfeffer und Tabasco abschmecken.
Beide Pasten in Spritzbeutel füllen und kleine und große Punkte auf vier Teller spritzen. Mit Kaviar, Mandeln und Mandelöl garnieren.

400 g d'amandes non décortiquées
200 ml de lait
Sucre

2 avocats mûrs
Lait
Sel, poivre, tabasco

4 c. à soupe de caviar noir
4 amandes non décortiquées
2 c. à soupe d'huile d'amande

Blanchir les amandes, les laisser refroidir et les décortiquer. Les mettre dans un mixeur et les réduire en une pâte lisse avec le lait. Saupoudrer de sucre.
Dénoyauter les avocats, les peler et les réduire également en purée. En fonction de la maturation des avocats, ajouter la quantité de lait nécessaire pour obtenir une pâte crémeuse. Assaisonner de sel, poivre et tabasco.
Remplir des douilles avec les 2 pâtes et déposer des points plus ou moins gros sur quatre assiettes. Garnir de caviar, d'amandes et d'huile d'amande.

400 g de almendras con piel
200 ml de leche
Azúcar

2 aguacates maduros
Leche
Sal, pimienta, salsa de tabasco

4 cucharadas de caviar negro
4 almendras sin pelar
2 cucharadas de aceite de almendra

Blanquear las almendras, pasarlas por agua fría y pelarles. Convertir en la batidora con la leche en una pasta uniforme. Añadir un poco de azúcar.
Pelar los aguacates, quitar la pipa y convertirlos igualmente en puré. Según el grado de madurez, añadir leche hasta obtener una pasta cremosa. Condimentar con sal, pimienta y salsa de tabasco.
Poner las dos pastas en mangas pasteleras y rociar puntos grandes y pequeños en cada uno de los cuatro platos. Decorar con caviar, almendras y aceite de almendras.

400 g mandorle con pelle
200 ml latte
Zucchero

2 avocado maturi
Latte
Sale, pepe, tabasco

4 cucchiai di caviale nero
4 mandorle non spelate
2 cucchiai di olio di mandorla

Sbollentare, raffreddare e spelare le mandorle. Porre in un mixer e girare col latte fino a ottenere una pasta omogenea. Aggiungere un po' di zucchero.
Togliere il nocciolo dagli avocado, pelarli e creare anche in questo caso un purè. A seconda di quanto sono maturi gli avocado aggiungere tanto latte fino a quando non si crea una pasta cremosa. Aggiungere sale, pepe e tabasco.
Mettere la pasta nel sacchetto a spruzzo e spruzzare dei punti grandi e piccoli su quattro piatti. Guarnire con caviale, mandorle e olio di mandorla.

Restaurant Prémisse

Design: Gubi | Chef: Rasmus Grønbech
Owners: Rasmus Grønbech, Christian Aarø Mortensen

Dronningens Tværgade 2 | 1302 København K
Phone: +45 33 11 11 459
www.premisse.dk
Opening hours: Mon–Fri noon to 2 pm, Mon–Sat 6 pm to 10 pm
Menu price: DKK 650–750
Cuisine: French avantgarde

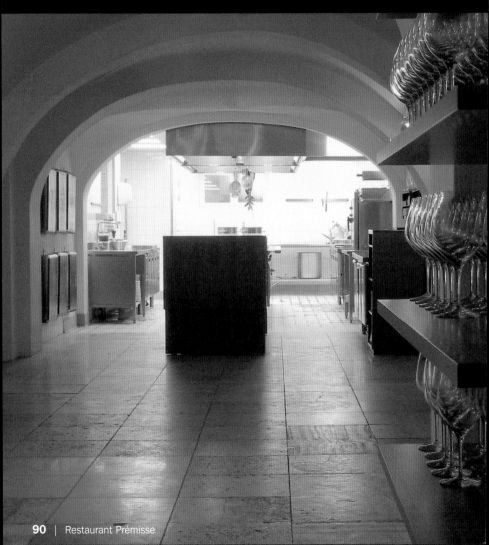

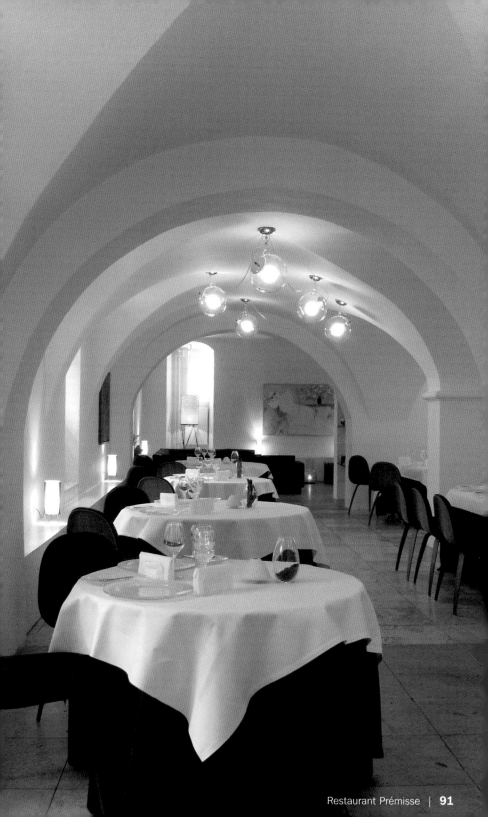

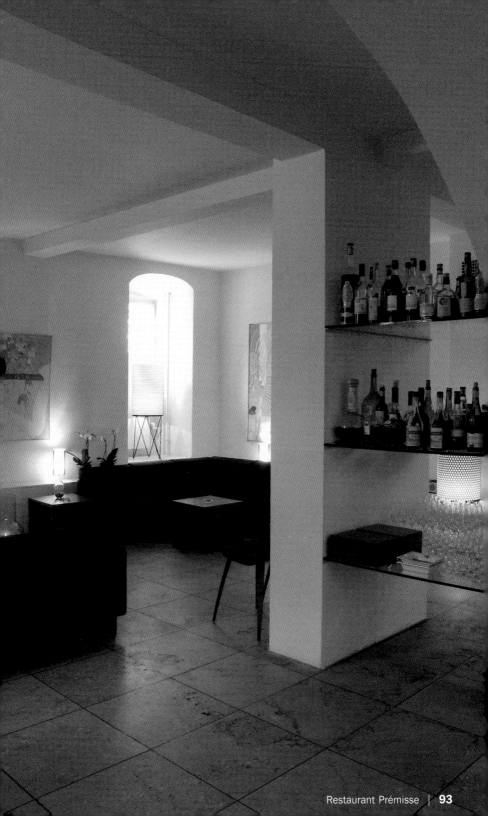

Toldbodgade 24 | 1253 København K
Phone: +45 33 74 14 48
www.saltrestaurant.dk
Opening hours: noon to 4 pm, 5 pm to 10 pm
Average price: DKK 200
Cuisine: French with a Mediterranean touch

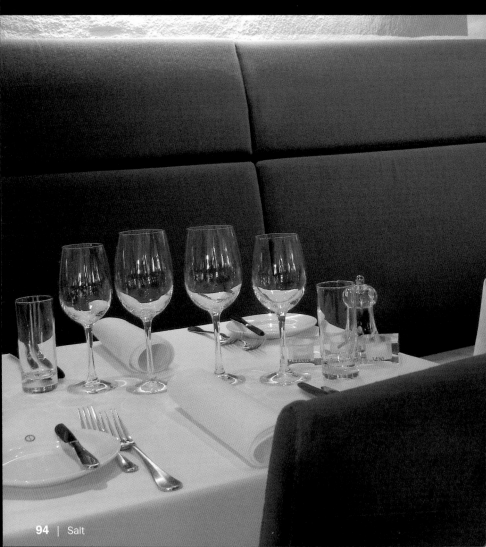

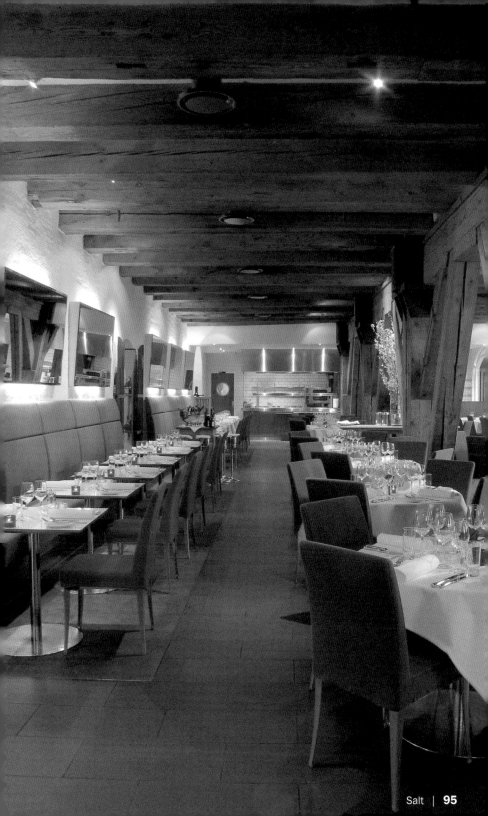

Cauliflower Soup
with Lumpfish Roe

Blumenkohlsuppe mit Seehasenkaviar
Soupe de chou-fleur au caviar de lompe
Sopa de coliflor con huevas de lumpo
Zuppa di cavolfiore con caviale di foca

1 cauliflower
2 tbsp apple vinegar
1 tbsp grape seed oil
1 shallot, diced
2 tbsp butter
1 tsp garlic, chopped
100 ml white wine
400 ml milk
4 tbsp cream cheese
2 tbsp chives, chopped
6 ½ oz lumpfish roe
Salt, pepper, sugar
Chervil and rye crackers for decoration

Cook the cauliflower in salted water until soft and divide into sprigs and stem. Cut 1 ½ oz of the stem into fine julienne and marinate with apple vinegar, grape seed oil, salt, pepper and sugar.

Sauté the leftover stem with shallot and garlic in butter, deglaze with white wine and let the liquid evaporate. Fill up with milk and season. Cook for 10 minutes, blend and keep warm.
Mash 6 ½ oz of the sprigs with the cream cheese, chives, salt and pepper and chill. Press the caviar in round metal moulds and chill.
To serve, divide the soup amongst four deep plates, flip the metal mould onto the center of the plate, remove the mould and cover with a scoop of cream cheese. Garnish with crackers, marinated cauliflower julienne and chervil.

1 Blumenkohl
2 EL Apfelessig
1 EL Traubenkernöl
1 Schalotte, gewürfelt
2 EL Butter
1 TL Knoblauch, gehackt
100 ml Weißwein
400 ml Milch
4 EL Sahnequark
2 EL Schnittlauch, gehackt
200 g Seehasenkaviar
Salz, Pfeffer, Zucker
Kerbel und Roggencräcker zur Dekoration

Blumenkohl in Salzwasser bissfest garen, in Röschen und Strunk zerteilen. 50 g des Strunkes in feine Streifen schneiden und mit Apfelessig, Traubenkernöl, Salz, Pfeffer und Zucker marinieren.

Den restlichen Strunk mit der Schalotte und dem Knoblauch in Butter anschwitzen, mit Weißwein ablöschen und einreduzieren lassen. Mit Milch auffüllen und würzen. 10 Minuten köcheln lassen, pürieren und warmstellen.
200 g der Röschen mit dem Quark, Schnittlauch, Salz und Pfeffer zerdrücken und kaltstellen. Den Kaviar in runde Metallförmchen drücken und kalt stellen.
Zum Servieren die Suppe in vier tiefe Teller verteilen, jeweils eine Form mit Kaviar in die Mitte stellen, den Ring abziehen und mit einer Nocke Quark bedecken. Mit Cräcker, marinierten Blumenkohlstreifen und Kerbel garnieren.

1 chou-fleur
2 c. à soupe de vinaigre de pomme
1 c. à soupe d'huile de pépin de raisin
1 échalote, coupée de dés
2 c. à soupe de beurre
1 c. à café d'ail, haché
100 ml de vin blanc
400 ml de lait
4 c. à soupe de fromage blanc crémeux
2 c. à soupe de ciboulette, hachée
200 g de caviar de lompe
Sel, poivre, sucre
Cerfeuil et craquelins de seigle pour décorer

Faire cuire le chou-fleur à point dans de l'eau salée et séparer les fleurs du trognon. Trancher finement 50 g de trognon et le faire mariner dans le vinaigre de pomme, l'huile de pépin de raisin, le sel, le poivre et le sucre.

Faire suer le reste du trognon dans du beurre avec l'échalote et l'ail, déglacer en versant du vin blanc et faire cuire. Ajouter le lait et assaisonner. Faire frémir pendant 10 minutes, réduire en purée et garder au chaud.
Ecraser 200 g de fleurs avec le fromage blanc, la ciboulette, le sel et le poivre et réfrigérer. Presser le caviar dans des formes métalliques rondes et réfrigérer.
Pour servir la soupe, la répartir dans quatre assiettes creuses, déposer une portion de caviar au milieu de chaque assiette, retirer la forme métallique, puis former une quenelle de fromage blanc à l'aide d'une cuillère et la déposer sur le caviar. Garnir avec les craquelins, les tranches de chou-fleur marinées et le cerfeuil.

1 coliflor
2 cucharadas de vinagre de manzana
1 cucharada de aceite de pepita de uva
1 chalota en cuadritos
2 cucharadas de mantequilla
1 cucharitas de ajo picado
100 ml de vino blanco
400 ml de leche
4 cucharadas de requesón de nata
2 cucharadas de cebollino picado
200 g de huevas de lumpo
Sal, pimienta, azúcar
Perifollo y tostas de centeno para decorar

Hervir la coliflor hasta que esté "al dente" y dividir en flores y tallo. Cortar 50 g del tallo en tiras finas y marinarlas con vinagre de manzana, aceite de pipa de uva, sal, pimienta y azúcar.

Sofreír en mantequilla el resto del tallo con la chalota y el ajo, rebajar con vino blanco y dejar que reduzca. Agregar leche y condimentar. Dejar hervir a fuego lento durante 10 minutos, hacer puré y mantener caliente.
Machacar 200 g de las flores con el requesón, el cebollino, la sal y la pimienta y conservar en frío. Poner el caviar en pequeños moldes redondos de metal y enfriar.
Servir la sopa en cuatro platos hondos, colocar un molde de caviar en el centro, quitar el anillo y cubrir con una bolita de requesón formada con una cucharra. Decorar con tostas, tiritas de coliflor y perifollo.

1 cavolfiore
2 cucchiai di aceto di mela
1 cucchiaio di olio di noce d'uva
1 cipolla, a dado
2 cucchiai di burro
1 cucchiaino d'aglio, tagliuzzato
100 ml vino bianco
400 ml latte
4 cucchiai di ricotta di panna
2 cucchiai di erba cipollina, tagliuzzata
200 g caviale di foca
Sale, pepe, zucchero
Gerfoglio e cracker di segale per la decorazione

Cucinare il cavolfiore in acqua salata e dividere a roselline e a ceppi. Tagliare 50 g del ceppo in sottili strisce e marinare con aceto di mela, olio di noce d'uva, sale, pepe e zucchero.

Cuocere il ceppo restante con lo scalogno e l'aglio in burro, aggiungere vino bianco e lasciar rimpicciolire. Aggiungere il latte e aromatizzare. Cuocere per 10 minuti, fare un purè e mettere in caldo.
Premere 200 g delle rose con la ricotta, erba cipollina, sale e pepe e mettere a freddo. Premere il caviale in forme di metallo rotonde e mettere a freddo.
Per servire, suddividere la zuppa in quattro piatti profondi, porre rispettivamente una porzione di caviale al centro del piatto, togliere la formina di metallo, poi dare forma alla massa di quark formaggio fresco usando un cucchiaio e posare sopra il caviale. Marinare con dei cracker, guarnire le strisce di cavolfiore e gerfoglio.

Le Sommelier

Design: Gemal og Boelskifte | Chef: Francis Cardenau
Owners: Jesper Boelskifte, Erik Gemal Witting, Francis Cardenau

Bredgaade 63–65 | 1260 København K
Phone: +45 33 11 45 15
www.lesommelier.dk
Opening hours: Mon–Thu noon to 2 pm, 6 pm to 10 pm, Fri noon to 2 pm, 6 pm to
11 pm, Sat 6 pm to 11 pm, Sun 6 pm to 10 pm
Menu price: DKK 350
Cuisine: French

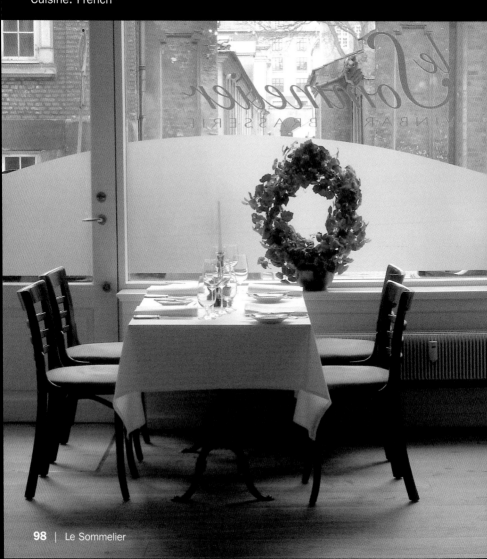

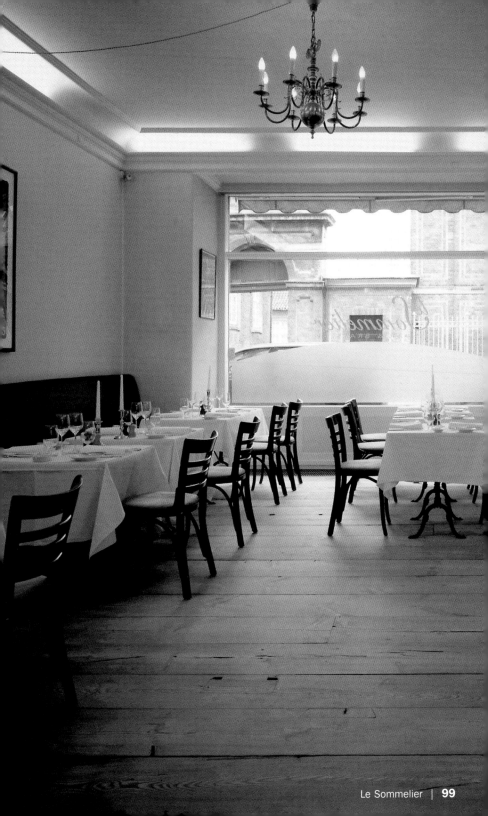

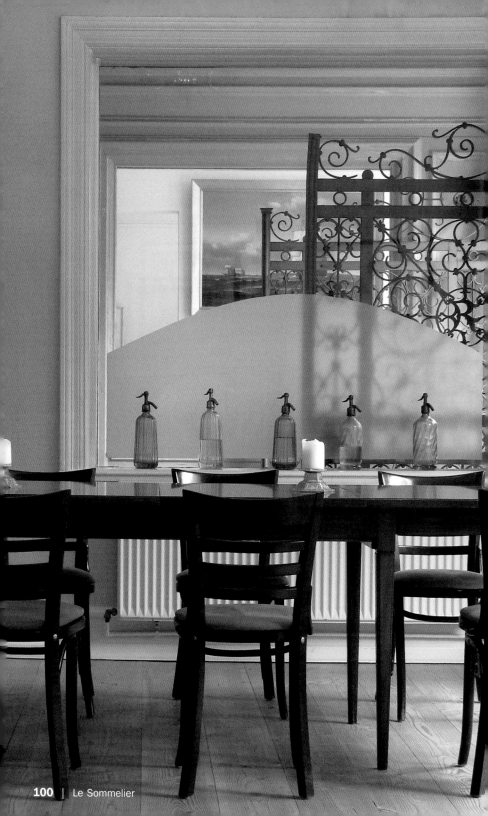

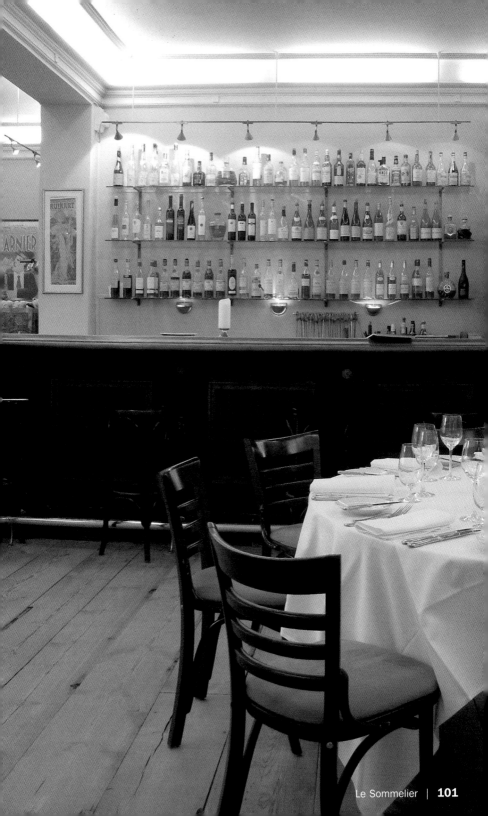

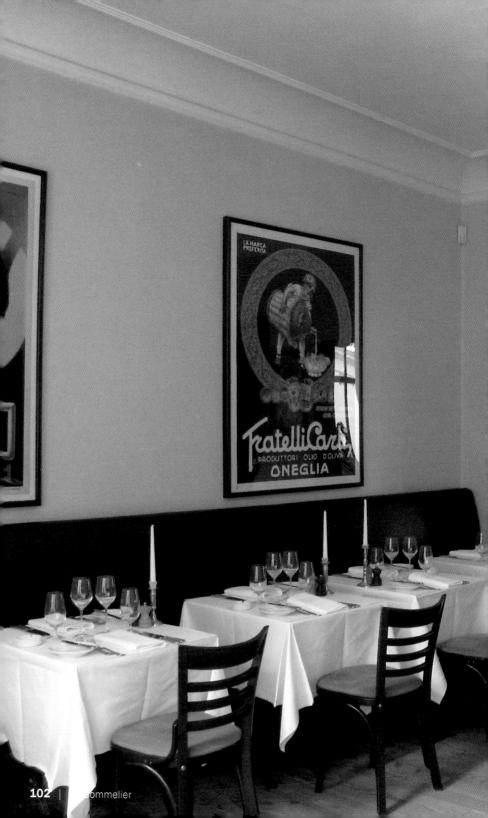

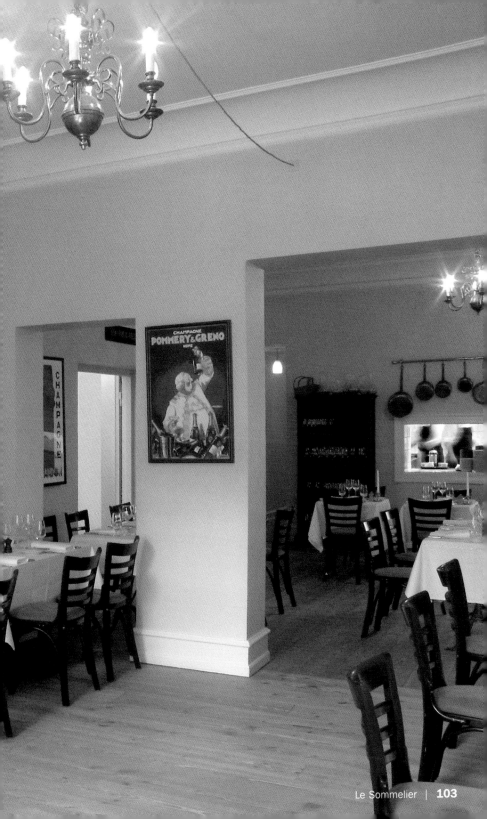

Søren K

Design: Schmidt, Hammer, Lassen | Chef: Tora Bjarnason
Owner: Jens Heding

Søren Kierkegaards Plads 1 | 1221 København K
Phone: +45 33 47 49 49
www.soerenk.dk
Opening hours: Mon–Sat noon to midnight
Menu price: DKK 350
Cuisine: Modern European

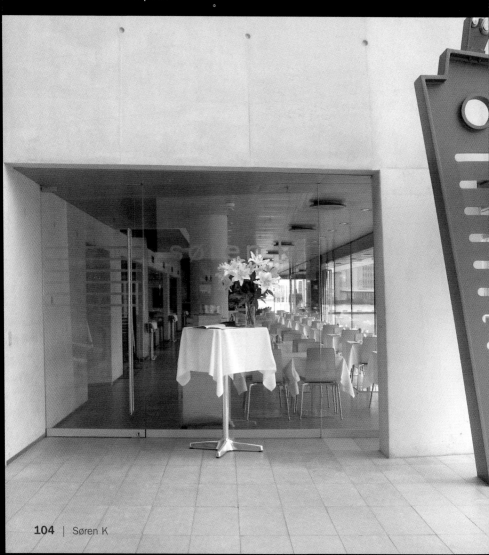

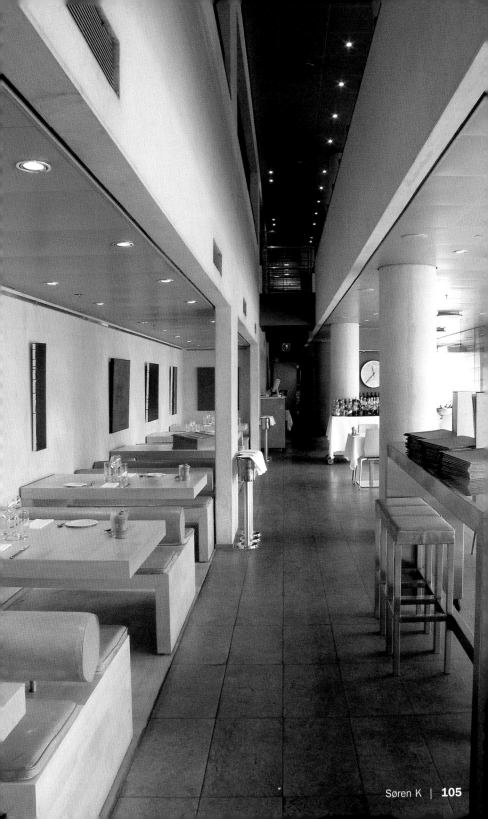

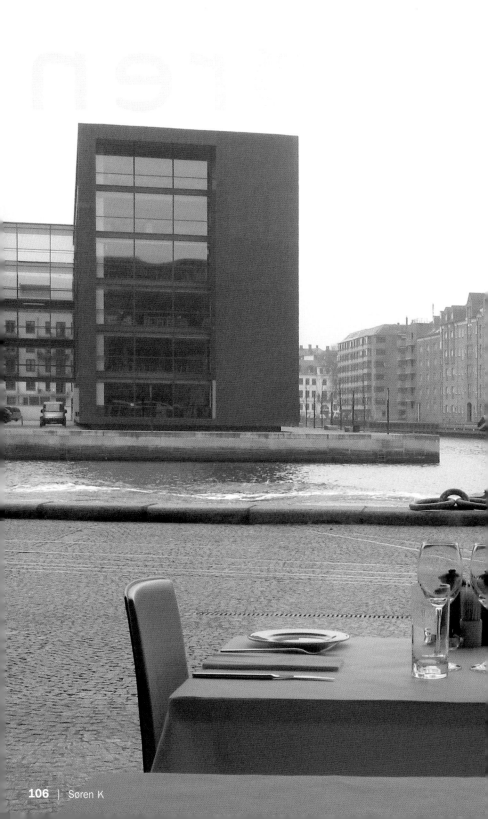

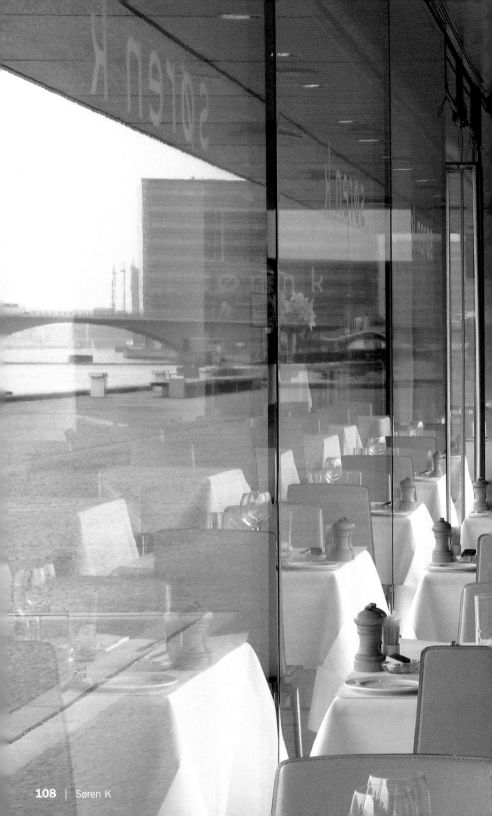

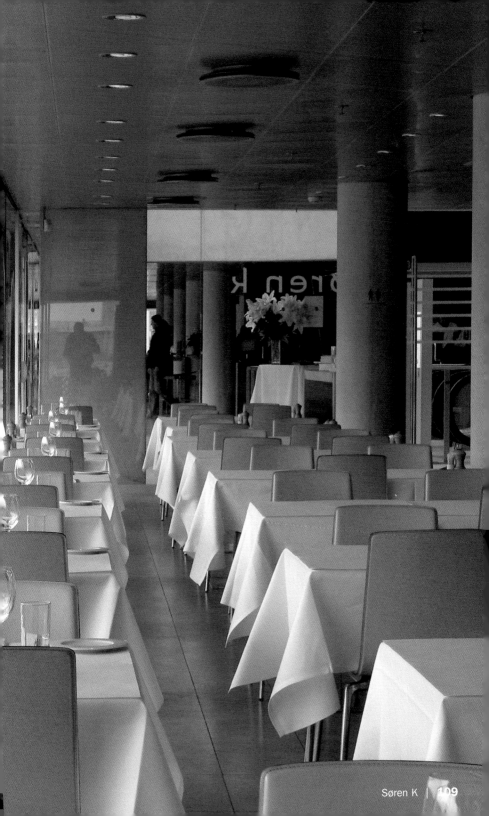

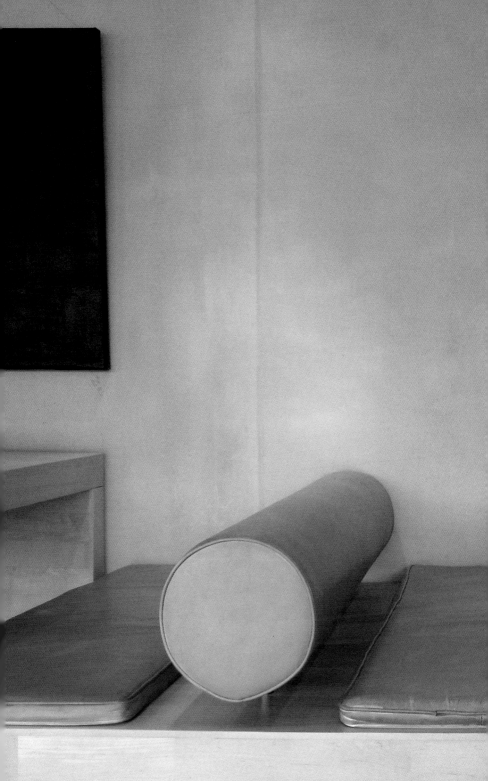

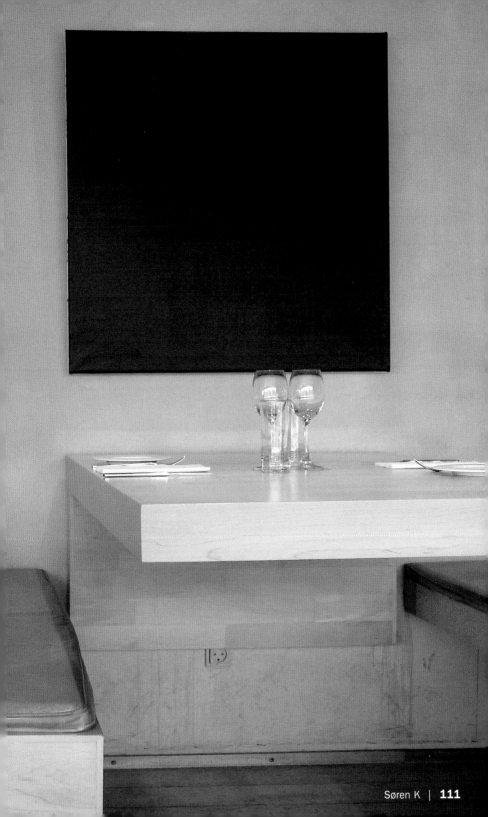

Sult

Design: Gubbi-designs | Chef: Frederik Olson
Owners: Christian Willumsen, Jacob Blom

Vognmagergade 8b | 1120 København K
Phone: +45 33 74 34 17
www.sult.dk
Opening hours: Tue–Fri noon to 10 pm, Sat 10 am to 10 pm, Sun 10 am to 9 pm
Menu price: DKK 145–295
Cuisine: Café, Mediterranean-Nordic mix

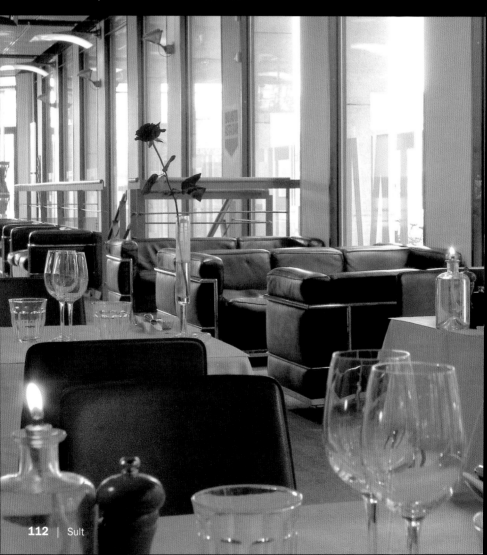

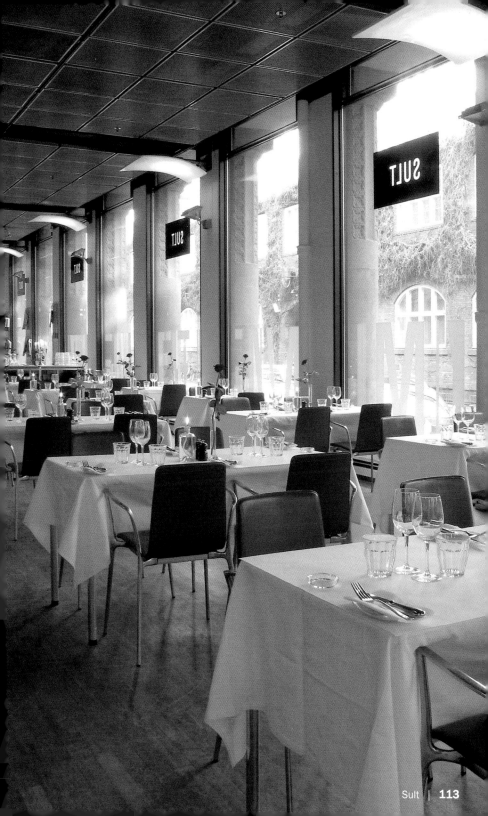

Gothersgade 3 | 1123 København K
Phone: +45 33 93 30 54
www.sushitarian.dk
Opening hours: Mon–Wed noon to 11 pm, Thu–Sat noon to midnight,
Sun 5:30 am to 11 pm
Average price: DKK 69
Cuisine: Sushi- and noodlebar

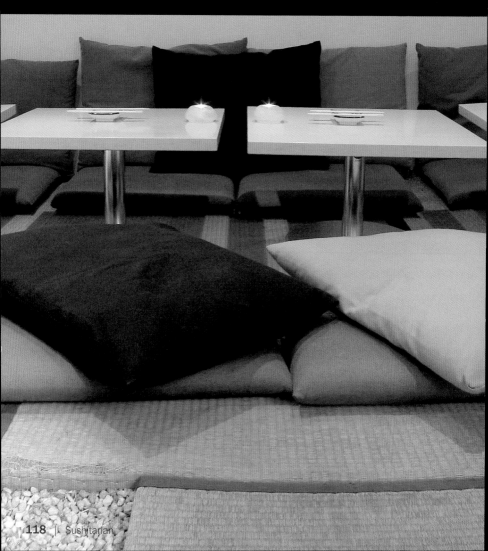

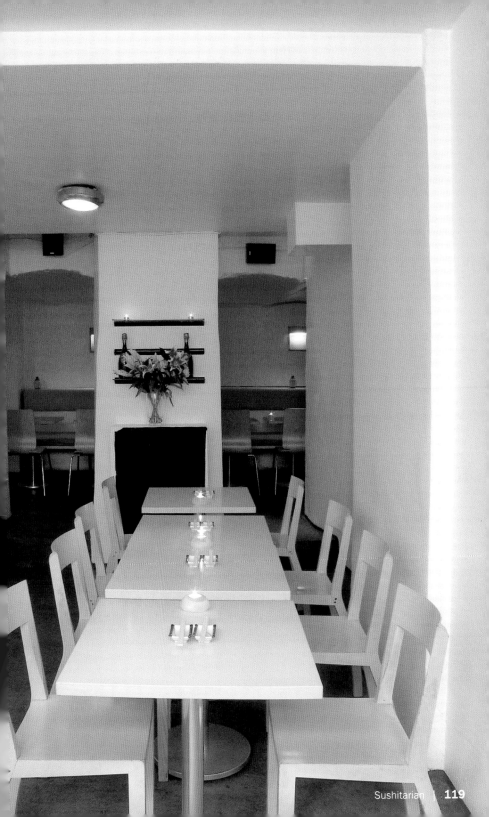

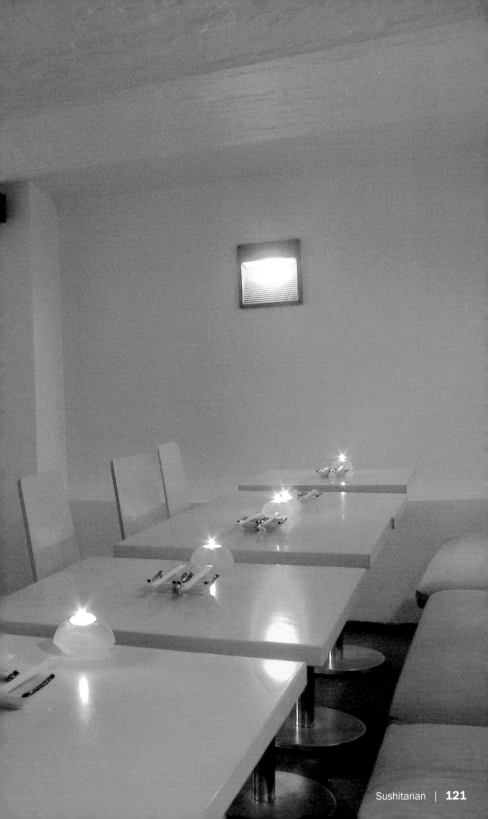

Futo Maki

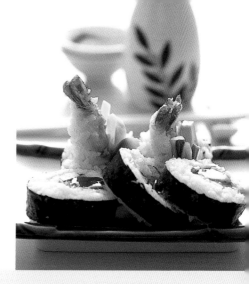

8 prawns
Salt, pepper
Flour for dusting
1 package tempura mix (Asia shop)
Vegetable oil for deep-frying
3 sheets nori
5 oz sushi-rice
3 tbsp rice vinegar
1 avocado
Lemon juice
1 cucumber
6 ½ oz tuna
Teriyaki sauce for decoration

Combine the tempura mix with water, according to the directions, heat the vegetable oil to 320 °F. Season the prawns, dust with a little flour and urn in the batter. Deep-fry for approx. 4 minutes. Keep warm.

Cook the sushi-rice with 400 ml water until soft, combine with rice vinegar and salt and season for taste. Peel the avocado, cut in thick strips and marinate with lemon juice. Peel the cucumber, remove the seeds and cut in strips as well. Cut the tuna in three parts. Place one sheet nori on a sushi mat at a time, press the sushi rice with 0.2 in. thickness on the nori, place avocado, cucumber and tuna in the middle of the mat and roll up tightly. Wrap in plastic foil and chill.

To serve, cut the rolls in finger thick slices, place 3 slices and 2 prawns on each plate and drizzle with Teriyaki sauce.

8 Garnelen
Salz, Pfeffer
Mehl zum Bestäuben
1 Packung Tempurateig (Asia-Shop)
Pflanzenöl zum Frittieren
3 Nori-Blätter
150 g Sushi-Reis
3 EL Reisessig
1 Avocado
Zitronensaft
1 Gurke
200 g Tunfisch
Teriyakisauce zum Beträufeln

Den Tempurateig nach Packungsanleitung mit Wasser verrühren, das Pflanzenöl auf 160 °C vorheizen. Die Garnelen würzen, mit etwas Mehl bestäuben und durch den Tempurateig ziehen. Ca. 4 Minuten frittieren. Warm stellen.

Den Sushi-Reis mit 400 ml Wasser garen, mit dem Reisessig und Salz mischen und abschmecken. Die Avocado schälen, in dicke Stifte schneiden und mit Zitronensaft marinieren. Die Gurke schälen, die Kerne entfernen und ebenfalls in Stifte schneiden. Den Tunfisch in drei Teile schneiden. Jeweils ein Nori-Blatt auf eine Sushi-Matte legen, ca. 5 mm dick den Reis festdrücken, Avocado, Gurke und Tunfisch in die Mitte der Matte legen und fest einrollen. In Frischhaltefolie wickeln und kalt stellen.

Zum Servieren die Rollen in fingerdicke Scheiben schneiden, jeweils drei Scheiben und zwei Garnelen auf einen Teller legen und mit Teriyakisauce beträufeln.

8 langoustines
Sel, poivre
Farine à saupoudrer
1 sachet de pâte à tempura (magasin asiatique)
Huile végétale à frire
3 feuilles de nori
150 g de riz à sushi
3 c. à soupe de vinaigre de riz
1 avocat
Jus de citron
1 concombre
200 g de thon
Sauce teriyaki pour arroser

Mélanger la pâte à tempura avec de l'eau conformément aux consignes figurant sur le sachet, faire chauffer l'huile végétale à 160 °C. Assaisonner les langoustines, les saupoudrer de farine et les poser sur la pâte à tempura. Faire frire env. 4 minutes. Tenir au chaud.

Faire cuire le riz à sushi dans 400 ml d'eau, mélanger au vinaigre de riz et au sel et assaisonner. Peler l'avocat, le couper en batônnets épais et le faire mariner dans le jus de citron. Peler le concombre, retirer les pépins et le couper également en batônnets épais. Diviser le thon en 3 parts. Poser une feuille de nori sur chaque rond de sushi, presser le riz sur env. 5 mm d'épaisseur, disposer l'avocat, le concombre et le thon au milieu du rond et bien enrouler. Envelopper dans du cellofrais et réfrigérer.

Pour servir, couper les rouleaux en tranches de l'épaisseur d'un doigt, disposer 3 tranches et 2 langoustines sur chaque assiette et arroser de sauce teriyaki.

8 langostinos
Sal, pimienta
Harina para espolvorear
1 paquete de masa de tempura (tienda de alimentos asiáticos)
Aceite vegetal para freir
3 hojas de nori
150 g arroz para sushi
3 cucharadas de vinagre de arroz
1 aguacate
Zumo de limón
1 pepino
200 g de atún
Salsa teriyaki para salpicar

Mezclar la masa de tempura con agua según las instrucciones del paquete, calentar el aceite vegetal a 160 °C. Condimentar los langostinos, espolvorearlos con un poco de harina y pasarlos por la masa de tempura. Freír durante unos 4 minutos. Mantener caliente.

Hervir el arroz para sushi con 400 ml, mezclar con el vinagre de arroz y la sal y condimentar. Pelar el aguacate, cortarlo en tiras gruesas y dejar macerar en zumo de limón. Pelar el pepino, quitar las pipas y cortarlo en tiras también. Cortar el atún en 3 trozos. Colocar una hoja de nori en una estera de bambú para sushi y colocar el arroz bien apretado con un grosor de aprox. 5 mm. Colocar el aguacate, el pepino y el atún en el centro de la estera y enrollar con fuerza. Envolver en celofán y conservar en frío.

Para servir, cortar los rollos en lonchas del grueso de un dedo, colocar 3 lonchas y 2 langostinos en cada plato y salpicar con salsa teriyaki.

8 gamberi
Sale, pepe
Farina da porre sopra
1 pacchetto pasta Tempura (Asia-Shop)
Olio vegetale per soffriggere
3 foglie di nori
150 g riso sushi
3 cucchiai di aceto di riso
1 avocado
Succo di limone
1 cetriolo
200 g tonno
Salsa Teriyaki da aggiungersi

Aggiungere acqua all'impasto di Tempura secondo le istruzioni sul pacchetto, riscaldare l'olio vegetale a 160 °C. Aromatizzare i gamberi, aggiungere farina e mettere nell'impasto di Tempura. Friggere per ca. 4 minuti. Lasciare a caldo.

Aggiungere 400 ml di acqua al riso sushi, mescolare con l'aceto di riso e sale e assaggiare. Pelare gli avocado, tagliare a pezzi e marinare con succo di limone. Pelare il cetriolo, togliere i semi e tagliarlo a pezzi. Tagliare il tonno in tre pezzi. Mettere rispettivamente una foglia di Nori su una base di Sushi, premere il riso con uno spessore di ca. 5 mm, posare l'avocado, il cetriolo e il tonno nel centro della base e arrotolare bene. Mettere in un foglio di cellophan e mettere a freddo.

Per servire tagliare i rollini a fette dallo spessore di un dito, rispettivamente porre 3 fette e 2 gamberi su un piatto e aggiungere il sugo Teriyaki.

Dronningens Tværgade 22 | 1302 København K
Phone: +45 33 36 07 70
www.tapasbaren.dk
Opening hours: Mon–Wed 5 pm to 11 pm, Thu–Sat 5 pm to midnight
Average price: DKK 35, Tapas Menue DKK 325
Cuisine: Spanish tapas, winebar

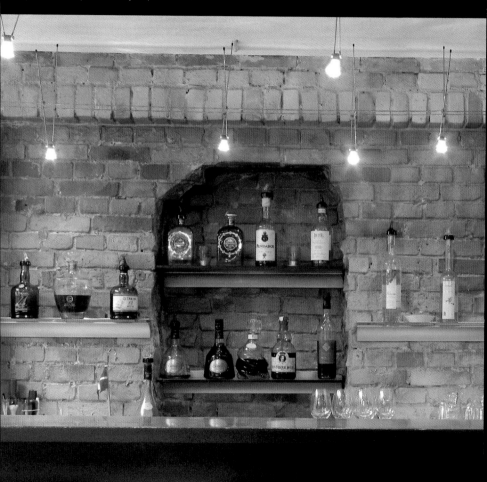

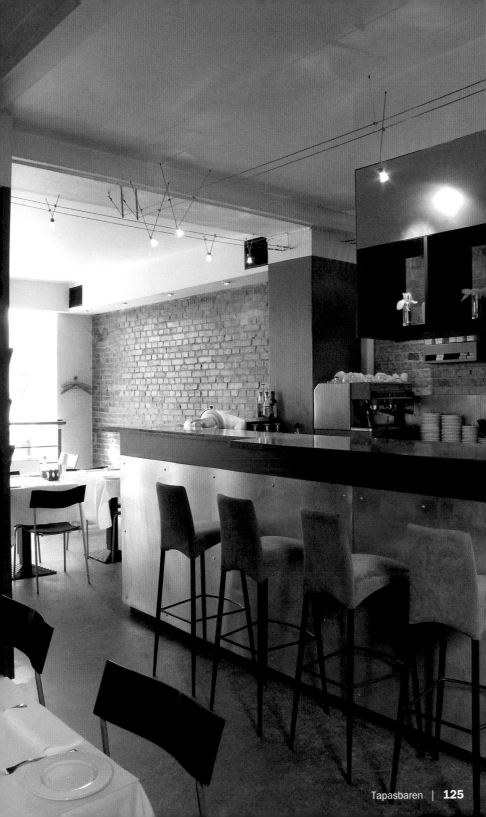

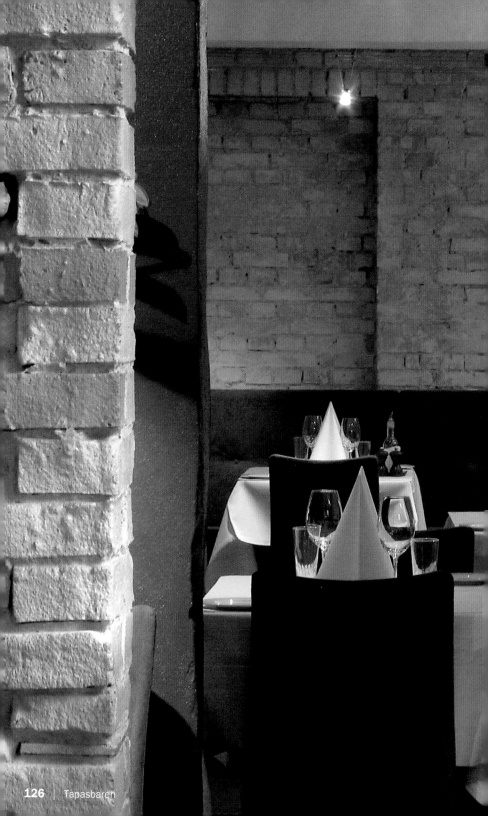

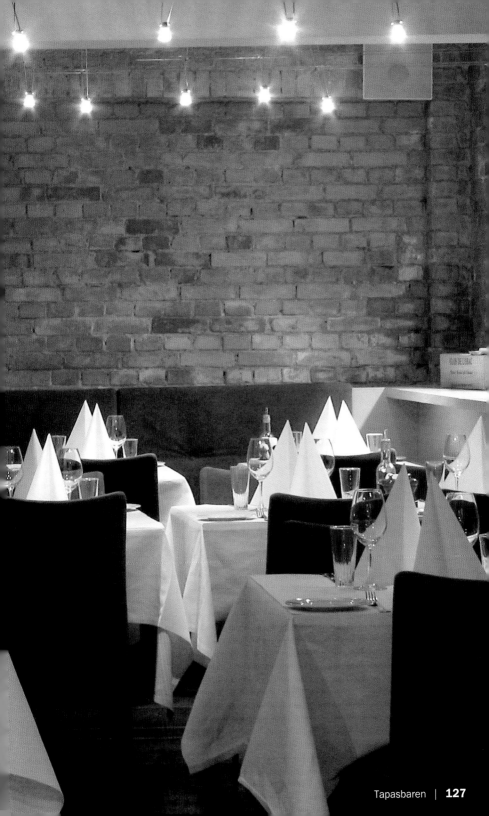

Pimientos de Padrón

Seared Bell Pepper

Gebratene Paprika
Piments cuits
Pimientos fritos
Peperoncini cotti

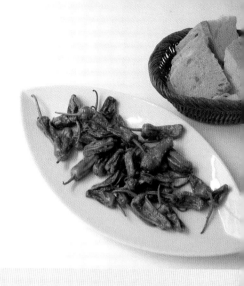

10 oz small green bell peppers (pimientos)
2 tbsp olive oil
Salt, pepper

Baguette or white bread

Wash and dry the bell peppers, in the meantime heat up the pan until very hot, add the olive oil and sear the bell peppers for approx. 1 minute. Season with salt and pepper and serve immediately with baguette.

300 g kleine grüne Paprika (pimientos)
2 EL Olivenöl
Salz, Pfeffer

Baguette oder Weißbrot

Die Paprika waschen und trocken tupfen, in der Zwischenzeit die Pfanne stark erhitzen, das Olivenöl zugeben und die Paprika ca. 1 Minute braten. Mit Salz und Pfeffer würzen und sofort mit Baguette servieren.

300 g de petits piments verts
2 c. à soupe d'huile d'olive
Sel, poivre

Baguette ou pain blanc

Laver les piments et les essuyer, faire chauffer entre temps la poêle, ajouter l'huile d'olive et faire cuire les piments pendant env. 1 minute. Les assaisonner de sel et de poivre et les servir aussitôt, accompagnés de baguette.

300 g de pimientos de padrón
2 cucharadas de aceite de oliva
Sal, pimienta

Pan

Lavar y secar los pimientos, calentar mientras tanto la sartén a fuego máximo, agregar el aceite de oliva y freir los pimientos durante aprox. 1 minuto. Condimentar con sal y pimienta y servir calientes con pan.

300 g piccoli peperoncini verdi (pimientos)
2 cucchiai di olio d'oliva
Sale, pepe

Baguette oppure pane bianco

Lavare e asciugare i peperoncini, scaldare nel frattempo fortemente la padella, aggiungere olio, cuocere i peperoncini per ca. 1 minuto. Aromatizzare con sale e pepe e servire subito con la baguette.

Vesterbrogade 3 | 1630 København V
Phone: +45 33 75 07 75
www.thepaul.dk
Opening hours: booking times; lunch noon to 2 pm, dinner 6 pm to 8 pm
Menu price: DKK 700
Cuisine: International

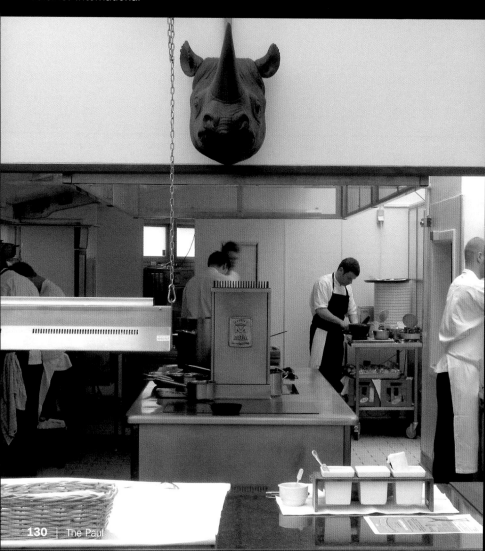

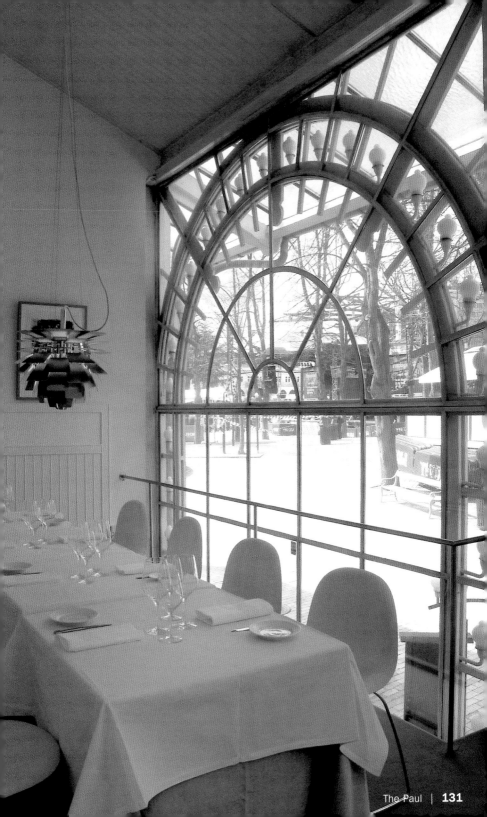

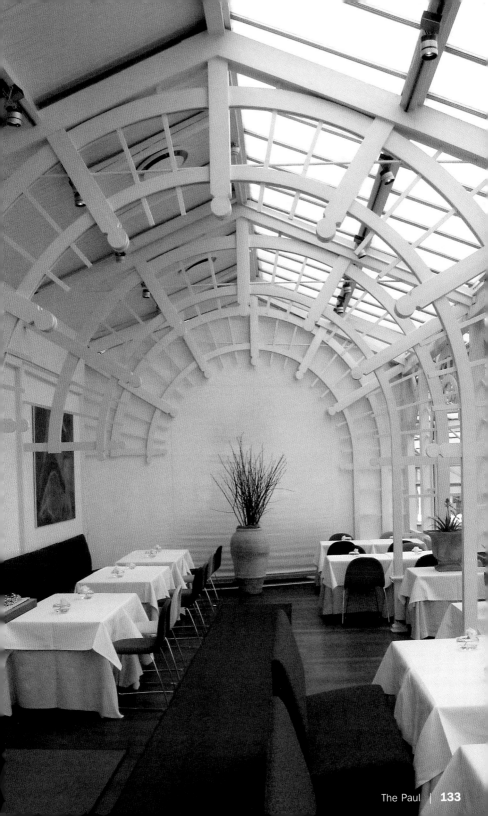

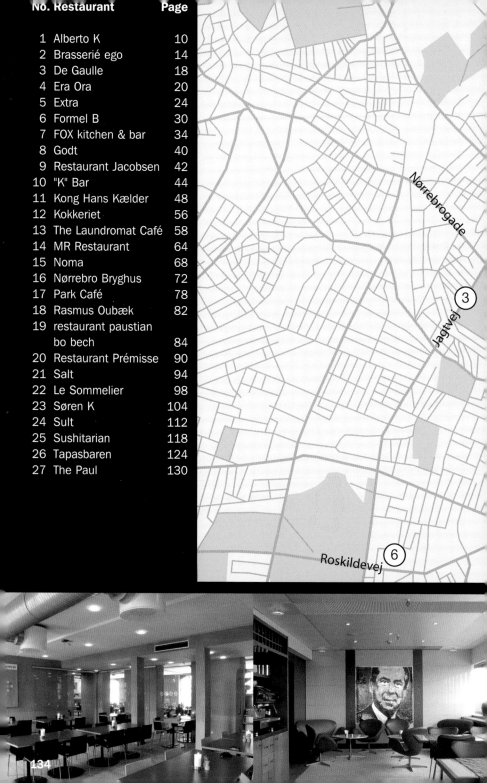

Nørrebrogade

Jagtvej

③

Roskildevej ⑥

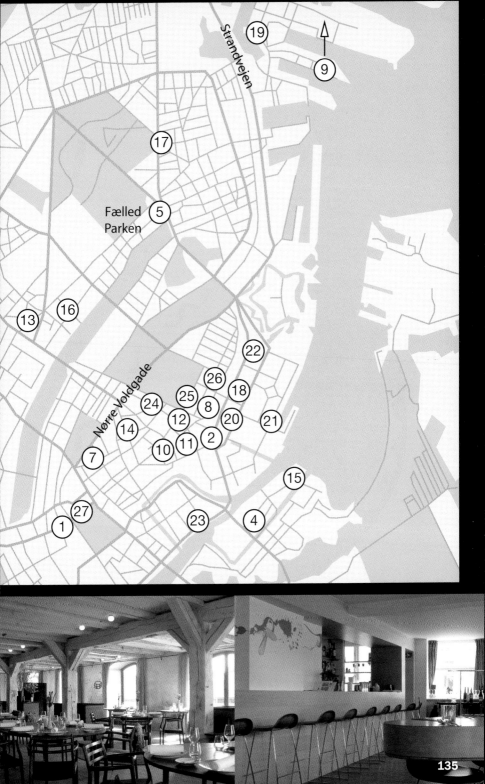

Strandvejen

⑲

⑨

⑰

Fælled ⑤
Parken

⑬ ⑯

㉒

㉖

㉕ ⑱

㉔ ⑧

Nørre Voldgade

⑫ ⑳

⑭

② ㉑

⑩ ⑪ ②

⑦

⑮

① ㉗

㉓ ④

Cool Restaurants

Amsterdam
ISBN 3-8238-4588-8

Barcelona
ISBN 3-8238-4586-1

Berlin
ISBN 3-8238-4585-3

Brussels (*)
ISBN 3-8327-9065-9

Cape Town
ISBN 3-8327-9103-5

Chicago
ISBN 3-8327-9018-7

Cologne
ISBN 3-8327-9117-5

Copenhagen
ISBN 3-8327-9146-9

Côte d'Azur
ISBN 3-8327-9040-3

Dubai
ISBN 3-8327-9149-3

Frankfurt
ISBN 3-8327-9118-3

Hamburg
ISBN 3-8238-4599-3

Hong Kong
ISBN 3-8327-9111-6

Istanbul
ISBN 3-8327-9115-9

Las Vegas
ISBN 3-8327-9116-7

London 2nd edition
ISBN 3-8327-9131-0

Los Angeles
ISBN 3-8238-4589-6

Madrid
ISBN 3-8327-9029-2

Mallorca/Ibiza
ISBN 3-8327-9113-2

Miami
ISBN 3-8327-9066-7

Milan
ISBN 3-8238-4587-X

Moscow
ISBN 3-8327-9147-7

Munich
ISBN 3-8327-9019-5

New York 2nd edition
ISBN 3-8327-9130-2

Paris 2nd edition
ISBN 3-8327-9129-9

Prague
ISBN 3-8327-9068-3

Rome
ISBN 3-8327-9028-4

San Francisco
ISBN 3-8327-9067-5

Shanghai
ISBN 3-8327-9050-0

Sydney
ISBN 3-8327-9027-6

Tokyo
ISBN 3-8238-4590-X

Toscana
ISBN 3-8327-9102-7

Vienna
ISBN 3-8327-9020-9

Zurich
ISBN 3-8327-9069-1

COOL SHOPS

BARCELONA
ISBN 3-8327-9073-X

BERLIN
ISBN 3-8327-9070-5

HAMBURG
ISBN 3-8327-9120-5

HONG KONG
ISBN 3-8327-9121-3

LONDON
ISBN 3-8327-9038-1

LOS ANGELES
ISBN 3-8327-9071-3

MILAN
ISBN 3-8327-9022-5

MUNICH
ISBN 3-8327-9072-1

NEW YORK
ISBN 3-8327-9021-7

PARIS
ISBN 3-8327-9037-3

TOKYO
ISBN 3-8238-9122-1

COOL SPOTS

LAS VEGAS
ISBN 3-8327-9152-3

MALLORCA/IBIZA
ISBN 3-8327-9123-X

MIAMI/SOUTH BEACH
ISBN 3-8327-9153-1

Size: 14 x 21.5 cm
5 1/2 x 8 1/2 in.
136 pp, Flexicover
c. 130 color photographs
Text in English, German,
French, Spanish, Italian
or (*) Dutch

teNeues

CAMPAIGN 348

THE NAVAL SIEGE OF JAPAN 1945

War Plan Orange Triumphant

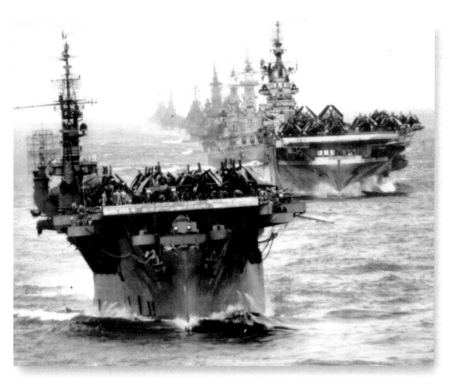

BRIAN LANE HERDER ILLUSTRATED BY DOROTHY J. HWEE

Series editor Marcus Cowper

OSPREY PUBLISHING
Bloomsbury Publishing Plc
Kemp House, Chawley Park, Cumnor Hill, Oxford OX2 9PH, UK
1385 Broadway, 5th Floor, New York, NY 10018, USA
Email: info@ospreypublishing.com
www.ospreypublishing.com

OSPREY is a trademark of Osprey Publishing

First published in Great Britain in 2020

© Osprey Publishing, 2020

A catalog record for this book is available from the British Library.

ISBN: PB 9781472840363; eBook 9781472840370; ePDF 9781472840349; XML 9781472840356

20 21 22 23 24 10 9 8 7 6 5 4 3 2

Maps by bounford.com
3D BEVs by The Black Spot
Index by Sandra Shotter
Typeset by PDQ Digital Media Solutions, Bungay, UK
Printed and bound in India by Replika Press Private Ltd.

Artist's note

Readers can find out more about the work of battlescene illustrator Dorothy J. Hwee at the following website:
http://artofdjh.blogspot.com

Osprey Publishing supports the Woodland Trust, the UK's leading woodland conservation charity.

To find out more about our authors and books visit **www.ospreypublishing.com**. Here you will find extracts, author interviews, details of forthcoming events, and the option to sign up for our newsletter.

Author's acknowledgements

Content from Commander Mathews' article "Bombarding Japan" is excerpted from *Proceedings* with permission; © 1979 U.S. Naval Institute/ www.usni.org.

Author's note

Throughout the text flag signals appear in italics, with standard radio transmissions in Roman.

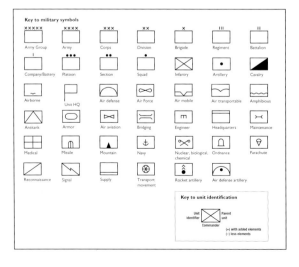

PREVIOUS PAGE
Light carrier USS *Langley* (CVL-27) leads the Task Group 38.3 battle line into Ulithi, December 12, 1944.

CONTENTS

Pacific situation, February 1, 1945

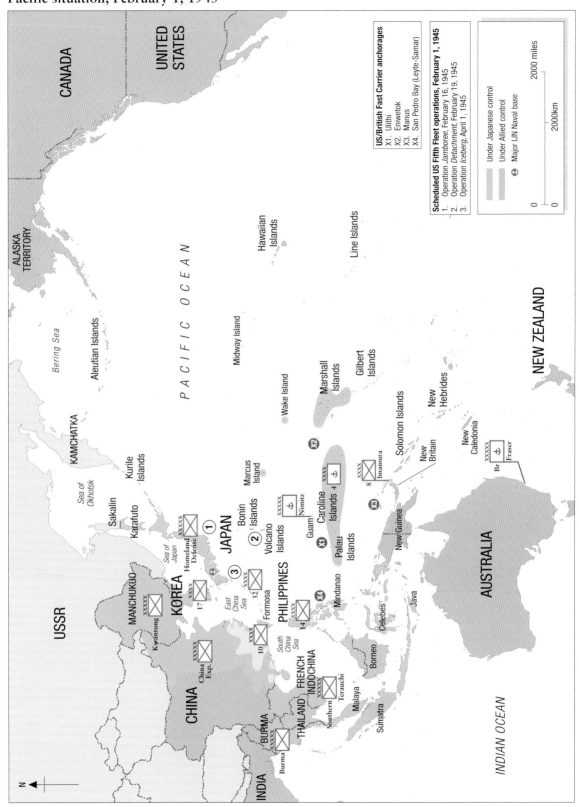

US/British Fast Carrier anchorages
X1. Ulithi
X2. Eniwetok
X3. Manus
X4. San Pedro Bay (Leyte-Samar)

Scheduled US Fifth Fleet operations, February 1, 1945
1. Operation *Jamboree*, February 16, 1945
2. Operation *Detachment*, February 19, 1945
3. Operation *Iceberg*, April 1, 1945

Under Japanese control
Under Allied control
Major IJN Naval base

0 2000 miles
0 2000km

ORIGINS OF THE CAMPAIGN

Execute unrestricted air and submarine warfare against Japan.
US Admiral Harold Stark, December 7, 1941

PRELUDE: NOVEMBER–DECEMBER 1944

By late 1944 the US submarine campaign against Japan approached its climax. Assisted by Magic codebreaking, ship movements to or from the Home Islands had become increasingly suicidal. The submarines' spectacular crescendo began on November 14, 1944, with the departure of 25-ship Japanese convoy Hi-81, en route to the Philippines from Kyushu's Imari Bay. Two US "wolfpacks" of three submarines each were dispatched to stalk the convoy. At noon, November 15, Commander Charles E. Loughlin's USS *Queenfish* (SS-393) torpedoed Imperial Japanese Army (IJA) auxiliary carrier *Akitsu Maru*, which exploded and sank in three minutes, taking 2,046 men with her. Then on November 17, USS *Picuda* (SS-382) torpedoed and sank landing ship *Misayan Maru*, killing another 3,437. Five hours later a surfaced USS *Spadefish* (SS-411) struck 17,200-ton escort carrier *Shinyo Maru*, which sank in ten minutes. The US subs were eventually repulsed, suffering no casualties, but Hi-81 had lost over 7,000 men killed and 40,000 tons sunk, including two carriers.

Barely three days after *Shinyo Maru*'s sinking, at 0020hrs, November 21, 1944, Lieutenant-Commander Eli Reich's USS *Sealion* (SS-315) made radar contact with an Imperial Japanese Navy (IJN) convoy in the Formosa Strait, which was fleeing Brunei for the Home Islands. *Sealion*'s nine-torpedo salvo immediately sank destroyer *Urakaze*, killing all 240 aboard, then struck the 37,187-ton battleship *Kongo*, causing her to fall out of formation. Later, at 0524hrs, November 21, *Kongo* exploded from a catastrophic magazine detonation. Only 247 survived; among *Kongo*'s 1,200 dead were Vice Admiral Yoshio Suzuki and *Kongo* skipper Rear Admiral Toshio Shimazaki. *Sealion* escaped, having claimed the only submarine-sunk battleship of the Pacific War.

A week later, on November 28, 1944, submarine USS *Archerfish* (SS-311) spotted the world's largest aircraft carrier, the 64,800-ton *Shinano*, departing Yokosuka for a 16-hour transfer to Kure. Thirteen hours later *Archerfish* slammed six torpedoes into *Shinano*, then survived the subsequent depth charging from escorting destroyers *Isokaze*, *Yukikaze*, and *Hamakaze*. *Shinano* capsized at 1057hrs, November 29, 1944—history's largest vessel

Unryu seen sinking through USS *Redfish*'s periscope at 1657hrs, December 19, 1944. *Redfish*'s Commander Louis D. McGregor had begun his attack 20 minutes early with a six-torpedo salvo from 1,647 yards. *Unryu* evaded all but one torpedo, which detonated directly below *Unryu*'s island. McGregor's next salvo put a torpedo into *Unryu*'s bow, setting off secondary explosions of avgas, ammunition, and *Ohka* rockets that doomed the carrier. (US Navy via NavSource)

ever sunk by submarine. Of 2,515 aboard, some 1,435 died, including Captain Toshio Abe. US submarines had claimed one battleship and three aircraft carriers.

Barely a week later, on December 9, a US wolfpack comprising submarines USS *Sea Devil* (SS-400), USS *Plaice* (SS-390), and USS *Redfish* (SS-395) collectively torpedoed 23,770-ton light carrier *Junyo*, outbound from Makung, Formosa to the Home Islands, killing 19. The crippled *Junyo* survived by steaming through shallow coastal shoals, reaching Sasebo on December 10, but never returned to service. Assisted by Magic, on December 19, 1944, *Redfish*'s Commander Louis D. McGregor found Captain Konishi Kaname's 17,480-ton fleet carrier *Unryu* in his periscope and promptly put two torpedoes into her. Shattered by secondary explosions, *Unryu* sank bow-first into the East China Sea, taking 1,238 men with her, including her captain. *Redfish* survived destroyer *Hinoki*'s two-hour counterattack by sitting on the bottom at 200ft.

In less than five weeks, US submarines had claimed five aircraft carriers and one battleship; their total IJN score for 1944 was seven carriers, one battleship, two heavy and seven light cruisers, 30 destroyers, and seven submarines.

THE LEGACY OF WAR PLAN ORANGE

Since November 1943 the US Army and the US Navy (USN) had waged two huge, virtually independent campaigns against Japan's Pacific empire, separated by thousands of miles. While MacArthur's US Army-dominated South-West Pacific campaign was essentially an accident of wartime politics, Nimitz's naval campaign in the Central Pacific had been intensively studied since 1906 as War Plan Orange (WPO)—ostensibly a product of the Army–Navy Joint Planning Committee, but essentially a USN-dominated affair. WPO's Phase I had been Japan's assumed conquest of the Philippines and ejection of US power from the Western Pacific. WPO's most heavily studied and debated phase was always Phase II, the United States' naval

and amphibious counteroffensive back across the Pacific. Phase II was to culminate somewhere in the Western Pacific with a decisive fleet battle the USN would win. This would signal the beginning of Phase III, a naval siege of Japan's Home Islands that would, without invasion, force Japan to surrender via a crushing air–sea blockade and bombardment.

In June 1944, Nimitz' Operation *Forager* had invaded the Central Pacific's Mariana Islands, putting United States Army Air Forces (USAAF) B-29 Superfortresses within range of Tokyo. Though often overlooked, one of WPO's primary objectives was to seize bases from which US strategic bombers could bombard the Home Islands. Prince Naruhiko Higashikuni, commander-in-chief of Japan's Home Defense Headquarters, recalled:

> The war was lost when the Marianas were taken away from Japan and when we heard the B-29s were coming out … We had nothing that we could use against such a weapon. From the point of view of the Home Defense Command, we felt that the war was lost and said so. If the B-29s could come over Japan, there was nothing that could be done.

On October 3, 1944 the US Joint Chiefs of Staff (JCS) had ordered US Pacific commanders to invade Luzon and Okinawa. The first phase of *Musketeer III* began with Lieutenant-General Walter Krueger's US Sixth Army landing at Leyte on October 17, 1944. Krueger's landing triggered the IJN counteroffensive, *Sho-1*, which had already been fatally weakened by Third Fleet's October 12–16 aerial rampage over Formosa that cost the IJN some 500 airplanes. Between October 23 and 26, 1944, the US Third and Seventh fleets would defeat *Sho-1* by mauling the IJN at the sprawling, chaotic, and titanic Battle of Leyte Gulf. For the cost of three small carriers, two destroyers, one destroyer-escort, and 200 aircraft, Third and Seventh fleets destroyed four Japanese carriers, three battleships, ten cruisers, 11 destroyers, and another 300 planes.

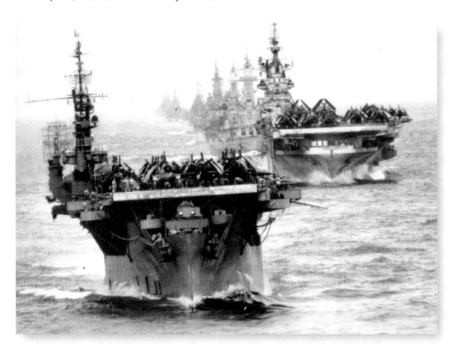

Light carrier USS *Langley* (CVL-27) leads the Task Group 38.3 battle line into Ulithi, December 12, 1944. Assembled around two dozen modern fleet carriers and fast battleships and defended by scores of escorts, the US Navy's Fast Carrier Task Force proved the epitome of naval striking power in 1944 and 1945. (NARA via NavSource)

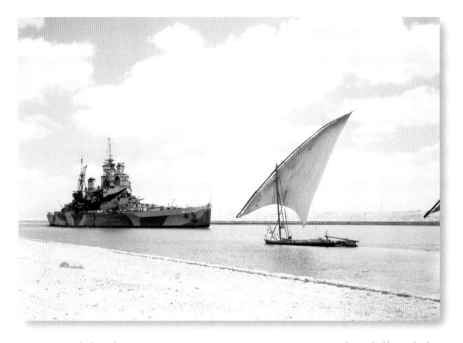

Meanwhile, during 1944 Prime Minister Winston Churchill and the
British Chiefs of Staff sharply disagreed on British Far East strategy. The
empire-oriented Churchill desired a methodical reconquest of Britain's
lost Southeast Asian colonies, but the British chiefs preferred leapfrogging
Southeast Asia and joining the Americans in a direct, war-ending offensive
on Japan. The latter was agreed to between October 12 and 16, 1944. The
ultimate motive was political—Britain's certain loss of prestige if the United
States appeared to have defeated Japan on its own.

OPERATION *KITA*: ABANDONING A COLLAPSING EMPIRE, JANUARY–FEBRUARY 1945

By 1945 Japan was being economically strangled. American submarines had
sunk 603 ships totaling 2.7 million tons in 1944, more tonnage than in the
period 1941–43 combined. US submarines had recorded their single most
devastating month of the war in October 1944, sinking 74 ships of 340,400
tons, including 18 warships of 125,900 tons. Another 214,506 tons of shipping
followed in November. By January 1, 1945 Japan's December 1941 merchant
fleet of 4.1 million tons stood at 2 million tons, while bulk imports of raw
materials had fallen from 16.4 million tons in 1943 to 10 million in 1944.

On November 11, 1944 the IJN had dispatched hybrid battleship-carriers
Ise and *Hyuga* from the Home Islands to Southeast Asian waters. Three
days later, each unloaded 1,000 tons of ammunition at the Spratley Islands
for Japanese forces fighting in the Philippines. Then on January 9, 1945
Krueger's US Sixth Army, executing Operation *Mike I*, landed the first of
193,901 US troops at Luzon. The next day, Admiral William Halsey initiated
Operation *Gratitude*, Third Fleet's South China Sea rampage supporting
Krueger's invasion and seeking *Ise* and *Hyuga*. Unknown to Halsey, *Ise* and
Hyuga would dock at Singapore on January 11. Third Fleet never found
the Japanese battleships, but Third Fleet would sink over 1 million tons

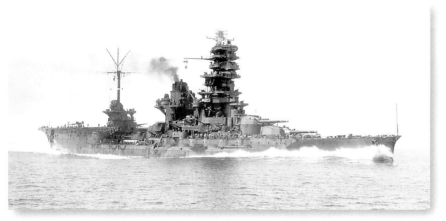

Japanese battleship *Ise* during August 1943 sea trials, after she and sister *Hyuga* had been rebuilt into hybrid battleship-carriers. Six of their original twelve 14in./45 (356mm) heavy guns have been removed. *Ise* and *Hyuga* would twice escape Halsey, first at Leyte Gulf in October 1944 and then in the South China Sea in early 1945. (Wikimedia Commons/ Public Domain)

of Japanese shipping by January 27, including 90 warships and over 550 merchantmen, while destroying an estimated 615 Japanese aircraft.

With the "corking" of the Luzon–Formosa bottleneck, Japan's Southern Resources Area was clearly doomed. At Singapore in early February, battleships *Ise* and *Hyuga*, light cruiser *Oyodo*, and destroyers *Kasumi*, *Asashimo*, and *Hatsushimo* took on one last shipment of critical raw materials for transport back to Japan before US forces inevitably cut communications completely. The strategic evacuation was codenamed Operation *Kita* (*North*). Now designated Kan-Butai (Completion Force), *Ise* and *Hyuga*, *Oyodo*, and *Kasumi*, *Asashimo*, and *Hatsushimo* sortied from Singapore at 2100hrs, February 10 to run the Allied gauntlet back to Japan. Heavy cruisers *Myoko*, *Haguro*, *Ashigara*, and *Takao* were left behind in Southeast Asia.[1] Fleeing desperately north, Kan-Butai quickly found itself stalked by an enormous wolfpack of Allied submarines. The Japanese were first sighted on February 11 by submarine HMS *Tantalus*, which was attacked by aircraft and forced to dive. The following afternoon submarine USS *Charr* (SS-328) reported detecting Kan-Butai on radar. Over the next 14 hours, eight US submarines struggled to reach attack positions.

The following day, February 13, USAAF B-24 Liberators, 40 B-25 Mitchells, and 48 P-51 Mustangs were dispatched from the Philippines to bomb Kan-Butai, but they were thwarted by cloud cover. Although unable to obtain prime attack position, submarine USS *Bergall* (SS-320) fired six torpedoes at *Ise* at 1213hrs. All missed, but *Bergall* survived the subsequent depth charging. Then at 1340hrs, submarine USS *Blower* (SS-325) loosed a six-torpedo spread that came up empty, although one torpedo came near enough to be destroyed by *Ise*'s antiaircraft guns. Shortly after, at 1618hrs, *Hyuga* lookouts sighted submarine USS *Bashaw* (SS-241) 11 miles off *Hyuga*'s port bow. After *Hyuga* landed a 14in. salvo within a mile of *Bashaw*, the submarine crash-dived. Three days later, on February 16, submarine USS *Rasher* (SS-269) made radar contact with Kan-Butai. *Rasher* fired six torpedoes from 1,800 yards, but Kan-Butai altered course and again all missed. This proved the Allies' last contact. Kan-Butai would finally dock at Kure at 1000hrs, February 20, having outrun a 2,723-mile onslaught of 26 Allied submarines and 100 aircraft. *Ise*, *Hyuga*, and *Oyodo* had just become the last major Japanese warships to depart the Home Islands and return alive.

1 On May 15/16, 1945 *Haguro* would be ambushed and sunk in the Strait of Malacca by five British destroyers (Operation *Dukedom*). *Ashigara* would be dispatched in the Bangka Strait by submarine HMS *Trenchant* on June 8, 1945.

CHRONOLOGY

1945

February 16–17	TF-58 launches first strikes against Tokyo area in Operation *Jamboree*.
February 18	US V Amphibious Corps invades Iwo Jima.
February 25	TF-58 strikes Tokyo area.
March 16	Iwo Jima declared secure.
March 18–19	TF-58 strikes Inland Sea; fast carriers USS *Wasp* and USS *Franklin* heavily damaged.
March 27	Operation *Starvation* commences.
March 28–29	TF-58 strikes Kyushu.
April 1	US Tenth Army invades Okinawa.
April 15–16	TF-58 strikes Kyushu airfields.
May 13–14	TF-58 strikes Kyushu and Shikoku.
May 26–27	Halsey and McCain replace Spruance and Mitscher; Fifth Fleet and TF-58 become Third Fleet and TF-38.
June 2–3	TF-38 strikes Kyushu airfields.
June 5	Third Fleet steams into Typhoon Viper, fast carrier USS *Hornet* and heavy cruiser USS *Pittsburgh* heavily damaged.
June 8	TF-38 strikes Kyushu airfields.
June 9–20	Operation *Barney* attacks Sea of Japan.
June 22	Okinawa declared secure.
July 10	TF-38 strikes Tokyo.
July 14	TF-38 strikes Hokkaido/northern Honshu, US fast battleships bombard Kamaishi.
July 15	TF-38 strikes Hokkaido/northern Honshu, US fast battleships bombard Muroran.
July 16	British TF-37 incorporated into Third Fleet.

July 17–18	TF-38 strikes Tokyo area, including battleship *Nagato* at Yokosuka, US/British fast battleships bombard Hitachi overnight.
July 17–23	TG-95.2 sweeps East China Sea.
July 18/19	TG-35.4 shells Cape Nojima.
July 23	Submarine USS *Barb* (SS-220) invades Karafuto, destroys train.
July 24–25	TF-38/TF-37 strikes Inland Sea/Kure, TG-35.3 bombards Shionomisaki.
July 28	TF-38/TF-37 and US Seventh Air Force strike Inland Sea/Kure.
July 29	Submarine *I-58* sinks heavy cruiser USS *Indianapolis*.
July 29/30	US/British fast battleships bombard Hamamatsu.
July 30	TF-38/TF-37 strikes Osaka–Nagoya area.
July 30/31	Destroyer Squadron (DesRon) 25 bombards Shimizu.
August 1–7	TF-95 sweeps East China Sea.
August 9	US fast battleships bombard Kamaishi, picket destroyer USS *Borie* heavily damaged by kamikaze.
August 9–10	TF-38/TF-37 strikes Hokkaido/northern Honshu.
August 11	Token British force absorbed into TF-38, remaining TF-37 retires.
August 12	Battleship USS *Pennsylvania* torpedoed at Buckner Bay, Okinawa.
August 13	TF-38 strikes Tokyo.
August 15	TF-38 strikes Tokyo; Japan surrenders.
August 27	Third Fleet enters Sagami Wan as vanguard of Operation *Blacklist*.
August 28	Minesweeper USS *Revenge* leads first Allied ships (TF-31) into Tokyo Bay, 11th Airborne Division begins landing at Atsugi.
August 29	Allied POW relief effort, Operation *Swift Mercy*, commences one day early.
August 30	US 4th Marine Regiment lands in Tokyo Bay; TF-31 occupies Yokosuka.
September 2	Tokyo Bay surrender ceremony aboard battleship USS *Missouri*.
September 8	US 1st Cavalry Division formally occupies Tokyo.

OPPOSING COMMANDERS

ALLIED

Fleet Admiral Chester W. Nimitz was commander-in-chief (CINCPAC–CINCPOA) of both the US Pacific Fleet and the Pacific Ocean Areas, a geographic area encompassing the entire Pacific Ocean except for MacArthur's South-West Pacific Area (SWPA). By January 29, 1945, Nimitz had moved his Pacific command to Advanced Headquarters Guam. From Pearl Harbor, deputy CINCPAC–CINCPOA **Vice Admiral John H. "Jack" Towers** facilitated Pacific logistics and administration, while Submarine Force, Pacific commander **Vice Admiral Charles Lockwood** directed over 200 US submarines in 13 Pacific squadrons.

In April 1945 **General of the Army Douglas MacArthur** would be named commander-in-chief US Army Forces Pacific. As ground commander for the proposed Operation *Olympic*, MacArthur would influence the Pacific Fleet's summer 1945 operations. From Harmon Field, Guam, **Major-General Curtis LeMay** (USAAF) led XXI Bomber Command, which partially coordinated strategic operations with Nimitz's Pacific Fleet.

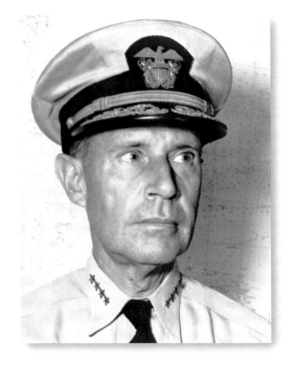

Most of Nimitz's surface assets resided within a single "Big Blue Fleet," which alternated commanders and designations as part of a scheduled "two-platoon" system. On January 27, 1945 Halsey turned the Big Blue Fleet over to **Admiral Raymond A. Spruance**. Third Fleet accordingly became Fifth Fleet. By February 1945 Fifth Fleet would command over 900 ships and more than 350,000 sailors, airmen, marines, and soldiers; beneath Spruance were five vice admirals, 31 rear admirals, seven commodores, one lieutenant-general, four major-generals, and three brigadier-generals. The fleet's offensive spearhead was the 17-carrier, 110,000-man Fast Carrier Task Force, known under Spruance as Task Force (TF) 58 and commanded by **Vice Admiral Marc Mitscher**. Mitscher's chief of staff was dashing destroyer ace **Commodore Arleigh Burke**. In charge of air tactics was Mitscher's air operations officer, **Commander Jimmy Flatley**.

Spruance's team would be relieved on May 27, 1945. Returning to Third Fleet command was aggressive, crusty sea dog **Admiral William Halsey**. Halsey was well loved by his men, but lacked Spruance's intellect, cool, and organization. Halsey's Third Fleet chief of staff was fiery **Rear Admiral Robert "Mick" Carney**, a tough, no-nonsense officer who never flinched from giving his opinion to Halsey. Replacing Mitscher was salty **Vice Admiral John S. McCain**, a virtual mirror image of Halsey. McCain's air operations officer and chief tactician was Flatley's close friend, **Commander John "Jimmy"**

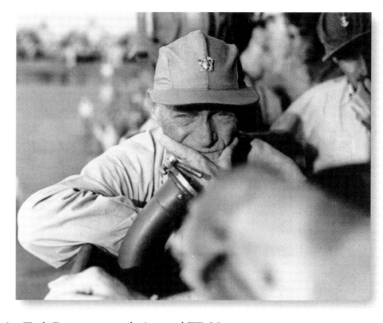

Thach. Under McCain, the Fast Carrier Task Force was re-designated TF-38.

Under Mitscher/McCain were the fast carrier Task Group (TG) commanders, all qualified aviators. By 1945 this revolving roster of rear admirals comprised the most skilled and aggressive carrier commanders in the world; the timid and mediocre were long gone. Gunnery savant **Vice Admiral Willis "Ching" Lee** commanded Fifth/Third Fleet's fast battleships as Commander, Second Battleship Squadron (TF-54/TF-34). Transferred ashore on June 18, 1945, Lee was replaced by senior fast battleship division commander **Rear Admiral John F. "Big Jack" Shafroth**.

The British Pacific Fleet (BPF) had been officially established on November 22, 1944, and was commanded from Sydney by **Admiral Sir Bruce Fraser**. By July 1945 the BPF's American-style fast carrier striking force was designated Task Force 37 (TF-37) and commanded by Fraser's deputy, **Vice Admiral Sir Bernard Rawlings**. Virtually coterminous with TF-37 was TF-37's carrier-based TG-37.1, commanded by **Vice Admiral Sir Philip Vian**. As carrier commander, Vian typically exercised tactical control, although Rawlings resumed tactical command at night aboard battleship *King George V*.

The wizened, elfin Mitscher proved a natural leader who shared Spruance's quiet professionalism. Rarely speaking above a whisper, Mitscher cared deeply for his men's well-being and commanded their immediate respect. However, by early 1945 Mitscher was secretly fighting exhaustion. In 1947 Burke would eulogize Mitscher: "A lifelong searcher after truth and trout streams, he was above all else—perhaps above all others—a naval aviator." (NARA 80-G-236832, via Naval History and Heritage Command)

JAPANESE

The Imperial General Headquarters (IGHQ) directed Home Islands defense through the IJA's General Defense Command. On February 6, 1945 the Home Islands were divided into five military districts (*Kanku*), each with its own IJA Area Army (*Homen Gun*). Each Area Army controlled its own IJA interceptor and antiaircraft artillery assets.

The Tokyo area's primary Imperial Japanese Army Air Force (IJAAF) interceptor unit was the 10th Hiko Shidan (Air Division), commanded by **Major-General Kihachiro Yoshida**. On March 1, 1945 10th Hiko Shidan command would fall to **Lieutenant-General Kanetoshi Kondo**. Defending the Inland Sea area was the 11th Hiko Shidan, while the 12th Hiko Shidan defended Kyushu. On April 8, 1945 **General Masakazu Kawabe** was named

commander Air General Army (*Koku Sogun*). On July 9, 1945 the Air General Army assumed command of the 10th, 11th, and 12th Hiko Shidan from ground army control.

The Imperial Japanese Navy Air Force (IJNAF) was reorganized on February 10, 1945. The Third Air Fleet under **Vice Admiral Kinpei Teraoka** would exclusively cover central and eastern Honshu from its Kanto (Tokyo area) district headquarters. In February 1945 **Vice Admiral Matome Ugaki** assumed command of Fifth Air Fleet, which covered Kyushu and the East China Sea.

Early 1945 found **Admiral Soemu Toyoda**'s once-formidable IJN Combined Fleet facing extinction. Tasked with defending the Home Islands was **Vice Admiral Seiichi Ito**'s IJN Second Fleet (*Dai-Ni Kantai*). Ito would die aboard *Yamato* on April 7, 1945, during the futile Operation *Ten-Go*. Having expended its last sortie, the IJN would abolish Second Fleet on April 18, 1945. **Vice Admiral Shigeyoshi Miwa** commanded the 52 remaining submarines of the IJN's Sixth Fleet (*Dai-Roku Kantai*). By May 1945 **Vice Admiral Jisaburo Ozawa** would replace Toyoda as commander Combined Fleet; Ozawa received no promotion as the command had become virtually ceremonial.

OPPOSING FORCES

ALLIED

By February 1945 the Ulithi-based US Fast Carrier Task Force—TF-58—comprised five separate carrier Task Groups totaling 17 fast carriers, eight fast battleships, five heavy cruisers, ten light cruisers, 81 destroyers, and 1,170 carrier aircraft. Powering TF-58 were the 33-knot, 27,500-ton Essex-class aircraft carriers, each wielding carrier air groups (CVGs) of 103 aircraft. Of these, 73 were F6F Hellcat and F4U Corsair fighters, which had dominated their Japanese counterparts since their 1943 debut. Rounding out the Essex-class air groups were 15 SB2C Helldiver dive-bombers and 15 TBF/TBM Avenger torpedo bombers. Supplementing the Essexes were 31.5-knot, 11,000-ton Independence-class light carriers carrying light carrier air groups (CVLGs) of 33 aircraft each (24 F6F Hellcat fighters and nine TBF/TBM Avenger torpedo bombers). By February 1945 the US carrier air groups were the best equipped and best trained in the world. However, rotations and replacements meant almost half the air groups were untested in battle at the time of the February 1945 Tokyo strikes.

The US Fast Carrier Task Force's "open secret weapon" was its phenomenal forward logistics system, which by February 1945 was of an efficiency and magnitude never before dreamed of in naval history. Replenishing TF-58/TF-38 underway was the At-Sea Logistics Group—TG-50.8/TG-30.8—comprising 34 oilers, 14 ammunition ships, 11 escort carriers, 19 destroyers, 26 destroyer-escorts, and ten fleet tugs. Hovering just out of range off the Home Islands, TG-50.8/TG-30.8 forward-supplied fuel, food, ammunition,

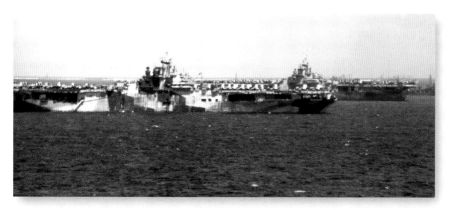

An early 1945 view of Essex-class carriers USS *Hancock* (CV-19), USS *Wasp* (CV-18), and an Independence-class light carrier at the Carolines' Ulithi atoll, a 212 square-mile tropical anchorage some 3,700nm forward from Pearl Harbor. Supplying Ulithi was Service Squadron 10 (ServRon-10), which comprised fleet tankers, ammunition ships, stores ships, small cargo ships, hospital transports, oilers, small craft, water and garbage barges, lighters, and even floating drydocks large enough to repair a carrier or battleship. (US Navy via Wikimedia Commons)

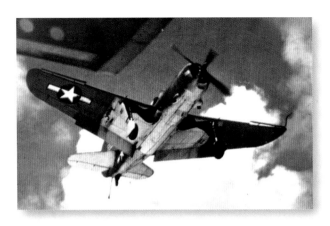

airplanes, clothing, general stores, pilots, and personnel to TF-58/TF-38 every three or four days, allowing the fast carriers to remain at sea almost indefinitely.

The British Pacific Fleet faced a daunting task. Fraser observed: "It was quite clear that in the intensive, efficient, and hard-striking type of war the US Fleet was fighting, nothing but the inclusion of a big British force would be noticeable and nothing but the best would be tolerated." Though heavily engaged at Okinawa, the Royal Navy's TF-37 would not strike Japan or be tactically incorporated into

An SB2C Helldiver of VB-81 lands aboard USS *Wasp* (CV-18), early 1945. The controversial Helldiver had a well-earned reputation for mechanical failures and dangerous low-speed handling. Although many aviators felt the Corsair was a superior dive-bomber, the Helldiver ultimately sank more Japanese tonnage than any other wartime aircraft. (World War II Database)

Halsey's Third Fleet until July 1945. Effectively structured like a single US fast carrier Task Group, TF-37 comprised four fleet carriers, battleship *King George V*, six light cruisers, and 18 destroyers. Each Illustrious-class carrier hosted 35 Corsairs/Hellcats and 15 Avengers, while HMS *Indefatigable* carried 40 Seafires, 20 Avengers, and nine Fireflies. TF-37 therefore carried 220 aircraft, somewhat less than the 240–340 aircraft carried by a US carrier Task Group.

Almost all BPF support had to be transferred in-theater or built from scratch. TF-112, the BPF's logistic train, was slow to develop but by July 1945 would comprise 78 auxiliaries. Manus Island in the Admiralties was designated TF-37's forward operating base.

JAPANESE

Japanese air defenses

In November 1944 the IJNAF had tentatively agreed it would be responsible for engaging intruding US aircraft to the south and east of Tokyo before they reached the Kanto Plain. Once enemy aircraft made landfall, their responsibility largely fell to the IJAAF, with the IJNAF generally responsible for ports and its own naval bases.

The IJA and IJN duplicated early-warning efforts and coordinated poorly. About 50 IJN picket boats of 100–300 tons were deployed up to 300nm south and east of Japan, but radioed visual sightings on IJN channels only. Mediocre Japanese early-warning radar was unable to discern altitude or formation. Both services organized military/civilian observer systems, whose visual contacts often provided a raid's earliest detailed information.

With a top speed of 342mph, the Yokosuka D4Y Suisei (codenamed "Judy" by the Allies) was one of the IJN's most effective weapons in 1945. Although kamikazes caused tremendous damage off Okinawa in 1945, most of the damage suffered by the Fast Carrier Task Force off the Home Islands was due to conventional attacks. (Wikimedia Commons/Public Domain)

Only 385 Japanese fighters were based in the Home Islands in February 1945. Fighter strength would increase to 450 by April and reach 535 by August. Fighter units patrolled and defended their parent IJA district only; when a neighboring district was under air attack, it was on its own. Operational strength averaged 20–50 fighters per air defense district, and rarely reached 100.

By July 1945 the average Japanese pilot had flown just 100 hours before going into combat, compared to 525 hours for a US carrier pilot.

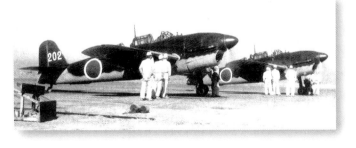

Home Islands air–sea defenses, February 14, 1945

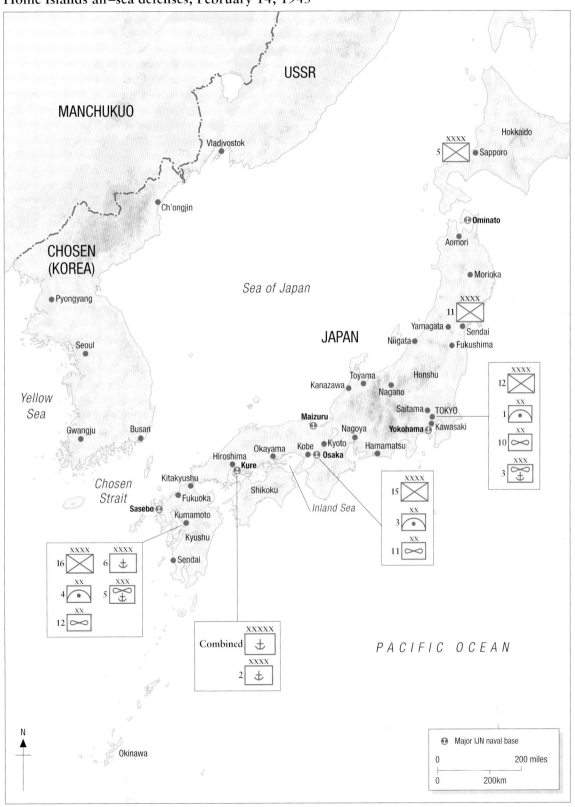

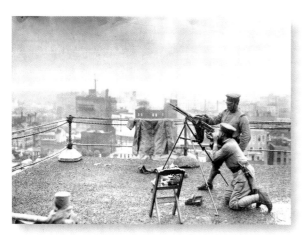

Immediately before the February 1945 Tokyo strikes, Mitscher told his US airmen: "[The Japanese pilot] is probably more afraid of you than you are of him." One Japanese veteran recalled an IJNAF-wide "horror of American fighters." Japanese aerial counterattacks were either conventional or *tokko* ("special" or suicide—"kamikaze" to the Americans). *Tokko* attacks were reserved for obsolete aircraft and inexperienced pilots; the best planes and personnel were not wasted so.

The IJA employed 1,250 antiaircraft guns defending the entire homeland. By early 1945 the IJN operated 55 radar sets, 980 heavy antiaircraft guns, and 3,700 25mm, 20mm, and 13.2mm automatic antiaircraft cannon defending only its own bases. Japanese antiaircraft guns were generally good but fire control was poor, while ammunition supply was increasingly strangled by the American blockade and bombardment. Japanese automatic cannon proved most dangerous to the relatively low-attacking Allied carrier planes. The Type 98 20mm machine cannon was the most common IJA low-altitude automatic weapon and possessed a practical firing rate of 120 rounds/minute and an effective altitude of 3,200ft. The IJN's primary antiaircraft machine cannon was the Type 96 25mm gun, with an effective firing rate of 110 rounds/minute; maximum effective range was 2,000 yards.

Japanese infantry prepare an improvised antiaircraft gun on the roof of a Tokyo department store in the final days of the war. This 6.5mm light machine gun could only have been intended for low-flying USN and USAAF fighters. Even so, actually knocking down a Hellcat or Corsair strafing at 300mph would have been quite a feat. (© Hulton-Deutsch Collection/Corbis via Getty Images)

Japanese naval forces and coast defenses

What was left of the IJN operated from six major Home Islands naval bases, each comprising an operational sector: Yokosuka, Kure, Maizuru, Sasebo, Ominato, and Osaka. Kure hosted the Kure Naval Arsenal shipyards and was the IJN's single largest base. Across Hiroshima Bay from Kure was Etajima (the IJN naval academy), Hashirajima (the Combined Fleet's main anchorage), and Hiroshima, a major military port. By early 1945 IJN Second Fleet comprised five battleships, two fleet carriers, two light carriers, two auxiliary carriers, two heavy cruisers, four light cruisers, and ten destroyers. These were largely immobilized in the Home Islands by disrepair and lack of fuel. However, IJN submarines and floating mines remained credible deep-water threats. Coastal artillery batteries, often obsolete, guarded harbors.

ORDERS OF BATTLE, FEBRUARY 1945

UNITED STATES NAVY

US FIFTH FLEET—ADMIRAL RAYMOND SPRUANCE (HEAVY CRUISER *INDIANAPOLIS*)

Task Force 58—Vice Admiral Marc Mitscher (*Bunker Hill*)
Task Group 58.1—Rear Admiral J.J. "Jocko" Clark (*Hornet*)
CV-12 *Hornet* (CVG-17)
 VF-17
 VB-17
 VT-17
CV-18 *Wasp* (CVG-86)
 VBF-86
 VF-86
 VB-86
 VT-86
CV-20 *Bennington* (CVG-82)
 VF-82
 VB-82
 VT-82
 VMF-112
 VMF-123
CVL-24 *Belleau Wood* (CVLG-30)
 VF-30
 VT-30

BB-59 *Massachusetts*
BB-58 *Indiana*
CL-64 *Vincennes*
CL-89 *Miami*
CL-54 *San Juan*
DesRon-25
 DesDiv-49
 DD-983 *John Rodgers*
 DD-573 *Harrison*
 DD-575 *McKee*
 DD-576 *Murray*
 DesDiv-50
 DD-500 *Ringgold*
 DD-501 *Schroeder*
 DD-502 *Sigsbee*
 DD-659 *Dashiell*
DesRon-61
 DesDiv-121
 DD-727 *De Haven*
 DD-728 *Mansfield*
 DD-729 *Lyman K. Swenson*
 DD-730 *Collett*
 DesDiv-122
 DD-744 *Blue*
 DD-745 *Brush*
 DD-746 *Taussig*
 DD-747 *Samuel N. Moore*

Task Group 58.2—Rear Admiral Ralph Davison (*Lexington*)
CV-16 *Lexington* (CVG-9)
 VF-9
 VBF-9
 VB-9
 VT-9
CV-19 *Hancock* (CVG-7)
 VF-7
 VBF-7
 VB-7
 VT-7
CVL-30 *San Jacinto* (CVLG-45)
 VF-45
 VT-45
BB-64 *Wisconsin*
BB-63 *Missouri*
CA-38 *San Francisco*
CA-69 *Boston*
CA-72 *Pittsburgh*
DesRon-52
 DesDiv-103
 DD-537 *The Sullivans*
 DD-538 *Stephen Potter*
 DD-539 *Tingey*
 DD-535 *Miller*
 DD 536 *Owen*
 DesDiv-104
 DD-676 *Marshall*
 DD-674 *Hunt*
 DD-675 *Lewis Hancock*
 DD-673 *Hickox*
DesRon-53
 DesDiv-105
 DD-797 *Cushing*
 DD-687 *Uhlmann*
 DD-686 *Halsey Powell*
 DD-658 *Colahan*
 DD-796 *Benham*
 DesDiv-106
 DD-541 *Yarnall*
 DD-540 *Twining*
 DD-683 *Stockham*
 DD-684 *Wedderburn*

Task Group 58.3—Rear Admiral Frederick "Ted" Sherman (*Essex*)
CV-9 *Essex* (CVG-4)
 VF-4
 VBF-4
 VB-4
 VT-4
CV-17 *Bunker Hill* (CVG-84)
 VF-84
 VBF-84
 VB-84
 VT-84
CVL-25 *Cowpens* (CVLG-46)
 VF-46
 VT-46
BB-57 *South Dakota*
BB-62 *New Jersey*
CA-35 *Indianapolis*
CL-65 *Pasadena*
CL-103 *Wilkes-Barre*
CL-90 *Astoria*
DesRon-50
 DesDiv-99
 DD-670 *Dortch*
 DD-668 *Clarence K. Bronson*
 DD-669 *Cotton*
 DD-671 *Gatling*
 DD-672 *Healy*
DesRon-55
 DesDiv-109
 DD-792 *Callaghan*
 DD-793 *Cassin Young*
 DD-794 *Irwin*
 DD-795 *Preston*
DesRon-62
 DesDiv-123
 DD-698 *Ault*
 DD-696 *English*
 DD-697 *Charles S. Sperry*
 DD-699 *Waldron*
 DD-700 *Haynsworth*
 DesDiv-124
 DD-703 *Wallace L. Lind*
 DD-701 *John W. Weeks*
 DD-704 *Borie*
 DD-702 *Hank*

Task Group 58.4—Rear Admiral Arthur Radford (*Yorktown*)
CV-10 *Yorktown* (CVG-3)
 VF-3
 VBF-3
 VB-3
 VT-3
CV-15 *Randolph* (CVG-12)
 VF-12
 VBF-12
 VB-12
 VT-12
CVL-27 *Langley* (CVLG-23)
 VF-23
 VT-23
CVL-28 *Cabot* (CVLG-29)
 VF-29
 VT-29
BB-55 *Washington*
BB-56 *North Carolina*
CL-60 *Santa Fe*
CL-80 *Biloxi*
CL-53 *San Diego*
DD-682 *Porterfield*
DD-725 *O'Brien*
DesRon-47

DesDiv-93
 DD-532 *Heermann*
 DD-530 *Trathen*
 DD-531 *Hazelwood*
 DD-534 *McCord*
DesDiv-94
 DD-556 *Hailey*
 DD-555 *Haggard*
 DD-554 *Franks*
DesRon-60
 DesDiv-119
 DD-724 *Laffey*
 DD-722 *Barton*
 DesDiv-120
 DD-693 *Moale*
 DD-694 *Ingraham*

Task Group 58.5—Rear Admiral Matt Gardner (*Enterprise*)
CV-6 *Enterprise* (CVG(N)-90)
 VF(N)-90
 VT(N)-90
CV-3 *Saratoga* (CVG(N)-53)
 VF(N)-53
 VT(N)-53
 VF-53
CB-1 *Alaska*
CA-68 *Baltimore*
CL-97 *Flint*
DD-559 *Longshaw*
DesRon-54
 DesDiv-107
 DD-688 *Remey*
 DD-678 *McGowan*
 DD-680 *Melvin*
 DesDiv-108
 DD-679 *McNair*
 DD-798 *Monssen*

JAPANESE

IJA TWELFTH AREA ARMY (*DAI-JUNI HOMEN GUN*) (KANTO AREA)

1st Antiaircraft Division
1st Kokugun (Air Army)
10th Hiko Shidan (Air Division)
17th Hiko Sentai (Air Group)
23rd Hiko Sentai
28th Hiko Sentai
47th Hiko Sentai
70th Hiko Sentai
244th Hiko Sentai
53rd Hiko Sentai
302nd Kokutai (IJN)

IJA FIFTEENTH AREA ARMY (*DAI JYUGO HOMEN GUN*) (KANSAI AREA)

3rd Antiaircraft Division
1st Kokugun (Air Army)
11th Hiko Shidan
16th Hiko Sentai
56th Hiko Sentai
5th Hiko Sentai
332nd Kokutai (IJN)

IJA SIXTEENTH AREA ARMY (*DAI JYUROKU HOMEN GUN*) (KYUSHU)

4th Antiaircraft Division
1st Kokugun (Air Army)
12th Hiko Shidan

19th Air Company
16th Air Brigade
 51st Hiko Sentai
 52nd Hiko Sentai
59th Hiko Sentai
4th Hiko Sentai
352nd Kokutai (IJN)

IJN COMBINED FLEET (*RENGO KANTAI*)—ADMIRAL SOEMU TOYODA (*OYODO*)

IJN Third Air Fleet (*Dai-San Koku Kantai*)—Vice Admiral Kinpei Teraoka
25th Sentai (Air Flotilla)
27th Sentai
131st Kokutai
210th Kokutai
252nd Kokutai
343rd Kokutai
601st Kokutai
706th Kokutai
722nd Kokutai
752nd Kokutai
801st Kokutai
1023rd Kokutai

IJN Fifth Air Fleet (*Dai-Go Koku Kantai*)—Vice Admiral Matome Ugaki
203rd Kokutai
701st Kokutai
721st Kokutai
762nd Kokutai
801st Kokutai
1022nd Kokutai
Kyushu Kokutai
Nansei-Shoto Kokutai

IJN Second Fleet (*Dai-Ni Kantai*)—Vice Admiral Seiichi Ito
Kure
 CV *Amagi*
 CV *Katsuragi*
 CVL *Ryuho*
 CVE *Kaiyo*
 CVE *Hosho*
 BBCV *Ise*
 BBCV *Hyuga*
 BB *Haruna*
 CA *Aoba*
 CL *Kitakami*
 CL *Oyodo*
 Destroyer Squadron 2
 DD *Fuyutsuki*
 DD *Yukikaze*
 DD *Hatsushimo*
 DD *Asashimo*
 DD *Kasumi*
 DD *Isokaze*
 DD *Hamakaze*
Hashirajima
 BB *Yamato*
 CL *Yahagi*
 CL *Sakawa*
Yokosuka
 BB *Nagato*
 DD *Hibiki*
 DD *Ushio*
Maizuru
 CA *Tone*
Sasebo
 CVL *Junyo*
 DD *Suzutsuki*

OPPOSING PLANS

The United Nations war objective is the unconditional surrender of the Axis Powers.
US Joint Chiefs of Staff memorandum, May 1943

UNITED STATES

Consistent with WPO's air–sea encirclement of Japan, on October 3, 1944 the JCS approved Spruance's two-pronged plan to seize Iwo Jima as a fighter field to support the carriers, and to capture Okinawa as an air–sea base to control the East China Sea. On February 19, 1945 Major-General Harry Schmidt's V Amphibious Corps would assault Iwo Jima with the 3rd, 4th, and 5th Marine divisions (70,000 troops) in Operation *Detachment*. Then on April 1, 1945 Fifth Fleet would execute Operation *Iceberg*, the invasion of Okinawa by Lieutenant-General Simon Bolivar Buckner's US Tenth Army (182,821 troops).

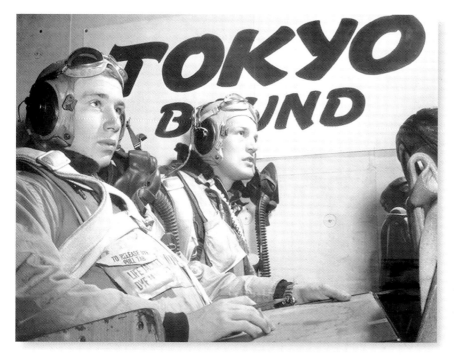

Aboard *Essex*, CVG-4 pilots are briefed before strikes against Tokyo, February 16–17, 1945. Although well trained, major air group rotations meant that over half of TF-58's air groups were going into combat for the first time over Tokyo. Consequently, Mitscher's air operations officer Commander Jimmy Flatley composed and circulated a memo of US strike tactics reminding his green pilots to follow their training. (NARA 80-G)

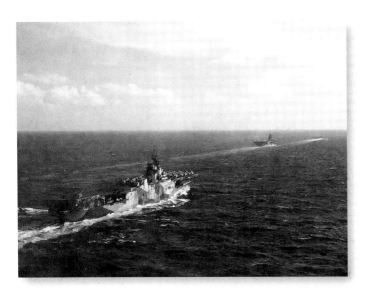

Task Force 58 fast carriers depart Ulithi through Mugai Channel, February 9, 1945. From left to right are carriers USS *Hancock* (CV-19), USS *Lexington* (CV-16), and USS *San Jacinto* (CVL-30). For about eight months the remote atoll of Ulithi was the greatest naval base in the world. (NARA 80-G-302748)

In October 1944 Nimitz and Halsey had prepared Operation *Hotfoot*, which would have coordinated TF-38 carrier strikes on Tokyo with raids by B-29s of Major-General Haywood Hansell's newly established Marianas-based XXI Bomber Command. Hansell's priority targets were the Nakajima, Mitsubishi, Kawasaki, and Tachikawa factories concentrated in the 220-mile industrial belt of Tokyo, Nagoya, and Osaka that produced over three-quarters of Japan's combat aircraft. Halsey's fast carriers expected to begin hitting Tokyo on November 12, 1944 and beat down Japanese fighter defenses by Hansell's first scheduled B-29 raid on November 17. However, unexpectedly slow progress on Leyte required the fast carriers' extended presence off the Philippines. Operation *Hotfoot* was reluctantly canceled. Meanwhile, the first XXI Bomber Command raids commenced on November 24, but proved vastly disappointing. Hansell's B-29s were precision-bombing visually, in wintry weather, from 27,000ft to 33,000ft and typically fighting a 145mph jet stream. By January 9, 1945 five different XXI Bomber Command missions totaling 422 B-29 sorties had been sent against Tokyo's massive Nakajima Musashino-Tama plant, which manufactured 27 percent of Japanese combat aircraft engines. Cumulative damage was negligible. Studying future operations, Spruance mused:

> Perhaps we should stop fighting the products of the Jap aircraft factories on the perimeter and take our carrier air into the center to knock out the factories themselves. We cannot afford to await the outcome of bombing with "precision instruments" from 30,000ft, often through solid overcast. That may work for large areas, but it is too slow and inaccurate to take out specific targets. Our Iwo operation will benefit by a precision carrier strike, provided we have enough ships by that time to do the job.

Codenamed Operation *Jamboree*, Spruance planned to hit Tokyo and Iwo Jima simultaneously to maintain operational surprise. With three days of pre-invasion bombardment planned for the Iwo Jima invasion, that meant striking Tokyo on D-3, or February 16, 1945.

JAPANESE

In November 1941, no more than small desultory raids by one or two US carriers had been expected and War Minister Hideki Tojo had explicitly instructed that homeland air defense should not interfere with Japanese offensives. But by late 1944 the Pacific War had turned heavily against Japan, and *Sho-Go* proved itself merely the latest unsuccessful Japanese scheme

to reverse the war. A new plan was needed. On January 20, 1945 IGHQ's "Outline of Army and Navy Operations" announced:

> The final decisive battle of the war will be waged in Japan proper ... The United States will now be considered Japan's principal enemy. Operational planning of all headquarters will be directed toward interception and destruction of American forces, all other theaters and adversaries assuming secondary importance.

Formosa, the Shanghai area, Iwo Jima, Okinawa, and southern Korea were acknowledged as inside Japan's "perimeter defense zone" with the "main defensive effort [to] be made in the Ryukyus area." Once the US penetrated this perimeter:

> A campaign of attrition [would] be initiated to reduce his preponderance in ships, aircraft, and men, to obstruct the establishment and use of advance bases, to undermine enemy morale, and thereby to seriously delay the final assault on Japan ... In general, Japanese air strength will be conserved until an enemy landing is actually underway.

Plans were made to assemble 1,315 aircraft in the Home Islands by April 1 (735 IJAAF and 580 IJNAF) with up to 500 more aircraft reinforcing Japan from other theaters. This joint IJAAF–IJNAF air policy was published on February 6, 1945. The defense of Iwo Jima and Okinawa were planned as *shukketsu sakusens* (bloodletting operations) intended to damage American national morale by inflicting maximum casualties, and also to buy time to implement *Ketsu-Go*, Japan's operational plan to defend the Home Islands against the assumed US invasion that was expected in mid to late 1945.

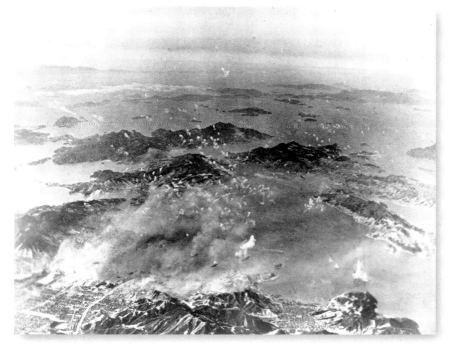

Heavy Japanese flak blossoms over the IJN's Kure naval base, March 1945. Kure was home to several hundred IJN antiaircraft guns, in addition to the many heavily armed warships typically in harbor. Desperate IJA requests to transfer some of the IJN's prolific antiaircraft guns to non-naval targets generally went unanswered. (US Navy/Interim Archives/Getty Images)

THE CAMPAIGN

If you attack us, we will break your empire before we are through with you. While you may have initial success due to timing and surprise, the time will come when you too will have your losses but there will be this great difference. You not only will be unable to make up your losses but will grow weaker as time goes on; while on the other hand we not only will make up our losses but will grow stronger as time goes on. It is inevitable that we shall crush you before we are through with you.

US Admiral Harold Stark to Japanese ambassador Admiral Kichisaburo Nomura, late 1941

FIRST RAIDS ON TOKYO, FEBRUARY 16–25

On January 25, 1945 TF-38 returned to Ulithi. The following day Admiral Raymond Spruance relieved Admiral Bill Halsey as fleet commander, and Third Fleet once again became Fifth Fleet. Simultaneously, Vice Admiral Marc Mitscher relieved Vice Admiral John McCain as Fast Carrier Task Force commander, and TF-38 once again became TF-58.

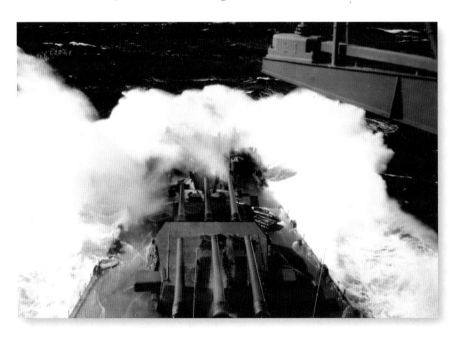

Battleship USS *South Dakota* (BB-57) plunges through Pacific surf en route to Tokyo, February 1945. *South Dakota* and battleship *Wisconsin* (BB-64) defended carriers *Essex*, *Bunker Hill*, and *Cowpens* from Japanese air and surface attack as part of Rear Admiral "Ted" Sherman's TG-58.3. (NARA 80-G-K-3345, via NavSource)

TF-58 sortied from Ulithi on February 10. The carrier force refueled from TG-50.8 oilers under Rear Admiral Donald Beary on February 13–14, then turned north toward Tokyo, 1,200nm away. Mitscher exercised tactical command from carrier *Bunker Hill* while Spruance rode along in heavy cruiser *Indianapolis*. Although the eight fast battleships were now primarily antiaircraft platforms, Spruance expected a possible fleet action and loaded them with 80 percent armor-piercing (AP) shells. At daybreak, February 15, rain slashed the Task Force. It had become notably chilly topside and US sailors broke out virtually unused cold weather clothing. After the battleships and carriers topped off the destroyers, Mitscher formed the Destroyer Scouting Group (TG-58.8). Over the course of four hours TG-58.8's 14 destroyers formed a 60nm-wide phalanx that operated 35nm ahead of the Task Force. Marianas-based B-29s flew ahead of TF-58 at 3,000ft on anti-picket boat sweeps. At 1600hrs, February 15, its five Task Groups in column, TF-58 began its 20-knot run-in to Tokyo, Rear Admiral J.J. "Jocko" Clark's TG-58.1 in the lead.

With a metropolitan population of eight million, Tokyo was the political, industrial, and commercial heart of Japan. Greater Tokyo resides in Japan's largest lowland region, the Kanto Plain, which is about the size of Connecticut. Yokohama, in west Tokyo Bay, was Japan's largest port. Twelve miles northwest of the Imperial Palace, Nakajima's Musashino and Tama plants were literally across the street from each other and produced 27 percent of Japan's warplane engines, including the 2,000hp Ha-45 that powered the advanced Ki-84 "Frank" Hayate and N1K2-J "George" Shiden-Kai fighters; six major aircraft assembly plants were partly or completely dependent on Musashino-Tama's output. Forty miles northwest of Tokyo, Nakajima's Ota plant had produced 300 Ki-84 "Frank" fighters in October 1944, although pre-emptive dispersal efforts had already caused production to fall to 100 per month by February 1945. A few miles south-southwest of Ota was Nakajima's Koizumi plant. Tachikawa Hikoki's primary plant at Tachikawa, 15nm west of downtown Tokyo, assembled almost 10 percent of Japan's airframes.

US intelligence was aware of 90 Tokyo airfields. The IJAAF 10th Hiko Shidan defended metropolitan Tokyo, and flew from seven primary airfields and 25 secondary airfields. The IJNAF defended its Tokyo Bay interests from three major airbases—Kisarazu (Chiba Prefecture, east side of Tokyo Bay), Oppama (adjacent to Yokosuka naval base), and the IJN's largest and most heavily defended airbase, Atsugi (15 miles west of Tokyo Bay). About 500 heavy antiaircraft guns protected the Tokyo–Kawasaki–Yokohama area, equaling Berlin at its peak.

TF-58 would first swamp the Tokyo area with successively deeper waves of fighter sweeps, bombing and strafing airfields to establish air supremacy. The subsequent Avengers' and Helldivers' targets were the Tokyo aircraft engine plants and airframe factories. Strikes would be accompanied by aggressive photoreconnaissance. Nimitz asserted that the attacks would fulfill the "deeply cherished desires of every officer and man in the Pacific Fleet."

The launch point was 60nm off the coast of Honshu's Boso Peninsula, which was 120nm from Tokyo. The

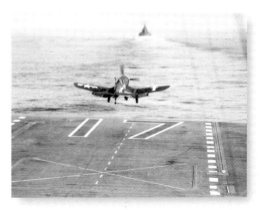

An F4U Corsair takes off from USS *Bunker Hill* (CV-17) on February 16, 1945 en route for Tokyo. The vast majority of the day's carrier sorties were by fighters, as the deteriorating weather canceled most of the bomber missions. With the temperature reading 23 degrees F on the ground at Tokyo, many US fighters reported their .50-caliber machine guns jamming because of the cold. (NARA)

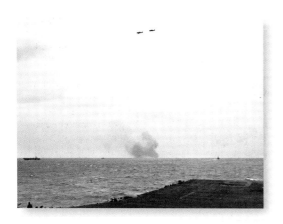

On the afternoon of February 16, destroyer USS *Haynsworth* (DD-700) spotted three Japanese picket boats and quickly sank them. In this view from TG-58.2's fast carrier *Essex* (CV-9), the smoke from the damaged Japanese pickets is visible from over the horizon. (NARA 80-G-308577)

Six Japanese prisoners seen in fresh US Navy uniforms aboard carrier USS *Essex* (CV-9). They have been recovered from three IJN picket boats sunk by USS *Haynesworth* (DD-700) on February 16, 1945. A total of nine Japanese survivors were picked up, including a 17 year old. (NARA 80-G-308465)

morning of February 16 TF-58 was greeted with a 4,000ft ceiling, broken clouds at 1,000ft, rain and snow squalls, and 30+mph northeast winds—"the damnedest, rottenest weather I could think of," Spruance remarked. In driving rain, TF-58 launched its first sweep of 168 fighters toward the Tokyo area at 0645hrs, February 16. Waves of Hellcats and Corsairs roared in over the coast at a mere 1,300ft. Radio Tokyo suddenly went off air. At Shirahama on the Boso Peninsula, 100nm south of Tokyo, a Japanese civilian lookout post reported "a flight of small enemy aircraft flying northward" at 0700hrs. Japanese radar teams, accustomed to high-altitude B-29s, had failed to detect the low-flying carrier planes.

Ten minutes later, TF-58 fighters began strafing IJNAF and IJAAF airfields in Chiba and Ibaragi prefectures. About 100 Japanese fighters rose to intercept this first sweep over the Chiba Peninsula east of Tokyo Bay, and 40 were shot down. In fact the IJAAF 10th Hiko Shidan immediately ordered an IJAAF night-fighter group and all "second-class" personnel to take cover, while all aircraft not intercepting were ordered to be dispersed, fuel tanks drained, and ammunition unloaded. In contrast, American pilots reported Tokyo antiaircraft fire "the most accurate and intense yet encountered."

Japanese sources indicate at least 68 A6M Zeros and 18 J2M Raidens of the IJNAF's 302nd, 601st, and 252nd Kokutai scrambled to meet the Americans. Late that morning, at least ten A6M Zeros, J2M Raidens, and N1K2-J Shiden-Kais scrambled from Oppama, circled Atsugi, then dove on inbound TF-58 aircraft. These IJN pilots claimed to have shot down 13 US planes. Possibly six of these were VF-82 Hellcats from *Bennington*. The Oppama pilots' one loss was Chief Petty Officer Mitsugi Yamazaki, who safely bailed from his plane but was beaten to death by civilians who mistakenly thought he was American.

Mitscher's fifth fighter sweep saw the war's first carrier planes reach Tokyo. By afternoon US fighters were roaming deeper inland over the Kanto Plain, ravaging Japanese airfields. With weather deteriorating, at 1130hrs Mitscher expedited TG-58.1's planned bombing strikes against Nakajima's Ota and Koizumi aircraft factories northwest of Tokyo. Even so, most of the 33 Avengers and 15 Helldivers were forced to unload on airfields. However, a few US bombers penetrated the weather to successfully bomb the Ota plant.

By 1500hrs TF-58 had launched 1,036 sorties, including 988 fighters in eight fighter sweeps. By 1800hrs the day's strikes were recovered, and TF-58 temporarily retired east. That night, as TG-58.4 zigzagged, destroyer *Ingraham* accidentally collided with destroyer *Barton*. Both detached to Ulithi.

TF-58's dedicated night Task Group, TG-58.5 (*Enterprise* and *Saratoga*), launched a sunset fighter sweep against major bomber fields in the Tokyo area and as far west as Hamamatsu. At 1615hrs *Enterprise* launched 12 night-trained Hellcats on a "zipper" twilight mission against Yokosuka airfields, although one crashed on takeoff. Then at 1730hrs *Enterprise*

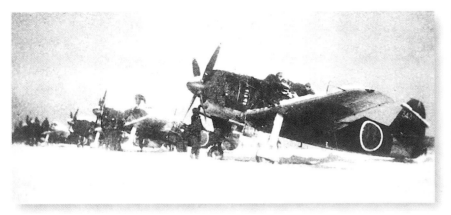

Powerful Kawasaki N1K2-J Shiden-Kai "George" fighters are seen at Matsuyama during a February 1945 snowfall. Perhaps the most famous Shiden-Kai unit was Captain Minoru Genda's elite 343rd Kokutai; its officers were all handpicked combat veterans and its pilots averaged 500 hours' flying time. They would adopt US-style tactics emphasizing teamwork and the four-fighter division. (Tony Holmes Collection)

launched a single TBM Avenger over southern Tokyo Bay to jam Japanese radar, identifying 23 Japanese radar stations in the process. At 0130hrs, February 17, *Enterprise* launched 11 radar-equipped Avengers, which ultimately heckled airfields on Hachijo Jima and Niishima.

The 10th Hiko Shidan recorded losing 37 planes shot down and two planes destroyed on the ground on February 16. The IJAAF decided that further such combat would quickly weaken Japanese fighter power beyond acceptable levels. Nevertheless, Major-General Kihachiro Yoshida, 10th Hiko Shidan commander, argued bitterly against passivity, claiming that intentionally pursuing "gradual decline" was contradictory and pointless. Yoshida further worried about the effect on his fighter pilots' morale. Nevertheless, IJAAF command chose to avoid a full-scale air defense against TF-58. Accordingly, on the night of February 16, the 10th Hiko Shidan's top two air groups were ordered to disperse and seek shelter, "lest strength be consumed prematurely." TG-58.3's Rear Admiral Sherman later remarked that he was "amazed by the lack of determined air opposition. No Japanese aircraft came within 20 miles of our disposition and our planes roamed at will over the enemy's territory seeking their targets."

At midnight TF-58 turned back toward Honshu to make launch positions by dawn, February 17. The February 16 attacks had barely touched the four major Tokyo aircraft factories. The Ota, Koizuma, Tachikawa, and Musashino-Tama plants were prime targets for February 17. The first sweep of 136 fighters took off from TF-58 at 0645hrs. The IJAAF's intentional hoarding of fighters and February 16's attrition meant Japanese aerial defiance was less spirited than the previous day. The IJNAF flew at least 71 interceptor sorties plus an unknown number by 302nd Kokutai and Third Air Fleet units. As usual, Japanese and American claims varied wildly. A TG-58.3 report boasted:

> A Hellcat drove one of the "sures" off the tail of an Avenger ahead, relentlessly pursued him at low altitude, and at last shot him flaming into the streets of suburban Tokyo, from an altitude of 2,000ft. All of Tokyo's teeming population, not covered up in air raid shelters, thus had a chance to witness the impotency of Japanese aircraft against America's mighty air power.

US aircraft from Rear Admiral Jocko Clark's TG-58.1 (*Hornet*, *Wasp*, *Bennington*, and *Belleau Wood*) attacked shipping in Tokyo Bay, including incomplete 15,864-ton IJA escort carrier *Yamashio Maru* moored in Yokohama

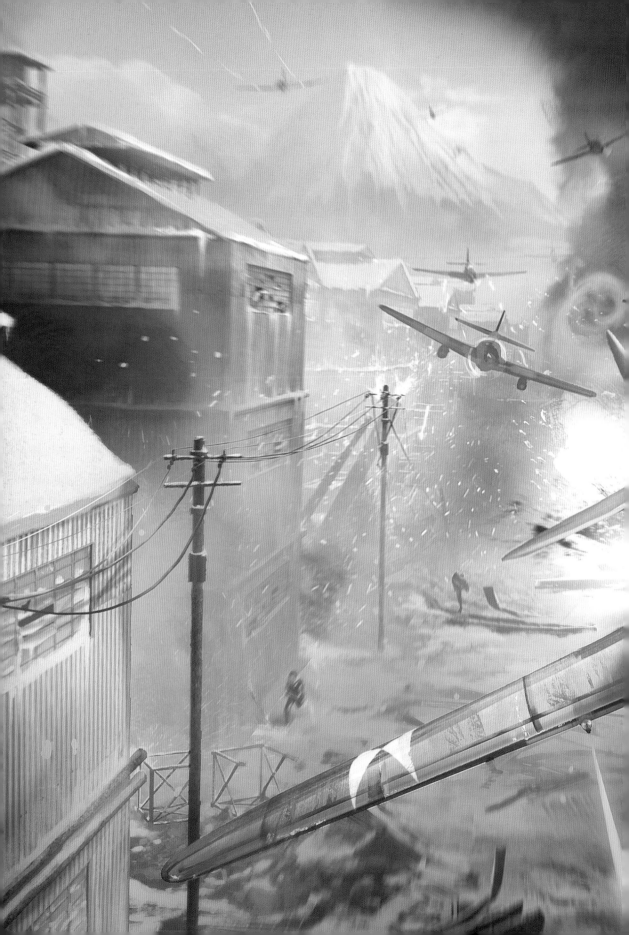

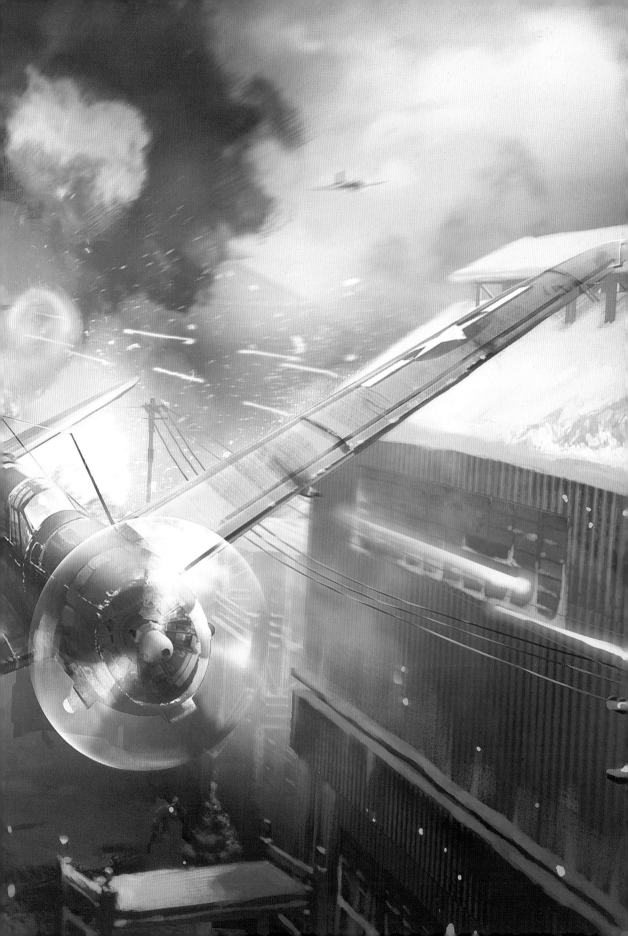

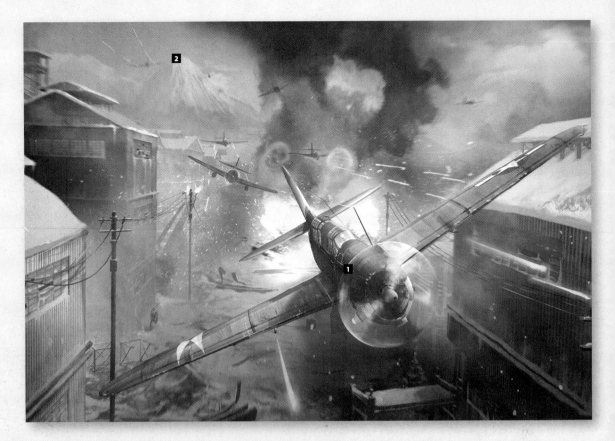

BUNKER HILL'S VB-84 HELLDIVERS DIVE-BOMB TOKYO'S NAKAJIMA MUSASHINO-TAMA PLANT, FEBRUARY 17, 1945 (PP. 28–29)

On February 17, 1945 USS *Bunker Hill* (CV-17) launched a strike of ten VB-84 Helldivers and 12 VT-84 Avengers against Tokyo. They were escorted by 24 F4U Corsairs of VF-84. The formation's target was the Nakajima Musashino-Tama aircraft plant 12 miles northwest of the Imperial Palace. En route to their objective the Americans flew past the visual spectacle of Fujiyama. What had been rainy, overcast weather over TF-58 gave way to perfect if frigid conditions over the target, with visibility unlimited.

Throughout the long overland approach and the subsequent bombing run, the Corsair escorts fended off Japanese fighters making persistent attack runs at the formation. The US strike approached from the north at 13,000ft, and easily spotted the sprawling 45-acre Musashino-Tama complex from three miles away. Heavy antiaircraft fire erupted, with black puffs exploding at the Americans' altitude. VB-84's Helldivers now entered their high-speed approach, accelerating past 230mph.

At 11,000ft the ten Helldivers pushed over into their dives, flak bursts erupting all around them. The aiming point was the central wing of the Tama plant, which US intelligence indicated was packed with machine tools for shaping engine parts. During the dive five Helldivers were damaged by flak, with backseat

gunner Airman 3rd Class O.G. Rice receiving a mild head wound. Nevertheless, all ten Helldivers successfully dropped their 1,500lb of GP bombs from 2,500ft. Pilots reported "lightning flashes and pillars of smoke dotted the top of the plant and soon heavy smoke and flames shot up through holes crushed in the roof." In total 32 out of 36 bombs were observed to strike the target. After bomb release the Helldivers pulled out at 1,000ft. The Americans inflicted further damage on the factory by strafing with forward guns and wing-mounted 5in. HVAR rockets.

VB-84's lead Helldivers (**1**) are seen here just after their Musashino-Tama bomb run, retiring at high speed and low altitude toward the rally point 12 miles to the southwest. A few dogged Ki-43 Oscar fighters (**2**) are still chasing them. Light snow is on the ground.

One of the damaged Helldivers, flown by Lieutenant Junior Grade Charles Stafford, made it 25 miles past the island of Oshima before ditching. Both Stafford and his gunner, Airman 3rd Class William Schmeling, were rescued by a US destroyer. VB-84's remaining nine Helldivers made it safely back to *Bunker Hill*. Upon debriefing, Lieutenant Junior Grade D.C. Avery exclaimed, "Gee, wasn't Fuji-San a beautiful sight?"

harbor. Hit with six 500lb bombs and five 5in. rockets, *Yamashio Maru* capsized and settled onto the harbor bottom. At 1100hrs Mitscher canceled further strikes due to deteriorating weather. Meanwhile, a planned IJAAF counterattack against TF-58 never materialized. TF-58 retired south at 1600hrs, having flown 1,379 daylight sorties on February 17, including 575 bomber or fighter-bomber missions. "I promised to return and finish what we'd started," Spruance recalled.

By 1745hrs DesDiv-99 had formed a scouting line 32nm wide patrolling 20nm ahead of the retiring TF-58. Late that night scouting-line picket destroyers *Barton* (DD-722), *Ingraham* (DD-694), and *Moale* (DD-693) engaged and sank Japanese picket boats *No. 35 Nanshin Maru*, *No. 3 Kyowa Maru*, and *No. 5 Fukuichi Maru*. At 0235hrs, February 18, destroyers *Bronson* and *Gatling* separately pursued two surface radar contacts. By 0405hrs *Gatling* had left her assigned Japanese patrol craft in a sinking condition. After *Bronson*'s radar failed, destroyer *Dortch* (DD-670) took over *Bronson*'s target, auxiliary subchaser *Ayukawa Maru*. Heavy Japanese gunfire drove *Dortch* off, inflicting moderate damage and killing three. Moments later, at 0509hrs, destroyer *Waldron* (DD-699) charged *Ayukawa Maru* at 21 knots and sliced her in half.

By late morning February 18 TF-58 was launching strikes on Chichi Jima. D-Day strikes on Iwo Jima began the following day, February 19. On February 21 Mitscher detached *Saratoga* to reinforce the Iwo Jima escort carriers. She had barely arrived when, beginning at 1700hrs, she was struck by two kamikazes and four bombs, losing 123 men killed, 36 planes destroyed, and being permanently knocked out of the war. Mitscher immediately detached *Enterprise* to replace her.

On February 23 TF-58 refueled, re-bombed, and took on replacement aircraft from Beary's TG-50.8, then headed for Tokyo. The following day TF-58 topped off destroyers, and the Destroyer Scouting Group again formed 35nm ahead of the lead Task Group. High seas and strong winds forced TF-58 to slow to 16 knots.

Mitscher launched the first fighter sweeps at 0715hrs, February 25, while 190nm southeast of Tokyo. They found solid overcast at 1,000–3,000ft and heavy snowfall over Tokyo. The Japanese sighted 600 US carrier aircraft on February 25, but Rear Admiral "Ted" Sherman reported, "The enemy opposition was only halfhearted and Japanese planes which were not shot down seemed glad to withdraw from the scene ... as swiftly and unceremoniously as possible. Even here, over their own capital, the enemy were notably inferior to our naval aviators in aggressiveness, tactics, and determination."

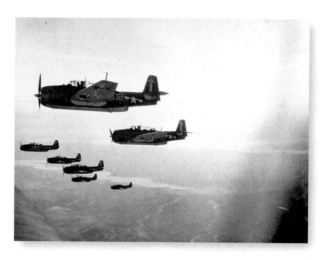

VT-84 Avengers fly over Japan en route back to USS *Bunker Hill* (CV-17), February 16, 1945. By early 1945 Hellcat and Corsair fighter-bombers were increasingly taking the place of the carrier's dedicated bombers. (W. Eugene Smith/ The LIFE Picture Collection via Getty Images)

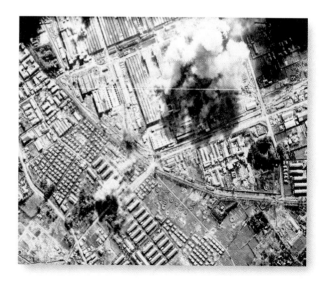

A gun camera view of Nakajima's Musashino-Tama factory being bombed by TF-58 planes, February 17, 1945. A light snowfall is evident. USN dive-bombing ultimately proved far more damaging to Japanese factories than the USAAF's high-altitude attacks. (US Navy)

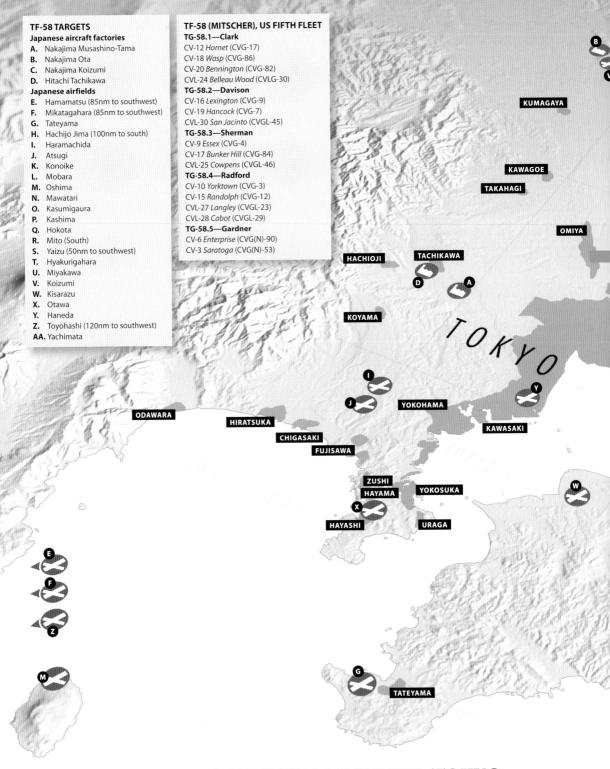

TF-58 TARGETS

Japanese aircraft factories
A. Nakajima Musashino-Tama
B. Nakajima Ota
C. Nakajima Koizumi
D. Hitachi Tachikawa

Japanese airfields
E. Hamamatsu (85nm to southwest)
F. Mikatagahara (85nm to southwest)
G. Tateyama
H. Hachijo Jima (100nm to south)
I. Haramachida
J. Atsugi
K. Konoike
L. Mobara
M. Oshima
N. Mawatari
O. Kasumigaura
P. Kashima
Q. Hokota
R. Mito (South)
S. Yaizu (50nm to southwest)
T. Hyakurigahara
U. Miyakawa
V. Koizumi
W. Kisarazu
X. Otawa
Y. Haneda
Z. Toyohashi (120nm to southwest)
AA. Yachimata

TF-58 (MITSCHER), US FIFTH FLEET
TG-58.1—Clark
CV-12 *Hornet* (CVG-17)
CV-18 *Wasp* (CVG-86)
CV-20 *Bennington* (CVG-82)
CVL-24 *Belleau Wood* (CVLG-30)
TG-58.2—Davison
CV-16 *Lexington* (CVG-9)
CV-19 *Hancock* (CVG-7)
CVL-30 *San Jacinto* (CVGL-45)
TG-58.3—Sherman
CV-9 *Essex* (CVG-4)
CV-17 *Bunker Hill* (CVG-84)
CVL-25 *Cowpens* (CVGL-46)
TG-58.4—Radford
CV-10 *Yorktown* (CVG-3)
CV-15 *Randolph* (CVG-12)
CVL-27 *Langley* (CVGL-23)
CVL-28 *Cabot* (CVGL-29)
TG-58.5—Gardner
CV-6 *Enterprise* (CVG(N)-90)
CV-3 *Saratoga* (CVG(N)-53)

KUMAGAYA
KAWAGOE
TAKAHAGI
OMIYA
HACHIOJI
TACHIKAWA
KOYAMA
T O K Y O
YOKOHAMA
ODAWARA
HIRATSUKA
CHIGASAKI
FUJISAWA
ZUSHI
HAYAMA
YOKOSUKA
KAWASAKI
HAYASHI
URAGA
TATEYAMA

OPERATION *JAMBOREE*, TOKYO, FEBRUARY 16–25, 1945

Spruance launches the first carrier plane strike against the Home Islands.

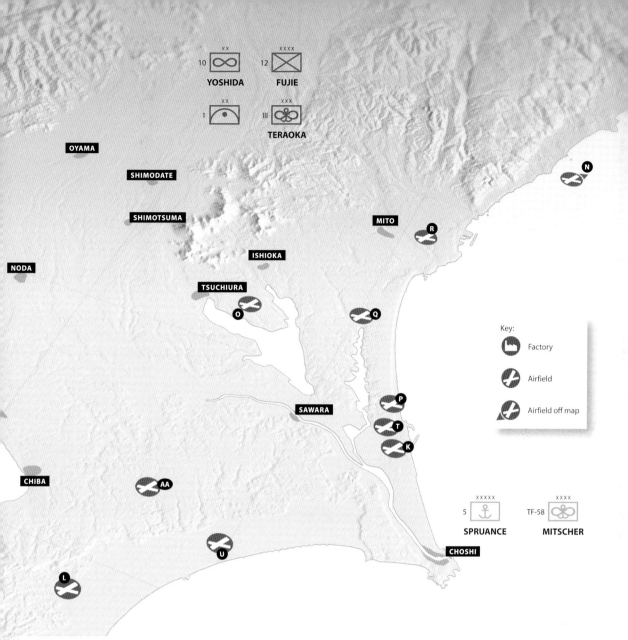

DAMAGE INFLICTED ON TOKYO AREA TARGETS, FEBRUARY 16–25, 1945

A. Nakajima Musashino-Tama: Struck with 40 tons of bombs in the center of the Tama plant, February 17.

B. Nakajima Ota: Struck with 45 tons of bombs on February 16 and 17, followed by 12.5 tons of bombs on February 25. Ultimately 60 percent destroyed and 30 percent heavily damaged.

C. Nakajima Koizumi: Struck with 35–40 tons of bombs on February 25, resulting in 20 percent roof area damaged.

D. Hitachi Tachikawa: Struck by one Task Group with many bomb hits, but damage inconclusive.

E. Hamamatsu: Three hangars destroyed and two hangars damaged.

F. Mikatagahara: One hangar and one shop destroyed, two hangars and two shops damaged.

G. Tateyama: Four hangars damaged.

H. Hachijo Jima: One oil dump and one ammunition dump destroyed, and several small buildings damaged.

I. Haramachida: One hangar destroyed and one hangar damaged.

J. Atsugi: Three buildings damaged south of field.

K. Konoike: One hangar and two shops destroyed, and four hangars and several small buildings damaged.

L. Mobara: One hangar destroyed, and two hangars damaged.

M. Oshima: One hangar and one radio station damaged.

N. Mawatari: Four hangars and three barracks destroyed, and one hangar damaged.

O. Kasumigaura: One large assembly type building and three hangars destroyed, and three assembly type buildings and four hangars damaged.

P. Kashima: Two hangars damaged.

Q. Hokota: Three hangars destroyed and two hangars damaged.

R. Mito (South): Six small hangars burned, and shops and barracks damaged.

S. Yaizu: One hangar destroyed.

T. Hyakurigahara: Fires started in hangar and shop area.

U. Miyakawa: One hangar destroyed.

V. Koizumi: One hangar damaged.

W. Kisarazu: Two hangars destroyed, and one hangar, one repair building, one modification or repair center, one bridge, one warehouse, and one oil tank damaged.

X. Otawa: One hangar damaged.

Y. Haneda: Two hangars and three buildings damaged.

Z. Toyohashi: Three hangars destroyed and two hangars damaged.

AA. Yachimata: One hangar damaged.

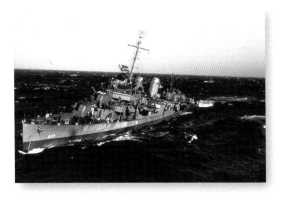

Fletcher-class destroyer USS *Cotten* (DD-669) is seen on March 14, 1945. US destroyers were vital for surface and radar picket roles. During the Iwo Jima campaign *Cotten* and sister ship *Dortch* were detached from TF-58 and successfully destroyed two Japanese radar pickets reporting inbound B-29 raids. (NH 104392-KN, via NavSource)

TF-58 aircraft hit the Ota and Koizumi aircraft plants, but increasingly snowy, stormy weather meant Mitscher canceled further Tokyo strikes at 1215hrs. Spruance and Mitscher decided to hit Nagoya instead. En route to Nagoya that night destroyers USS *Hazelwood* (DD-531) and *Murray* (DD-576) sank three small Japanese craft. But at 0030hrs, February 26, destroyer *Porterfield* (DD-682) found herself in a vicious shoot-out with a 100ft picket boat, suffering one killed and 12 wounded when the Japanese boat scored on *Porterfield*'s bridge, damaging radios and instrumentation. After punishing the impudent vessel with 5in./38 and automatic fire, *Porterfield* reported the Japanese boat was sinking and passed on. The blazing picket boat drifted deep inside the retiring TG-58.3's screen, nearly colliding with *Pasadena* (CL-65) before brazenly opening fire on the 11,744-ton US light cruiser. After suffering two wounded from 13 hits at point-blank range, *Pasadena* retaliated with 40mm fire. Refusing to slow, the cruiser swept past her assailant and into the night. At 0130hrs destroyer *Stockholm* (DD-683) was charged with finishing the job. *Stockholm* and the feisty picket traded hits, but by 0300hrs *Stockholm*'s 5in./38 and 40mm guns had finally left the enemy vessel wrecked and sinking.

A westerly 53mph wind would develop by 0430hrs, February 26. TF-58 reduced speed to 16 knots so the destroyers could keep up. Eventually Mitscher realized TF-58 would not reach launching position on time, and at 0530hrs Spruance and Mitscher canceled the Nagoya strikes and headed south to refuel.

TF-58 claimed 47 Japanese planes shot down and 111 destroyed on the ground for a total of 158 Japanese planes destroyed on February 25. Two hangars, one radar station, and two trains were destroyed. About 75 percent of the Ota engine plant's buildings were destroyed and an additional 15 percent heavily damaged. The Koizuma plant had also been heavily hit, and five coastal vessels and several smaller craft sunk, with another 14 vessels damaged. Total US losses were nine aircraft to antiaircraft fire and four to operational causes; four pilots were lost. Six US destroyers suffered storm damage.

Between February 16 and February 25 TF-58 had launched 2,471 sorties against the Tokyo area, while delivering 378 tons of bombs and firing 2,910 rockets on Japanese targets. Total US combat losses were 38 Hellcats, 17 Corsairs, three Avengers, and two Helldivers, with 52 aircrew lost. Another 28 aircraft and 11 airmen were lost to operational causes. TF-58 aircraft claimed a dubious 383 Japanese aircraft shot down, including 364 over Tokyo. Another 228 Japanese planes were estimated destroyed on the ground. TF-58 had attacked 23 Tokyo area airfields, claiming 37 hangars, shops, barracks, and miscellaneous buildings destroyed.

After TF-58 aircraft had plastered the Nakajima Ota airframe plant with 45 tons of bombs, February 25 photoreconnaissance revealed Ota to be 60 percent destroyed and 30 percent heavily damaged, although half of this was believed due to B-29s. After the photos TF-58 aircraft dropped another 13 tons on the plant. The Nakajima Koizuma plant was attacked on February 25 with 35 to 40 tons of bombs, with hits concentrated in the center of the plant. Reconnaissance showed 20 percent of the Koizuma roof

damaged. The Hitachi–Tachikawa aircraft engine plant was attacked by one Task Group strike, with US airmen reporting "excellent results." Photographs showed many bomb hits, but smoke made precise damage assessments difficult. Slight damage was also inflicted on the Tachikawa airframe plant. TF-58 planes struck the B-29s' nemesis, the Musashino-Tama aircraft engine plant, with 40 tons of bombs in the center of the Tama complex. A postwar assessment revealed TF-58's February 17 strike did more damage to Musashino-Tama than 835 B-29 sorties launched in eight raids between November 24, 1944 and March 4, 1945.

The Nakajima Ota plant viewed on February 25, 1945 by a TF-58 photoreconnaissance plane. Heavy snow is visible on the ground. Damage is visible to factory buildings in the upper left of the photo, although some of it may be due to B-29 attacks. (US Navy)

TF-58 ships and aircraft claimed one escort carrier, 12 picket boats, three patrol craft, and 30 small vessels sunk or probably destroyed. Of these, TF-58 destroyers had sunk six picket boats or armed trawlers on February 16, two more the night of February 17/18, and three more picket boats, a lugger, a small coastal freighter, and a patrol craft on the night of February 25/26. Most of the picket boats US destroyers had sunk on February 16 had already been heavily strafed by fighters.

TF-58 returned to Ulithi on March 4. From Kyushu's Kanoya airfield, 24 IJN P1Y1 "Frances" bombers sortied on March 11 on a one-way mission to Ulithi—Operation *Tan No. 2*. One Frances successfully crashed the illuminated carrier *Randolph*, which was taking on ammunition. Twenty-seven Americans were killed and 105 wounded. With *Randolph* under repairs, *Saratoga*, *Lexington*, and *Cowpens* departed to the United States and were replaced by *Franklin*, *Intrepid*, and *Bataan*. *Enterprise* reached Ulithi from Iwo Jima on March 12.

HOME ISLANDS STRIKES IN SUPPORT OF OPERATION *ICEBERG*, MARCH 18–JUNE 8

Strikes on Kyushu, March 18–19

TF-58 prepared to launch pre-emptive strikes against Kyushu airfields in preparation for *Iceberg*, the invasion of Okinawa. Mitscher's TF-58 departed Ulithi on March 14 and was spotted by a snooping IJNAF plane out of Truk. TF-58 replenished on March 16, and made its high-speed run-in the night of March 17/18.

IGHQ correctly expected attacks on Kyushu on March 18. Kyushu's Fifth Air Fleet was alerted, but its commander, Vice Admiral Matome Ugaki, was ordered to attack the US fleet only if it contained invasion transports. Ugaki strongly protested, fearing his force would get destroyed on the ground. IGHQ relented and informed Ugaki to use his best judgment.

TF-58 reached its launching point 90nm southeast of Kyushu at dawn, March 18. The first TF-58 sweeps of 32 fighters per Task Group began launching at 0545hrs. Forty-five minutes later the Task Groups launched airfield strikes of 60 bombers and 40 fighters each. Over the course of the

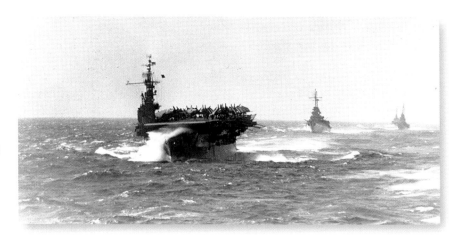

Light carrier USS *Langley* (CVL-27) and escorting light cruisers are seen en route to attack Japan on March 18, 1945. Converted from Cleveland-class light cruisers in 1942, the Independence-class light carriers were a wartime stopgap to put fast carrier hulls quickly into service. (NARA 80-G-313864, via Naval History and Heritage Command)

day TF-58 would attack 45 Kyushu airfields and claim 102 aircraft shot down and 275 destroyed or damaged on the ground. Photoreconnaissance would reveal superbattleship *Yamato* and three cruisers at Kure, but not in time for Mitscher to launch a targeted strike against them.

Meanwhile, many of Ugaki's aircraft had gotten airborne that morning and attacked TF-58. Radford's TG-58.4 was 75nm south of Shikoku that morning and received the brunt of Japanese attention. At 0725hrs *Enterprise* was struck by a dud bomb. Then a Mitsubishi G4M "Betty" tried to crash *Intrepid* but was shot down just before impact, killing two Americans and wounding 43, while starting a fire on the hangar deck. Three D4Y Suisei dive-bombers attacked *Yorktown* at 1300hrs, delivering a single bomb hit that struck *Yorktown*'s island, penetrated a deck, and exploded alongside the hull. Five men died and 26 were wounded. TF-58's CAP shot down 12 Japanese attackers, while 21 fell to antiaircraft fire.

The following morning, March 19, TF-58 launched a strike of 321 aircraft (158 bombers and 163 fighters) from TG-58.1, TG-58.3, and TG-58.4 against Kure, while 114 Hellcats and Corsairs from TG-58.2 swept the Kobe area. At 0650hrs three C6N Saiun "Myrt" recon planes discovered TF-58, and by 0700hrs Captain Minoru Genda's elite, handpicked 343rd Kokutai had scrambled 63 advanced Kawasaki N1K2-J "George" Shiden-Kai fighters from Shikoku to intercept the Americans. Minutes later, Genda's powerful Shiden-Kais "waded into the Hellcats and Corsairs as if the clock had been turned back to 1942." Soon the 343rd Kokutai was engaged in a wild maelstrom with 80 US fighters, including VF-17 and VBF-17 Hellcats from *Hornet* and VMF-112 Corsairs from *Bennington*. For once the Japanese broke about even, losing 24 fighters and one scout plane to the Americans' 14 fighters and 11 bombers. Nevertheless, Genda's expert but outnumbered 343rd Kokutai proved unable to blunt the American onslaught.

Mitscher's Kure strike had originally targeted shore installations, but upon discovering most of the Combined Fleet at Kure, airborne strike coordinator Commander

Struck by antiaircraft guns ringing the Kanoya East airfield, a VB-82 Helldiver from *Bennington* (CV-20) goes down in flames over Kyushu on March 18, 1945. Crew members Lieutenant Carlyle Newton and Aviation Radioman 2nd Class Eddie Curtin have already bailed out. While an unpleasant captivity awaits them, both men would survive to be repatriated. (US Navy/Interim Archives/Getty Images)

George Ottinger directed his 321 planes to attack the IJN warships instead. Some 160 heavy antiaircraft guns defended Kure, along with hundreds more automatic weapons. Flak proved extremely heavy and accurate, ultimately downing 11 Helldivers and two Avengers.

Superbattleship *Yamato* was observed underway in the Inland Sea and was attacked by *Intrepid* bombers; *Yamato* took a single bomb hit to her bridge. Ten TF-58 aircraft attacked battleship *Ise,* scoring one bomb hit that severely damaged her aircraft elevator, while *Wasp*'s CVG-86 scored a direct hit on battleship *Hyuga,* killing 40. Another 15 planes attacked battleship *Haruna,* claiming one hit aft of her bridge that caused light damage.

Carrier *Amagi* was hit by one bomb that damaged an antiaircraft battery and an adjacent elevator. About ten planes struck carrier *Katsuragi,* hitting her with one 500lb bomb that skipped into her starboard side, killing one and wounding three. Carrier *Ryuho* was attacked while underway and suffered five hits, three from 500lb bombs and two from rockets, while another seven dud rockets also hit *Ryuho,* killing 20 and wounding 30. The Americans also damaged incomplete carrier *Ikoma* and auxiliary carriers *Hosho, Kaiyo,* and *Shimane Maru.*

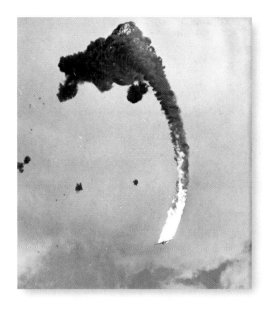

Eight Hellcats attacked armored cruiser *Iwate,* which was en route from Kure to Bungo Nado to conduct gunnery practice. *Iwate* suffered three near misses, but no damage. Strafing killed one and wounded 12. Three bomb hits caused light cruiser *Oyodo* to flood, and she was beached at Etajima to avoid sinking. TF-58 also damaged submarines *I-400* and *RO-67* and auxiliary subchaser *SC-229* at Kure, and destroyer-escort *Kaki* at Osaka. Submarine *I-205* was destroyed incomplete at drydock.

Another air–sea battle raged over TF-58, which steamed under snow flurries, low overcast, and unlimited horizontal visibility. Although TF-58 would claim 97 planes shot down and 225 destroyed or damaged at Japanese airfields this day, events subsequently proved this performance not enough.

At 0710hrs *Wasp* (CV-18) was hit by a 500lb bomb that penetrated her flight deck and hangar deck, then exploded in the crew's galley. *Wasp* suffered 101 killed and 269 wounded, but was able to resume flight operations within 27 minutes.

Rear Admiral Ralph Davison flew his TG-58.2 flag from Captain Leslie E. Gehres' USS *Franklin* (CV-13). Although a "mustang" who had risen from the enlisted ranks, much of *Franklin*'s crew considered Gehres an arrogant, career-obsessed tyrant, although some, including navigator Commander Stephen Jurika, found the captain tough, candid, and fair. Beginning at 0654hrs, March 19, *Franklin* made a succession of approaching radar contacts beginning 30nm out. However, *Franklin*'s exhausted crew had gone to General Quarters 12 times the previous night, and Gehres had ordered Condition III

A US Navy photographer snapped this photo of carrier USS *Hornet* (CV-12) shooting down a Japanese plane off the coast of Japan, March 18, 1945. At this stage of the war most aerial attacks against US carriers were kamikazes. At a minimum this required the stopping power of 40mm Bofors or even the 5in./38 DP guns. (US Navy)

Superbattleship *Yamato* maneuvers furiously in the Inland Sea while under attack from TF-58, March 19, 1945. *Yamato* would survive the many American bombs aimed at her this day, suffering a single hit to her bridge. She would not fare quite so well a few weeks later. (US Navy/ Interim Archives/Getty Images)

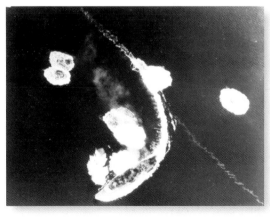

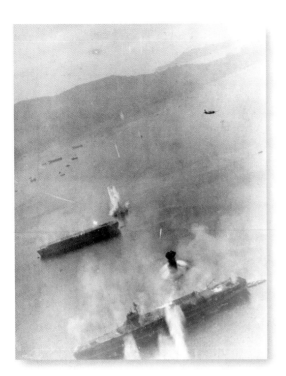

Japanese carriers are seen under US aerial attack at Kure harbor, March 19, 1945. The carrier at top is the escort carrier *Kaiyo*; the heavy carrier at bottom is either *Amagi* or sister *Katsuragi*. An *Essex* SB2C Helldiver is visible at top right. The March 1945 Kure raids did relatively little damage compared to those just a few months later. (Naval History and Heritage Command, NH 95778)

to allow men not manning guns to eat and sleep. Other ships transmitted *Franklin* increasingly tense warnings until, at 0705hrs, *Hancock* suddenly radioed *Franklin* in the clear, "Bogie closing you!" On *Franklin*'s stern sat 31 fully fueled and idling aircraft preparing for their strike. They were armed with 500lb bombs, 250lb bombs, and 1,255lb "Tiny Tim" air-dropped rockets. Below in the hangar were another 21 aircraft.

At 0708hrs a D4Y Suisei dive-bomber broke through the 2,000ft cloud ceiling 1,000 yards ahead of *Franklin* and quickly dropped two 550lb bombs. The first struck near *Franklin*'s island, and the second landed on *Franklin*'s after flight deck amidst fully fueled and armed planes ready to launch. "Resultant damage was severe," noted Davison's laconic post-action report. Too late, a vengeful Corsair shot the Suisei into the sea.

The first bomb penetrated to the hangar deck, destroyed the Combat Information Center and Air Plot, started fires, and blew the forward elevator into the air. The second bomb penetrated the after flight deck, then exploded in the hangar. Seconds later "a tremendous gasoline vapor explosion" slaughtered all but two men in *Franklin*'s hangar. Within 5–10 minutes the resultant fires spread to bombs and fully fueled planes. As the various munitions cooked off, a cascading series of secondary detonations rapidly turned *Franklin* into a blazing inferno. Over the next five hours *Franklin* would be rocked by cataclysmic explosions as nearly 70 bombs on *Franklin*'s flight deck cooked off. Over the horizon in *Bunker Hill*, Mitscher could feel the explosions, although he could not see *Franklin*. The first blasts had caused "deck heave"—a whiplash effect that instantaneously rippled the floor into the ceiling, literally crushing men between converging decks; as many as 400 men standing in line for breakfast in the gallery deck were killed instantly.

As nearby warships observed *Franklin*'s torment with horrified awe, a 400ft-long, 100ft-tall curtain of fire commenced roaring up abaft *Franklin*'s island and began consuming the shattered after flight deck. Smoke poured through the bridge and incapacitated *Franklin*'s commanding officers; Gehres fell to the deck choking for 15 minutes, while Jurika attempted to breathe through a wet handkerchief. A mile-high column of smoke billowed into the clouds. Some 75 tons of 100-octane avgas had been loaded on the flight deck; incandescent rivers of flame now flowed over multiple decks and poured into the sea. One seaman, looking into the holocaust raging on the hangar deck, remembered, "The fire was alive … you can't appreciate 100-octane fuel burning in that magnitude until you see it." For those trapped below, the glowing bulkheads "flashed different colors, changing dark red to yellow to orange to white as the heat moved through the steel."

Lieutenant-Commander Joseph O'Callahan, *Franklin*'s popular Catholic chaplain, headed to the blazing hangar deck, but found only a "solid mass of fire. Here and there, like coals of special brilliance, were airplane engines glowing white hot, glaring so intensely that their image hurt the eye and

branded the memory forever." O'Callahan fired off a quick prayer and returned topside. By all accounts, O'Callahan, a natural leader, seemed to be everywhere that morning—comforting shipmates, administering last rites, manning firehoses, directing the jettisoning of hot ordnance, taking control of repair parties, and leading trapped men to safety.

Above deck, Jurika observed: "fifty-caliber ammunition in the planes on the deck set up a staccato chattering, and the air was well punctuated with streaks of tracer." Meanwhile, sixteen 10.5ft-long, 1,255lb Tiny Tim rockets with their 148.5lb TNT warheads inevitably cooked off and began detonating or roaring off *Franklin* at 550mph. Executive officer Commander Joe Taylor recalled:

> Some screamed by to starboard … some to port and some straight up the flight deck. The weird aspect of this weapon whooshing so close is one of the most awful spectacles a human has ever been privileged to see. Some went straight and some tumbled end over end. Each time one went off, the firefighting crews forward would instinctively hit the deck … their heroism was the greatest thing I have ever seen. They simply would not leave their hoses in spite of what appeared to be certain death and disaster.

By 0725hrs Gehres had ordered magazines flooded, not knowing the necessary water mains had been destroyed. Sixteen minutes later a Zero dove on *Franklin* but was brought down by *Franklin* gunners. Destroyers *Miller* and *Hickox* pulled alongside *Franklin* and began playing firehoses onto her. By now *Franklin*'s stern was completely consumed in fire and cut off from all communications. Gehres observed, "Large numbers of men and a considerable number of officers and chief petty officers were blown over the side aft of the island or forced aft when faced with a choice of going overboard or being burned to death." Over a thousand *Franklin* sailors, many badly wounded, bobbed in the wake of their former ship, and were continuously picked up by trailing destroyers.

Unable to command TG-58.2 from *Franklin*, Davison's staff transferred flag, leaving via breeches buoy to destroyer *Miller*. As Davison departed, he repeatedly told Gehres, "Captain, I think there's no hope … I think you should consider abandoning ship—those fires seem to be out of control." Gehres merely nodded silently. But Gehres had no intention of abandoning ship, stating years later, "It was none of the admiral's damn business," and noting that such an order would have condemned hundreds of men trapped below to certain death.

By midmorning all Inland Sea strikes had been canceled; all US fighters were to hammer Kyushu airfields to protect *Franklin*. Decisive damage to the IJN would not be inflicted this day. At 0930hrs light cruiser *Santa Fe* pulled abeam *Franklin*'s starboard side, spraying firehoses. The errant Tiny Tims had smashed *Franklin*'s engine ducts; by now *Franklin*'s hellish engineering spaces had become uninhabitable. Engineers jammed *Franklin*'s throttles open before escaping. At 0952hrs, the ammunition in *Franklin*'s after 5in./38 guns detonated. Jurika remembered:

Stricken US fast carrier USS *Franklin* (CV-13) explodes after being hit by a Japanese D4Y Suisei the morning of March 19, 1945. A perfect storm of sympathetic detonations by munitions and avgas explosions shortly transformed *Franklin*'s hangar deck and stern into an utter inferno. (US Navy)

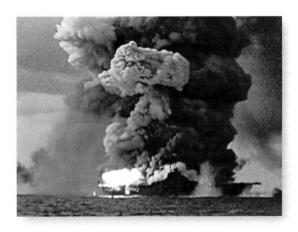

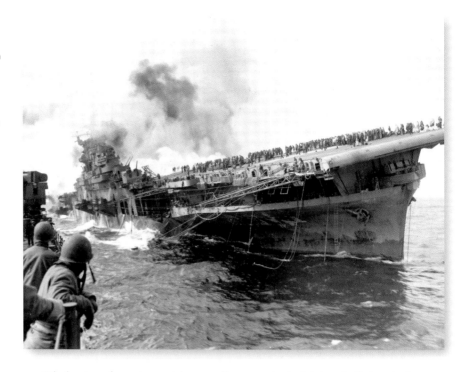

Whole aircraft engines with propellers attached, debris of all description, including pieces of human bodies were flung high into the air and descended on the general area like hail on a roof. One engine and a prop struck the navigation bridge a glancing blow about three feet from my head.

By 1000hrs *Franklin* was dead in the water and listing 11 degrees. *Santa Fe*'s skipper, Captain Harold Fitz, jammed *Santa Fe* into *Franklin*'s side at full power to keep *Franklin* steady, then began rigging aerial trolleys to *Franklin*. Both Gehres and Jurika called Fitz's handling of *Santa Fe* the best seamanship they had ever seen. Once the trolleys were secure, *Santa Fe* began sending firefighting parties and equipment across to *Franklin*, while Gehres ordered *Franklin*'s now-useless air group to *Santa Fe*. However, ignoring Gehres' screaming threats, numerous unauthorized *Franklin* officers also highlined across to *Santa Fe*.

Deep within *Franklin*, 300 trapped men huddled in a blacked-out mess, surrounded on all sides by raging fire. "If you want to pray, go ahead," a ship's surgeon advised. "But pray to yourself to conserve oxygen." Panic inevitably began to swell. Searching for trapped men, assistant engineer Lieutenant J.G. Donald Gary suddenly burst into the darkened mess, having penetrated the furious smoke wearing an oxygen breathing apparatus with a 60-minute air supply. "I know the ship," Gary told them. "I'll find a way out and I'll be back to get you. I mean that. I'll be back to get you!" Groping through *Franklin*'s dark, smoke-filled interior, Gary eventually found his way topside. He then plunged back below and returned to the mess. "I've found a way out," Gary announced. "I'll take the first ten men closest to the door first. If I get them through, I'll come back and get the rest of you." One by one, Gary began taking small parties up through 600ft of engine ducts, instructing each man to crouch low and hold the belt of the man in front of him. They formed a human chain as Gary led them groping their

way blindly up through the smoke-filled, pitch-black labyrinth. After getting the first men past the flames and flooding water to the flight deck, Gary returned to the mess three more times, eventually pulling all 300 trapped men to safety. Gary then plunged back into the blazing hangar deck to help organize firefighting efforts.

Without power, *Franklin* was drifting toward Shikoku. Mitscher signaled from *Bunker Hill* that *Franklin* had permission to abandon ship. Gehres angrily signaled back, "Hell, we're still afloat!" At 1200hrs *Santa Fe* messaged Davison on behalf of Gehres: "Fires practically under control. Skeleton crew aboard. List stabilized. If you save us from the Japanese, we will save you the ship."

At 1254hrs a D4Y Suisei suddenly erupted straight toward *Franklin* and dropped a bomb that detonated 200 yards abeam. Scrambling crewmen manned *Franklin*'s last operational 40mm guns and shot the Suisei down. By now most major explosions had ceased, and at 1400hrs heavy cruiser *Pittsburgh* began towing *Franklin* at three knots. *Franklin* was 52nm from Japan, the closest any US carrier came during the war. By 1555hrs *Franklin*'s fires were largely out. *Franklin*, the worst-damaged American ship to survive World War II, ultimately suffered 798 dead and 487 wounded. Among those killed was Captain Arnold J. Isbell, scheduled to command *Yorktown*. Another 1,700 men were pulled from the water.

Meanwhile, Lieutenant J.G. Donald Gary led an engineering team into *Franklin*'s No. 3 fireroom and successfully relit a boiler. By 0930hrs, March 20, *Franklin* was steaming at six knots, and by 1138hrs she was maintaining 14 knots. "Down by the tail but reins up!" reported Gehres. That afternoon *Franklin* cast her towline with *Pittsburgh*. But before reaching Ulithi on March 24, Gehres ordered all *Franklin* officers rescued by other ships returned to *Franklin*. As soon as they arrived, they were handed a letter:

> The Commanding Officer requires an immediate explanation in writing as to when, where, and why you able-bodied and uninjured left this vessel while she was in action and seriously damaged when no order had been issued to abandon ship.

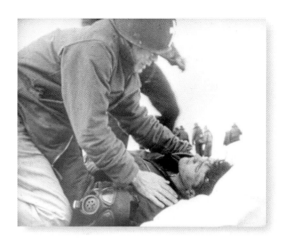

Franklin's Lieutenant-Commander Father O'Callahan administers last rites to Robert C. Blanchard, who has been overcome with smoke inhalation, March 19, 1945. O'Callahan would eventually be awarded the Medal of Honor for his actions on March 19. Blanchard would actually recover, dying in 2014 at age 90. (NARA 80-G-49132, via NavSource)

Her flight deck visibly wrecked, USS *Franklin* (CV-13) arrives at New York, April 28, 1945. The West Coast was backed up repairing kamikaze damage, and so it was decided to send *Franklin* to the New York Navy Yard in Brooklyn. The carrier's very last body aboard was found just as *Franklin* entered New York's harbor. (NARA 80-G-K-4760, via NavSource)

Gehres further published membership cards to the "Big Ben 704 Club" for the 704 survivors who remained aboard *Franklin*. This notably excluded those who were blown off the ship or trapped by fire and forced off. Several *Franklin* survivors recalled that it was "spitting snow" and "the air was cold, and the water colder, and no one wanted to go into the water unless they absolutely had to." Although Gehres threatened wholesale desertion charges, ultimately no courts martial were ever filed.

Franklin became the most-decorated ship in US Navy history. Her men were ultimately

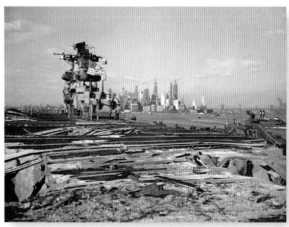

awarded 234 Letters of Commendation, 115 Bronze Stars, 22 Silver Stars, 18 Navy Crosses (which included Captain Gehres, Commander Taylor, and Commander Jurika), and two Medals of Honor, awarded to Lieutenant-Commander Joseph O'Callahan and Lieutenant J.G. Donald Gary.

Franklin's hellish crucible seemed to bitterly and permanently divide those who lived through it. For Commander Stephen Jurika:

> I was amazed at how some of our big, good-looking officers whom you would expect to be towers of strength turned out to be little pipsqueak people ... and some other nondescript 135-pounders who turned out to be real tigers and real lions. And the same thing was true of enlisted men ... It was the little people who really came through ... I made up my mind then that I'd never judge a man, let alone a naval officer or a naval aviator, by whether he looked the go-go vigorous, hot-to-trot type. I found out a lot of things there.

As TF-58 slowly withdrew the afternoon of March 20, a damaged Zero crashed destroyer *Halsey Powell*, killing 12 and wounding 29. Shortly afterwards friendly antiaircraft fire started fires aboard *Enterprise*. At 2300hrs eight Japanese torpedo planes unsuccessfully attacked TF-58, while three overnight snoopers were splashed by antiaircraft fire. Between March 17 and March 20 Ugaki had committed 193 aircraft to battle and lost 161. On March 21 Ugaki dispatched a 48-plane strike, including 16 G4M "Betty" bombers, carrying the very first *Ohka* ("Cherry Blossom") suicide missiles. A TF-58 combat air patrol (CAP) of 150 Hellcats and Corsairs repulsed them. *Franklin*, *Wasp*, and *Enterprise*, all damaged, steamed to Ulithi as a reorganized TG-58.2. Ugaki's Fifth Air Fleet was effectively incapacitated for several weeks, but Ugaki nevertheless reported five carriers, two battleships, and three cruisers sunk, which IGHQ found scarcely credible.

Kyushu sweeps, March 29 and April 15–16

The long, grueling, and extraordinarily violent air–sea struggle off Okinawa was a full naval campaign in itself. Although Okinawa operations lasted from April into June, space permits only a brief summary here. TF-58 commenced pre-landing poundings of Okinawa on March 24. Then at 0545hrs, March 29, TG-58.3's *Essex*, *Bunker Hill*, *Hancock*, *Bataan*, and *Cabot* launched 172 sorties against aircraft, air facilities, and ground installations on Kyushu. Mitscher canceled further strikes at 1424hrs due to deteriorating weather and expected counterattacks. TG-58.3 lost 13 airmen, mostly due to a mid-air collision. Twenty-two ships and 20 enemy aircraft were destroyed by TG-58.3.

Lieutenant-General Simon Bolivar Buckner's US Tenth Army landed at Okinawa on April 1. The first of ten *Kikisui* ("Floating Chrysanthemum") mass kamikaze attacks launched on April 6. On April 7 TF-58 aircraft sank the approaching superbattleship *Yamato*, light cruiser *Yahagi*, and four destroyers at the cost of 12 men and ten planes.

At 1315hrs, April 15, TF-58 launched a 125-strong fighter sweep against Kanoya

Fletcher-class destroyer USS *Halsey Powell* (DD-686) seen at the moment of impact on March 20, 1945 when she was crashed by a damaged Zero. She is alongside fast carrier USS *Hancock* (CV-19). *Halsey Powell* suffered 41 total casualties, including 12 dead. *Halsey Powell* would reach San Pedro, California for repairs on May 8, and would return to Pearl Harbor by July 19, 1945. (US Navy)

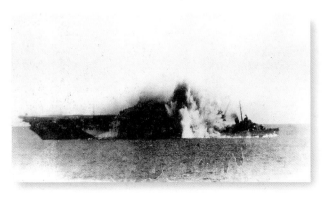

and Kushira air bases on Kyushu. A particularly notable event was when VF-46 skipper Lieutenant-Commander Robert "Doc" Weatherup shot down two 343rd Kokutai Shiden-Kais taking off from Kanoya airfield. One of these was 70-kill ace Chief Petty Officer Shoichi Sugita. TF-58 sweeps claimed 29 planes in the air and 51 on the ground. Another 60 aircraft were claimed damaged. Two US fighters fell to flak, but both pilots were recovered.

TF-58 fighter sweeps over Kyushu on April 16 shot down 17 more aircraft and claimed 54 destroyed and 73 damaged on the ground. TF-58 antiaircraft fire shot down 15 aircraft, and 67 more planes were shot down by CAPs near Okinawa. On April 17 Mitscher disestablished TG-58.2 and dispatched the damaged *Enterprise* and *Hancock* back to Ulithi, while *Cabot* was detached for refurbishing.

Kyushu and Shikoku sweeps, May 13–14
TF-58 continued its Okinawa air support throughout April and early May. The morning of May 11 two kamikazes knocked Mitscher's flagship *Bunker Hill* out of the war, killing 396 Americans, including 14 of Mitscher's staff. Mitscher transferred his flag to the recently returned *Enterprise*.

Sixteen *Enterprise* Avengers heckled Kyushu airfields the night of May 12/13. At 0500hrs, May 13, TG-58.1 and TG-58.3 launched the first of 700 daylight sorties against Kyushu. That night *Enterprise* covered all of Kyushu and part of Shikoku with bombing and strafing attacks. TG-58.3 day strikes on Kyushu resumed on May 14. Although TG-58.3 shot down 20 enemy aircraft that day, *Enterprise* was crashed by a kamikaze, killing 13 and knocking her too out of the war. "Jimmy," Mitscher told Flatley, "tell my task group commanders that if the Japs keep this up they're going to grow hair on my head yet." The following day Mitscher transferred his flag to *Randolph*.

Total TF-58 claims were 72 enemy planes shot down (including 16 at night), 73 planes destroyed and 167 damaged on the ground, along with hangars, ships, barracks, and other installations destroyed or damaged at 17 bases and airfields. The Kumamoto aircraft factory was also bombed and damaged. TF-58 air losses were 14 planes.

Halsey returns, May 27
In late March USN chief Fleet Admiral Ernest King had informed an incredulous Admiral Bill Halsey that "certain high officials" somehow feared an IJN carrier raid on San Francisco during April's United Nations conference. On March 27 King duly appointed Halsey commander Mid-Pacific Striking Force, comprising carriers *Bon Homme Richard* and *Ranger*, plus all Hawaii- and West Coast-based warships, and charged Halsey "with interception and destruction of enemy raiding forces." Halsey's Third Fleet staff outlined contingency plans to intercept the phantom raid. King simultaneously ordered Spruance to form plans for dispatching two TF-58 carrier Task Groups to intercept a Japanese

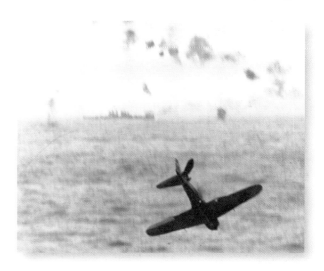

An A6M Zero nearly crashes into USS *Essex* (CV-9) on May 14, 1945. *Essex*'s fellow fast carrier USS *Enterprise* (CV-6) would not be so lucky that day. In the background a Cleveland-class light cruiser is visible. Although the Japanese still used conventional attacks, sometimes escorted by Zeros, a Zero this close to a US carrier in 1945 was probably on a kamikaze mission. (US Navy)

The self-described "Dirty Tricks Department" of admirals Bill Halsey (right) and John McCain (left) discuss tactics aboard battleship *New Jersey*, late 1944. Though less celebrated than Mitscher, Halsey's carrier commander McCain was more tactically flexible and open to suggestions. McCain claimed, "I like to talk to the people who are actually doing it … if I want to learn how to tie a bowline on a bite, I'll go to the bosun's mate, not my chief of staff." (NARA 80-G-302244, via Naval History and Heritage Command)

force retiring from a West Coast strike. Aside from reinforcing San Francisco with US Army antiaircraft batteries, no attack or defense of California came to pass.

In late 1944, in accordance with WPO strategy, Spruance had suggested invading Chusan, China, where Ningpo's airfields and Nimrod Sound's deepwater anchorage would provide a base to encircle and bombard Japan. By early 1945 Nimitz's planners urged the Chusan landings be augmented by subsequent landings on the Shantung Peninsula. The proposed Operation *Longtom* would begin with July 7–8 and July 17–18, 1945 diversionary strikes on Hong Kong and Canton by the British Pacific Fleet. Then, on August 14, the "Eastern Carrier Force" of one British and two US carrier Task Groups would strike Kyushu and Honshu, while the "Western Carrier Force" of three US Task Groups, assisted by land-based air forces, would carry out strikes against Shanghai, Ningpo, southern Korea, and Kyushu until the Chusan D-Day, August 20, 1945.

Ordered by King, Halsey's staff convened at Pearl Harbor on April 7, 1945 and began exploring four potential *Longtom* operations for Third Fleet:

1. Covering a landing on the coast of China at Ningpo Peninsula–Chusan Archipelago–Nimrod Sound, about 100nm south of Shanghai.

2. Covering landings on China's Shantung Peninsula 350nm north of Shanghai.

3. Establishing a North Pacific line of communications with the Soviet Union through La Pérouse Strait, north of Hokkaido.

4. Entry into the Sea of Japan through the Korea Strait.

Among the USN high command, Halsey alone preferred to invade Japan, believing "the strategy of gradual encirclement and strangulation a waste of time—like two bites at a cherry." His staff studied the Ningpo–Chusan–Nimrod Sound landings as ordered, but Halsey recommended all planning be reoriented to Japan.

Halsey hoisted his flag aboard battleship *Missouri* on May 18, then joined the fleet at Okinawa on May 26. At midnight, May 27, Halsey relieved Spruance of fleet command. Fifth Fleet again became Third Fleet. Hours later Vice Admiral John S. McCain relieved Mitscher and raised his flag on carrier *Shangri-La* as commander, TF-38. Halsey sent Mitscher a farewell dispatch: "It is with the very deepest regret that we watch a great fighting man shove off. I and my staff and the Fleet send all luck to you and your magnificent staff." Far more exhausted than anyone knew, Mitscher never again commanded the Fast Carrier Task Force. A deeply private man, Mitscher promptly destroyed his wartime diary. He would die on February 3, 1947, a quiet and beloved enigma.

Return to Kyushu and Typhoon Viper, June 2-8

On June 2 and 3 Radford's TG-38.4 launched 173 fighter sorties against southern Kyushu airfields, but they were virtually negated by poor weather. Four aircraft were lost operationally. TF-38 attacked Okinawa the following day.

Then careless seamanship by Halsey and McCain saw TF-38 blunder into a damaging typhoon the early morning of June 5. The retroactively named Typhoon Viper proved unusually small, tight, and given to erratic movements. Storm conditions varied greatly between Task Groups, further coloring Halsey's and McCain's judgment. Typhoon Viper ultimately damaged 33 Third Fleet ships, destroyed 142 aircraft, and killed six men. The severely damaged carrier *Hornet* and heavy cruiser *Pittsburgh* were detached to the United States, but were replaced by the brand-new Essex-class night carrier *Bon Homme Richard* on June 6.

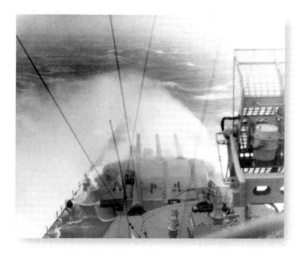

Halsey also detached Sherman's TG-38.3 for rest and replenishment. While anchored at Leyte–Samar on June 8 a showboating USAAF P-38 Lightning would crash into *Randolph*, smashing planes, shredding flight deck, and killing 11 men and wounding 14 more. That same day Radford's TG-38.4 swept southern Kyushu airfields armed with new Variable Time (VT)-fuzed 260lb bombs. TG-38.4 lost two planes in 108 offensive sorties, but their pilots were recovered.

TF-38 ended *Iceberg* operations on June 10, and on June 13 began 17 days of rest and repair at San Pedro Bay, Leyte. Meanwhile, the USN's Typhoon Viper inquiry ultimately recommended Halsey and McCain be reassigned. Halsey's public reputation saved him, but Nimitz scheduled Vice Admiral Jack Towers to relieve McCain of TF-38 command in August.

Battleship USS *Indiana* steams through Typhoon Viper, June 5, 1945. This was Halsey's and McCain's second wartime typhoon they had blundered into, the first being December 1944's Typhoon Cobra that killed a staggering 790 Third Fleet personnel when three destroyers capsized. After Viper only Halsey's home front popularity prevented the US Navy from removing him from command. (NARA 80-G-342732, via Naval History and Heritage Command)

OPERATION *STARVATION*

As early as 1942 far-sighted USN and USAAF officers had cooperated to research and develop aerial mining tactics. At USN request a number of USAAF pilots attended the Navy Mine Warfare School at Yorktown, Virginia, while the USAAF School of Applied Tactics at Orlando, Florida added aerial mining to its curriculum. In September 1944 a US intelligence report in the China–Burma–India theater predicted, "A complete blockade … by aerial mining would virtually paralyze Japanese war industry once the stocks of raw materials inside Japan had been absorbed." In 1944 Nimitz's staff had proposed a detailed plan to mine Home Island waters with B-29s, but the idea was received coolly by Washington USAAF brass. Hansell recalled, "It looked like one more diversion to the local needs of a ground commander, and away from primary industrial targets leading to the defeat of the enemy air force." Eastern Air Command's Major-General George E. Stratemeyer (USAAF) was far more enthusiastic, writing to USAAF chief General Henry "Hap" Arnold in December 1944:

> Many persons, both in Army and Naval Air Forces, still think that mining is a means of warfare which should be accomplished by surface craft or submarine, and that when aircraft undertake aerial mining they are actually undertaking so much extra duty for the Navy. This is fundamentally false. In actual fact, the aerial mine is an Air Force weapon with very great potential against the surface Navy and shipping. It may be used defensively or offensively with great flexibility.

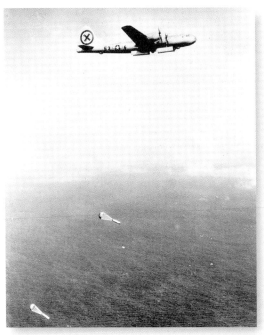

A USAAF B-29 drops mines off Japan in Operation *Starvation*. About half of *Starvation's* mines were the USN's Mark 25, weighing 2,000lb and armed with 1,250lb of explosive. Parachute-retarded, they were dropped from at least 200ft altitude into water between 16ft and 150ft deep, and armed for magnetic, acoustic, or pressure actuation. Operation *Starvation* was arguably the most successful and cost-effective US operation of the Pacific War. (NARA)

A reluctant Arnold eventually compromised, promising downsized support once XXI Bomber Command reached full strength, and then only during "weather periods which preclude our normal visual bombing operations so that minimal interference with [the] primary [strategic bombing] mission will result." On December 22, 1944 Hansell's XXI Bomber Command was directed to prepare a naval mining program of 150–200 sorties per month, to begin in April 1945. But by then Major-General Curtis LeMay had replaced Hansell as commander XXI Bomber Command. LeMay proved enthusiastically supportive, and successfully recommended to Washington a re-upgraded program of 1,500 mines per month using a full B-29 wing. The campaign was named Operation *Starvation* and given three objectives: the prevention of raw materials and food from reaching the Home Islands, the prevention of supply and deployment of Japanese forces, and the disruption of Inland Sea transportation.

The 313th Bombardment Wing arrived at Tinian in February 1945. By February 20, 1945 12 USN officers and 171 enlisted men had established Tinian's Mine Assembly Depot No. 4, stocked with 1,500 mines. The USN began supplying and training the 313th Bombardment Wing for the minelaying mission, while 313th B-29s were modified to carry either twelve 1,000lb Mark 26 or Mark 36 mines or seven 2,000lb Mark 25 mines each. Individual B-29s would fly between 5,000ft and 8,000ft altitude for night drops directed by the addition of AN/APQ-13 radars.

Phase I of Operation *Starvation* targeted the narrow Shimonoseki Strait between Kyushu and Honshu, "the single most vulnerable point in the enemy's shipping position." Phase I would also mine the naval/military shipping bases of Kure, Sasebo, and Hiroshima. The first mission was the night of March 27. Brigadier-General John Davies led four 313th Bomb Wing groups on the first of 246 sorties in seven missions through April 12, dropping 2,030 mines. The Shimonoseki Strait was closed for two weeks, forcing IJN vessels to exit the Inland Sea through the easily covered Bungo Strait. This included, as it turned out, Vice Admiral Ito's doomed *Yamato* task force.

Phase II was intended to "destroy sea-borne commerce between Japan's great industrial zones" and attacked the Shimonoseki Strait, Tokyo, Nagoya, Kobe–Osaka, and the Inland Sea. This was accomplished with almost 200 B-29s in just two missions on May 3 and May 5. A total of 1,422 mines were laid, mostly 2,000lb Mark 25 mines and many of a new pressure type considered "unsweepable." By now aerial reconnaissance revealed ships and tonnage passing through the Shimonoseki Strait had plummeted to barely 10 percent of pre-mining levels.

Phase III would "blockade the bulk of enemy shipping moving from the Asiatic mainland to Japan" by extending *Starvation* minefields from the Shimonoseki Strait to Kyushu and northwest Honshu. A total of 209 sorties in eight missions laid 1,313 mines beginning on May 13. By May mines were sinking more ships than were submarines. Mines had sunk 113

Japanese ships in the Shimonoseki Strait alone, about 9 percent of Japan's merchant fleet.

Phase IV lasted between June 7 and July 8 and extended and strengthened minefields on the western coast of Japan and replenished existing minefields in the Shimonoseki Strait and Inland Sea. A total of 404 sorties in 14 missions laid 3,542 mines.

Phase V was the "total blockade" that began on July 9 and lasted to the end of the war. A total of 474 sorties dropped 3,746 mines that both replenished existing minefields and extended them to Korean harbors. B-29s additionally dropped 4.5 million propaganda leaflets informing Japanese civilians that the minelaying was a major factor in their increasing dietary starvation.

Ultimately, XXI Bomber Command, in 46 missions, would lay 26 minefields totaling 12,135 mines. *Starvation*'s 1,529 sorties comprised only 5.7 percent of total XXI Bomber Command sorties. Only 15 B-29s would be lost, a rate below 1 percent. *Starvation* mines, however, would sink or damage 670 Japanese ships for a total loss of 1.25 million tons.

Despite the obvious vulnerability of Japan's economy to intracoastal shipping disruption, Japanese authorities proved categorically unprepared to meet the air-dropped mining threat. By August 1945 Japan had devoted 349 ships and 20,000 personnel to countering the *Starvation* campaign, overwhelmingly without success. The shipping crisis became so critical that searchlights and antiaircraft batteries were drawn from cities to expected mining targets while suicide craft were used to help clear the fields.

Royal Navy historian S.W. Roskill reported:

> The blockade had, in fact, been far more successful than we realized at the time. Though the submarines had been the first and main instruments for its enforcement, it was the air-laid mines which finally strangled Japan.

Japanese authorities agreed. A Tokyo steel company director ultimately noted that the denial of raw materials to the factories exceeded the disruption caused by the direct bombing of the plants themselves—in direct contradiction to the USAAF experts in Washington. A Japanese minesweeping officer would tell Americans after the war, "The result of B-29 mining was so effective against the shipping that it eventually starved the country. I think you probably could have shortened the war by beginning it earlier."

NAVAL PLANS FOR OPERATION *OLYMPIC*

Fearing eventual American war-weariness, JCS planners had determined that defeating Japan through air–sea blockade alone would demand "unacceptable delay" in ending the Pacific War. Only "invasion of the industrial heart of Japan" would assure the unconditional surrender of Japan within one year of Germany's defeat. With American military power now surging far beyond anything prewar planners had ever imagined, the previously unthinkable had suddenly become plausible. On May 25, 1945 the JCS rejected the USN's proposed China landings and instead authorized Operation *Downfall*, the invasion of Japan. *Downfall* was divided into two phases. The first, Operation *Olympic*, was the invasion of southern Kyushu by US Sixth Army

on November 1, 1945 (X-Day). However vast *Olympic* was, it was intended only to secure the southern one-third of Kyushu, including primarily Kagoshima Bay. Staging from *Olympic*'s Kyushu lodgment would be *Downfall*'s second phase, Operation *Coronet*, scheduled for March 1, 1946 (Y-Day). *Coronet* was the presumed Pacific War *coup de grâce* and would employ the 25 divisions of US First and Eighth armies to invade Honshu's Kanto Plain, the industrial and political heart of Japan. *Downfall* would ultimately hurl 1,792,700 US troops onto the Home Islands; at 13 and 14 assault divisions respectively, *Olympic* and *Coronet* would be the two largest amphibious invasions in history, each exceeding the 1944 *Overlord* landings.

While *Coronet* plans were only broadly outlined by war's end, *Olympic* had been planned in detail. For the first time, Spruance's US Fifth Fleet and Halsey's US Third Fleet would operate simultaneously. Based out of Okinawa, the Philippines, and the Marianas, Fifth Fleet would "conduct the operations connected with the seizure and occupation of beachheads in southern Kyushu." Third Fleet, operating out of Eniwetok, would "provide strategic support by raiding Honshu and Hokkaido."

By July 1945 Third Fleet's TF-38 would have 16 fast carriers (ten heavy and six light), with the Royal Navy's TF-37 contributing four more carriers. On X-75 (July 28) Halsey's Third Fleet would begin cutting Honshu–Kyushu communications and softening up Home Islands air, naval, and shipping strength. By mid-August TF-38 would return to Eniwetok for replenishment where TF-38 commander Vice Admiral John McCain would be replaced by Vice Admiral Jack Towers. *Essex* and *San Jacinto* would be detached for overhaul in the United States and be replaced by fast carriers *Intrepid*, *Antietam*, and *Cabot*. TF-38 would then strike the Home Islands from late August through September, although operations would be limited to east of the 135th meridian (Hokkaido and most of Honshu, including Tokyo), while General George C. Kenney's Ryukyus-based Far Eastern Air Forces (USAAF) would hit targets to the west, primarily Kyushu, Shikoku, and western Honshu. The Royal Navy's TF-37, reinforced to nine carriers, would launch diversionary strikes against Hong Kong (September 18) and Canton (September 28). Beginning on X-14 (October 18) Third Fleet would hammer aircraft, airfields, and shipping in Kyushu, Shikoku, and Honshu to isolate the Kyushu assault area. On October 24, 1945 the US Fast Carrier Task Force would be divided into TF-38 and TF-58 simultaneously. The 25 fast carriers, 11 fast battleships, 30 cruisers, and 107 destroyers of Towers' US TF-38 and Vice Admiral Rawlings' British TF-37 (1,827 total aircraft) would remain with Halsey's Third Fleet, ranging up and down Honshu and Hokkaido hammering strategic targets.

At Kyushu Admiral Spruance's Fifth Fleet of 2,902 ships would land the 582,560 troops of General Walter Krueger's 14-division US Sixth Army. The 35 *Olympic* landing beaches were given automobile codenames, such as Austin, Buick, and Cadillac. Total US invasion strength would be 766,700 combat and support troops. Forty USAAF, USMC, and USN air groups (2,760 aircraft) would provide land-based air support from Okinawa. Fifth Fleet's ten US fast carriers (seven heavy and three light) of Vice Admiral "Ted" Sherman's TF-58 (815 aircraft) would directly support the Kyushu landings, as would Rear Admiral Cal Durgin's 16 escort carriers of TF-55 (448 aircraft). Four escort carriers would host USMC air groups and three would be dedicated night carriers. Fifth Fleet would additionally wield 13 old

Operation *Olympic* plans, projected November 1, 1945

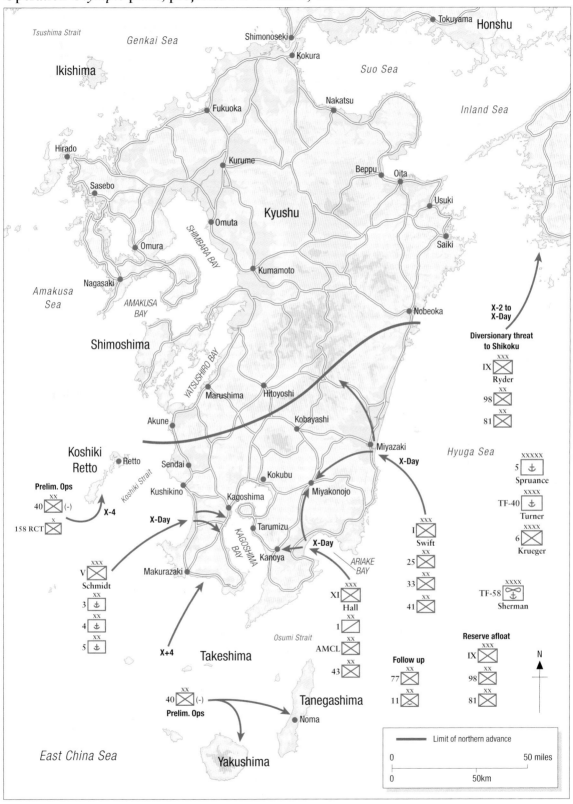

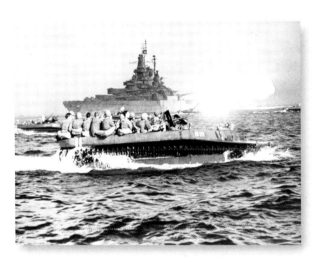

An LVT en route to landfall passes in front of battleship USS *Tennessee* bombarding Okinawa, April 1, 1945. Okinawa was the last scheduled amphibious operation before the invasion of Japan; had Operation *Olympic* taken place, scenes such as this would have ringed Kyushu. The sheer scale and violence of the landings and defense would have been unprecedented. (Naval History and Heritage Command)

battleships, 24 cruisers, 139 destroyers, and 167 destroyer-escorts, plus support ships, for a total of 800 warships and 1,500 transports. Among these were 20 headquarters ships, 210 attack transports, 12 troopships, 84 attack cargo ships, 92 destroyer-transports, 515 LSTs, 16 LSDs, 360 LSMs, six LSVs, and three hospital ships. Some 4,023 land-based and carrier-based planes would directly support the landings, with another 768 Marianas-based and 225 Iwo Jima-based aircraft providing indirect support striking Honshu. Combined with Third Fleet, a total of 6,653 US and British aircraft would participate in *Olympic*, from escort carrier-based FM-2 Wildcats to Twentieth Air Force B-29 Superfortresses. Additionally, several thousand Republic-Ford JB-2/KGW-1 Loon cruise missiles (reverse-engineered V-1 buzz bombs) would bombard Japan from escort carriers, LSTs, USAAF/USN heavy bombers, and Philippines bases. USN estimates were that up to 5,000 kamikazes would be hurled at the invasion fleet. The location and destruction of Kyushu's 60-plus estimated airfields and attendant dispersed aircraft was therefore a top priority. No major IJN surface units were assumed to interfere, but up to 50 large IJN submarines were expected, as well as hundreds of midget submarines and suicide craft deploying from hidden lairs in southern Kyushu's rugged coastline.

US pre-invasion air strikes, surface bombardments, and minesweeping operations of the Kyushu landing zones would begin when Admiral Richmond K. Turner's Advance Force (TF-41) and Sherman's First Fast Carrier Force (TF-58) arrived off Kyushu on October 24 (X-8), and would steadily increase in intensity until climaxing on X-Day, November 1. Three Fire Support groups, each accompanied by an escort carrier group, would pre-emptively hammer designated *Olympic* landing zones. Off southeastern Kyushu's Ariake Bay, Rear Admiral Richard Connolly's Third Fire Support Group (TG-41.3) of six old battleships, six cruisers, 13 destroyers, and 34 support craft would eliminate coastal batteries at Toi Misaka, Hi Saki, and Ariake Bay, as well as seaplane bases and suicide boat/submarine pens at Oshima, Odatsu, Biro Jima, and Sakida. TG-41.3 would then soften up defenses at the XI Corps landing beaches. Some 30 miles north, up Kyushu's southeastern coast, Rear Admiral Ingolf Kiland's Seventh Fire Support Group (TG-41.7) of three old battleships, eight cruisers, 11 destroyers, and 35 support craft would bombard coastal batteries, suicide-boat nests, and seaplane bases at Tozaki Hana, Hososhima, and Miyazaki, then wreck rail junctions at Tsumo Jogasaki and Tsuno to interdict reinforcements south, before finally shelling I Corps invasion beaches near Miyazaki. Off southwestern Kyushu, Rear Admiral Giraud Wright's Fifth Fire Support Group (TG-41.5) of four old battleships, ten cruisers, 14 destroyers, and 74 support craft would hammer fortifications in the Koshiki Retto and the beaches between Kaminokawa and Kushikino, knocking out Noma Misaki and Hashimi Saki coastal batteries, the Akune seaplane base, and Kushikino's airfield, as well as cutting the Akune–Kushikino road and rail lines, before finally pounding V Amphibious Corps landing beaches.

The outlying Kyushan islands of Koshiki Retto, Uji Gunto, Kusakakishima, Kuroshima, and Kuchinoerabushima would be seized by the Western Attack Force (TF-42)'s 40th Infantry Division on October 27 (X-5) to install early warning radar and fighter director stations and clear sea lanes to X-Day beaches. That same day Underwater Demolition Team (UDT) frogmen would begin reconnoitering Kyushu beaches and clearing underwater obstacles. If necessary, 158th Regimental Combat Team (RCT) would land at Tanegashima on X-5 to neutralize any Japanese interference with minesweepers clearing Osumi Kaikyo. Otherwise Western Attack Force (TF-42) would land 158th RCT at Kyushu on X+3 or later as reinforcements.

At 0600hrs on November 1 (X-Day), Admiral Turner's Advance Force (TF-41) would be dissolved and absorbed into Turner's Amphibious Force (TF-40). Under Turner were three X-Day attack forces, each tasked with landing its own three-division corps. Landings would be the standard "two up, one back" arrangement, except reserve regiments would be afloat off Kyushu beaches on X-Day, while reserve divisions would arrive on X+2. In the center Vice Admiral Theodore Wilkinson's Third Attack Force (TF-43) would land Lieutenant-General Charles P. Hall's XI Corps in the Ariake Bay area. To the northeast the Seventh Attack Force (TF-47) would land Major-General Innis P. Swift's I Corps at Miyazaki. In the west, Vice Admiral Harry Hill's Fifth Attack Force (TF-45) would land Major-General Harry Schmidt's V Amphibious Corps off Kushikino. After an October 30 (X-2) demonstration feint against Shikoku, Rear Admiral Bertram Rodgers' Reserve Force (TF-48) would land the three divisions of Major-General Charles P. Ryder's IX Corps wherever circumstances dictated, beginning on November 4 (X+3).

Rear Admiral Mel Pride would coordinate all USN, USMC, and USAAF air coverage and air support of the Kyushu invasion beaches. TF-58, TF-55, and USAAF strike groups would continuously cover the landings between 0700hrs and 1700hrs daily. Eighteen night fighters (12 F6F-5N Hellcats and six USAAF P-61 Black Widows) would maintain nocturnal patrols over the invasion area. Night fast carriers *Enterprise* and *Bon Homme Richard* would cover TF-58 and launch night strikes while the night escort carriers covered the invasion flotilla. Anti-kamikaze defense would be facilitated by 13 afloat and five landing-force fighter director teams. Airborne early warning would be provided by radar-equipped "Cadillac" aircraft—carrier-based TBM-3W Avengers and land-based license-built Douglas PB-1W Flying Fortresses (USN B-17s).

Once landed, all four Sixth Army corps (13 assault divisions) were to drive inland, beginning construction of Kyushu airfields and supporting installations immediately. By November 23 (X+22) the 11th Airborne Division would arrive from Luzon. Presumably *Olympic*'s northern stop-line would have been reached by this point. Once Kagoshima Bay had been secured, Rear Admiral Bertram Rodgers would assume command as Senior Officer Present, Afloat and oversee construction of a major Naval Operating Base at Takasu, a base for defensive craft at Uchinoura Wan, and a PT boat base at Yamakawa Ko.

It was hoped that USAAF and USMC aircraft would be operating from Kyushu airfields by November 4 (X+3), freeing Sherman's ten fast carriers of TF-58 to head north and pound strategic targets alongside Towers' TF-38. By December refurbished US fast carriers *Essex, Franklin, Bunker*

Hill, and *San Jacinto* would arrive in theater, along with British fast carriers *Victorious*, *Illustrious*, and brand-new Canadian night light carrier *Ocean*. Reinforcements could be expected in the form of brand-new Essex-class carriers *Antietam* (CV-36), *Boxer* (CV-21), and *Lake Champlain* (CV-39). Excepting losses, 40 fast carriers and 25 battleships would be bombarding Japan by December 1945.

OPERATION *OLYMPIC* (PROJECTED NOVEMBER 1, 1945)

US Pacific Fleet—Fleet Admiral Chester W. Nimitz
US Army Forces Pacific—General of the Army Douglas MacArthur
US Far Eastern Air Forces—General George C. Kenney
US Strategic Air Forces in the Pacific—General Carl Spaatz

THIRD FLEET (USN)—ADMIRAL WILLIAM HALSEY

TF-38 Second Fast Carrier Force—Vice Admiral Jack Towers
TG-38.1—Rear Admiral Arthur Davis
 CV-12 *Hornet* (CVG-19)
 CV-18 *Wasp* (CVG-86)
 CV-21 *Boxer* (CVLG-93)
 CVL-26 *Monterey* (CVLG-34)
TG-38.2—Rear Admiral Thomas Sprague
 CV-10 *Yorktown* (CVG-88)
 CV-16 *Lexington* (CVG-94)
 CV-36 *Antietam* (CVG-89)
 CVL-24 *Belleau Wood* (CVLG-31)
TG-38.3—Rear Admiral Clifton Sprague
 CV-15 *Randolph* (CVG-16)
 CV-38 *Shangri-La* (Replacement Air Group)
 CVL-22 *Independence* (CVLG-27)
 CVL-27 *Langley* (CVLG-51)

TF-37 (Royal Navy)—Vice Admiral Bernard Rawlings
TG-37.6 1st Aircraft Carrier Squadron—Vice Admiral Phillip Vian
 CV *Implacable* (8th Carrier Air Group)
 CV *Indefatigable* (7th Carrier Air Group)
 CV *Indomitable* (11th Carrier Air Group)
 CV *Formidable* (2nd Carrier Air Group)
TG-37.7 11th Aircraft Carrier Squadron—Rear Admiral Cecil Harcourt
 CV *Victorious* (1st Carrier Air Group)
 CVL *Venerable* (15th Carrier Air Group)
 CVL *Vengeance* (13th Carrier Air Group)
 CVL *Glory* (16th Carrier Air Group)
 CVL *Colossus* (14th Carrier Air Group)

FIFTH FLEET (USN)—ADMIRAL RAYMOND A. SPRUANCE

TF-58 First Fast Carrier Force—Vice Admiral "Ted" Sherman
TG-58.4—Rear Admiral Arthur Radford
 CV-20 *Bennington* (CVG-1)
 CV-14 *Ticonderoga* (CVG-87)
 CV-19 *Hancock* (CVG-6)
 CV-6 *Enterprise* (CVG(N)-52)
 CVL-29 *Bataan* (CVLG-49)
TG-58.5—Rear Admiral Donald Duncan
 CV-11 *Intrepid* (CVG-10)
 CV-39 *Lake Champlain* (CVG-14)
 CV-31 *Bon Homme Richard* (CVG(N)-91)
 CVL-25 *Cowpens* (CVLG-50)
 CVL-28 *Cabot* (CVLG-32)

TF-40 Amphibious Force—Admiral Richmond K. Turner (AGC *El Dorado*)
TG-40.10 Air Support Control Group—Rear Admiral Mel Pride (AGC *El Dorado*)
TF-46 Sixth Army—General Walter Krueger (AGC *El Dorado*)
 XI Corps—Lieutenant-General Charles P. Hall
 1st Cavalry Division—Major-General Verne Mudge

 Americal Infantry Division—Major-General William Arnold
 43rd Infantry Division—Major-General Leonard Wing
 V Amphibious Corps—Major-General Harry Schmidt (USMC)
 2nd Marine Division—Major-General Leroy Hunt
 3rd Marine Division—Major-General Graves Erskine
 5th Marine Division—Major-General Thomas Bourke
 I Corps—Major-General Innis P. Swift
 25th Infantry Division—Major-General Charles Mullins
 33rd Infantry Division—Major-General Percy Clarkson
 41st Infantry Division—Major-General Jens Doe
 IX Corps—Major-General Charles P. Ryder
 81st Infantry Division—Major-General Paul Mueller
 98th Infantry Division—Major-General Arthur Harper
 77th Infantry Division—Major-General Andrew Bruce
 40th Infantry Division—Brigadier-General Donald Myers
 158th RCT—Brigadier-General Hanford MacNider
 11th Airborne Division—Major-General Joseph Swing
TF-41 Advance Force (Turner)
 TG-41.1 Underwater Demolition Flotilla
 TG-41.2 Service and Salvage Group
 TG-41.3 Third Fire Support Group—Rear Admiral Richard Connolly
 TG-41.4 Hydrographic Survey Group
 TG-41.5 Fifth Fire Support Group—Rear Admiral Jerauld Wright
 TG-41.7 Seventh Fire Support Group—Rear Admiral Ingolf Kiland
 TF-42 Western Attack Force—Rear Admiral Glenn Davis
 TG-42.2 Western Fire Support Group
 TF-44 Southern Attack Force—Rear Admiral Robert Briscoe
 TG-44.2 Southern Fire Support Group
 TF-54 Gunfire and Covering Force—Vice Admiral Jesse Oldendorf
 TF-55 Escort Carrier Force—Rear Admiral Calvin Durgin
 TF-56 Mine Force—Rear Admiral Alexander Sharp
TF-43 Third Attack Force—Vice Admiral Theodore Wilkinson (AGC *Mt. Olympus*)
 XI Corps—Lieutenant-General Charles P. Hall
TF-45 Fifth Attack Force—Vice Admiral Harry Hill
 V Amphibious Corps—Major-General Harry Schmidt
TF-47 Seventh Attack Force—Vice Admiral Daniel Barbey (AGC *Ancon*)
 I Corps—Major-General Innis P. Swift
TF-48 Reserve Force—Rear Admiral Bertram Rodgers
 TG-48.2 Reserve Fire Support Group
 IX Corps—Major-General Charles P. Ryder
TF-49 Reinforcement Force—Rear Admiral Arthur Struble
TG 40.1 Screen Group—Commodore Frederick Moosbrugger
 TG-40.11 Radar Pickets
 TG-40.12 Western Screen (under TF-42)
 TG-40.13 Third Screen (under TF-43)
 TG-40.14 Peninsula Screen (under TF-48)
 TG-40.15 Fifth Screen (under TF-45)
 TG-40.17 Seventh Screen (under TF-47)
 TG-40.18 Reserve Screen (under TF-48)
TG-40.2 Pontoon Causeway Group—Commander Joseph Plichta
TG-40.3 Pontoon Barge Group—Commander Joseph Plichta
TG-40.4 Area Sweeping Groups

AIR AND SURFACE BOMBARDMENTS OF NORTHERN JAPAN, JULY 10–16

That summer, US Navy commander-in-chief Fleet Admiral Ernest J. King had established the Special Defense Section at Casco Bay, Maine "to expedite readiness to defeat Jap suicide attacks" under Commodore Arleigh Burke. For his staff Burke incidentally drafted fast battleships commander Vice Admiral Willis "Ching" Lee, who on June 18 was transferred on temporary duty back to the United States and named Commander, Experimental Task Force (ETF) 69 on July 1. ETF-69 would publish an "Anti-Suicide Action Summary" that was quickly disseminated throughout the Pacific Fleet on July 31. Meanwhile, Rear Admiral John "Big Jack" Shafroth was named acting Battle Squadron (BatRon) 2 commander. "Don't get yourself settled in that job, because I'm coming back!" Lee told him. But Lee would die suddenly of a heart attack on August 25, never returning to the Pacific.

July 10 Tokyo strikes

On July 1 Halsey's Third Fleet departed San Pedro Bay, Leyte, bound for Tokyo—the opening phase of Operation *Olympic*. TF-38 now comprised three five-carrier Task Groups: Rear Admiral Thomas Sprague's TG-38.1, Rear Admiral Gerald Bogan's TG-38.3, and Rear Admiral Arthur Radford's TG-38.4. The 15 fast carriers were charged with maintaining pressure on Japan during the run-up to Kyushu's November 1 X-Day. Halsey's strategic strikes would complement LeMay's B-29 raids, which since March 1945 had become truly devastating. Battleships and heavy cruisers would carry out surface bombardments of industrial targets in eastern Japan, while light forces would conduct antishipping sweeps of coastal waters. Halsey at last had the mission he'd long desired:

> We sortied from Leyte under a broad directive: we would attack the enemy's home islands, destroy the remnants of his navy, merchant marine, and air power, and cripple his factories and communications. Our planes would strike inland; our big guns would bombard coastal targets; together they would literally bring the war home to the average Japanese citizen.

TF-38 refueled on July 8, then at 1815hrs, July 9, commenced its 25-knot run-in to the Home Islands. A 100nm-wide front of US submarines advanced ahead of TF-38 to destroy picket boats and assume lifeguard positions. TF-38 began launching strikes at 0400hrs, July 10. Targets were primarily in the Tokyo area, but extended north to Koriyama and southwest to Hamamatsu, a 210nm front. A total of 1,732 sorties were launched, of which 1,160 were offensive. US aircraft expended 454 tons of bombs and 1,648 rockets over Honshu.

The IJNAF and IJAAF had lost 3,000 aircraft (including 1,465 kamikazes) in the unsuccessful defense of Okinawa. By July IGHQ adopted a policy of "extreme conservation" for the expected full-scale invasion of the homeland. Aircraft were defueled and elaborately dispersed and camouflaged. Even standard air search operations were cancelled. A VF-88 Hellcat pilot from *Yorktown* reported:

> We struck at Katori and Konoike airfields on the coast of Honshu. The great Tokyo plain was so thickly studded with airfields that ten or a dozen were

TF-38 actions, July 1–August 15, 1945

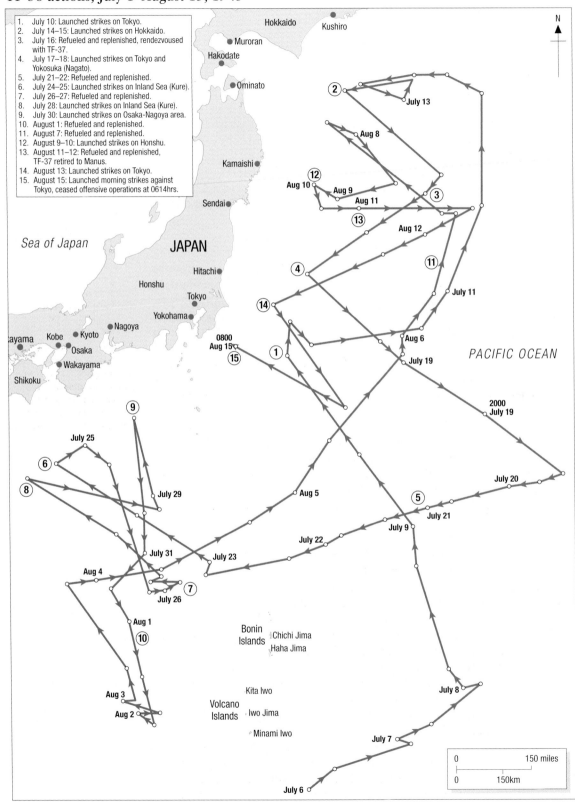

1. July 10: Launched strikes on Tokyo.
2. July 14–15: Launched strikes on Hokkaido.
3. July 16: Refueled and replenished, rendezvoused with TF-37.
4. July 17–18: Launched strikes on Tokyo and Yokosuka (Nagato).
5. July 21–22: Refueled and replenished.
6. July 24–25: Launched strikes on Inland Sea (Kure).
7. July 26–27: Refueled and replenished.
8. July 28: Launched strikes on Inland Sea (Kure).
9. July 30: Launched strikes on Osaka-Nagoya area.
10. August 1: Refueled and replenished.
11. August 7: Refueled and replenished.
12. August 9–10: Launched strikes on Honshu.
13. August 11–12: Refueled and replenished, TF-37 retired to Manus.
14. August 13: Launched strikes on Tokyo.
15. August 15: Launched morning strikes against Tokyo, ceased offensive operations at 0614hrs.

Hokkaido
Kushiro
Muroran
Hakodate
Ominato

Kamaishi

Sendai

Sea of Japan

JAPAN

Honshu
Hitachi
Tokyo
Yokohama
Nagoya
Kobe Kyoto
Osaka
Wakayama
Shikoku
ayama

PACIFIC OCEAN

0800
Aug 15

2000
July 19

July 20

July 21

July 9

July 22

July 23

July 25

July 29

July 26

July 31

Aug 4

Aug 5

Aug 6

July 19

July 11

Aug 12

Aug 11

Aug 9

Aug 10

Aug 8

July 13

Aug 1

Aug 3

Aug 2

Bonin
Islands Chichi Jima
Haha Jima

Kita Iwo

Volcano
Islands Iwo Jima

Minami Iwo

July 8

July 7

July 6

0 150 miles

0 150km

visible from almost any point at 5,000ft altitude. No aerial opposition was encountered although several of our planes were damaged by antiaircraft. Our pilots discovered that the Japs were playing it very cagey with their air force. Planes were cunningly camouflaged and hidden in dispersal areas and covered revetments sometimes as far as two miles from the field itself. Hunting out and destroying such planes was a primary mission of the squadron and a tough one, in the face of the enemy's concentration of antiaircraft fire.

A Japanese air commander complained that "this new doctrine of dispersal meant not only was he unable to scramble his pilots within reasonable time, but that he could not even communicate with them." TF-38 nevertheless claimed 109 aircraft destroyed and 231 damaged. American airmen reported meager antiaircraft fire and airborne fighters virtually non-existent. "We began to re-estimate the probable duration," Halsey remembered.

Hokkaido and northern Honshu were outside effective B-29 range and had thus far escaped bombardment. Following the July 10 strikes Third Fleet charged north to address the issue. "Every turn of our screws," Halsey described, "now took us further north than any ships of the fleet, except submarines, had ever ventured before." Eager to bombard Japan, Halsey had ordered McCain to create some "battleship jobs." The general mission of Halsey's assigned surface attacks was "to destroy industries, demoralize transportation, and lower the will to resist of the Japanese people." Third Fleet was scheduled to attack Hokkaido and northern Honshu on July 13, but northern fog from the Kuriles swept over the target area and Halsey "had to postpone for a day, much as I would have enjoyed staging the first surface bombardment of the Japanese homeland on a Friday the thirteenth."

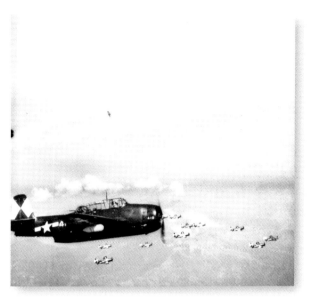

One of *Essex*'s VT-83 TBM Avengers flies past Mount Fuji, July 10, 1945. In the background are SB2C Helldivers. The attacking Americans were always quite taken with Fujiyama's seeming aesthetic perfection; comments on the mountain's beauty frequently appear in carrier squadrons' official post-action reports. (World War II Database)

Kamaishi bombardment, July 14
At 0559hrs, July 14, Rear Admiral John Shafroth's Bombardment Group Able (Task Unit 34.8.1) detached from Sprague's TG-38.1. Shafroth's TU-34.8.1 comprised battleships *South Dakota*, *Indiana*, and *Massachusetts*, heavy cruisers *Quincy* and *Chicago*, and nine destroyers, and was covered by a special bombardment CAP of 20 fighters from TG-38.1.

Kamaishi, population 40,000, was nestled in the steep, narrow Otatari River valley on the east coast of northern Honshu. After weeks of planning, Shafroth's target was the Kamaishi Works of the Japan Iron Company, supplied by nearby iron ore mines. At 0856hrs the peaks of Honshu were sighted 56nm away. Commander Edward Mathews recalled, "We picked up the coast of Honshu in the gray dawn of 14 July and bore down at high speed on the unsuspecting little city. Our force constituted a formidable phalanx of gray ships, with spray creaming over our bows and signal flags snapping at the halyards." At 1055hrs flagship *South Dakota* hoisted, "*Never forget Pearl Harbor*." A low haze limited visibility to 7–10nm and there were a few scattered clouds at 9,000ft. Japanese antiaircraft guns opened fire on the

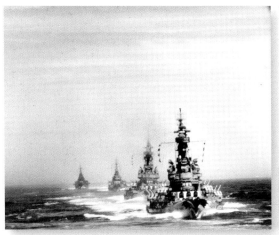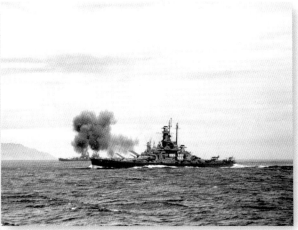

ABOVE LEFT
Shafroth's Bombardment Group Able bears down on Kamaishi the morning of July 14, 1945. Within 30nm of Kamaishi the strong radar returns of Honshu's high mountains made radar detection of bogeys difficult, but the few snoopers that were detected were driven off by the bombardment force CAP. (NARA 80-G-490143, via Naval History and Heritage Command)

ABOVE RIGHT
Battleship USS *Indiana* (BB-58) opens fire on the Kamaishi steel works on the Honshu coast, July 14, 1945. The photo was taken from sister *South Dakota* (BB-57), which seconds earlier had opened this first surface bombardment of Japan. Behind *Indiana* is third South Dakota-class battleship *Massachusetts* (BB-59) and a Baltimore-class heavy cruiser, either *Quincy* (CA-71) or *Chicago* (CA-136). (NARA 80-G-K-6035, via Naval History and Heritage Command)

orbiting CAP at 1140hrs. Meanwhile, the ragged coastline and high interior peaks allowed TU-34.8.1 excellent radar fixes, but lack of minesweepers compelled the force to remain outside the 100-fathom (600ft depth) curve. Range was approximately 26,000 yards. At 1210hrs all battleships and cruisers opened fire on Kamaishi, the first surface bombardment of Japan by a hostile fleet in over 80 years.

As the bombardment began, an American POW at a camp forward of the Kamaishi steel mill observed the "16in. rounds starting at the water and walking up the hill to the works," and he "could see plainly the ship offshore belching smoke and fire moments before the concussion of the shells passing over hurt his hands which now covered his head."

The destroyers had been restricted to firing on "targets of opportunity," which the US planners assumed would not be forthcoming. "As we rounded onto the bombardment track," recalled Mathews:

> I was surprised to see a large merchant ship emerge from the inner bay. She was followed by two others, then by a miniscule gunboat which had the impertinence to pop tiny shells at us that fell halfway. They had sneaked in since the last photoreconnaissance. The screen was screaming for permission to release batteries. None of them had ever encountered so juicy a target. Just then we opened fire on the mill with the 16in. guns, and either someone cut the screen loose or they just couldn't stand it any longer. At any rate, the air became solid with flying metal. The merchantmen and their escort disappeared behind curtains of spray from concentrated salvoes. They were directly in line with the town, and soon red gouts of flame showed where the "overs" had ignited the little frame houses. Smoke from the burning town began to obscure the mill, but the merchantmen continued on their way and finally disappeared behind a headland, seemingly unscathed.

The US destroyers would eventually close within 3,000 yards of the Honshu coast. Halsey later related that Shafroth maneuvered the bombardment force:

> close enough in to permit a leisurely, broad-daylight, two-hour shelling of the large steel plant at Kamaishi. In this case, "close enough" means that the force was clearly visible from the beach. However much propaganda a Japanese civilian will swallow, it must have been hard for him to digest the news that

certain American warships had been sunk when he had just watched them blast his job from under him.

Technical Sergeant Jess Stanbrough (US Army), captured at Java in March 1942, was being force-worked at the nearby Ohasi powerplant when he began hearing the American 16in. guns thundering offshore. Japanese guards claimed the IJN was conducting gunnery practice, but Stanbrough had picked up some Japanese and knew better. "Where are our planes?" he overheard Japanese civilians asking. "We didn't see any," came the reply, "We only saw Americans."

Japanese documents from Kamaishi's Sendai No. 5 concentration camp recorded:

At 1220hrs, July 14, the US destroyers started firing on small vessels sighted in port. Concussions from the shell blasts spread cooking fires throughout Kamaishi's flimsy Japanese houses, and minutes later Kamaishi was obscured by smoke. This view is from flagship *South Dakota*. (NARA 80-G-K-6036, via Naval History and Heritage Command)

At 1155hrs about 30 American airplanes flew circling over the city of Kamaishi, and our antiaircraft guns and minesweepers began firing at them. At 1215hrs they began shelling at Kamaishi iron mill, the first shell hitting one of the storehouses. Some 20 kilometers off the coast, directly in front of the city, four American warships could be seen to cruise down to the southeast, keeping up the bombardment all the while … POWs in the kitchen conducted themselves bravely … Fire broke out on the roof of 1st POW quarters, but was put out immediately. Another house was directly hit on the roof. They kept on firing as fiercely as ever, American airplanes continually circling over our head. Fire was witnessed to break out at several places across the city … Raging flames and dark clouds of smoke covered the iron mill, and a rain of shells continued to fall upon us.

Commander Mathews recalled a favorite absurdity of the July 14 bombardment:

Shafroth's battleships are seen making a southerly pass off Kamaishi, July 14, 1945. Battleship *Indiana* (BB-58) is visible. The smoke is actually from battleship *Massachusetts* (BB-59) firing from astern *Indiana*. This was the first hostile surface bombardment of Japan since 1864. (NARA 80-G-K-6037, via Naval History and Heritage Command)

In the meanwhile, the battleships were throwing everything they had in the direction of the mill. Several tiny islands stood across the mouth of the big bay below the mill. As we bellowed back and forth on our bombardment track, one small island in particular drew our attention. It was close aboard, a particularly charming one, with the conventional white paper house in which dwelt a little white-kimonoed man with a tiny white dog … the little dog, frightened by the noise, was careering around the island with the man in hot pursuit. Around they went, and each time we repassed the island we shouted encouragement. Finally, the man caught the dog, gave him a whack, dashed into the paper house and banged the paper door behind him, obviously convinced that therein lay security. A triumphant cheer rose from our formation as we turned away.

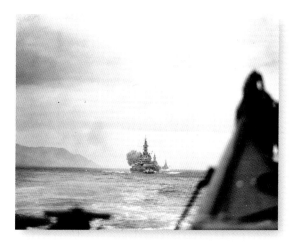

All US warships ceased fire at 1419hrs and commenced a high-speed retirement at 1426hrs. A total of 802 16in., 728 8in., and 825 5in. shells

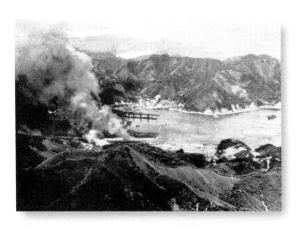

Kamaishi seen burning from an overhead spotter plane, July 14, 1945. In an experiment, battleship and cruiser spotters were embarked in *Bennington* SB2C Helldivers. Their own floatplanes were feared too slow to resist Japanese air attack and were left aboard. Consequently, the battleships and cruisers fired only from their forward guns. The experiment was not repeated. (Wikimedia Commons/Public Domain)

Essex TBM Avengers and SB2C Helldivers bomb Hakodate, Japan, July 14–15, 1945. The USAAF's Marianas-based B-29 Superfortresses could not safely reach northernmost Japan, so strategic bombings of Hokkaido and other northern targets were largely carried out by TF-38. (NARA 80-G-490232, via World War II Database)

had been expended. Shellfire concussions had started widespread cooking fires in the flimsy houses throughout Kamaishi, setting the town ablaze. Shafroth claimed four confirmed hits in open hearths, two in coke ovens, and one hit each in Kamaishi's foundry, soaking pit, southern rolling mill, and gas holder, the last "causing a tremendous explosion." Twenty-six additional salvoes were observed landing in the target area. One oil tanker, two barges, and one small ship in harbor were sunk. Shafroth's sole casualty had been a CAP Corsair shot down in the harbor while strafing an IJN destroyer-escort.

According to the postwar *United States Strategic Bombing Survey*:

Interrogations seemed to indicate that even officials knew little of what was transpiring away from their own localities. For this reason, surface bombardments caused people to wonder what had happened to their own ships and planes, and with the realization that our ships could approach the shores of Japan with impunity they knew that the progress of the war was even more unfavorable than they had suspected. People invariably stated that gunfire was more terrifying than either HE or incendiary bombing. When asked why, the most common answer was that there was normally ample warning before major air attacks, and the duration of the danger could be judged by the arrival and departure of the planes. Surface bombardments, however, usually came without warning, the fall of projectiles was more prolonged, and people were perplexed and confused by the uncertainty of where the attack was coming from and how long they would be forced to endure it.

That night the glow from the burning Kamaishi was visible for 40 miles.

Hokkaido and northern Honshu airstrikes, July 14-15

Simultaneous with the battleship bombardment, McCain's TF-38 closed to within 80nm of Honshu and let fly 1,391 July 14 sorties against Hokkaido

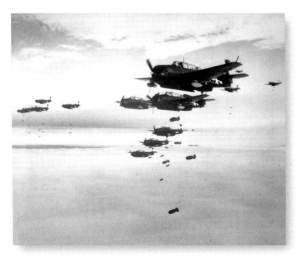

and northern Honshu, targeting railways, shipping, and airfields, and again found light resistance. Over 50,000 tons of shipping and naval craft were sunk by TF-38 planes, including destroyer *Tachibana*, two destroyer-escorts, eight naval auxiliaries, and 20 merchantmen, largely at Muroran and Hakodate. Twenty-five enemy planes were destroyed. Twenty-four aircraft and 17 airmen were lost, about half in combat.

TF-38 struck again on July 15, launching 966 combat sorties that dropped 355 tons of bombs and expended 2,093 HVAR "Holy Moses" rockets. TF-38 sank 65 vessels and damaged 128. Forty-eight locomotives were destroyed and 28 damaged. "Widespread damage" was reported against warehouses, railroad yards,

factories, power plants, oil facilities, hangars, lighthouses, radio stations, bridges, paper mills, ammunition depots, barracks, and docks.

The Aomori–Hakodate railcar ferry system, carrying 30 percent of the coal between Hokkaido and Honshu, was devastated over July 14–15. TF-38 airstrikes sank eight ferries, forced eight to beach, and damaged two more, while sinking 70 and severely damaging 11 of 272 auxiliary sailing colliers. Another ten steel freighters were sunk and seven damaged. The ferry strikes were the brainchild of Halsey's operations officer, Captain Ralph "Rollo" Wilson. "When the first action reports began to sift in," Halsey related:

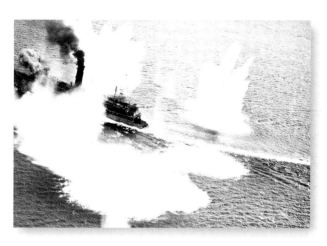

Essex planes bomb a Hakodate–Aomori ferry on July 14, 1945. The destruction of the Hakodate–Aomori ferry system virtually severed industrial communications between Honshu and Hokkaido in preparation for the scheduled *Olympic* landings. By mid-1945 Third Fleet was largely hitting strategic targets. (NARA 80-G-490113, via Naval History and Heritage Command)

He snatched them up and pored over them; the ferries were not mentioned. Later reports also ignored them. Rollo was sulking and cursing when the final reports arrived. I heard him whistle and saw him beam. "Six ferries sunk!" he said. "Pretty soon we'll have 'em moving their stuff by oxcarts and skiffs!"

Third Fleet racked up 140 ships and small craft sunk (71,000 tons), plus 38 planes and 84 locomotives destroyed on July 14 and 15. Another 61 ships and 174 small craft (88,000 tons) were damaged, along with 46 planes and 24 locomotives. Additionally, 20 city blocks of Kushiro, Hokkaido were razed. A single G4M Betty bomber snooping TF-38 was shot down. According to a postwar US Army report, "The most important single effect of the carrier raids was the virtual severance of Hokkaido from Honshu. The choking off of the flow of coal, iron ore, lumber, and marine products was a deathblow to the already crippled Japanese industrial machine."

Muroran bombardment, July 15

During the night of July 14/15, Rear Admiral J. Cary Jones' TG-35.3, comprising light cruisers *Pasadena*, *Springfield*, *Wilkes-Barre*, *Astoria*, and six destroyers swept the east coast of Honshu prowling for Japanese shipping, but made no contacts.

That same night, Halsey detached Rear Admiral Oscar Badger's TU-34.8.2 (Bombardment Group Baker) comprising battleships *Iowa*, *Missouri*, and *Wisconsin*, light cruisers *Atlanta* and *Dayton*, and eight destroyers, to bombard Muroran, Hokkaido, an industrial city of 130,000. Muroran produced 45 percent of Japan's coal and was Japan's second largest producer of coke and pig iron.

At 0936hrs, July 15, the three battleships opened fire on the Nihon Steel Company and the Wanishi Ironworks. After Badger's *Iowa* delivered two salvoes at the Nihon complex, the spotter plane radioed with satisfaction, "Right in the furnaces." *Missouri* opened fire on Nihon and subsequently a huge explosion was observed, followed by flames erupting 300ft high. The battleship then worked over the Wanishi coal liquefaction plant and coke ovens, collapsing four of eight smokestacks, before demolishing all but one

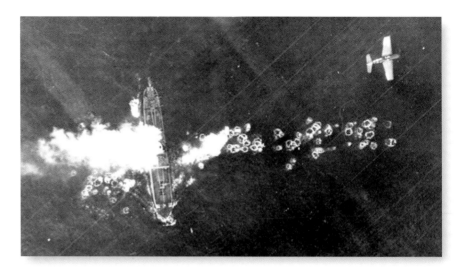

An American F6F-5 Hellcat fighter strafes a Japanese freighter off Hokkaido, July 15, 1945. Each US fighter mounted six 0.50-caliber machine guns; strafing runs could heavily damage or even explode unarmored freighters or destroyers. In addition to machine guns, Hellcats could strafe with six 5in. HVAR "Holy Moses" rockets, while each Corsair was armed with eight 5in. rockets. (NARA)

of Wanishi's blast furnaces. Meanwhile, *Wisconsin*'s ninth salvo triggered "a terrific explosion" followed by multiple fires at Nihon.

As *Missouri* was Third Fleet flagship, Halsey himself rode along to observe the bombardment:

> Rear Admiral Oscar C. Badger took another heavy bombardment force, including the *Missouri*, right into the enemy's jaws. The chart justifies my metaphor; during the hour that we shelled our objective—the city of Muroran, a coal and steel center on southern Hokkaido—we were landlocked on three sides. We opened fire from 28,000 yards and poured in 1,000 tons of shells. It was a magnificent spectacle, but I kept one eye on the target and the other on the sky. Our three-hour approach had been in plain view, as would be our three-hour retirement, and I thought that every minute would bring an air attack. None came; the enemy's only resistance was desultory AA fire against our spotting planes; but those were the longest six hours in my life.

At 1025hrs the battleships ceased fire and retired at 26 knots. Of 860 16in. shells fired, some 170 had struck the plant. The Wanishi Ironworks had lost 75 days of coke production and sustained damage equivalent to 60 days of repairs. Some 2,541 Muroran houses were also destroyed or damaged. "These sweeps and bombardments accomplished more than destruction," Halsey explained, "they showed the enemy that we made no bones about playing in his front yard. From now on, we patrolled his channels and shelled his coast almost every night that the weather permitted." The following day, War Minister Korechika Anima would formally apologize to Tokyo military commanders for Third Fleet's dominance of Home Island waters.

Integration of the British Pacific Fleet, July 16
Early on July 16 TF-38 retired east of Honshu and began refueling from Beary's TG-30.8. Within hours TG-30.8 escort carrier USS *Anzio* (CVE-57) and destroyer-escorts *Lawrence C. Taylor* (DE-415) and *Robert F. Keller* (DE-419) would sink lurking Japanese submarine *I-13*. Meanwhile, having departed Sydney on June 28, Vice Admiral Sir Bernard Rawlings' British TF-37 rendezvoused with the refueling TF-38. "The American task force,"

a British historian described, "stretched as far as the eye could see from horizon to horizon, a sight that Admiral Rawlings described as both striking and unforgettable." By midmorning Rawlings' and Vian's staffs were aboard *Missouri* to conference. Months earlier Halsey had been informed that TF-37 would report to Third Fleet, yet for political reasons was required to retain its own tactical control. Unable to directly command TF-37, Halsey laid out three tactical options to Rawlings:

1. TF-37 could operate close aboard, as another Task Group in TF-38. It would not receive direct orders, but it would be privy to the orders that Halsey gave TF-38; these TF-37 would consider as "suggestions" to be followed to the Task Forces' mutual advantage, thereby assuring both a concentrated force with concentrated weapons.

2. TF-37 could operate semi-independently, some 60–70nm away, thereby preserving its technical identity at the cost of a divided force (Halsey stipulated that he would consent to this choice only if the request were put into writing).

3. TF-37 could operate completely independently, against soft spots in Japan which TF-38 would recommend if so desired.

Rawlings' response was immediate: "Of course I'll accept Number 1." Halsey admitted, "My admiration for him began at that moment. I saw him constantly thereafter, and a finer officer and a firmer friend I have never known." Because of the British ships' smaller fuel capacity and slower rate of refueling, Halsey had expected TF-37 to strike two days for every three days of successive TF-38 strikes. However, Halsey found that by refueling from US oilers when necessary, TF-37 was "able to match us strike for strike."

TASK FORCE 37 (ROYAL NAVY)—VICE ADMIRAL SIR BERNARD RAWLINGS (*KING GEORGE V*)

TASK GROUP 37.1 —VICE ADMIRAL SIR PHILLIP VIAN (*FORMIDABLE*)

1st Carrier Squadron (Vian)
CV *Formidable*
 No. 1841
 No. 1842
 No. 1848
 No. 848
CV *Victorious*
 No. 1834
 No. 1836
 No. 849
 Ship's flight
CV *Implacable*
 No. 801
 No. 880
 No. 1771
 No. 828
CV *Indefatigable*
 No. 887
 No. 894
 No. 1772
 No. 820

1st Battleship Squadron (Rawlings)
BB *King George V*

4th Cruiser Squadron—Rear Admiral Patrick Brind (*Newfoundland*)
CL *Newfoundland*

CL *Achilles* (New Zealand)
CL *Uganda* (Canada)
CL *Euryalus*
CL *Gambia* (New Zealand)
CL *Black Prince*

4th Destroyer Flotilla
DD *Grenville*
DD *Undaunted*
DD *Undine*
DD *Urania*
DD *Urchin*
DD *Quiberon* (Australia)
DD *Quickmatch*
DD *Quality*
DD *Quadrant*
DD *Ulysses*

24th Destroyer Flotilla
DD *Troubridge*
DD *Tenacious*
DD *Termagant*
DD *Teazer*
DD *Terpsichore*
DD *Barfleur*
DD *Wrangler*
DD *Wakeful*

RETURN TO TOKYO, JULY 17–18

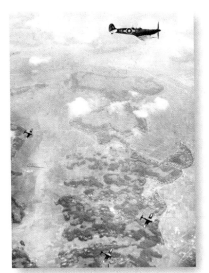

The very first Seafires to violate Japan's airspace are seen on July 17, 1945. The Supermarine Seafire was adapted from the Spitfire and was an excellent fighter, but as a carrier plane it was handicapped by the short range and flimsy undercarriage intrinsic to land-based interceptors. By June 1945 the BPF adapted 90-gallon RAAF drop tanks and 89-gallon USAAF drop tanks to their Seafires, greatly increasing their endurance. (Imperial War Museum A 29964)

In what proved the final month of hostilities, Third Fleet would hurl over 10,000 offensive sorties against the Home Islands. At 0350hrs, July 17, TF-38 and TF-37 began launching strikes against central Honshu. Only 205 TF-38 strike sorties were flown on July 17, mostly against the Mito area with 56 US planes dropping bombs through overcast. TF-37 Corsairs and Fireflies attacked airfields and rail yards on the northwest Honshu coast, totaling 87 offensive sorties, including a *Formidable* Corsair squadron that flew across Honshu and successfully attacked airfields at Niigata. Adverse weather nevertheless caused the day's attacks to be canceled after two strikes. Several small craft and locomotives were destroyed, but nine Third Fleet aircraft and four airmen were lost.

Hitachi bombardment, July 17/18

The afternoon of July 17 Halsey again detached Badger's TU-34.8.2 on a bombardment mission, this time to Hitachi, a major industrial and electronics-producing city of 85,000 about 80nm northeast of Tokyo. Badger's augmented force comprised battleships *Iowa*, *Missouri*, *Wisconsin*, *North Carolina*, and *Alabama*, light cruisers *Atlanta* and *Dayton*, and eight destroyers. Halsey again accompanied TU-34.8.2 aboard *Missouri*, as did Rawlings aboard battleship *King George V*, accompanied by destroyers *Quality* and *Quiberon*.

The 53-minute bombardment opened in fog and rain at 2314hrs, July 17. A *North Carolina* officer recalled:

> We were edgy about operating so close to the Japanese homeland. Admiral Halsey was confident and authorized for the first time a live radio broadcast by a CBS correspondent from flagship *Iowa* describing the action to folks back home. We were able to get Radio Central to pipe the broadcast to our speakers in Plot so that we could follow the action.

The five US battleships hurled 1,207 16in. shells against Hitachi, while *King George V* contributed 267 14in. shells. *Atlanta* and *Dayton* expended 292 6in. rounds. The Tago and Mito Works of the Hitachi Manufacturing Company were damaged, as were the Yamate Plant and copper refining plants of Hitachi Mine. Hitachi's 40,000-ton monthly copper production subsequently collapsed to 1,500 tons.

TF-38 strikes Yokosuka, July 18

The July 10 TF-38 strikes had discovered the heavily camouflaged battleship *Nagato* at Yokosuka Naval Base. Photoreconnaissance revealed *Nagato* was intentionally moored deep in a tight anchorage, hemmed in by steep mountains, and covered by extensive antiaircraft batteries, ruling out torpedo attacks. To inflict damage below the waterline American flyers were ordered to aim for near-misses rather than hits. Covering *Nagato* from across Yokosuka's east loch was the destroyer *Ushio*.

Though scheduled for 0400hrs, poor weather delayed the July 18 strikes until 1120hrs, when the first of three strikes totaling 592 sorties were launched toward Yokosuka. Armed with four VT-fuzed 500lb bombs each, 62 Avengers

made a coordinated attack against 154 heavy and 225 automatic antiaircraft guns ringing the harbor. At 1540hrs a wave of 60 *Yorktown* and *Randolph* planes dove out of the sun at *Nagato*. Her position clearly known, *Nagato* opened fire. A storm of flak erupted, but at 1552hrs an American 500lb bomb slammed into *Nagato*'s bridge, killing 12 men, including *Nagato* skipper Rear Admiral Miki Otsuka and executive officer Captain Higuchi Teiji. In the chaos an ensign briefly took command of *Nagato* until the badly burned Commander Takeshi Okuda assumed the conn.

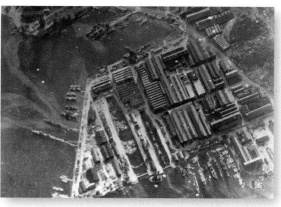

Yokosuka naval base on July 18, 1945. This is likely a post-strike photoreconnaissance image, as there are clearly several oil slicks polluting the harbor. *Nagato* is moored to the upper left. The US Navy ultimately failed to sink the IJN's last battleship. (National Museum of Naval Aviation 1996.488.027.036)

Moored alongside *Nagato* was minesweeper *Harashima Maru*, which was shortly blasted in two by a direct bomb hit. *Nagato* then received a second hit aft of the mainmast on her No. 3 barbette, killing 22 men and destroying several 25mm guns. A dud 5in. rocket may have additionally scored on *Nagato*'s fantail, piercing the battleship's stern and flying out the opposite side. TF-38's attack ended at 1610hrs, having sunk the old 7,080-ton armored cruiser *Kasuga*, submarine *I-372*, and incomplete destroyer-escort *Yaezakura*, while damaging obsolete destroyer *Yakaze* and pre-dreadnought battleship *Fuji*. Yet despite being targeted by 270 tons of bombs, *Nagato* herself refused to sink.

While *Yorktown* and *Randolph* groups had been attacking *Nagato*, aircraft from *Essex*, *Shangri-La*, and *Belleau Wood* had struck Tokyo airfields and targets of opportunity. Halsey routed the 58 British planes to a seaplane base at Kitaura and airfields at Nobara, Naruto, Chosi, Kanoike, Natori, and Kitakawa. TF-37 Corsairs dropped 13.5 tons of bombs on targets northeast of Tokyo. Together TF-38 and TF-37 claimed 43 planes destroyed and 77 planes damaged on the ground along with three locomotives destroyed and four electrified train cars derailed with rockets. No Japanese fighters resisted, but the Americans and British lost a total of 14 aircraft and 18 aircrew to what Third Fleet flyers called the fiercest antiaircraft fire they had yet seen; accurate Japanese shooting through solid overcast indicated extensive radar-laying. At 1900hrs Third Fleet retired toward its July 20 fueling rendezvous.

The night of July 18/19, Rear Admiral Carl Holden's TG-35.4 of light cruisers USS *Topeka*, *Duluth*, *Oklahoma City*, *Atlanta*, and five destroyers detached from TF-38 to sweep shipping off Sagami Wan. After finding nothing, TG-35.4 opened fire on Cape Nojima's radar site for five minutes. All 240 6in. shells fell short, ravaging only rice paddies and a small village.

OPERATION *BARNEY* AND USS *BARB*'S EXPLOITS

After much careful planning, Vice Admiral Charles Lockwood had initiated Operation *Barney*, the planned submarine penetration of the Sea of Japan. Assisted by new mine-detecting FM sonar, a nine-submarine wolfpack under Commander Earl Hydemann had departed Guam on May 27, 1945, and penetrated the Tsushima Strait on June 4. From June 9 to 20 "Hydemann's Hellcats" sank 27 merchantmen totaling over 57,000 tons; *Sea Dog*'s

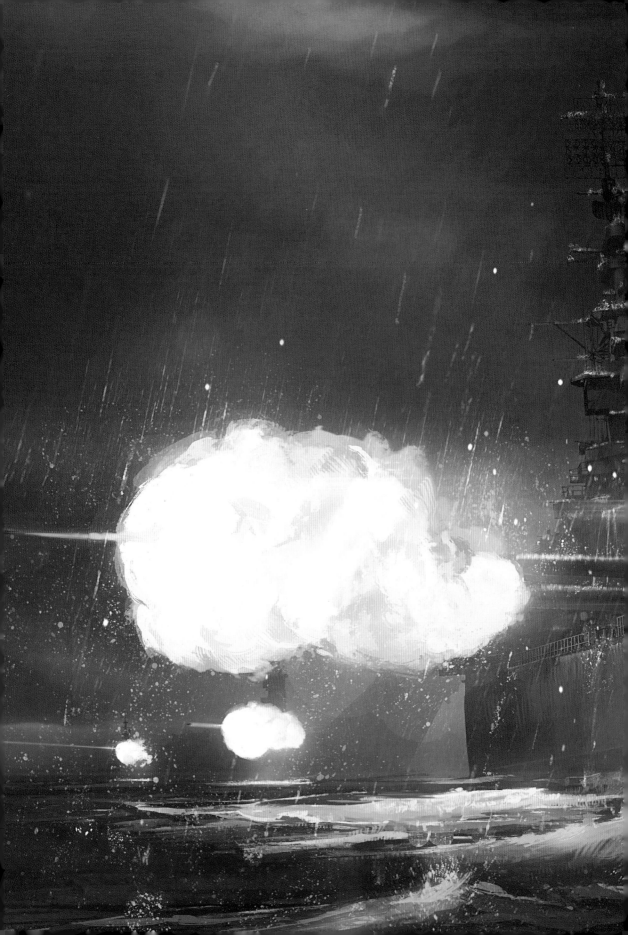

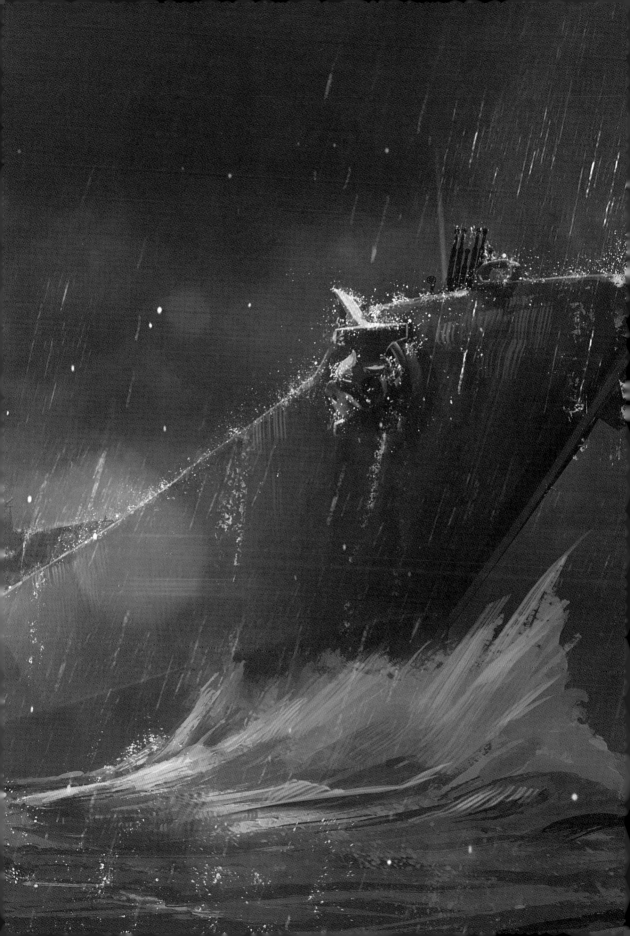

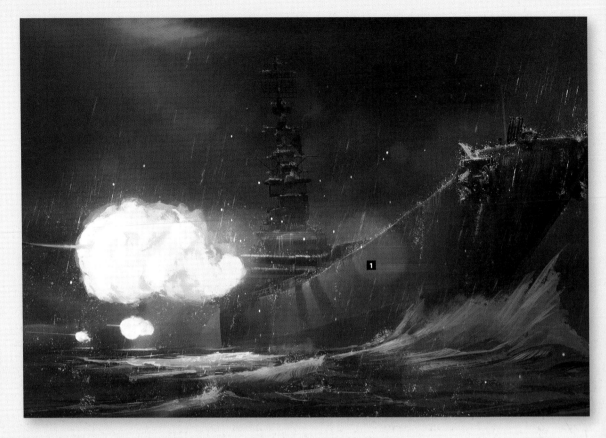

ALLIED BATTLESHIPS BOMBARD HITACHI, JAPAN, JULY 17/18, 1945 (PP. 64–65)

Iowa-class battleship USS *Wisconsin* (BB-64) (**1**) leads sister battleships *Iowa*, *Missouri*, *Alabama*, and *North Carolina*, light cruisers *Atlanta* and *Dayton*, and ten destroyers of Rear Admiral Oscar C. Badger's Bombardment Group Baker (TU-34.8.2) in the nighttime shelling of Honshu's Hitachi–Mito area, July 17/18, 1945. Overhead, radar-equipped F6F-5N Hellcat night fighters from USS *Bon Homme Richard* (CV-31) provide the force's combat air patrol.

Rain and overcast combined for a three-mile nighttime visibility. Navigation was consequently provided by soundings, radar, and LORAN (long range navigation). The five US battleships unleashed 1,238 16in. rounds at the Hitachi and Mito area targets, with US light cruisers firing 292 6in. rounds. Astern Badger's force, Vice Admiral Rawlings' battleship HMS *King George V* fired a total of 297 14in. rounds at her targets, which included 91 rounds at Hitachi's Densen engineering works, 79 rounds at Hitachi's Taga engineering works, and 97 rounds at an unidentified industrial complex. Escorting *King George V* were British Pacific Fleet destroyers HMS *Quality* and HMAS *Quiberon*. The 53-minute Anglo-American bombardment began at 2314hrs, July 17 and ended at 0007hrs, July 18. There was only a single southerly pass before all American and British ships

retired. No enemy opposition was encountered, and no Allied ships suffered any damage.

Hitachi was the largest battleship bombardment of Japan, with six battleships combining to drop 1,805 heavy battery shells (about 2,000 tons) into the Hitachi and Mito areas. The battleship gunfire of July 17/18 damaged three of nine target areas: the Taga Works and Mito Works of the Hitachi Manufacturing Company, the Yamate Plant of the Hitachi Works of the Hitachi Manufacturing Company, and the copper refining section of the Hitachi mines. Numerous errant shells fell in built-up urban areas, causing serious damage to housing and various utilities such as telephone, power, water, and gas facilities. Actual physical damage proved somewhat disappointing, but as was typical for surface bombardments, the most significant consequences were severely damaged civilian morale and soaring worker absenteeism. After the bombardment Hitachi copper miners refused to continue working in mineshafts that could be flooded. Huge numbers of Hitachi civilians fled to the countryside the morning after the shelling, leaving virtually no firefighters or civilian volunteers to fight fires. When LeMay's B-29s firebombed the virtually depopulated, defenseless Hitachi the following night, the city was thoroughly devastated.

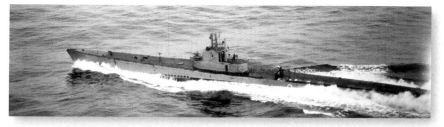

USS *Barb* (SS-220) prowls through the Pacific in May 1945. Her famous skipper Eugene "Luckey" Fluckey would win four Navy Crosses and the Medal of Honor; Fluckey was already popular for illegally sneaking cases of beer aboard to let his men celebrate after sinking enemy ships. (NavSource)

Lieutenant James Lynch claimed, "It was like shooting fish in a barrel." On June 24 submarine USS *Trutta* (SS-421) shelled the Tsushima Strait island of Hiradoshima to mask Hydemann's escape far to the north. Hydemann's Hellcats returned to Pearl Harbor on July 4, minus USS *Bonefish* (SS-223), which Japanese escorts had sunk with all hands on June 19.

Meanwhile, on June 8, 1945 submarine USS *Barb* (SS-220) had commenced her twelfth patrol, this time to terrorize the Sea of Okhotsk with her recently installed 5in. rocket launchers. In the following weeks skipper Commander Eugene "Luckey" Fluckey would successfully mount rocket bombardments of Shari, Hokkaido as well as Shikuka, Kashiho, and Shiritoru on Karufuto (southern Sakhalin), before using *Barb*'s deck guns to destroy 35 sampans at the Karafuto town of Kaihyo To.

Having observed Karafuto trains bringing military supplies to ports, Fluckey brainstormed a way to intercept the trains. Engineman 3rd Class Billy Hatfield remembered placing nuts on railroad ties as a boy and watching the passing train's weight crack them between rail and tie; a landing party could use the same principle to rig an automatic detonator. Fluckey had plenty of volunteers, including a Japanese POW. Fluckey carefully chose Hartfield and seven others, having been dissuaded from leading the shore party himself.

Just after midnight, July 23, 1945, Fluckey took *Barb* within 950 yards of the Karafuto coast. Led by Lieutenant William Walker, at 0030hrs the eight men pushed off in two rubber rafts. "Boys," Fluckey instructed, "if you get stuck, head for Siberia, 130 miles north, following the mountain ranges. Good luck."

The Americans came ashore, found the tracks, and began burying the 55lb scuttling charge and battery under the rails, just beneath a water tower they planned to use as a lookout. As Motor Machinist's Mate 1st Class John Markuson clambered up, he realized he was climbing a sentry tower. Markuson slunk back down without waking the sleeping guard. When a train rolled through, the party dove for cover, then resumed its work after the train passed. Shortly after 0130hrs Walker's men signaled they were returning to *Barb*, now just 600 yards offshore. Fifteen minutes later, with the boats halfway to *Barb*, Fluckey heard rumbling down the tracks. Fluckey hoisted a megaphone: "Paddle like the devil, boys!" At 0147hrs a 16-car Japanese train struck Hatfield's detonator. The huge explosion blew debris 200ft high and reportedly killed 150 Japanese. Minutes later all eight Americans were safely aboard. *Barb* slipped back into the night, having successfully mounted the only amphibious invasion of Japan in World War II.

STRIKES ON THE INLAND SEA, JULY 24–28

Third Fleet spent July 21–22 replenishing from Beary's TG-30.8 in what was likely history's largest at-sea replenishment operation. Reinforcing TF-38 on

July 21 was newly returned carrier *Ticonderoga*, light cruiser *Duluth*, and three destroyers.

On July 21 the nine US destroyers of Captain T.H. Hederman's DesRon-61 detached for an anti-shipping sweep off Sagami Wan. Chasing four radar contacts, at midnight July 22/23, DesRon-61 opened up with guns and torpedoes from 7,000 yards, sinking 800-ton freighter *No. 5 Hakutetsu Maru* and damaging 6,919-ton freighter *Enbun Maru*. Japanese coastal artillery, minesweeper *W-1*, and subchaser *Ch-42* returned fire, but DesRon-61 retired without damage. The Sagami Wan sweep proved the last surface action of the war.

By July 24 TF-38 strength comprised 15 fast carriers (nine Essex-class heavy carriers and six Independence-class light carriers), eight fast battleships, 15 cruisers, and 61 destroyers. Aboard US carriers were well over 1,200 aircraft. Halsey ordered TF-38 to finish off the Combined Fleet at heavily defended Kure. McCain and most of McCain's staff bitterly opposed the Kure strikes, considering the Combined Fleet a spent force. Halsey later justified the complete destruction of the Combined Fleet for four reasons:

1. For the sake of national morale, as the only retaliation appropriate for Pearl Harbor.

2. To pre-empt any Japanese attacks on the planned supply line to the Soviet Union that was to run between Hokkaido and Kamchatka.

3. To remove the existence of any part of Japan's fleet as a bargaining chip in negotiations.

4. Halsey had been ordered to by his commanding officer.

"If the other reasons had been invalid," Halsey argued of Nimitz's directive, "that one alone would have been enough for me." Additionally, as early as December 1944 Nimitz had informed the BPF's Admiral Fraser that the IJN's capital ships were off-limits to the British; Halsey thus assigned TF-37 an alternate target, Osaka, claiming "it was imperative that we forestall a possible postwar claim by Britain that she had delivered even a part of the final blow that demolished the Japanese Fleet." US Navy brass, professionally humiliated at Pearl Harbor, had long marked the Combined Fleet for a ceremonial and very personal annihilation.

At 0440hrs, July 24, TF-38 commenced launching the first of 1,363 sorties against Kyushu, Shikoku, and Honshu ships and airfields ringing the Inland Sea. Hellcats and Corsairs swept aside Japanese aerial opposition, including Genda's 343rd Kokutai, shooting down 18 Japanese planes in the process. Forty Japanese aircraft were claimed destroyed and 80 damaged on the ground at Nagoya–Osaka and Miho airfields.

The Americans' prime targets were the Japanese carriers, battleships, and cruisers at Kure. Braving severe flak, TF-38 aircraft unloaded 599 tons of bombs and 1,615 rockets into area targets, sinking or severely damaging 22 warships totaling 258,000 tons. Among these were battleship *Hyuga*, fleet carrier *Amagi*, heavy cruisers *Tone* and *Aoba*, light cruisers *Oyodo* and *Kitakami*, one large oiler, and two destroyers. Moderate damage was inflicted on battleships *Ise* and *Haruna*,

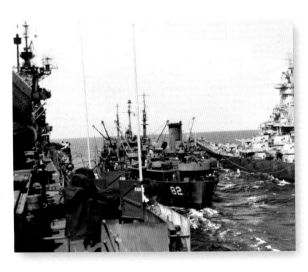

An Essex-class carrier and battleship USS *Iowa* (BB-61) refuel from fast oiler USS *Cahaba* (AO-82) off Japan, 1945. On July 21 and 22, over 100 Third Fleet warships would line up for 40 miles, making successive runs on TG-30.8 oilers, ammunition ships, and stores ships. TG-30.8 ultimately transferred 6,369 tons of ammunition, 379,157 barrels of fuel oil, and 1,635 tons of stores and provisions, plus 99 replacement aircraft and 412 replacement personnel. (NARA 80-G-K-6112, via Naval History and Heritage Command)

fleet carrier *Katsuragi*, auxiliary carrier *Hosho*, escort carrier *Kaiyo*, two destroyers, one transport, and one destroyer-escort. An additional 53 vessels totaling 17,000 tons were sunk at Hiroshima Wan, Niihama, Bungo Suido, Kii Suido, and various other Inland Sea locations. At Kobe the incomplete fleet carrier *Aso* was attacked and damaged.

Around the Inland Sea 16 locomotives were destroyed and five damaged, 20 hangars were damaged, three oil tanks were set afire at Kure and one at Tano, four electric trains and one roundhouse were strafed at Hamamatsu, and "barracks, warehouses, power plants, and factories around the airfields received the usual treatment." Additionally, Rawlings' TF-37 flew 257 sorties against targets in Japan or just offshore, sinking destroyers, small escorts, and some coasters, but TF-37's biggest prize was discovering and sinking escort carrier *Shimane Maru* in Shido Bay—the Royal Navy's first ever carrier-vs-carrier action.

TF-38 and TF-37 operated off southeastern Honshu the night of July 24/25, while night-trained hecklers, zippers, and intruders kept Kure gunners awake. Additionally, Rear Admiral Cary Jones' TG-35.3, comprising light cruisers USS *Wilkes-Barre*, *Pasadena*, *Springfield*, *Astoria*, and six destroyers, swept Kii Suido, then bombarded the Kushimoto seaplane base and airfields at Cape Shionomisaki. TG-35.3 rejoined TF-38 at dawn.

At 0430hrs, July 25, TF-38 resumed launching strikes against airfields and shipping in the Inland Sea and Nagoya–Osaka area. A total of 655 offensive sorties were flown by TF-38 until bad weather forced strikes to be canceled at 1309hrs. Nevertheless, TF-38 aircraft expended 185 tons of bombs and 1,162 rockets, sinking nine ships totaling 8,000 tons. Another 35 ships were damaged, among them a destroyer and numerous freighters. Eighteen Japanese planes were shot down, including three snoopers over TF-38. Sixty-one Japanese planes were reported destroyed and 68 damaged on the ground. Numerous locomotives and gasoline trucks were blown up or damaged, another 20 hangars set afire, plus "many railroad stations, bridges, roundhouses, and tunnels rocketed, and considerable damage [inflicted] upon the Saganoscki copper smelter." The 2,018 sorties TF-38 hurled against the Inland Sea on July 24 and 25 were nearly six times the 343 sorties with which Vice Admiral Chuichi Nagumo had struck Pearl Harbor. Incidentally, none of Halsey's 15 fast carriers had even been launched on December 7, 1941.

Rawlings' TF-37 commenced its July 25 strikes at 0430hrs, ultimately launching 155 offensive sorties before weather forced strikes to be suspended in the afternoon. At dusk British Hellcats shot down three incoming torpedo planes and drove off a fourth. British losses were one Avenger.

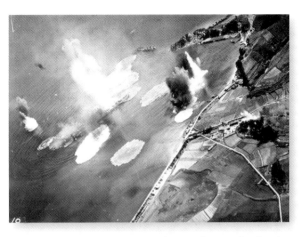

Japanese heavy cruiser *Tone* is targeted by American bombs in this July 24, 1945 photograph. Postwar analysis found that the heavy cruisers especially were sunk mostly by near misses alongside the hull; they continued to be attacked long after they had settled on the Kure harbor bottom. (NARA)

Japanese battleship *Haruna* under severe aerial attack at Kure, July 28, 1945. Commissioned a Kongo-class battlecruiser in 1915, by 1933 *Haruna* had been reconstructed into a fast battleship. *Haruna* escaped destruction at Midway, Guadalcanal, the Philippine Sea, and Leyte Gulf, but at Kure her luck ran out. (NARA 80-G-490224, via Naval History and Heritage Command)

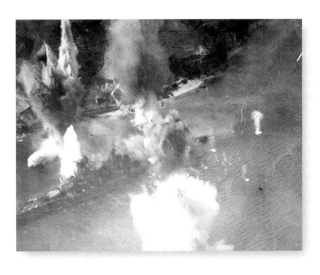

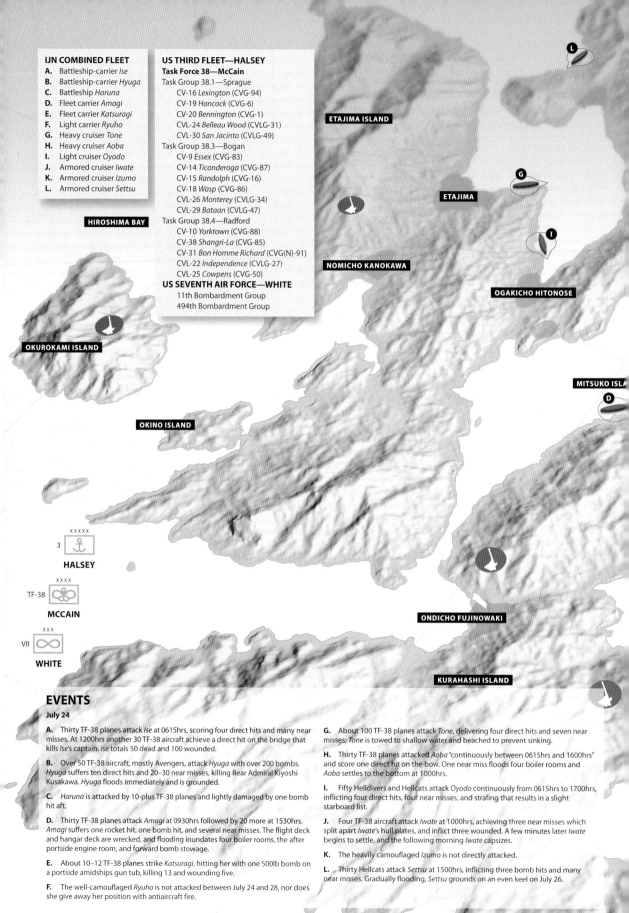

IJN COMBINED FLEET

A. Battleship-carrier *Ise*
B. Battleship-carrier *Hyuga*
C. Battleship *Haruna*
D. Fleet carrier *Amagi*
E. Fleet carrier *Katsuragi*
F. Light carrier *Ryuho*
G. Heavy cruiser *Tone*
H. Heavy cruiser *Aoba*
I. Light cruiser *Oyodo*
J. Armored cruiser *Iwate*
K. Armored cruiser *Izumo*
L. Armored cruiser *Settsu*

US THIRD FLEET—HALSEY

Task Force 38—McCain
Task Group 38.1—Sprague
 CV-16 *Lexington* (CVG-94)
 CV-19 *Hancock* (CVG-6)
 CV-20 *Bennington* (CVG-1)
 CVL-24 *Belleau Wood* (CVLG-31)
 CVL-30 *San Jacinto* (CVLG-49)
Task Group 38.3—Bogan
 CV-9 *Essex* (CVG-83)
 CV-14 *Ticonderoga* (CVG-87)
 CV-15 *Randolph* (CVG-16)
 CV-18 *Wasp* (CVG-86)
 CVL-26 *Monterey* (CVLG-34)
 CVL-29 *Bataan* (CVLG-47)
Task Group 38.4—Radford
 CV-10 *Yorktown* (CVG-88)
 CV-38 *Shangri-La* (CVG-85)
 CV-31 *Bon Homme Richard* (CVG(N)-91)
 CVL-22 *Independence* (CVLG-27)
 CVL-25 *Cowpens* (CVG-50)

US SEVENTH AIR FORCE—WHITE

 11th Bombardment Group
 494th Bombardment Group

ETAJIMA ISLAND

HIROSHIMA BAY

OKUROKAMI ISLAND

NOMICHO KANOKAWA

ETAJIMA

OGAKICHO HITONOSE

MITSUKO ISLA

OKINO ISLAND

3 **HALSEY**

TF-38 **MCCAIN**

VII **WHITE**

ONDICHO FUJINOWAKI

KURAHASHI ISLAND

EVENTS

July 24

A. Thirty TF-38 planes attack *Ise* at 0615hrs, scoring four direct hits and many near misses. At 1200hrs another 30 TF-38 aircraft achieve a direct hit on the bridge that kills *Ise*'s captain. *Ise* totals 50 dead and 100 wounded.

B. Over 50 TF-38 aircraft, mostly Avengers, attack *Hyuga* with over 200 bombs. *Hyuga* suffers ten direct hits and 20–30 near misses, killing Rear Admiral Kiyoshi Kusakawa. *Hyuga* floods immediately and is grounded.

C. *Haruna* is attacked by 10-plus TF-38 planes and lightly damaged by one bomb hit aft.

D. Thirty TF-38 planes attack *Amagi* at 0930hrs followed by 20 more at 1530hrs. *Amagi* suffers one rocket hit, one bomb hit, and several near misses. The flight deck and hangar deck are wrecked, and flooding inundates four boiler rooms, the after portside engine room, and forward bomb stowage.

E. About 10–12 TF-38 planes strike *Katsuragi*, hitting her with one 500lb bomb on a portside amidships gun tub, killing 13 and wounding five.

F. The well-camouflaged *Ryuho* is not attacked between July 24 and 28, nor does she give away her position with antiaircraft fire.

G. About 100 TF-38 planes attack *Tone*, delivering four direct hits and seven near misses; *Tone* is towed to shallow water and beached to prevent sinking.

H. Thirty TF-38 planes attacked *Aoba* "continuously between 0615hrs and 1600hrs" and score one direct hit on the bow. One near miss floods four boiler rooms and *Aoba* settles to the bottom at 1000hrs.

I. Fifty Helldivers and Hellcats attack *Oyodo* continuously from 0615hrs to 1700hrs, inflicting four direct hits, four near misses, and strafing that results in a slight starboard list.

J. Four TF-38 aircraft attack *Iwate* at 1000hrs, achieving three near misses which split apart *Iwate*'s hull plates, and inflict three wounded. A few minutes later *Iwate* begins to settle, and the following morning *Iwate* capsizes.

K. The heavily camouflaged *Izumo* is not directly attacked.

L. Thirty Hellcats attack *Settsu* at 1500hrs, inflicting three bomb hits and many near misses. Gradually flooding, *Settsu* grounds on an even keel on July 26.

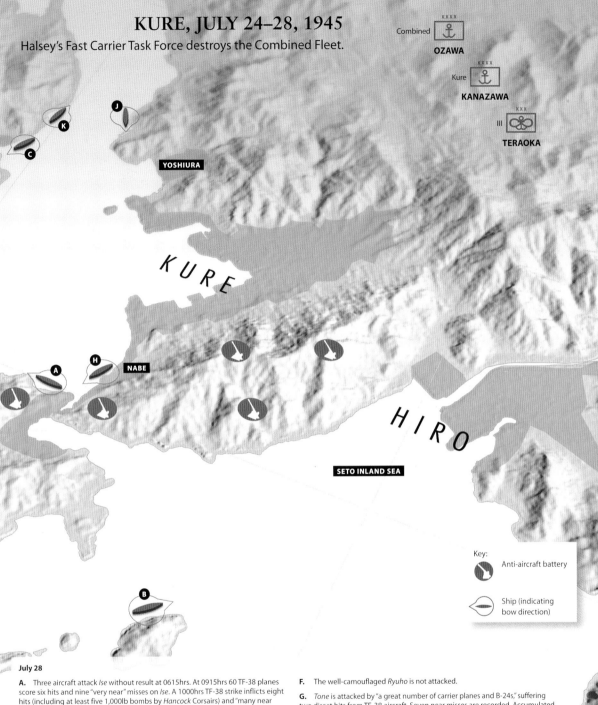

KURE, JULY 24–28, 1945

Halsey's Fast Carrier Task Force destroys the Combined Fleet.

Combined — OZAWA

Kure — KANAZAWA

III — TERAOKA

YOSHIURA

K U R E

NABE

H I R O

SETO INLAND SEA

Key:

Anti-aircraft battery

Ship (indicating bow direction)

July 28

A. Three aircraft attack *Ise* without result at 0615hrs. At 0915hrs 60 TF-38 planes score six hits and nine "very near" misses on *Ise*. A 1000hrs TF-38 strike inflicts eight hits (including at least five 1,000lb bombs by *Hancock* Corsairs) and "many near misses." Listing 20 degrees, *Ise* settles on the bottom, main deck awash. Eighteen B-24s attack at 1400hrs without results. *Ise* is written off as a total loss at 1800hrs.

B. Already fatally damaged, *Hyuga* takes "many" hits and is completely abandoned on August 1.

C. TF-38 aircraft reportedly concentrate on *Haruna*, which is attacked continuously between 0800hrs and 1700hrs and suffers "many" hits and near misses. Severely damaged, *Haruna* is abandoned and nearly capsizes. B-24 attacks at 1300hrs inflict no damage.

D. *Amagi*, already abandoned, is attacked by 50 carrier planes at 0930hrs, by 11 B-24s at 1200hrs, and by 30 more TF-38 planes at 1530hrs. She suffers one hit amidships by a carrier plane and many near misses from TF-38 planes and B-24s. By 1000hrs, July 29, *Amagi* has settled at a 70-degree list.

E. *Katsuragi* is attacked by 10–12 TF-38 aircraft, which score two hits amidships with 1,000lb bombs, badly wrecking the flight and hangar decks, killing 13, and wounding 12. *Katsuragi* shoots down one plane which has just attacked *Amagi*.

F. The well-camouflaged *Ryuho* is not attacked.

G. *Tone* is attacked by "a great number of carrier planes and B-24s," suffering two direct hits from TF-38 aircraft. Seven near misses are recorded. Accumulated damage is fatal, and personnel and equipment are evacuated. On August 4 *Tone* is completely abandoned.

H. Ten TF-38 aircraft strike *Aoba* in the morning, followed by ten more in the afternoon, achieving four direct hits and setting *Aoba* ablaze. At 1600hrs B-24s score four more direct hits, blowing off *Aoba*'s stern. *Aoba* is abandoned.

I. *Oyodo* is under attack between 0700hrs and 1600hrs by 40 SB2Cs and F6Fs, which score four direct hits and "many" near misses. By 1000hrs *Oyodo* lists heavily to starboard, before capsizing at 1200hrs and killing 300 men.

J. *Iwate* is not attacked.

K. Twenty Hellcats score three near misses against *Izumo*, causing gradual flooding. *Izumo* abruptly capsizes one hour after the attack, suffering two killed and three wounded. Two shot-down US planes crash on the beach nearby.

L. Only three US planes attack the already grounded *Settsu*, scoring two near misses. *Settsu* is completely abandoned on July 29.

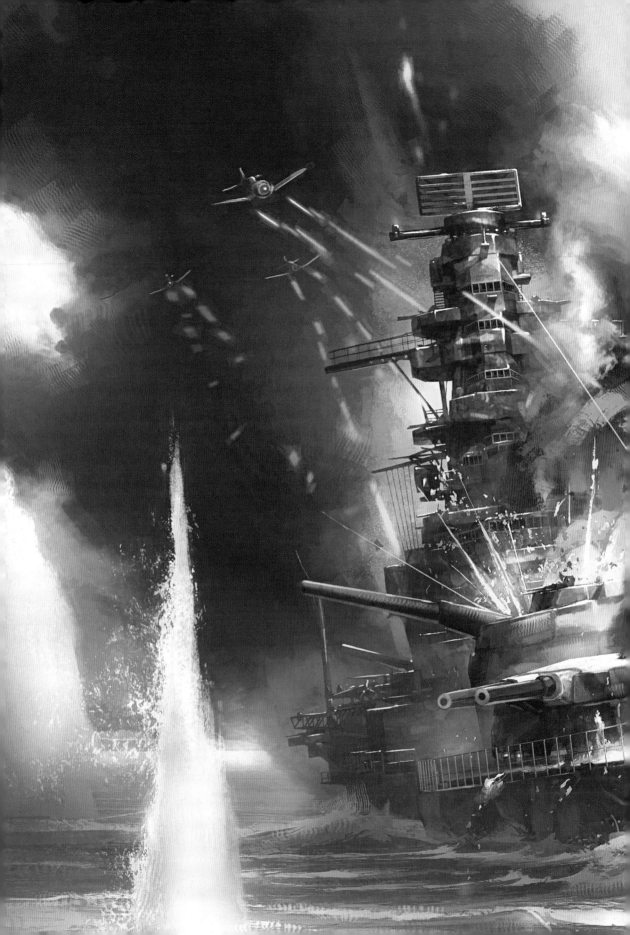

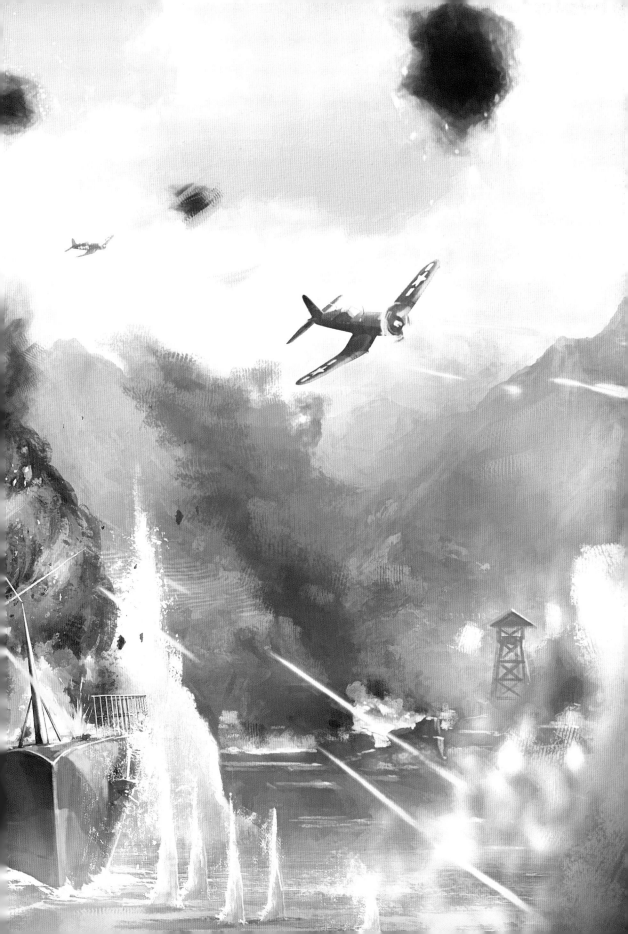

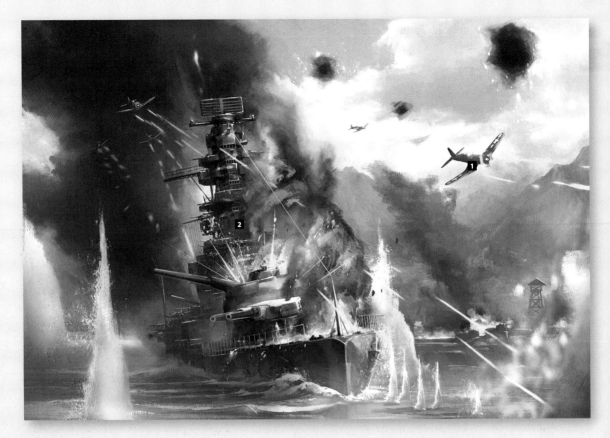

USS *HANCOCK* (CV-17)'S VBF-6 ATTACKS THE JAPANESE HYBRID BATTLESHIP-CARRIER *ISE* AT KURE, 1100HRS, JULY 28, 1945 (PP. 72–73)

For the July 24–28, 1945 Inland Sea strikes, USS *Hancock* (CV-17)'s Air Group Six (CVG-6) was tasked with destroying Japanese heavy warships in Kure Harbor. Early on July 28, 1945 *Hancock* launched its contribution to TF-38's Sweep Able—a lightly armed, all-fighter sweep designed to wear down Japanese Inland Sea defenses before the heavy US strikes hit. Air Group Six's Strike Able, consisting of VBF-6's Vought F4U-4 Corsair fighter-bombers, first attacked shipping in the harbor of Owashi, hitting a 2,500-ton cargo ship which exploded and set fire to a 1000-ton vessel moored nearby. Next came *Hancock*'s Grumman F6F-5 Hellcats of Sweep Baker, which hit Honshu's Akenogahara airfield. The VF-6 Hellcats attacked hangar and administration areas and set four hangars afire.

Around 1000hrs the heavily armed Strike Charlie departed TF-38. Earlier that morning previous air groups' strikes had already hammered *Ise* with six hits and nine near misses. Preceding *Hancock*'s Strike Charlie were TBM-3 Avenger torpedo bombers

of VT-6, which were carrying 500lb bombs. The Avengers focused on antiaircraft positions surrounding *Ise*, and reportedly knocked out 50 percent of the flak batteries.

Following the Avengers, at 1100hrs VB-6's SB2C Helldivers dive-bombed *Ise* and claimed four bomb hits forward. Trailing the Helldivers, Lieutenant Commander Lavell M. Bigelow's VBF-6 Corsairs (**1**), armed with 1,000lb bombs, began their 45-degree bombing run against the reeling *Ise* (**2**), defying intense Japanese flak from both land batteries and ships in harbor. Three Corsairs, including Bigelow, were credited with direct hits, seen here. Behind them, another two VBF-6 Corsairs scored on *Ise* with 1,000lb bombs, while additional aircraft produced "many near misses" during the attack. Listing at 20 degrees, the shattered *Ise* quickly settled on the Kure harbor floor. Later that day the wrecked battleship-carrier would be further bombed, unsuccessfully, by 18 B-24 Liberators of the US Seventh Air Force.

At 1821hrs, July 25, TF-38 and TF-37 retired to refuel, having launched a combined 2,589 Anglo-American strike sorties in 36 hours. The following morning TF-38 and TF-37 rendezvoused with their respective replenishment groups—TG-30.8 for the Americans, and the Logistic Support Group (LSG) for the British. Accompanying Beary's oilers was the returning USS *Wasp* (CV-18), increasing McCain's strength to 16 fast carriers. At 1130hrs, July 27, the 20 fast carriers of TF-38 and TF-37 cleared their tankers and proceeded to launch points 96nm off Shikoku.

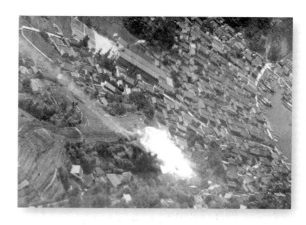

An unidentified plane, likely American, crashes and explodes in a Kure residential section on July 28, 1945. As the heart of the Combined Fleet, Kure was extraordinarily well defended. Both anchored ships and land-based batteries had spent many months optimizing antiaircraft firing arcs. (NARA 80-G-490221, via Naval History and Heritage Command)

The following morning, at 0443hrs, July 28, Third Fleet resumed strikes against the Inland Sea from north Kyushu to Nagoya, along with airfields across Honshu on the Sea of Japan. McCain reported, "The weather was favorable and damage to shipping, both naval and mercantile, was devastating." TF-38 flew 1,602 offensive sorties, dropped 605 tons of bombs, and expended 2,050 rockets. The Americans reported sinking 27 ships totaling 43,000 tons, including Combined Fleet flagship *Oyodo*, heavy cruiser *Aoba*, a large oiler, a destroyer-escort, a medium transport, a small freighter, and 17 luggers and small craft at Kure and Nagoya Bay. Seventy-nine vessels totaling 216,000 tons were reported damaged or probably sunk, including battleships *Ise* and *Haruna*, heavy cruiser *Tone*, fleet carriers *Amagi* and *Katsuragi*, six destroyers, three submarines, four destroyer-escorts, 15 freighters and transports, four oilers, and 41 luggers and small craft. American planes even sank the ancient 9,180-ton armored cruisers *Izumo* and *Iwate*, Tsushima veterans commissioned in 1900 and 1901 respectively.

TF-38 flyers claimed 21 Japanese aircraft shot down and 115 destroyed on the ground at 30 area airfields, primarily at Miho, Yonago, and Tsuika. Fourteen locomotives, four oil cars, two roundhouses, three oil tanks, three warehouses, one hangar, and a transformer station were destroyed. Another eight locomotives, 13 hangars, eight factories, two copper smelters, two lighthouses, one railroad station, multiple roundhouses, numerous oil tanks, two radio stations, and various barracks and miscellaneous shops were reported damaged, including bombs dropped on the Kawasaki aircraft factory at Kakamigahara.

Japanese battleship *Ise* billows smoke during heavy US air attacks at Kure, July 28, 1945. *Ise* and sister *Hyuga* had twice evaded Halsey during the Philippines campaign. The IJN's odd battleship-carrier hybrids finally met their end at Kure. (National Museum of Naval Aviation 1996.488.027.051)

That same day the US Seventh Air Force's 11th and 494th Bombardment groups suddenly bombed Kure in a day-long raid that can only be described as a recalcitrant attempt to steal Third Fleet's thunder. The 79 Okinawa-based B-24 Liberators registered only four 500lb bomb hits, all on the grounded *Aoba*, ripping off her stern. The B-24s reported "a most terrific curtain of flak" which shot down two B-24s and damaged 14 more.

Meanwhile, TF-37 flew 260 offensive sorties against the eastern Inland Sea. The Royal Navy's Avengers struck the dockyard at Harima, while British Corsairs attacked Maizuru, sinking or

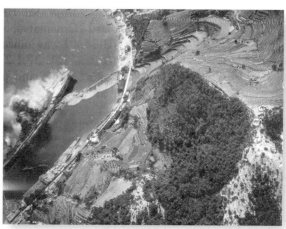

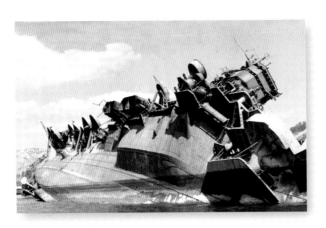

Japanese fleet carrier *Amagi* capsized at Kure, 1946. Built to a simplified *Hiryu* design, *Amagi* was an Unryu-class carrier ordered in 1942 after the Midway disaster. Damaged by the July 24–28 Kure attacks, *Amagi* capsized on July 29, 1945. She would be fully scrapped by December 1947. (Wikimedia Commons/Public Domain)

severely damaging four IJN destroyer-escorts. TF-37 lost eight aircraft and two airmen.

At 1930hrs, July 28, Third Fleet commenced its retirement from the area and laid course to reach the initial launching point for July 30 strikes on the Osaka–Nagoya area. Since July 24 Third Fleet had flung 4,292 total sorties at the Inland Sea. Of Japan's 12 wartime battleships, only the crippled *Nagato* remained afloat at Yokosuka; of Japan's 25 aircraft carriers, only five remained afloat, and they were all damaged. Sixteen of Japan's 18 wartime heavy cruisers had been sunk (the last two were at Singapore and damaged) while 20 of Japan's 22 light cruisers had been destroyed. Halsey relished:

> By sunset that evening the Japanese navy had ceased to exist. Photographs showed the battleship *Ise* down by the bow and resting on the bottom; her sister ship, *Hyuga*, was awash amidships; the *Haruna* was beached and burning, with a large hole in her stern. The *Katsuragi*'s flight deck was torn and buckled; the *Amagi*'s could have been used as a ski slide. The heavy cruisers *Tone* and *Aoba* were beached. The Commander-in-Chief of the Combined Japanese Fleet could reach his cabin in his flagship, the *Oyodo*, only in a diving suit.

In three days of strikes from July 24 through July 28, the Americans alone had flown 3,620 strike sorties, dropped 1,389 tons of bombs, fired 4,827 rockets, and claimed 52 planes shot down and 216 destroyed on the ground. Some 170 Navy Crosses would be awarded, five posthumously. Rawlings' British flyers had contributed an additional 672 offensive sorties. American losses, however, had been particularly heavy: 101 planes and 88 men.

ENDGAME, JULY 29–AUGUST 15

Bombardment of Hamamatsu, July 29/30
At 1100hrs, July 29, Shafroth's Bombardment Group Able (TU-34.8.1) of battleships *South Dakota*, *Massachusetts*, and *Indiana*, heavy cruisers *Quincy*, *Boston*, *Saint Paul*, and *Chicago*, and ten destroyers detached to bombard Hamamatsu, a manufacturing city of 162,000.

TU-34.8.1 was joined by *King George V* and destroyers *Undine*, *Ulysses*, and *Urania* (TU-37.1.2). At sunset, July 29, the weather turned to light rain, patchy fog, and poor visibility with a ceiling of 600ft. Before the bombardment *Ulysses* suffered light damage colliding with *Urania*. Radar contact was established with Honshu at a range of 63nm.

Beginning at 2203hrs TU-34.8.1 made a high-speed approach to the target. The battleships commenced firing at 2315hrs, July 29. A total of two bombardment runs were made, and at 0027hrs, July 30, the bombardment groups ceased fire and retired. Several snoopers were detected on radar, but none attacked.

US battleships and cruisers had unloaded 810 16in. and 1,035 8in. shells against Hamamatsu, damaging an Imperial Government Railway locomotive

Allied naval bombardments of the Home Islands, February 1–August 15, 1945

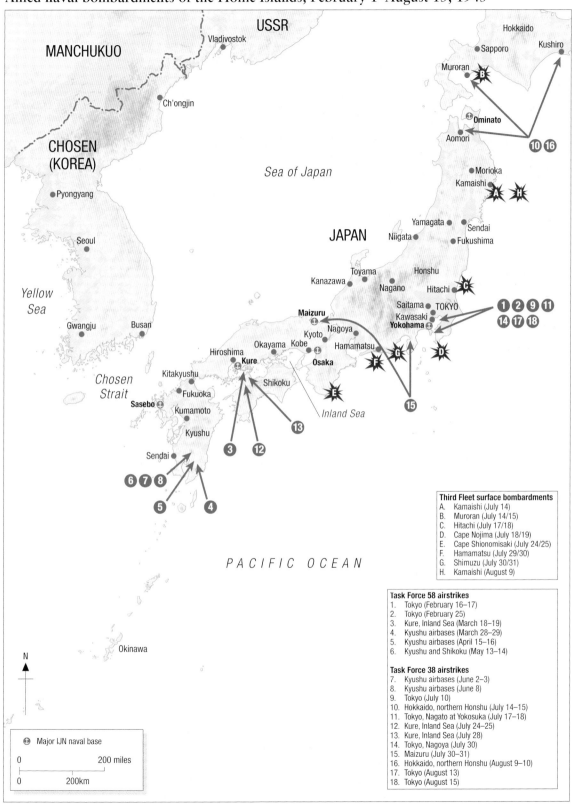

Third Fleet surface bombardments
A. Kamaishi (July 14)
B. Muroran (July 14/15)
C. Hitachi (July 17/18)
D. Cape Nojima (July 18/19)
E. Cape Shionomisaki (July 24/25)
F. Hamamatsu (July 29/30)
G. Shimuzu (July 30/31)
H. Kamaishi (August 9)

Task Force 58 airstrikes
1. Tokyo (February 16–17)
2. Tokyo (February 25)
3. Kure, Inland Sea (March 18–19)
4. Kyushu airbases (March 28–29)
5. Kyushu airbases (April 15–16)
6. Kyushu and Shikoku (May 13–14)

Task Force 38 airstrikes
7. Kyushu airbases (June 2–3)
8. Kyushu airbases (June 8)
9. Tokyo (July 10)
10. Hokkaido, northern Honshu (July 14–15)
11. Tokyo, Nagato at Yokosuka (July 17–18)
12. Kure, Inland Sea (July 24–25)
13. Kure, Inland Sea (July 28)
14. Tokyo, Nagoya (July 30)
15. Maizuru (July 30–31)
16. Hokkaido, northern Honshu (August 9–10)
17. Tokyo (August 13)
18. Tokyo (August 15)

works and wrecking infrastructure on the critical Tokaido main line. *King George V* fired 265 14in. shells at the Japanese Musical Instrument Company, starting extensive fires that were "pleasingly visible from the ship." This proved the last time a British battleship ever fired her guns in anger. As the bombardment group retired, *South Dakota* signaled, "Well done to all hands. Let's do it again. Signed RAdm Shafroth." Despite having previously endured over 30 air raids, the naval bombardment so shattered Hamamatsu's civilian morale that within two days 30,000 citizens had fled the city.

Penultimate actions, July 30–August 8

After approaching within 70nm off Suruga Wan, at 0412hrs, July 30, TG-38.1 opened TF-38 strikes against Osaka–Kobe–Nagoya airfields. Poor weather north of Tokyo saw some strikes shifted to Maizuru on the Sea of Japan. A total of 1,224 sorties expended 397 tons of bombs and 2,532 rockets. Twenty vessels were sunk, totaling 6,000 tons. Another 56 ships totaling 73,000 tons were damaged, including light cruiser *Kashima*. Some 115 aircraft were claimed destroyed on the ground, many camouflaged up to two miles from airfields. Heavy damage was done to numerous industrial targets, including aircraft factories and naval docks and buildings at Maizuru. While under TF-38 attack at Miyazu Bay, Kyoto, the 1,600-ton *Hatsushimo* maneuvered into an air-dropped naval mine and became the last of 129 Japanese destroyers sunk in World War II. TF-38 losses were 11 planes and 11 airmen.

On a fruitless anti-shipping sweep the night of July 30/31, Captain J.W. Ludewig's DesRon-25 of seven US destroyers steamed deep inside Suruga Wan and in seven minutes unleashed 1,100 5in. shells at an oil company and an aluminum plant at Shimizu, a manufacturing city of 60,000. A total of 118 industrial buildings were damaged or destroyed. The metals plant had supplied 32 percent of Japan's aluminum and was heavily damaged, but it had already nearly ceased production due to materiel shortages.

During July TF-38 aircraft had shot down 55 enemy aircraft over Japan. Another 508 planes were claimed destroyed on the ground, including 256 single-engine aircraft, 159 twin-engine aircraft, 31 trainers, 15 float planes, three flying boats, and three gliders. TF-38 strikes had additionally sunk 71 ships totaling 217,300 tons, including 22 warships (109,700 tons) and 49 merchant ships (107,600 tons), plus 168 small craft. Another 168 ships totaling 517,780 tons had been damaged, plus 335 small craft. Some 130 locomotives and 15 hangars were destroyed and 82 locomotives and 93 hangars damaged. Enormous additional damage had been inflicted upon enemy docks, warehouses, barracks, industrial buildings, residential areas, fuel storage, transportation facilities, bridges, shipyards, airfield facilities, lighthouses, and radio stations. This was all exclusive of damage wrought by surface bombardments, submarines, mines, and Rawlings' TF-37. TF-38 losses came to 130 planes in combat (73 Hellcats and Corsairs, 28 Helldivers, and 29 Avengers),

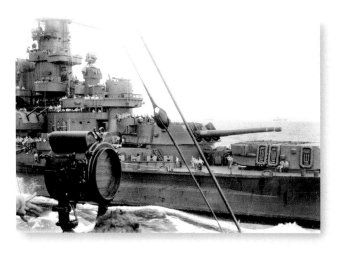

USS *South Dakota* off Honshu, August 1, 1945, as viewed from the Australian destroyer HMAS *Norman*. With no IJN surface threat remaining by mid-1945, many US carrier commanders wished to replace the fast battleships with additional cruisers, as the slowest fast battleships, the South Dakota-class, limited the Fast Carrier Task Force to 25 knots. (NavSource)

plus another 68 planes lost operationally. A total of 98 TF-38 pilots and 58 airmen had been lost. Of 123 ships Japan lost in July 1945 all but three were sunk in Home Island waters or the East China Sea.

On July 28 Captain Charles McVay's unescorted heavy cruiser *Indianapolis* had departed Guam en route to Leyte. At 2332hrs, July 29, Lieutenant-Commander Mochitsura Hashimoto's submarine *I-58* fired six torpedoes at *Indianapolis*. Two direct hits sent *Indianapolis* to the bottom in less than 15 minutes. About 850 Americans survived the sinking, but a series of tragic, inexcusable administrative failures meant the USN was unaware *Indianapolis* was overdue. By August 8 belated search and rescue attempts eventually saved 316 of *Indianapolis*' 1,199 men, including McVay. Perhaps 500 died of shark attacks and exposure. McVay was court-martialed and arguably scapegoated, despite strong testimony that largely exonerated him. McVay would commit suicide in 1968.

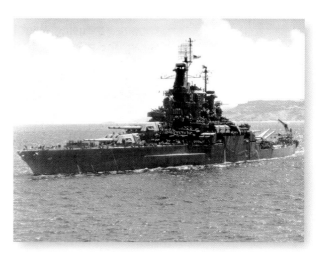

Battleship USS *Tennessee* (BB-43) at Okinawa's Buckner Bay, July 17, 1945. She would eventually be assigned to Vice Admiral Jesse Oldendorf's TF-95 as distant cover to Oldendorf's cruiser striking force. *Tennessee* had been one of the battleships damaged at Pearl Harbor; by summer 1943 she had been rebuilt into almost a brand-new warship. Had *Olympic* proceeded, *Tennessee* would have found herself bombarding Kyushu in late 1945. (NARA 80-G-326899, via Naval History and Heritage Command)

Meanwhile, on July 26 the Allies had released the Potsdam Declaration, which pronounced Allied terms for Japan's surrender, accompanied by stern threats in case she did not. The Japanese government responded with *mokusatsu*—"silent contempt." However, that same month Premier Kantaro Suzuki had been invited to tour a display of weapons to be issued to civilians: muzzle-loading muskets, longbows, bamboo spears, and pitchforks. Suzuki was horrified. "This is awful," he muttered. The Japanese people were being deceived, Suzuki felt. Somehow the war must be ended.

In early July a new USN surface striking force, TF-95, had been established under the overall command of Vice Admiral Jesse Oldendorf, headquartered at Buckner Bay, Okinawa. TF-95 was tasked with anti-shipping sweeps of the East China Sea. TF-95's first sweep, comprising large cruisers *Alaska* and *Guam*, light cruisers *Cleveland*, *Columbia*, *Montpelier*, and *Denver*, and nine destroyers, had been between July 17 and 24 and proved fruitless. On August 1 TF-95 began its second anti-shipping sweep of the East China Sea off Shanghai. The original July 17–24 force made nightly forays toward the Asiatic mainland north of the Yangtze minefields, but found nothing. By now TF-95 also included escort carriers *Makin Island*, *Cape Gloucester*, and *Lunga Point*, battleships *Tennessee*, *California*, and *Nevada*, cruisers *Wichita* and *St. Louis*, six destroyers, and three destroyer-escorts. Two shipping strikes from the escort carriers sank a coastal barge and damaged shore installations and a small cargo vessel, while TF-95 fighters shot down four Japanese planes. One FM-2 Wildcat and its pilot were lost to antiaircraft fire while three Corsairs and two Wildcats were damaged. TF-95 retired on August 6 and re-entered Buckner Bay on August 7. Oldendorf's report notably stated:

> The operation confirmed the fact that American Air and Submarine efforts had already practically eliminated enemy shipping in the East China Sea and along the China Coast. Appropriate targets for Naval guns no longer existed in the area near the Yangtze mouth.

Despite producing scant material results, TF-95 tightened the pressure on Japan, and its mere existence demonstrates the extravagance of naval power the Allies were bringing to bear the final weeks of the war.

By August 1 McCain's TF-38 strength stood at 16 fast carriers (ten heavy, six light), eight battleships, four heavy cruisers, 15 light cruisers, and 62 destroyers. Rawlings' TF-37 claimed four fast carriers, one battleship, three light cruisers, three antiaircraft cruisers, and 18 destroyers. When combined, Halsey's total Third Fleet strength came to 20 fast carriers, nine battleships, 25 cruisers, and 80 destroyers. Unknown to the Americans, early on August 2 the IJN ordered *Nagato* to intercept a supposed US landing. However, the order was canceled before *Nagato* could complete repairs to get underway.

Typhoon weather would frustrate Third Fleet the next two weeks, but this incidentally allowed Rawlings' slower, less-experienced TF-37 to keep up with the Americans' relentless operational tempo. As August broke, Nimitz ordered Halsey to stand clear of southern Japan. In mid-July Third Fleet had been given a list of off-limits Japanese cities; only on July 22 had an arriving US admiral told Halsey, in private, of the atomic bomb. On August 4 Halsey sent a staff officer across to *King George V* to personally inform Rawlings. Two days later, on the morning of August 6, a single B-29 out of Tinian dropped the heretofore secret weapon on the major Japanese base of Hiroshima, just across the bay from Kure. The 16-kiloton blast killed 80,000 people, including at least 12 USN and USAAF prisoners who had been shot down between July 24 and 28.

Second bombardment of Kamaishi, August 9

The Americans mistakenly believed the July 14 battleship bombardment of the Kamaishi steel mill had caused little damage, and so Halsey organized an encore, detaching Shafroth's TU-34.8.1 of battleships *South Dakota*, *Indiana*, *Massachusetts*, heavy cruisers *Quincy*, *Chicago*, *Boston*, and *Saint Paul*, and nine destroyers. They were joined by Rear Admiral Patrick Brind's British TU-37.1.8 comprising cruisers HMS *Newfoundland* and HMNZS *Gambia*, and destroyers HMS *Tenacious*, *Termagant*, and *Terpsichore*. Suffering from machinery problems, *King George V* was scrubbed from the mission.

Under a CAP of 20 US fighters, the force opened fire at 1247hrs, August 9. Average range was 14,000 yards. After heavy Japanese flak against the US spotting planes was observed, *Gambia* opened fire on the shore antiaircraft batteries. "By now," Halsey related, "our contempt for Japan's defenses was so thorough that our prime consideration in scheduling this bombardment was the convenience of the radio audience at home."

A US Marine Corps prisoner captured at Corregidor, Private 1st Class Glenn William McKasson, had been transferred to Sendai No. 5 in time for the August 9 bombardment. He remembered:

The Navy shelled constantly … The mill was almost completely destroyed; it was a total disaster! Our POW camp was hit and burned to the ground. Knowing that our fleet was able to get that close to Japan with no obvious counterattack from the Japanese, I realized that the war might be coming to an end and sometime in the near future, I would be

Battleship USS *Massachusetts* (BB-59) bombards Kamaishi, Japan on August 9, 1945. *Massachusetts'* outbound 16in. shells are visible in the upper left of the photograph. A mistaken belief that the original July 14 bombardment had done little damage inspired this second Kamaishi bombardment in August, the last battleship bombardment of World War II. (World War II Database)

freed from POW life, so I actually stood in the center of all the bombardments, watched the steel mill being demolished and waved and cheered as the U.S. Navy planes flew over.

Fifteen-year-old high-school student Otoko Wada remembered fleeing from the attack to a tunnel, along with Korean slave laborers. Afterward she saw "a sea of dead bodies" because Kamaishi's air-raid shelters had suffered direct hits from shells. "After the raid was over," McKasson recalled, "we worked 24 hours a day removing bodies. We accounted for 42 POWs."

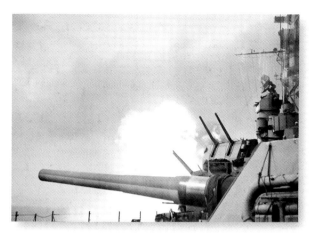

USS *Indiana*'s forward 16in. turrets are seen firing against Kamaishi, in this August 9, 1945 shot by Photographer's Mate 2nd Class Frank P. Fish. The *Indiana* bluejacket had unknowingly photographed the last battleship salvo of World War II fired in anger. (NARA 80-G-339340, via Naval History and Heritage Command)

TU-34.8.1 ceased fire at 1445hrs. Spotter planes were recovered by 1548hrs, but at 1600hrs a lone D4Y began snooping Shafroth's force until a *Bennington* fighter shot it down at 1648hrs. The US battleships had unleashed 850 16in. shells at Kamaishi on August 9. Heavy cruisers committed another 1,440 8in. rounds and US destroyers contributed approximately 2,500 5in. shells. Combined with the July 14 action, US warships alone had bombarded Kamaishi with 1,652 16in., 2,168 8in., and 3,325 5in. shells. The combined bombardments required repairs costing 65 percent of the Kamaishi plant's total value to restore to pre-attack condition. Fires initiated by gunfire heavily damaged the town of Kamaishi, including destroying refrigeration plants of Kamaishi's sizable fishing industry. The second Kamaishi bombardment proved the last surface bombardment of the war. Postwar analysis indicated that the three surface bombardments of steel mills caused the loss of a projected 220,000 tons of pig iron in the upcoming year, or 22 percent of Japan's total.

Death throes, August 9–15
At 0001hrs, August 9, the Soviet Union declared war on Japan and 1.6 million Soviet troops began pouring into Japanese-held Manchuria and southern Sakhalin. Before noon a USAAF B-29 would drop a 21-kiloton atomic bomb on Nagasaki, instantly killing 40,000 people.

Meanwhile, MacArthur urgently requested TF-38 carrier strikes on northern Honshu's Misawa airfields, where US intelligence believed a large Japanese air fleet and commando force was marshalling for a one-way mission to Okinawa. In fact, Lieutenant-General Michio Sugahara's *Giretsu*

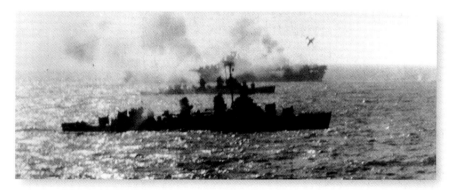

Photographed from USS *Bon Homme Richard* (CV-31), a Japanese B7A "Grace" torpedo-bomber nearly crashes fast carrier USS *Wasp* (CV-18) off Honshu, August 9, 1945. After virtually no attacks in July, IJN air attacks against the fast carriers resumed the final weeks of the war. (NARA 80-G-455702, via Naval History and Heritage Command)

RYOISHI

Yokosuka

xxxx

⚓

TOZUKA

2 KAMAISHI

7

HEITA

14 11

OZAKI POINT

6

▼ EVENTS

1. At 1244hrs destroyers *Erben* and *Stembel* take patrol station off Kamaishi's harbor mouth.

2. Battleship spotting planes report on station at 1247hrs, with *Massachusetts'* plane reporting heavy if inaccurate antiaircraft fire over Kamaishi.

3. At 1247hrs flagship *South Dakota* gives signal to open fire.

4. Destroyer *Stembel* explodes Japanese mine, 1258hrs.

5. Heavy cruiser *Boston* opens fire on two small Japanese ships in cove, 1302hrs.

6. Light cruiser HMNZS *Gambia* opens fire at Japanese shore antiaircraft batteries, 1315hrs.

7. At 1317hrs a *Bennington* CAP fighter takes over shell spotting for *Massachusetts*, whose plane has withdrawn with mechanical problems.

8. Up to 1327hrs all *Indiana* salvoes have missed by 2,000–3,000 yards due to a serious navigational plotting error. *Indiana* checks fire for five minutes to correct her plotting. At 1332hrs *Indiana* resumes fire and immediately registers hits on targets.

9. *South Dakota* commences firing 5in. guns at Japanese barracks, 1341hrs.

10. *South Dakota* scores multiple 16in. hits on the coke ovens beginning at 1351hrs.

11. Destroyers *Stembel* and *Erben* sink one small Japanese ship and two luggers, 1412hrs.

12. After 270 16in. rounds, *Indiana* concludes main battery firing, 1417hrs.

13. After 263 16in. rounds, *South Dakota* concludes main battery firing, 1422hrs.

14. *Stembel* destroys Ozaki Point observation post at 1437hrs.

15. Action ceases at 1445hrs; Allied ships commence retirement.

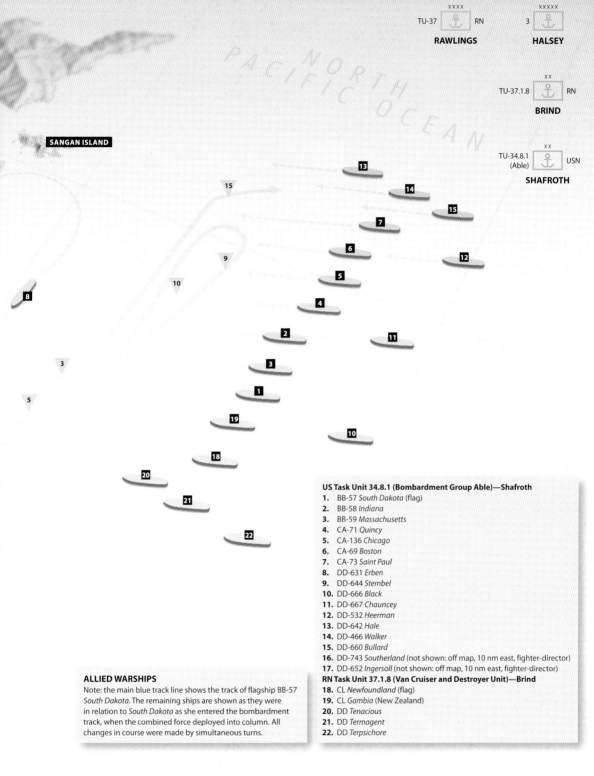

TU-37 ⚓ RN
xxxx
RAWLINGS

3 ⚓
xxxxx
HALSEY

TU-37.1.8 ⚓ RN
xx
BRIND

TU-34.8.1 ⚓ USN
(Able)
xx
SHAFROTH

SANGAN ISLAND

NORTH PACIFIC OCEAN

US Task Unit 34.8.1 (Bombardment Group Able)—Shafroth
1. BB-57 *South Dakota* (flag)
2. BB-58 *Indiana*
3. BB-59 *Massachusetts*
4. CA-71 *Quincy*
5. CA-136 *Chicago*
6. CA-69 *Boston*
7. CA-73 *Saint Paul*
8. DD-631 *Erben*
9. DD-644 *Stembel*
10. DD-666 *Black*
11. DD-667 *Chauncey*
12. DD-532 *Heerman*
13. DD-642 *Hale*
14. DD-466 *Walker*
15. DD-660 *Bullard*
16. DD-743 *Southerland* (not shown: off map, 10 nm east, fighter-director)
17. DD-652 *Ingersoll* (not shown: off map, 10 nm east, fighter-director)

RN Task Unit 37.1.8 (Van Cruiser and Destroyer Unit)—Brind
18. CL *Newfoundland* (flag)
19. CL *Gambia* (New Zealand)
20. DD *Tenacious*
21. DD *Termagent*
22. DD *Terpsichore*

ALLIED WARSHIPS
Note: the main blue track line shows the track of flagship BB-57 *South Dakota*. The remaining ships are shown as they were in relation to *South Dakota* as she entered the bombardment track, when the combined force deployed into column. All changes in course were made by simultaneous turns.

SECOND BOMBARDMENT OF KAMAISHI, AUGUST 9, 1945

US and British warships return to shell the Kamaishi Works steel mill in the final surface bombardment of World War II.

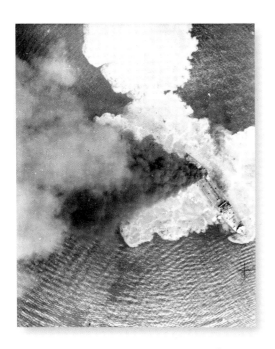

British Pacific Fleet bombs find a 10,000-ton Japanese tanker at Harima in the Inland Sea, August 9–10, 1945. Black smoke and a large oil slick are noticeably visible. Between July 17 and September 2 the Royal Navy's TF-37 would fly 2,950 sorties, shoot down 14 Japanese aircraft, and destroy or damage 442 aircraft on the ground. About 350,000 tons of shipping would be sunk or badly damaged by TF-37. Forty-two RN aircraft would be shot down, with 35 airmen lost. (Imperial War Museum A 30368)

Kuteitai ("Heroic Paratroopers") were targeting the Marianas B-29 complex for August 19–23 nighttime suicide raids by 200 transports and 2,000 commandos.

TF-38 launched the first of 1,212 offensive sorties at 0330hrs, August 9 to hit airfields and shipping in the northern Honshu–Hokkaido area. While Shafroth was bombarding Kamaishi, TF-38/TF-37 strikes sank all remaining shipping in Onagawa Wan. TF-37 aircraft delivered 120 tons of ordnance, the Fleet Air Arm's single-day record in World War II. When *Formidable* Lieutenant Robert Hampton Gray, DSC, Royal Canadian Navy Volunteer Reserve's Corsair was struck by flak and set on fire, the crashing, inverted Gray continued driving home his attack against escort sloop *Amakusa*, destroying both himself and the enemy. Gray was posthumously awarded the Victoria Cross. TF-37 destroyed 50 Japanese aircraft on August 9 airfield sweeps, losing seven aircraft and five men. American flyers claimed 189 Japanese planes destroyed on the ground and 102 damaged, and six warships and two merchantmen sunk. The British claimed sloops *Amakusa* and *Inagi* and two minesweepers. "An excellent day," a self-satisfied Halsey wrote in his war diary. It had not been entirely excellent. At 1454hrs a D3A "Val" dive-bomber had snuck into a four-destroyer radar picket formation 50nm southwest of TF-38. After surviving antiaircraft fire, the Val crash-dived destroyer USS *Borie* (DD-704), killing 48 and wounding 66. This proved the last major damage suffered by TF-38 ships during the war.

To support the Soviets, the following day, August 10, Halsey ordered more airstrikes against northern Japanese airfields. The 1,364 US sorties produced "a record day" and inspired McCain to report, "Damage was too enormous and widespread to be reported in detail. We didn't need any atoms." TF-38 claimed 558 Japanese planes destroyed in attacks that even saw Avenger tail gunners strafing airfields at treetop level. Meanwhile, TF-37 destroyed 50 aircraft on the ground, sank or severely damaged six escorts at Maizuru and in the Inland Sea, and damaged factories, shipyards, and barracks. The Americans lost 34 aircraft and 19 airmen during the August 9–10 strikes; British losses were 13 aircraft and nine men.

The *Olympic* timetable had called for Third Fleet to retire to Eniwetok and Manus in mid-August, but late on the night of August 10 *Missouri* intercepted a cryptic radio transmission: "Through the Swiss government, Japan has stated that she is willing to accept Allied surrender ultimatum at Potsdam, provided they can keep their Emperor." Halsey had long predicted an early Japanese collapse, and had accordingly kept his logistic pipeline full. The following morning, August 11, flagships *Missouri* and *King George V* refueled simultaneously alongside oiler USS *Sabine*. Halsey recalled, "I went across to the 'Cagey Five' as we called her, on an aerial trolley, just to drink a toast with Vice Admiral Rawlings." Although Japan teetered near collapse, TF-37 lacked its own fast oilers and would have to retire immediately. With Nimitz's permission Halsey offered to sustain a token British force with Third Fleet so that the Royal Navy would be in "at the death." Rawlings enthusiastically accepted. After replenishment, *King George V*, *Indefatigable*,

Gambia, *Newfoundland*, and ten destroyers were re-designated TG-38.5 and absorbed into McCain's TF-38. The rest of TF-37, under Vian, reluctantly retired for Manus.

In a truly desultory attack the following day, August 12, a single Japanese plane penetrated Buckner Bay, Okinawa undetected and torpedoed TF-95's just-arrived battleship *Pennsylvania*. Twenty Americans were killed, while Oldendorf and nine others were wounded. Back off Honshu, Halsey canceled August 12 strikes due to a typhoon. Late that night Third Fleet intercepted a confusing and ambiguous radio bulletin announcing that Japan had, with qualifications, accepted Allied terms. After a heated staff conference Halsey decided that, without firmer information, the following day's strikes were still on. Nevertheless, the prolonged negotiations were causing Third Fleet considerable logistical problems; Halsey recalled, "Our galleys were reduced to serving dehydrated carrot salad. If the war was over, we could provision on the spot; if it was not, we would have to retire, reprovision, and return."

On August 13 McCain's newly Anglo-American TF-38 launched 1,167 sorties against Tokyo, expending 372 tons of bombs and 2,175 rockets. Only seven planes and one pilot were lost, none to combat. Airborne opposition was virtually nil, as Lieutenant-General Kanetoshi Kondo, commander of Tokyo's defending 10th Hiko Shidan, "failed to urge his men to press the attack to the utmost, because it seemed absurd to incur additional losses with the war obviously lost and its termination due in a matter of days."

While TF-38 refueled on August 14, Halsey signaled McCain, "I intend striking same general target area on [the] fifteenth." McCain announced to TF-38, "Our orders to strike indicate the enemy may have dropped an unacceptable joker into the surrender terms. This war could last many months longer. We cannot afford to relax. Now is the time to pour it on." In fact the Western Allies had sunk their last Japanese ships of the war that day when submarines USS *Torsk* (SS-423) and USS *Spikefish* (SS-404) torpedoed *I-373* and two small escort ships in the East China Sea, killing 112 Japanese.

The following morning, August 15, Third Fleet launched its first strike of 103 aircraft at 0415hrs. At 0614hrs, with the first strike returning and second strike five minutes from the target, Halsey was ordered by Nimitz, "Air attack will be suspended. Acknowledge." Shortly afterwards an officer burst in waving a transcript—President Truman's official peace announcement.

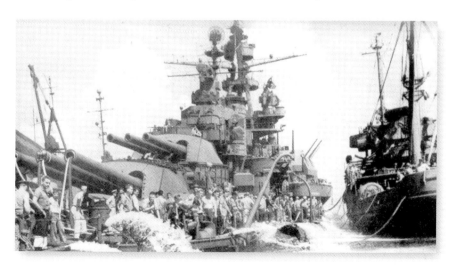

Battleship USS *Pennsylvania* (BB-38) torpedoed at Okinawa's Buckner Bay, August 12, 1945. With urgent damage control efforts underway, she is seen riding low in the water. Two salvage tugs assisted the massive pumping operation that ultimately saved her. Note the hoses trailing into her 14in. gun barrels. *Pennsylvania* would be towed to Guam for temporary repairs before reaching Puget Sound in September 1945. (US Navy)

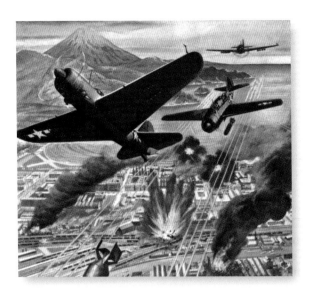

An artist's impression of US carrier planes bombing and strafing Tokyo during the summer of 1945. Although frustrated by typhoons and the two atomic bombings, TF-38 would launch nearly 4,000 strike sorties against the Japanese Home Islands in August 1945. (GraphicaArtis/Getty Images)

Halsey erupted boisterously, and "pounded the shoulders of everyone within reach." Halsey recalled, "My first thought at the great news was, 'Victory!' My second was, 'God be thanked, I'll never have to order another man out to die.'"

Within minutes four retiring *Hancock* Hellcats were attacked by seven Japanese fighters; the Hellcats shot down four without loss. Over Tokorazawa airfield northwest of Tokyo, 20 IJAAF Ki-84 "Franks" jumped six VF-88 Hellcats from *Yorktown*. The Hellcats shot down nine Franks but lost four Hellcats and their pilots. Rawlings' dawn strikes were intercepted by about 12 Zeros. Escorting Seafires shot down eight Zeros and lost one, while an Avenger shot down a ninth Zero. Seven TF-38 flyers never returned. Among them was Seafire pilot Sub-Lieutenant Fred Hockley, Royal Naval Volunteer Reserve, who was captured and summarily executed that evening by the IJA.

By 1020hrs all strikes were back aboard. Thirty-five minutes later Nimitz messaged his entire Pacific command, "Offensive operations against Japanese will cease at once." At 1110hrs *Missouri* ran up battle flags and sounded whistle and siren for one minute, joined by the Task Force, followed by Halsey's flag hoist, "*Well Done*." Almost immediately a D4Y Suisei popped out of the clouds gunning for *Indefatigable*, but was shot down by a pursuing American F4U Corsair, showering *Gambia* with wreckage. "*Splice the mainbrace*," Halsey signaled Third Fleet. "Do you know what that means?" *Iowa*'s Lieutenant Vernon C. Squires wrote his wife. "The onboard pharmacies knew; their whiskey stores soon ran out."[2] Halsey ordered, "Investigate and shoot down all snoopers. Not vindictively, but in a friendly sort of way." Third Fleet would splash eight attacking Japanese planes after the morning ceasefire, including four during Halsey's victory speech to the Fleet.

Meanwhile, at noon, August 15, Japan's national broadcast corporation NHK transmitted Hirohito's pre-recorded announcement that Japan had ceased hostilities. The four-and-a-half-minute speech proved a breathtaking masterpiece of obfuscation:

> After pondering deeply the general trends of the world and the actual conditions obtaining in our empire today, we have decided to effect a settlement of the present situation by resorting to an extraordinary measure … We declared war on America and Britain out of our sincere desire to ensure Japan's self-preservation and the stabilization of East Asia, it being far from our thought either to infringe upon the sovereignty of other nations or to embark upon territorial aggrandizement … Despite the best that has been done by everyone … The war situation has developed not necessarily to Japan's advantage.

Nowhere within the Emperor's soaring, magnanimous prose did the word "surrender" ever make an appearance.

2 Halsey's 1947 autobiography obscures this illegal order with a rather charming lie.

From July 1 to August 15 TF-38 had flown 10,678 offensive sorties and 12,878 CAP sorties, dropped 4,620 tons of bombs, and expended 22,036 rockets. TF-38 had lost a total of 338 aircraft—238 in combat and 100 operationally. The Royal Navy's TF-37 had flown 1,172 strike sorties and expended 460 tons of bombs and 56 rockets, while losing 43 aircraft.

During this period, TF-38 aircraft had sunk one fleet aircraft carrier, three battleships, two heavy cruisers, one light cruiser, three old armored cruisers, nine destroyer-escorts, and ten railroad ferries. Another three aircraft carriers, one battleship, four destroyers, one minelayer, ten destroyer-escorts, and two railroad ferries had been damaged. Japanese sources claimed that 1,386 aircraft had been lost in the air and on the ground (901 IJNAF, 485 IJAAF) plus another 1,980 planes lost operationally, for a total of 3,366 aircraft destroyed (2,606 IJNAF, 760 IJAAF) between July 1 and August 15. The Imperial Japanese Navy concluded the Pacific War having lost 334 warships and 300,386 men.

Among Japan's warlords there remained one last personal drama to play out. At Kyushu on the afternoon of August 15, a stunned Vice Admiral Matome Ugaki unexpectedly heard the Emperor's static-filled surrender announcement over the radio. "I've never been so ashamed of myself," Ugaki wrote in his final diary entry. Ugaki stripped his uniform of all distinction, save a samurai sword personally given to him by Admiral Yamamoto. Intent on flying the final kamikaze mission himself, Ugaki climbed into the backseat of a D4Y Suisei, incidentally taking the place of radioman Warrant Officer Akiyoshi Endo, who protested hysterically. "I have relieved you," Ugaki insisted, but Endo defiantly forced himself into the Suisei anyway. Deeply moved, Ugaki relented and let Endo squeeze in beside him. Ugaki's Suisei, seating three men in a plane meant for two, took off for the US fleet at 1800hrs, August 15. Endo transmitted Ugaki's farewell:

> I alone am to blame for our failure to defend the homeland and destroy our arrogant enemy. The valiant efforts of all officers and men the last six months have been greatly appreciated. I am making an attack at Okinawa where my men have fallen like cherry blossoms. I trust that the men under my command will understand my motives, will overcome all hardships of the future, and will strive for the reconstruction of our great homeland that it may survive forever.

At 1924hrs Endo made a final cryptic transmission that they were diving on an American warship. At about this time, USS *LST 296* was attacked by eight kamikazes off the islet of Iheyajima. In the fading twilight all eight Japanese planes were shot down or crashed into the sea. One of these was likely Ugaki's.

That evening the sun set on the greatest naval war of all time. Weeks later a high-ranking IJN planner admitted: "After the Coral Sea and Midway I still had hope. After Guadalcanal I felt we could not win, only we would not lose. After the Marianas we had little chance. After Okinawa it was all over."

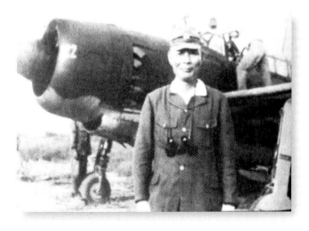

Stripped of all rank and insignia, Vice Admiral Matome Ugaki—IJN Fifth Air Fleet commander and kamikaze mastermind—poses a few hours before his own death on August 15, 1945. After the Emperor's unexpected surrender broadcast, a guilt-laden Ugaki spontaneously resolved to fly the final kamikaze mission himself. (Wikimedia Commons/Public Domain)

AFTERMATH

We have shown the Japanese and the world the superiority of our arms. We must now demonstrate to the world and the Japanese people the superiority of these standards of justice and decency for which we fought.

US Vice Admiral Frank "Jack" Fletcher

US Third Fleet and British Pacific Fleet battleships at anchor in Sagami Wan, August 28, 1945. Mount Fujiyama looms behind them. In the foreground is Third Fleet flagship USS *Missouri* (BB-63). Behind her is Fraser's flagship HMS *Duke of York* and then Rawlings' flagship HMS *King George V.* Farther back is USS *Colorado* (BB-45). Several US and British cruisers are also visible. (NARA 80-G-339360, via Naval History and Heritage Command)

Vigilantly maintaining standard wartime patrols, Halsey ordered TF-38 to "Area McCain" 100–200nm southeast of Tokyo. Between August 16 and September 2 TF-38 aircraft would fly 7,726 sorties, largely divided between CAP (61.7 percent), airfield patrols (20.6 percent), and POW relief (8.7 percent). Meanwhile, Allied forces prepared to undertake the peaceful occupation of Japan, Operation *Blacklist*, which MacArthur's and Nimitz's staffs had been working on for months. *Blacklist* would progressively occupy 14 major areas of Japan, the Tokyo area first, which would itself be carefully occupied in stages. Landing areas would be demilitarized and appropriately evacuated by Japanese forces before Allied landfall.

On August 16 and 17 TF-38 maneuvered in unusually tight formation for Operation *Snapshot*'s aerial photos of the Fleet. Then on August 18, the Royal Navy's TG-38.5 was joined by Admiral Fraser's TF-113, comprising battleship HMS *Duke of York* and destroyers *Wager* and *Whelp*. That same day, in a final spasm of defiance, a desultory IJNAF attack against a USAAF B-32 Dominator reconnaissance flight would mortally wound Sergeant Anthony Marchione—the last American killed in combat in World War II. Two days later Vice Admiral "Ted" Sherman broke his flag aboard USS *Wasp*, followed by Vice Admiral Jack Towers aboard *Shangri-La* on August 22. Overhead, massed fly-bys of Third Fleet aircraft were photographed for Operation *Tintype*.

TF-38 was reorganized for occupation. *Missouri* and three destroyers became TG-30.1 (Fleet Flagship Group). Battleship *South Dakota*, light carrier *Cowpens*, eight cruisers, and 13 destroyers were assigned to TF-35 (Support Force). Battleship *Iowa*, light cruiser

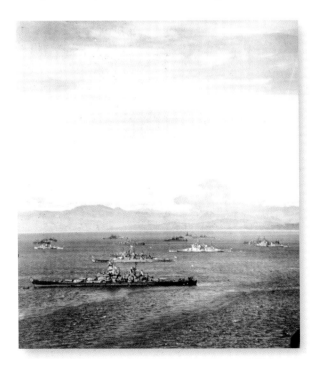

Operation *Blacklist*, late 1945

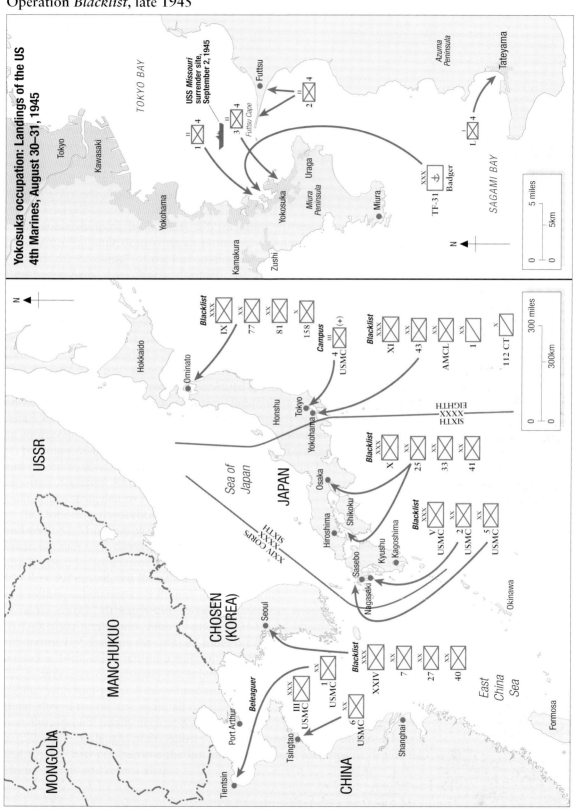

Yokosuka occupation: Landings of the US 4th Marines, August 30–31, 1945

USS *Missouri* surrender site, September 2, 1945

TOKYO BAY

Tokyo

Kawasaki

Yokohama

Futtsu

Futtsu Cape

Azuma Peninsula

Tateyama

Miura Peninsula

Uraga

Yokosuka

Miura

Kamakura

Zushi

TF-31 Badger

SAGAMI BAY

5 miles

5km

N

Yokosuka occupation: Landings of the US 4th Marines, August 30–31, 1945

N

Blacklist

IX 77 81 158

Campus

4 USMC

Blacklist

XI 43 AMCL 1 112 CT

Hokkaido

Ominato

Honshu

Tokyo

Yokohama

EIGHTH

SIXTH

Blacklist

X 25 33 41

Osaka

Shikoku

Blacklist

V USMC 2 USMC 5 USMC

Sea of Japan

JAPAN

XXIV CORPS

SIXTH

Hiroshima

Sasebo

Kyushu

Kagoshima

Nagasaki

Okinawa

USSR

MANCHUKUO

CHOSEN (KOREA)

Seoul

Beleaguer

III USMC

1 USMC

6 USMC

Port Arthur

Tsingtao

Blacklist

XXIV 7 27 40

Shanghai

CHINA

East China Sea

Formosa

MONGOLIA

Tientsin

300 miles

300km

89

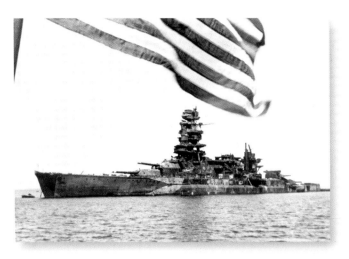

Though framed by an American flag, the battered *Nagato* still projects a formidable appearance immediately postwar. The day before the American occupation *Nagato*'s men destroyed the battleship's chrysanthemum bow crest to avoid it becoming an American war trophy. The Japanese wisely left her 16in. guns fore and aft, rather than facing the American occupation fleet. (Paul Popper/Popperfoto via Getty Images)

San Diego, and three destroyers were assigned to Rear Admiral Oscar Badger's TF-31 (Yokosuka Occupation Force). Light cruiser *San Juan* led Commodore Rodger Simpson's POW relief group, TG-30.6. British ships reorganized into either TF-37 or TG-30.2 (British Flagship Group).

Badger's TF-31 carried two US Marine regiments, three US naval infantry battalions (about 1,200 hastily trained TF-38 bluejackets), and one RN naval infantry battalion (37 officers and 499 men under RAN Captain H.J. Buchanan). MacArthur originally scheduled L-Day for August 28, but typhoons delayed landings to August 30. Transferred to *San Diego*, Lieutenant Squires wrote his wife: "Admirals Badger and Halsey—and doubtless, somewhere, Chester Nimitz—were laying their bet they could beat the Army to the goal line."

On August 27 TF-31 entered Sagami Wan and took aboard Japanese harbor pilots. Heavy air support was provided by TF-38 far offshore; the only US carrier that would enter Sagami Wan/Tokyo Bay was TF-35's *Cowpens*. That morning destroyer *Hatsuzakura* pulled alongside Halsey's flagship *Missouri* in Sagami Wan. "She was so frail, so woebegone, so dirty, that I felt ashamed of our needing four years to win the war," remembered Halsey. Carney, Halsey's chief of staff, gestured to *Hatsuzakura*: "You wanted the Jap Navy, Admiral. Well there it is." Halsey remembered, "We also had a view of Fujiyama … that evening its peak was clear, and the sun seemed to sink directly into the crater … the symbolism was strongly suggestive."

Under waves of Corsairs and Hellcats, 16 Okinawa-based C-46s touched down at Yokohama's Atsugi airfield at 0828hrs, August 28. Colonel Charles Tench and his US Army technicians were received by Lieutenant-General Seizo Arisue. Immediately greeting Tench's party was the banner "WELCOME TO ATSUGI FROM THIRD FLEET." In complete defiance of orders an unusually brazen *Yorktown* pilot had reportedly landed there the previous day and forced the Japanese to hang it.

That same morning, led by minesweeper USS *Revenge*, TF-31 weighed anchor and rounded the Miura Peninsula into Tokyo Bay; an officer aboard *San Diego* noticed civilians waving white handkerchiefs through the trees as TF-31 passed. By 1200hrs *San Diego* was in Tokyo Bay and anchored off Yokosuka. The night before, *Nagato*'s crew had towed their battleship out into the harbor so that *Nagato* would not meet the Americans passively tied up dockside. Halsey signaled that all Third Fleet was to light ship that night, but Badger insisted TF-31 darken as usual.

The following morning, August 29, ten Hellcats escorted 35 C-46s, C-47s, and C-54s that began landing at Atsugi at 0935hrs. By evening Tench commanded 150 US engineers and their equipment at Atsugi. With mere hours to build airstrips long enough to land waves of B-29s and C-54s, Tench would recruit Japanese workers to build the necessary runways overnight. That same morning *Missouri* and *Iowa* cruised up Sagami Wan into Tokyo Bay, followed by *South Dakota*, *Duke of York*, transports, smaller craft,

and escort carrier HMS *Speaker*. That afternoon Nimitz arrived by plane from Guam. Two days earlier a US picket boat had inadvertently picked up two escaped British POWs; based on the POWs' horrifying reports, Halsey requested to initiate Operation *Swift Mercy*, the POW relief landing, one day early. "Go ahead," Nimitz responded, "General MacArthur will understand." Within hours Simpson's TG-30.6 began liberating Tokyo area POW camps. Meanwhile, on August 27, Third Fleet and Twentieth Air Force B-29s had begun air-dropping the first of 4,470 tons of food and medical supplies to 63,500 Allied POWs in camps scattered across Japan, Korea, and China. Third Fleet's drops included many handwritten notes of encouragement to the prisoners, who found the gesture deeply moving.

At 0930hrs, August 30, TF-31 landed the US 4th Marine Regiment on Tokyo Bay's deserted waterfront, although "down in Sagami Wan, a few miles away, every heavy ship was awaiting word to start shooting." At last *San Diego* weighed anchor, steamed past *Nagato*, and moored at Yokosuka. Lieutenant Squires reflected, "For the first time in the history of Japan, a 'barbarian' man-of-war, with unsociable intentions, had control of a piece of the Empire." With NBC and CBS journalists reporting live to an American radio audience, US marines raised the Stars and Stripes over the Yokosuka Naval Yard. Halsey's flag joined them later that day, as Nimitz now flew his flag from *Missouri*.

Meanwhile, *Iowa*'s executive officer Captain Cornelius Flynn led a party out to *Nagato*. At 0930hrs the Americans boarded *Nagato* with grappling hooks and icily confronted Captain Shuichi Sugino on the battleship's quarterdeck. Flynn commanded Sugino to lower *Nagato*'s colors. When Sugino delegated the unpleasant task to a rating, Flynn snarled, "No. Haul them down yourself!"

The landings continued. The first echelon of 7,000 11th Airborne Division combat troops would touch down at Atsugi early on August 30, and planes continued arriving at three-minute intervals. Vice Admiral Theodore Wilkinson's III Amphibious Force convoy landed the US 1st Cavalry Division at Yokohama on September 2. Their entry into Tokyo would be delayed until September 8, to allow Japanese forces time to evacuate.

The 0900hrs, September 2 surrender itself, of course, has been well documented. MacArthur was named Supreme Allied Commander and master of ceremonies. Nimitz signed the surrender document on behalf of the United States; Fraser signed on behalf of the United Kingdom. Immediately after MacArthur concluded the sober 24-minute ceremony, the Supreme Commander put his arm around his old South Pacific buddy Halsey: "Now where are those planes, Bill?" Almost on cue, 450 TF-38 planes thundered overhead, followed by hundreds of USAAF B-29s.

Towers had relieved McCain as TF-38 commander on September 1, but Halsey had insisted the embittered McCain stay for the surrender, for which McCain was ultimately grateful. By September 5 McCain was back home in Coronado, California. The following

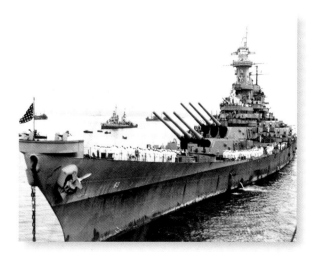

Battleship USS *Missouri* (BB-63) anchored in Tokyo Bay on September 2, 1945 as part of the surrender ceremony officially ending World War II. Although controversial, the choice of *Missouri* as the surrender location nevertheless made sense: *Missouri* was the Third Fleet flagship, President Truman was a Missourian, *Missouri* possessed enormous deck space, and the handsome, unusually sleek battleship was certainly photogenic. (NARA SC 210649, via Naval History and Heritage Command)

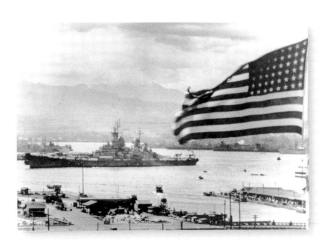

Victory at last. Framed by the American flag, battleship USS *Missouri* enters Pearl Harbor, late September 1945. The recent Japanese surrender had suddenly made the barely year-old battleship the most famous ship in the world. Although a heady homecoming tour of the United States mainland awaited, an uncertain postwar future already loomed over the Allies' triumph. (Naval History and Heritage Command)

day McCain invited his old TF-38 operations officer Commander Jimmy Thach over to visit. That afternoon, before Thach went home, McCain said, "I'm not feeling too well. I think I'll go in and get some rest." A few hours later Thach received a telephone call that McCain had died of a heart attack. Thach mourned, "I felt like I'd lost my father for the second time."

That same day, September 6, Vice Admiral Frank "Jack" Fletcher's North Pacific Force occupied Hokkaido and Honshu's Ominato naval base. By late September all of Hokkaido and much of Honshu had been occupied by US Eighth Army. US Fifth Air Force and an infantry battalion had established an airhead at Kanoya airfield on September 2, and by September 6 LSTs had begun landing the first US Sixth Army troops at Kyushu. Vanguard units of the US 41st Infantry Division secured the Kure Naval Arsenal on October 6, while the US 24th Infantry Division would land at Shikoku's Matsuyama on October 22.

Spruance had relieved Halsey of command on September 20 and Third Fleet had once again become Fifth Fleet. At 1100hrs, October 15, Halsey's flagship *South Dakota* passed beneath San Francisco's Golden Gate Bridge, fulfilling MacArthur's farewell: "When you leave the Pacific, Bill, it becomes just another damned ocean!" Welcomed by hundreds of thousands of spectators, battleships *Missouri* and *New York*, carriers *Enterprise* and *Monterey*, and many others would reach New York in time for Navy Day, October 27, 1945. Nearly 50 warships stretched seven miles up the Hudson to be personally reviewed by President Harry Truman.

Once the United States committed to a total war of unconditional surrender, there could only be one outcome. The question was how it would transpire and at what cost. One observes that the USAAF's B-29 campaign, however spectacular, was nonetheless a 20-year-old (if technologically updated) element of the comprehensive, USN-dominated War Plan Orange of air–sea blockade and bombardment. Furthermore, the XXI Bomber Command's B-29 bombardment of the Home Islands was only possible after 32 months of vicious naval, air, and amphibious combat resulted in the Americans' July 1944 conquest of the Mariana Islands. Less certain is whether, by mid-1945, either the atomic bomb or an invasion had ever been required to ensure the unconditional surrender of Japan. This question remains contentious and forever unresolvable; as with the original wartime debate, the conclusions remain stubbornly partisan. But the conclusion of the largest single Allied postwar study, the 1946 *United States Strategic Bombing Survey*, cannot easily be dismissed:

> Based on a detailed investigation of all the facts and supported by the testimony of the surviving Japanese leaders involved, it is the Survey's opinion that certainly prior to 31 December 1945, and all probability prior to 1 November 1945, Japan would have surrendered even if the atomic bomb had not been dropped, even if Russia had not entered the war, and *even if no invasion had been planned or contemplated.*

THE BATTLEFIELDS TODAY

The Tokyo-area Nakajima aircraft plants bombed so heavily in February 1945 have been rebuilt and now produce Subaru cars and Sanyo televisions. The world-class Kure Maritime Museum ("Yamato Museum") and Japan Maritime Self-Defense Force Kure Museum currently stand atop the former Kure Naval Shipyard that built *Yamato* and was subsequently ravaged by Halsey's carriers in July 1945.

Nagato, a US war prize, steamed to Bikini atoll in April 1946 for use as an atomic bomb target ship in Operation *Crossroads*. *Nagato* survived the July 1, 1946 Able airburst with little damage. However, the subsequent underwater Baker blast on July 25 caused mild but progressive flooding, and *Nagato* capsized and sank on the night of July 29/30, 1946. *Nagato* now rests upside down in 160ft-deep Bikini Lagoon. In 2007 she was named one of the world's top diving spots by *The Times*.

The campaign's very last warship on active duty was battleship USS *Missouri* (BB-63), which was finally decommissioned on March 31, 1992. From 1967 through 1989 Independence-class light carrier USS *Cabot* (CVL-28) served in Spain's *Armada Española* as the carrier *Dédalo*. She was returned to the United States in 1990. Attempts to preserve *Cabot* as a museum failed and she was scrapped in 2002. The last surviving Royal Navy warship that took part in the 1945 campaign, destroyer HMS *Grenville*, was scrapped in 1983. However, 21 American warships that participated in the final naval siege of Japan have survived as museums in the United States.

SELECT BIBLIOGRAPHY

Research for this title relied primarily on 60-plus US war diaries, action reports, and operations plans dated between February 1 and August 15, 1945. They were authored by relevant command staffs, particularly Third Fleet, Fifth Fleet, TF-38, TF-58, TF-95, constituent Task Groups and Carrier Divisions, BatRon-2 (TF-34/TF-54), constituent Battleship Divisions, various Carrier Air Groups, and DesRon-50. Further sources included official histories, plans, intelligence summaries, academic studies, and postwar reports produced by the USN, USAAF, US Army, USMC, the United States Strategic Bombing Survey, and the US federal government. Additional noteworthy sources follow below:

Books/Histories
Buel, Thomas B., *The Quiet Warrior*, Little, Brown, and Company, 1974
Cate, James Lea and Craven, Wesley Frank, *The Pacific: Matterhorn to Nagasaki June 1944 to August 1945*, Office of Air Force History, 1983
Halsey, Fleet Admiral William F., *Admiral Halsey's Story*, McGraw-Hill Book Company, Inc., 1947
Hata, Ikuhiko; Izawa, Yashuho; and Shores, Christopher, *Japanese Naval Fighter Aces 1932–45*, Stackpole Books, 2013

Hobbes, David, *The British Pacific Fleet: The Royal Navy's Most Powerful Strike Force*, Naval Institute Press, 2017

Holmes, Tony, *Hellcat vs Shiden/Shiden-Kai: Pacific Theater 1944–45*, Osprey Publishing Ltd, 2019

Miller, Edward S., *War Plan Orange: The U.S. Strategy to Defeat Japan, 1897–1945*, Naval Institute Press, 1991

Morison, Samuel Eliot, *Victory in the Pacific 1945*, Castle Books, 2001

Reynolds, Clark B., *The Fast Carriers: The Forging of an Air Navy*, Naval Institute Press, 1992

Wooldridge, E.T. (ed.), *Carrier Warfare in the Pacific: An Oral History Collection*, Smithsonian Institute Press, 1993

Articles/Essays

Coox, Alan C., and Bauer, K. Jack, "Olympic vs Ketsu-Go," in *Marine Corps Gazette*, Vol. 49, No. 8, August 1965

Coox, Alvin D., "Air War Against Japan," in *Case Studies in the Achievement of Air Superiority*, Air Force History and Museums Program, 1994

Mathews, Commander Edward J., "Bombarding Japan," In *U.S. Naval Institute Proceedings*, Vol. 105, February 1979

Squires, Vernon C., "Landing at Tokyo Bay," in *American Heritage*, Vol. 36, Issue 5, 1985

Tully, A. P. "Tony", "*Nagato's* Last Year: July 1945–July 1946," Combinedfleet.com, 2003

Websites

http://www.armouredcarriers.com/
http://www.alternatewars.com/
http://www.combinedfleet.com/
http://www.cv6.org/site/association.htm
https://www.fold3.com/
http://pwencycl.kgbudge.com/
http://www.ibiblio.org/hyperwar/
www.mighty90.com
http://www.navsource.org/
http://pacific.valka.cz
https://ww2db.com/
http://www.ww2pacific.com

LIST OF ABBREVIATIONS

AP	armor-piercing
BatRon	Battle Squadron
BPF	British Pacific Fleet
CAP	Combat Air Patrol
CINCPAC–CINCPOA	commander-in-chief US Pacific Fleet and Pacific Ocean Areas
CVG	carrier air group
CVLG	light carrier air group
DesDiv	Destroyer Division
DesRon	Destroyer Squadron
ETF	Experimental Task Force
HVAR	High Velocity Aircraft Rocket
IGHQ	Imperial General Headquarters
IJA	Imperial Japanese Army
IJAAF	Imperial Japanese Army Air Force
IJN	Imperial Japanese Navy
IJNAF	Imperial Japanese Navy Air Force
JCS	Joint Chiefs of Staff
LSG	Logistic Support Group
nm	nautical miles
RAN	Royal Australian Navy
RCT	Regimental Combat Team
RN	Royal Navy
ServRon	Service Squadron
SWPA	South-West Pacific Area
TF	Task Force
TG	Task Group
TU	Task Unit
UDT	Underwater Demolition Team
USAAF	United States Army Air Forces
USN	US Navy

VT	Variable Time (fuze)
WPO	War Plan Orange

Air squadron designations

VB-	bombing squadron
VBF-	fighter-bomber squadron
VC-	composite squadron
VF-	fighter squadron
VMF-	Marine fighter squadron
VT-	torpedo squadron

Hull classifications

BB	battleship
BBCV	battleship-carrier
CA	heavy cruiser
CB	large cruiser
CC	command cruiser
CL	light cruiser
CV	fleet aircraft carrier
CVE	escort aircraft carrier
CVL	light aircraft carrier
DD	destroyer
DE	destroyer-escort
SS	submarine

Landing ships

LSD	Landing Ship Dock
LSM	Landing Ship Medium
LST	Landing Ship, Tank
LSV	Vehicle Landing Ship

INDEX

Page numbers in **bold** refer to illustration captions.